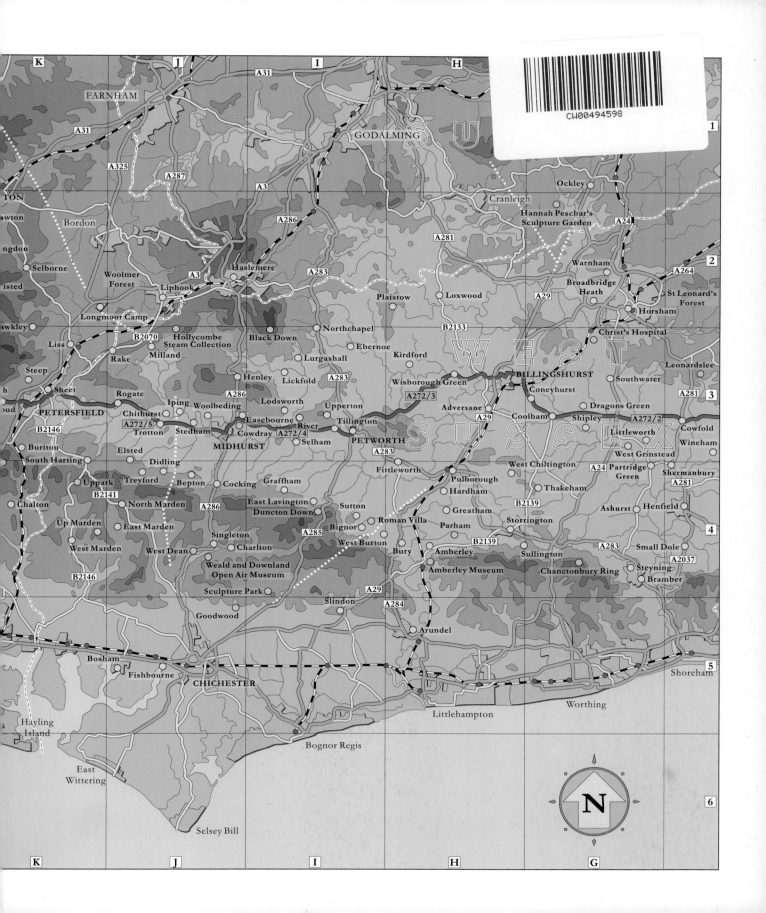

CW00494598

K · J · I · H · U · 1

FARNHAM

A31

GODALMING

A325

A287

A3

Ockley

Cranleigh

Bordon

A286

Hannah Peschar's
Sculpture Garden

A24

Selborne

A281

Warnham

A2

ngdon

Woolmer
Forest

Haslemere

A283

Plaistow

Loxwood

Broadbridge
Heath

A264

isted

Liphook

A3

Longmoor Camp

A29

Horsham

St Leonard's
Forest

wkley

Hollycombe
Steam Collection

Black Down

Northchapel

B2133

Christ's Hospital

Liss

Milland

Ebernoe

Kirdford

W E S T

Leonardslee

Steep

Rake

Henley

Lickfold

Lurgashall

A283

Wisborough Green

BILLINGSHURST

Southwater

A281

3

Sheet

Rogate

Iping

A286

Lodsworth

A283

Coneyhurst

Dragons Green

PETERSFIELD

Chithurst

Woolbeding

Upperton

Adversane

A29

Coolham

Shipley

A272/2

Cowfold

B2146

A272/5

Trotton

Stedham

Easebourne

River

Tillington

A29

S U S S E X

Littleworth

Wineham

Buriton

Cowdray

A272/4

Selham

PETWORTH

West Grinstead

South Harting

Elsted

MIDHURST

A283

West Chiltington

A24

Partridge
Green

A281

Uppark

Didling

Fittleworth

Pulborough

Thakeham

Ashurst

Henfield

Chalton

Treyford

Bepton

Cocking

Graffham

Hardham

B2139

Storrington

Sullington

4

B2141

North Marden

A286

East Lavington
Duncton Down

Sutton

Greatham

Small Dole

A2037

Up Marden

East Marden

Singleton

Charlton

Bignor

Roman Villa

Parham

B2139

Chanctonbury Ring

Steyning

West Marden

West Dean

West Burton

Bury

Amberley

A283

Bramber

B2146

Weald and Downland
Open Air Museum

A285

A29

Slindon

A284

Amberley Museum

Sullington

Sculpture Park

Goodwood

Arundel

Shoreham

5

Bosham

Fishbourne

CHICHESTER

Worthing

Hayling
Island

Littlehampton

East
Wittering

Bognor Regis

N

6

Selsey Bill

K · J · I · H · G

'Ivy', Milland

Pieter and Rita Boogaart

A272

An Ode to a Road

PALLAS ATHENE

contents

TO HARTINC

To
Rita

THOU BLESSED CHRIST
SPEED THEE TO-DAY
AND LIFT THY HEART UP
ALL THE WAY

a user's guide

The A272 and the areas to the north and south of the road are described in three separate bands of text per chapter. Each can be read independently, and they are also co-ordinated on the page, so that at any point on the road you can see what there is immediately to the north and south of you.

The A272 itself is described in the central section of the pages, starting at Poundford in East Sussex and running west to Stockbridge.

If you are an armchair A272 lover, you may find it easier to tackle the book chapter by chapter, middle, north, south.

Sights up to six or sometimes seven miles north of the road are described in the upper sections of the pages

North of ┊ the A272

A272

South of ┊ the A272

NOTES

NOTES

Sights up to six or sometimes seven miles south of the road are described in the lower sections of the pages

The margins to the left and right of these texts are used for notes: biographical details, stories, poems, technical terms

Stars ★ in the text refer to an addendum, printed on pages 205-259

to this guide

Westward. When I first thought about it, the cry 'Go West, young man!' sprang to mind. I didn't know why, so I looked it up. It's a quotation from a 19thC American journalist called Horace Greeley and was taken from his *Hints toward Reform*. That does not particularly sound as if one would gladly follow the advice. The full quotation serves to explain the idea a bit better perhaps: 'Go West, young man, and grow up with the country.'

There has always been a deep-seated feeling of longing for the west in European culture, perhaps related to the fact that most peoples on the continent have moved from east to west. Civilization has often moved westward. In our case we know about Babylon and Egypt, then Greece and on to Rome. The direction is clear: it's the same as the course of the sun. The ideal seems to be: Westward Ho! Off into the sunset. Where the spirit should find rest. The pyramids were built on the western side of the Nile. The Celts mainly moved westward. Traces of this ancient race are still to be found in the west of western Europe: the west of France and Spain, and in Britain in Cornwall, Wales and the Scottish isles, or even further, in Ireland. And for the Irish again they are in the west of the island, in counties Kerry, Galway, Mayo and Donegal. 'Go West, young man!': in the United States again western civilisation moved westward. The Far West was conquered, as celebrated in books and films called Westerns. Pioneers moved from the east coast, where the first ships landed, to what is still often regarded by Americans as the promised land: California, Hollywood, what have you.

Maybe we tend to move from east to west because the earth itself moves from west to east (the sun standing still) and we want to compensate.

From East to West

Thinking of a road running from east to west one is bound to consider at some point why it doesn't run from west to east. Of course it does, but that direction feels wrong here. The choice for **westward** was made on instinct.

But apart from this apparently inherent urge to go westward there are also logical reasons for choosing to follow the A272 in this direction. The road comes in areas where road numbers generally start with A2.... on the eastern side, and A3.... on the western side. If our road had started in the west its number would have begun with A3.... . This is because roads are supposed to radiate from London clockwise. In the south of England road numbers are in ascending order from east to west. The A272 meets the A22, A23 and A24 in that order.

PREFACE

England's Epitome

There is something incongruous in choosing a road as the subject-matter for a book. A road is not supposed to be an objective, a goal. A road takes you to where you want to be. It's not in itself a destination.

I think my main motive for writing about a road is gratitude. From the first holidays my wife and I had in England, long ago in the mid-1960's, I have tremendously enjoyed driving around. I used to teach English language and literature, and developed a special affection for the country and the people, while my wife Rita is a versatile and enthusiastic art historian. So anywhere was interesting really, and we travelled all over the place. The first time we came over by car we saw Dover, Land's End and John O' Groats; and all sorts of places in between, to see where we would like to go back. We enjoyed the roads themselves as well, and their **quality**. English roads are beautiful, a fact the English may need to be reminded of. Traffic may not be beautiful; the roads are. The A272 is a case in point.

Okay, so why write about the A272 specifically? The best answer to that question may be the counter-question: why not?

That the number A272 has a nice ring to it can't be sufficient. My wife and I had done bits of it in the past at some times and other bits at other times, and we liked it better than most, but there were other roads we particularly liked as well. The A25 for instance, the A466 from Monmouth to Chepstow or the A9 to John

Acknowledgements

In gathering the material for this book I have often had to rely on information from all sorts of sources. I am not a very gullible person. Every bit of information in this book is correct as far as I have been able to ascertain. I have always tried to get second opinions or look facts up on maps, in archives, books and brochures. If I have been misinformed I'm sorry and I hope this doesn't cause trouble for you. I have enjoyed reading lots of **books** to prepare myself for this one on the A272. New books and second-hand books, on general and specific subjects. ★

Fortunately most towns and villages nowadays have produced their own guide books and story books, as have most gardens that are open to the public, and estates, even some of the

Another down-to-earth practical reason for following the road westward is that this way we have the only city, Winchester, an obvious highlight, near the end of our journey. It gives something to head for, and climaxes should be near the end, not at the beginning of a journey.

*A*nother reason could be that foreigners *come into the country in the east. If we manage to guide them along this road, they will* have enjoyed a fair and representative part of England before we release them on their way to wherever they wanted to be. Probably popular holiday destinations like Devon and Cornwall, or Wales. My guess would be that once they have started on our road they will get hooked on it and won't get much further than the A272 and its immediate surroundings. Quite rightly, too. Since the A272 is England's epitome they*

Quality. The quality of British roads is generally high. Additionally attractive is the fact that minor roads twist and turn and go up and down. That may not be very convenient for English people on their way to work, but it is very pleasant for holiday-makers. Especially for Dutch holiday-makers, since in most of the Netherlands one can drive a hundred straight miles in almost any direction without ever noticeably getting a foot higher, except for bridges. Not two hundred miles, by the way, for by then you have left the country.

Books: a full or even a select bibliography would be inappropriate here. On travel and on the subject of roads there are the classics: Daniel Defoe, William Cobbett, E. V. Lucas, Edward Thomas and of course Hilaire Belloc (who lived along the A272). General reference works like AA books on towns and villages and more specialised books on architecture, follies, history, mythology, sculpture or gardens, or works like the *Oxford Illustrated Literary Guide* have also been a help. Any good second-hand bookshop will have a shelf full of regional and local stuff. Some of these books may be regarded as classics too, but a good deal of the information is too outdated to use them as guidebooks. On Sussex clearly the best recent books are by David Arscott, on his own for *The Sussex Story* and the 'Curiosities' books, and in collaboration with Warden Swinfen, for the 'Hidden' series headed by *Hidden Sussex*. On Hampshire there are *Hidden Hampshire* by John Barton and *Hampshire Curiosities* by Jo Draper among others. For the tourist the three relevant *Philip's County Guides* are the most attractive and comprehensive books.✪

O'Groats. Beautiful roads. The A272 is only marginally special as a road. But for some reason it always filled me with a sense of nostalgia when we came across it or when I saw it on a map. It's a bit like falling in love and trying to explain why in a level-headed and rational way. I could argue that it is a country road exactly 90 miles long. Your map may give a slightly different figure, but drive it and you'll see that I am right: it's 90 miles. A gross of kilometres: 144. Nice figures, but so what? I could also argue that it runs almost exactly east-west. It wraps itself round the fifty-first degree of latitude in a most sensuous manner. That may be a bit rare, but it's nothing to write home about, let alone a book. I could argue that it is in the south of England, not too far from London. Not bad at all, of course. Far enough from the capital to be in the country, close enough to have ties with London. It's not too far away from the continent either. Is that good? I could also say that it runs between two ranges of hills: the North Downs and the South Downs. Ah, that's a bit better. That tells us that we might expect to see some lovely scenery.✳

*B*ut what is perhaps most special or surprising about the A272 is that it seems to *go on all the time. Looking at it on a map you see it going in the direction of a certain town or another road as if it was going to stop there, but then looking at the other side it appears to go on again, often slightly more to the south or to the north. That happens lots of times. This road continually survives itself. For ninety miles it keeps cropping up again, coming back undefeated. A tenacious whole-hogger. But all these reasons put together would not provide a valid excuse for writing a book about it.

*H*ere follows the real reason. I had this vague idea when I started my investiga-*tions, but now I know for certain. With hindsight I can unequivocally say why I have come to love this road. It represents England. It epitomises England.

private ones. For other local history books I have usually relied on what the libraries had to offer. There have been only few occasions when the Ordnance Survey Landranger maps 1:50 000 gave insufficient information, but then there were always the County Record Offices. Church guides: I have read well over a hundred, I should think, and of course Tourist Information brochures and booklets, whose quality varies enormously, but which were always cheerfully provided.*

*G*etting the right information has not al-*ways been easy. Nice, polite letters often remain unanswered. Parish Council clerks are an oblivious race. Higher authorities are better. Some went out of their way to accommodate me. At other times I got the impression that civil servants are very busy bees. Busy Bs with*

Welcome. Let me give you a few examples of how I have fared. I had read Edward Thomas in *The South Country*: 'But the South is tender and will harbour any one; her quiet people resent intrusion quietly, so that many do not notice the resentment.' I was reminded of these words when I told a lady, who had very kindly provided me with the key to a church door, that I was thinking of writing a book. She scowled. 'You will only bring in more tourists,' she said. And her manner suggested: 'You will only bring in more bloody tourists.'

And then there was my B&B lady Magda in Winchester. I had settled the bill and said goodbye, and had just packed the car and was ready to go, when she came running across the street, waving a £20 note. 'Glad I caught you in time,' she panted and handed me the money, explaining that she thought I had paid too much. Instead of my money she stole my heart.

Literary figures. Without exaggeration it can be said that virtually all the best of English authors lived here, at least for a while. Even Dickens and Shakespeare stayed for longish times in Hampshire. Shakespeare with his patron in Titchfield, while Dickens was born in Portsmouth and also stayed in Brighton. They must have crossed the A272 lots of times and simply declined the opportunity to enrich the road's history by dying here.♣

Abbreviations. Don't you wish there were a simple two-letter code for all the counties as they were before 'conservative' governments messed them up? I've got one. Is this proof that I'm a foreigner?

will have seen all of England, at least everything that is important about England, by the time they have reached Stockbridge. Well, let's not begrudge them a few days of London on their way back home.

So we go west: the instinctive, logical and practical way. And the nostalgic way. For some reason, also instinctive, one supposes, going west has often been celebrated by poets and thinkers as taking an almost inevitable course. Allow me to give you a few examples. Mary Elizabeth Coleridge spoke lovingly of a 'woman with the West in her eyes', when describing a lady who followed her destiny. We'll have the West in our eyes. Another Romantic, William Wordsworth, said:

> *And stepping Westward seemed to be*
> *A kind of heavenly destiny.*

It's England in short. It captures the Englishness of English life. The rest of this book may be needed to prove this to you, but we'll have a lovely time doing it. Enjoy. Join the journey. We'll follow the road from east to west. From its humble beginnings past the good, the bad and the ugly, the beautiful, the trivial and the glorious, to the quiet end. Past Uckfield and Cuckfield, Wineham and Twineham, past Littleworth and Fittleworth towards Pittleworth. Past Ovington and Avington. And in the distance we'll have quick looks at places like Lewes, Brighton and Chichester, at Barcombe and Balcombe, Duncton, Runcton and Buncton, Havant and Lavant, Walderton, Walberton and Warbleton. We'll be in East Sussex, West Sussex and Hampshire. In towns, suburbs, villages and hamlets. And mainly on the road, travelling. Doing the A272, doing England.

What (not) to expect

There are seven chapters for seven stages in the route. Each chapter is subdivided into two main parts. On the one hand the A272 road and everything immediately alongside, let's say within ambling distance, and on the other hand anything else interesting in the surroundings, with very few exceptions up to 6 or 7 miles (10 kilometres, 10 minutes by car) from the A272. The emphasis will be on what can be experienced, things that are open to the public. Sometimes I'll give details about history or atmosphere. When I mention a poet in association with a village, it generally implies that the village was a source of inspiration. (It's amazing by the way how many famous people have chosen Sussex or Hampshire to die in. Especially **literary figures**.)

So mainly the book will be about things you can see for yourself. For full historical details on the landscape, on places, people and their stories, on facilities for

names like Brittas and Bucket, not to mention the occasional B'stard. Some people should simply be ashamed of themselves. But I mustn't exaggerate or even grumble. On the whole I have been generously helped with my enquiries.

People along the road, usually inhabitants of the area and sometimes in an official capacity (such as guardians, caretakers, guides and tourist information officers) have made me feel

welcome. Telephones have been answered, letters written, photocopies made. I am very grateful to you all. I apologise if I have made a nuisance of myself, trying to get information. I would hate the idea of having contributed to the feelings of xenophobia that the English sometimes associate with themselves. Wrongly.

Just as it may be useful to remind you British people that you have beautiful roads, it may

Who would want to argue with that? But for those who are still sceptical I can quote some people who actually lived near the road and of course know best. Rudyard Kipling lived quite near the beginning of the A272 and he was obviously on the right track when he wrote about Sussex:

The Weald is good, the Downs are best,
I'll give you the run of 'em, East to West.

But the poet Edward Thomas, who lived at Steep, expresses it most beautifully in his book called The South Country. *I quote: 'Even in the bosom of the South Country, when the tranquil bells are calling over the corn at twilight, the westward-going hills, where the sun has fallen, draw the heart away and fill us with a desire to go on and on forever, that same way.' What a clincher.*

Attractions. This book is not primarily about tourist attractions, even though I will mention them and often describe them. It's about a typically English part of England, about the land and the people. And of course I have an eye out for literary links, for art and for Dutch connections here and there. But the purpose of a book like this would be defeated if it were full of practical details extraneous to the description of the road and its surroundings. In other words, I'll tell you where you can enjoy a ride on a steam train, but I won't give you a timetable.

the disabled and on thousands of varying opening times and admission prices for tourist **attractions** you are referred to other sources of information. I recommend **tourist offices** (usually called TIC's nowadays), when they are open. The ones that are part of libraries may not be all that well equipped, but the assistants are usually helpful and generous with their time.

This is all a selection. It couldn't but be. It's my choice of the wealth of England, based on our experience and on our love for the country. I am looking forward to your comments. If you think I deserve a slap on the wrist or if you know a folly I don't know or whatever: please write.

Practicalities

Finally, let's agree on a few arrangements. ES means East Sussex, WS = West Sussex, HA = Hampshire. These are practical **abbreviations** that I would like to see more often (instead of some irregular derivations from Latin names), to be used after place-names wherever it might be enlightening. And 16thC means: sixteenth century (or sometimes sixteenth-century).

Brackets [] are used to give an indication of the correct pronunciation of place-names, with the vowel in the stressed syllable in bold print. I have based the system on how (let's be politically correct here) an English speaking person would properly pronounce vowels and consonants, and it is supposed to be foolproof. I'll use it whenever I suspect that someone, anyone, might be uncertain. See also p. 21.

Bold Print (no note this) is used for landscape features, towns, villages, estates that are open to the public etc. that are discussed in the normal running text. It is also used for names and terms that might be unfamiliar and are discussed in the margins (perhaps I should say: the cyclepaths of the pages): the **notes.**

Tourist offices. There is an excellent network of Tourist Information Centres in the south-east. For the eastern part of our road the best TIC is in Lewes. Haywards Heath and Billingshurst have tourist information in the libraries. Both Petworth and Midhurst have their own tourist offices, while Chichester has the main TIC for West Sussex. Petersfield has its own, as does Winchester of course for the city and the county of Hampshire. Do make use of them for help with accommodation or detailed information on places to visit locally.

Notes. There are two types of notes in the book. Most notes are very specific and refer to terms or names that occur on that particular opening only. Other notes are more general and expand on terms found throughout the book. In order to prevent the first few chapters from getting clogged up with these more general notes they have been spread equally through the book. If a topic is explored in a note somewhere in the book you will find it in the index.

be useful to tell you that you are very friendly to foreigners. People have been extremely kind. A few must be mentioned by name. Alexander Fyjis-Walker for believing in the project. Ron Martin and John Stringer. Philippa Stevens, in whom I honour all librarians. Arno Cools and Rob Remmen. Wim Boerdijk. Also David Arscott and Warden Swinfen, not only for helping me by writing trustworthy and enjoyable books about

Sussex, but for being kind and generous with advice as well. And a special word of thanks to the Plumridges: Sally, Norman, Matthew and (as always) Andrew, for putting us up and putting up with us. But, last and first, and always in between, I am most grateful to my wife Rita. For her care for the illustrations and the decrassification of the text of this book, for her companionship and for sharing her love of life.

Ridgeways. A number of them, thousands of years old, have last century been opened again as long-distance footpaths. Most of them, like the Icknield Way and Fosse Way, radiated from the area of Salisbury Plain, where we find our oldest monuments. Sussex and Hampshire, for lots of reasons like denser population, better climate, fertile land and natural resources, were better provided with good trackways than most regions: the North Downs Ridgeway, from Canterbury, and the South Downs Ridgeway, from Beachy Head, both leading to Winchester and then Stonehenge, towards what we may call the Heart of Ancient England.

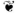

Care. The general disrespect for roads is well illustrated by the story told in *Medieval Panorama* (G. G. Coulton, 1943), in which a miller told his servants to get a certain type of clay for him, and they dug a pit where the road also happened to be. The pit (eight foot deep) filled with water during the rest of the day and a glover on his way home from the market later fell into it and drowned. This was near Aylesbury in 1499, where the roads were considered good compared to Sussex!

Roman Road, end of A272

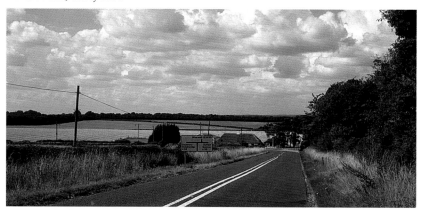

Maps

Maps and atlases have always fascinated me. In fact one of the reasons for writing this book was that the A272 looked so remarkable to me on the map. When I see an Environment Study of Bypass Options for Billingshurst 1994 in the local library, I'm lost to other causes for the next hour. Historical maps are always beautiful. But we can't go back to medieval maps and look for certain roads on them. Not only because there were so few of them. Maps did not normally show roads, they just showed the lie of the land and rivers at that time. After the Castorius-Peutinger map (which almost schematically showed the Roman roads from town to town throughout the entire Roman Empire, with the obstacles and various types of fortifications)

INTRODUCTION

Roads

There have always been connections from one settlement to the next, even before the dawn of civilization. Ancient trackways began when people started to travel longer distances regularly. The safest and most reliable routes were along the watersheds. High ground was more open with fewer obstacles in the shape of trees, bushes, animals or water, and was better for use in all seasons. And staying just below the horizon you were less visible and less vulnerable on these **ridgeways.**

England was gradually occupied by tribes coming over from the continent, like the Angles and the Saxons. The process of infiltration always followed much the same pattern, and concentrated on two major **centres:** Winchester and Canterbury. The Romans before them had needed north-south connections, towards places like London, Silchester and Cirencester. They liked their roads straight and they liked them paved, if only for military purposes. The A272, going east-west in the heart of Sussex and Hampshire is intersected by a number of Roman roads, a good example being the A29 at Billingshurst, called Stane Street (stone street).

In the centuries following the Roman occupation a finer network of roads developed, consistent with the importance of fairs and markets, trade and industry. In most counties this process was linked with through traffic. But in Sussex not so much, because The Weald (weald = wood), in between the North and South Downs made travel difficult. The faster routes avoided the heart of Sussex, except for a few between London and the coast. So the A272 and its predecessors have always been country lanes.

Road numbers

Why is the A272 called the A272? The A and B road system was developed from a classification used by the War Office during the First World War. The Ministry of Transport completed the classification and numbering of roads in 1922. We also have C roads. M numbers for motorways date from the early 1960's. The numbering system is based on zones

cartographers apparently lost interest in roads. Not until the end of the 16thC did they appear on maps at all. And even then maps were rarely so detailed that they would be of much use for travellers. A 1611 map of England mentions no Haywards Heath, no Billingshurst and no Petworth. 'Midherst' is there, Petersfield isn't, Winchester is larger than all other places in the area and finally there is 'Stokebridg'. No

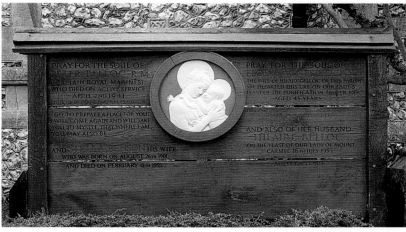

Hilaire Belloc memorial, West Grinstead

All sorts of people have made use of roads for all sorts of reasons, but generally speaking people didn't travel in the old days. There was even a time in the middle ages when labourers and peasants simply were not allowed to travel, in order to prevent them from working elsewhere for higher wages. And there are some other medieval peculiarities. For one thing the local authorities were gradually made completely responsible for roads and bridges, for construction, maintenance as well as protection. The Statute of Winchester of 1285 decreed that roads between market towns should be cleared of obstructions for up to two hundred feet on either side, so that nobody could hide and do mischief.

Another development was that of Pilgrim Ways. Winchester, where St Swithun was buried in 861 (but re-interred in the enlarged Old Minster in 971), became a popular destination for pilgrims. After Thomas à Becket had been murdered in the cathedral of Canterbury in 1170, his grave became an even better known shrine. The old **Pilgrims' Way** to Canterbury was immortalised by Geoffrey Chaucer towards the end of the 14thC. Other roads in Britain developed because of trade and industry, like the Saltways packhorse route in Sussex serving the hundreds of salt works there. Drove roads came into being for cattle driven from Wales to London and Southampton; they were broad of course and preferably unpaved. Near Billingshurst the drove road ran parallel to Stane Street.

Even after the middle ages travel remained hard work. It was travail. Road quality undulated just as much as the roads themselves. People didn't **care.** Serious overall deterioration set in during the centuries of the Tudors and the Stuarts.

Centres. In the middle ages travel by sea was far from secure. The southern counties had many landing places for all those who crossed the Channel. Most people started out from two main centres in France. Calais offered the shorter route to landing places in the Dover area, but the crossing from Cherbourg to Southampton, though longer, tended to have much calmer waters. In each case it was convenient to have an inland town on a river at a day's march from the various ports, where new arrivals could converge. At the same time they would be good assembly places for people travelling the other way, towards the continent. These towns are now Canterbury and Winchester respectively. Small wonder that these two later came to be the capitals of secular and religious government.

bounded by the most important roads that radiate clockwise from London. London to Edinburgh is A1. London to Dover is A2. All the roads between A1 and A2 are in zone 1 and their numbers begin with 1. After the A2 numbers in zone 2 comes the A3 to Portsmouth, A4 to Bristol, the A5 London to Holyhead and A6 London to Carlisle. Edinburgh and Belfast have similar systems. In the road hierarchy two

digits are more important than three digits and where they overlap the lesser road gives way. Busy routes can retain their numbers across zone boundaries, as the A272 does after Petersfield. Streets have names, roads have numbers. In residential areas the two may overlap without problems. The A272 is not automatically in between the A271 and the A273. It just doesn't always work that way, since

Pilgrims' Way. Centuries later the exact route was researched by Hilaire Belloc, who lived along the A272. He called it the Old Road and it went from Winchester north-east towards Farnham and then roughly followed the North Downs Ridgeway before bending south-east towards Canterbury.

Shipley, toll house detour

Stopped. In a literal sense coaches were often stopped by robbers, some of whom became famous and even popular. Ladies' man Claude du Val in the 17thC for instance, and Dick Turpin, Jack Rann and Gentleman Highwayman Captain Maclean in the 18th. Glorification in books and films makes all this seem romantic, but at the time travel was still considered a necessary evil.

Techniques. Thomas Telford, backed by the Postmaster General, strengthened the foundation of the roads by placing two layers of stones under the gravel surface. This was the safe, elaborate and expensive method. John Loudon MacAdam, supported by the Office of Works which wanted things done cheaper, worked with firm, dry beds and managed to strengthen the surface layers of the road by making them more compact. Both were successful, but which was the better method in the end is perhaps best shown by the fact that (tar)macadam is still a generic name (also in Dutch).

roads. John Norden's An Intended Guide for English Travellers *of 1625 had the first maps that were really useful. Fifty years later John Ogilvy's* Britannia *appeared. Ogilvy had personally gone over all of Britain's main roads with a 'dimensurator', a wheel fitted with a cord that was ten miles long, and for the first time actual distances were established. The A272 as we know it now was not important on*

Measures had to be taken. Halfway through the 16thC an Act of Parliament ordered virtually every man to work on the roads in his district for six days a year. This act officially remained in force for almost 300 years. No standards were specified however, and the local authorities often failed in their responsibilities. Sussex roads especially continued to be appalling. In between the North Downs and the South Downs most of the country was dense forest and elsewhere the soil of sticky, heavy clay made journeys difficult. It was accepted that for most of the year the roads were practically impassable. We'll see one famous account later on. Inns on the other hand greatly improved. The foundations were laid for the system of countless good hotels and pubs we still see today. We will see some excellent ones right along our road.

After 1565 coaches were introduced. The very first came from Holland, I'm pleased to say. They made travelling more comfortable. Almost immediately a Bill was proposed to ban them on the grounds that they would make men lazy and effeminate. How very English. But the progress of coaches couldn't be **stopped.** Figuratively speaking.

Then in the last few decades before 1700 the single most distinctive period in the history of roads started, introduced by a novel idea: that highways got paid for by road users instead of local parishioners. A truly revolutionary concept. The toll-paying roads were called turnpikes and were managed by turnpike trusts. Highly unpopular with both locals and travellers, as can be imagined, but eventually

roads run in all directions. So if you have a complaint about a road number you should realise that it was given by a civil servant poring over maps in 1922. Nowadays a new bit of road will just get the next available number for a road of equivalent importance in that zone.

Roads are owned and managed (planned, constructed, maintained or torn up) by Highway Authorities. Motorways and the

designated trunk roads in England are national and come under the Secretary of State for Transport and the Highways Agency. In our area these are the M23, A3, M3 and A34. All other roads come under the Local Highway Authorities, i.e. Borough Councils in big cities and County Councils everywhere else. They rely on the central government for most of their funds. Very few roads are privately owned.

maps, if only because most traffic in the south of England was directed north-south. A 1724 map of Sussex by Richard Budgen shows the fore-runner of the A272 east of Maresfield and then there is a gap until it continues west from Billingshurst onwards. Even on the 1795 map of Sussex by William Gardner and Thomas Gream the Billingshurst-Petworth-Midhurst-Petersfield road is a very minor one. Not until

the detailed map by Christopher and John Greenwood of 1825 do we see most bits of the road between Cuckfield and Billingshurst (Haywards Heath was not yet a place then). We must keep in mind that the roads were there all the time, but there was insufficient traffic to make them important enough to mention. Not until the Ordnance Survey series, the best of general maps, do we get the route of the

accepted as inevitable. See the picture for an example of dodging the tolls on the A272: this road at Shipley WS went straight on, originally. The toll-house-dodging detour later became the official route.

The system spread like wildfire, fanned by the rapidly increasing population with accompanying growth in manufactures and trade. Still, most people didn't travel. The tolls for the ninety miles of the A272 (if it had been there and turnpiked) would have cost as much as a labourer earned in a year. Travel was for the rich.

Road quality gradually increased and journey time decreased during the course of the 17thC. But Sussex lagged behind other counties, to general complaint. Halfway through the 18thC Horace Walpole warned George Montagu in a letter: 'If you love good roads, good inns, plenty of postillions and horses, be so kind as never to go into Sussex.' ❋

The main boost for road conditions came when two Scots developed new methods of roadmaking and repair around the year 1800: Telford and MacAdam. New roads were built with new and different **techniques.** Between them these two contemporaries reconstructed virtually all the existing roads of England. The early 19thC became the Golden Age of travel. Speed picked up, coaches became more comfortable and inns better equipped. People enjoyed themselves. Only exceptional individuals, who travelled for fun with the excuse of educating themselves, scorned the turnpike roads. William Cobbett was one of those who preferred the smaller lanes, where adventure waited and new discoveries could be made. 'Those that travel on turnpike-roads know nothing of England,' he cried with typical bloody-mindedness. Still, the turnpike era was a highly successful and exciting period. For lots of people it couldn't last long enough. But it was superseded by the age of steam, which had its own charm, and the development of railways.

Let's get physical

*The A272 is for most of the way constructed on a sturdy limestone base, with dense bituminous macadam surfacing. Periodical assessments by **measuring** include the foundation (for subsidence of the carriageway) and the surface (for skidding resistance).*

The foundation of a road is always slightly convex to help prevent water penetration.

That usually makes country roads unsuitable for checking if the wheels of your car are well aligned. The surface layers are supposed to be impermeable to protect the foundation and they have to be renewed regularly. The wearing course is designed to last 15 years, but the exponential growth of traffic and the increased weight of HGVs often shorten its life to 12 years. Renewal is fairly easy: 40 mm of hot

Measuring road deflection (the road engineer's word for subsidence) used to be done by the so-called Deflection Design Method, in which a reference beam and a dial gauge were positioned between the two wheels of the rear axle of a moving lorry with a known load. The deflection beam principle is still followed, but is now an automated and self-contained system mounted on a lorry. Another type of periodical check is done using a so-called SCRIM (Sideways-force Coefficient Routine Investigation Machine). You sometimes see these lorries moving slowly and not getting out of your way, so let me also tell you what this SCRIM does: it measures the wet skidding resistance of the road. A test wheel, mounted mid-machine at an angle of 20 degrees to the direction of travel, is applied to the road surface under a known load. A controlled jet of water wets the surface immediately in front of the test wheel. The vehicle moves forward and the test wheel, whilst rotating freely in its own plane, slides in the forward direction. The resistance force is measured.

Maresfield milestone

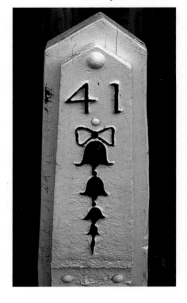

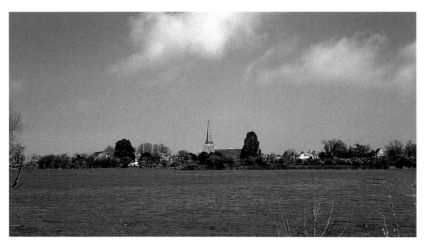

Cuckfield, from bypass

Charm. To give just one example: the view of Cuckfield from the by-pass may be nice, but the village it-self is infinitely more attractive. In this book I shall discuss places like Maresfield and Cuckfield as if they are in fact on the A272, where in my mind they belong. Similarly, other places will always be on the A272 for me, even if they are going to be bypassed in the future. Wisborough Green and Rogate for instance: their loss to the A272 would be equally heartbreaking.

Eastern end. Before 1967 our road took a more southerly course. Here is the story for anyone who might share my delight in the details. The A265 went westwards through Heathfield and Cross in Hand to Blackboys. And that's where the A272 started. It followed the course of what is now the B2102 through Framfield and Uckfield and then that of the C10 towards Piltdown, between Newick and Maresfield. Uckfield was hell for motorists. Even now, when both the A272 and the A22 go right round it, ☛

A272 complete. Four of the modern O.S. Landranger maps, nos. 199, 198, 197 and 185, cover the whole of the A272. Almost indispens-able, if you want to take Cobbett's advice and take the byroads too.

Pilgrims' Way?
Ever since I started my investigations on the A272 I have tried to find proof that it was

Trains started to take over long-distance travel and transport halfway through the 19thC. Roads were disen-turnpiked and there is little left of this phase in road history beyond some mile-stones and a few tollhouses here and there, though most of these have fallen victim to subsequent road-widening schemes. The age of the train changed the face of Britain once more. New towns arose, like Haywards Heath, which had hardly been on the map before. Roads were less necessary and fell into disrepair again. This continued right into our century until the rapidly increasing popularity of the mo-torcar made man more mobile. The car brought us a new age of travel, transport and tourism, and provided the basis for the fine network of highways and byways that we enjoy today.

The A272

A number of special features along the road will be discussed as and when we come across them in the course of our journey, but one major question is: was it, is it and will it be on the map where we see it today? The simple answer to all three parts of the question is no.

It all depends on how closely you want to look and what you want to

Road works

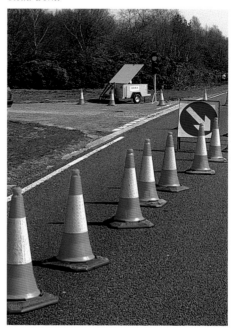

rolled asphalt with applied granite chippings do the trick. Nowadays you don't see the old-fashioned and romantic great steam rollers any more, at least not in use. The procedure is as follows usually: hot tar is sprayed onto the sur-face of the road and loose chippings are rolled into it. Slow moving traffic helps push it all together, so you could say that you personally still do your bit of road constructing as well,

used in the middle ages as a direct connection between Winchester and Canterbury, or in other words between the secular capital of England and the spiritual capital of England. I knew about the Pilgrims' Way between the two cities that roughly followed the ancient ridge-way along the North Downs. That must have been the best and probably safest route. But going along the A272 as we know it now would

have been shorter, and the A272 (avant la lettre) might have been used as a secondary route between the two capitals, a sort of lowland route. It is very hard to say if it was there at all. Every village has always been connected to every other village, so there must have been some way to get from the one place to the other, but a through route requires a standard of reliability, speed and comfort.

 Uckfield High Street is often jammed. Something had to be done.

The solution was a wise one. As an east-west connecting road the old course of the A272 might have been more logical than it is at present, with its start at right angles with the A267, but Buxted and Hadlow Down along the road make up for the loss of Blackboys and Framfield. The problem was really that in 1920 the civil servants in London made a mistake. The A272 shouldn't have been there in the first place. It should have avoided Uckfield and followed the more northerly course of the turnpike road of 1771, which ran from where the A272 starts nowadays at Poundford between Mayfield and Heathfield and went along the ridge, through Hadlow Down, to Buxted, Maresfield, Fletching (now one mile to the north), Newick, Chailey and then to Beadles or Bedales Hill (in the parish of Lindfield, between Scaynes Hill and Haywards Heath). That would have been better, historically speaking and in practice. So it was almost fifty years before the mistake was corrected. And we should always have had this splendidly inconspicuous beginning to the A272.

see. By and large the A272 still runs where it was when it was given its name in the 1920's. It doesn't matter much when I say that the bridge between Petworth and Midhurst is relatively new, and that the old road used to run to the north of where the new road is now, south of the Halfway Bridge pub. There have been other minor changes and improvements.

More radical are the bypasses. Not so much because the road slightly changes its course on the map, but rather because the road also changes its function. Local roads may become through roads and roads through villages may become streets again. Roads were made to go from one place to the other as quickly and comfortably as possible. But in the interest of speed towns and villages are often bypassed nowadays. It is ironic that roads go past the places they were created to go through. And what is gained in speed is lost in **charm.**

The greatest change in the route of the A272 between the maps of 1922 and modern maps is at the **eastern end** of the road and it took place in the 1960's. A further major change in 1996 involved the end of the A272. It used to run right through Winchester and then on towards Stockbridge. But nowadays the A272 half curves around Winchester and then stops. Questions about this messy alteration, like where, when, who, why and what exactly, are dealt with at the beginning of Chapter 7.

The A272 is busy. Commuters to London cause slightly extended rush hours. It's too busy, almost everyone agrees. New road signing will soon be directing most of the heavy east-west through traffic towards the M25 and the M27, but by then lighter traffic

The charm of a country road

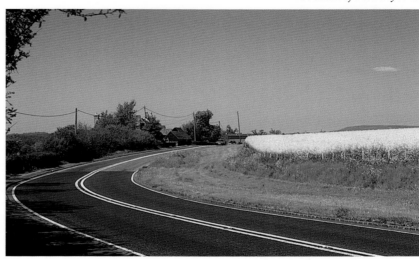

though it's a far cry from working six days every year on roads, as you would have had to in previous centuries. From April to September the roads are soft enough to allow the chippings to bed down safely. That's why most delays caused by road works are in summer.

What other action is taken to keep roads in good shape? Assessment for maintenance involves studying traffic and accident records,

Passage. 'The A272 has traditionally formed a route between Winchester and Canterbury and some current road signing in East Sussex reflects this role. Although parts of the route through Hampshire, West Sussex and East Sussex cannot be considered to be of a modern standard, around 50 miles between Petersfield and Batt's Farm roundabout at Maresfield are part of the Department of Transport's Primary Route Network. Via the A265 the route connects with the A229 Primary Route leading to the M2 near the Medway Towns, and still forms one of the only west-east routes south of the M25.'

I'm not sure this is entirely correct. I would have thought that, coming from Winchester, after the A265 it would make more sense to continue north-east towards the A28 and Ashford, where one would have a choice of continuing north-east towards Canterbury or east towards Folkstone and Dover. And even at an earlier stage one had a choice to turn south-east in the direction of the sea, in order to continue the journey over the water. From Uckfield you can go to Eastbourne and from Heathfield to Hastings. However, that is not the main point of the argument. What they are saying is that there are very few east-west routes south of London, and that the A272 used to connect Winchester with Canterbury. And what could easily be added is that the A272 was also used to connect Winchester with Dover. Modern maps don't show the advantages of the route any more. Especially at its eastern end the road can't be said to run straight. Nearer Winchester things are straightforward indeed. Petersfield, founded at existing crossroads where the North and South Downs almost come together, has always been connected to Winchester in the west by a main through route.

I was greatly encouraged when I read a 1995 report by the East Sussex County Engineer on the status of the A272 around Buxted, in which a **passage** *occurred that seemed to corroborate the idea of a Pilgrims' Road. The importance of the passage lies in the observation that a lowland route ran from Petersfield due east through the heart of Sussex. Not along the North or South Downs, but in between.*

From early medieval times onwards woods in the Wealden area were gradually cleared and roads became easier to develop. There is no doubt that cathedrals and monasteries greatly influenced road making. Some roads were even called Abbot Way. A Lowland Route in between the downs is a distinct possibility. It could have been used as a messengers' route, but that function would leave no trace. There

will have increased again. At the moment traffic counts show that hundreds of thousands of cars are on this road every day. To give an example: west of Pound Green, Buxted, a 1993 count showed a daily average of 10,600 cars, while east of Pound Green, Buxted, 6,600 cars were counted (these 4,000 lost cars do not vanish into thin air, but move onto roads north and south).

What about the future of the A272? Minor things can always happen to it of course. In the spring of 1996 it was decided to paint some small areas of the road surface red or sometimes yellow, in a bid to calm down traffic. It does the job and makes life more colourful. So why not? Even the bigger red-areas-with-stripes-in-between on entering and leaving a village are fine with me. Where I draw the line and what I consequently object to is the bright yellow background as part of road-signs that began to appear in 1997. It looks vulgarly loud to me and violates the view of the countryside. What is one to do? Do we sigh and say: 'sense usually beats sensibility in these cases', or do we organise a protest campaign?

Otherwise no great changes are planned either in East Sussex at the eastern end of the road, or in Hampshire at the western end (where the recent changes are supposed to last at least fifty years). But West Sussex often has interesting things to say in its County Surveyor's reports. For road planners and through traffic alike Petworth has been a bottleneck for years. The 1993/94 report says that based on recommendations contained in an independent consultant's report, the safety and environmental aspects of a

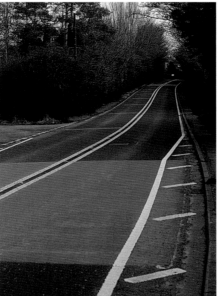

Road surface and section

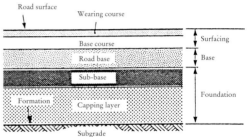

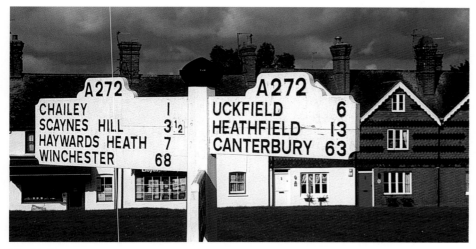

Newick signpost

bypass for Petworth, incorporating a long tunnel underneath the whole of Petworth Park, are being investigated. Hey, imagine that. Another area of outstanding natural beauty around here, Shimmings Valley, may not be safe either. It is part of a continuing story, I'm afraid, now carried into the realm of the absurd. **Developments** elsewhere are less dramatic, fortunately. That does not mean that they are not controversial. They always are. The problem is that it is very easy for everybody to have an opinion on these matters. Even foreigners do, sometimes!

So the local people who say that the A272 will always have only two lanes and will always be slow are most probably right. It is supposed to be a quiet country road. For motorists who want to use it in order to be somewhere else it will continue to be exasperatingly rural. Cyclists will usually find it busy at all times of the day. For car drivers on holiday it is ideal. And, may I say, much much better than the 272 in the Netherlands; or anywhere else!

The A272 has never acquired fame. Apart from a brief mention in a TV commercial in 1999, the only cultural reference I have found was fully thirty years earlier, in 1969, when Monty Python had a sketch in which Pablo Picasso was introduced on a bicycle and the excited comment was: 'It's the first time that a modern artist of such stature has taken the A272!' Well, what will they say when they see you there?

site inspection and testing. Other activities are sweeping and drain clearing. Grass and hedges must be cut and defective bits patched. There is maintenance of bridges, footways, white lines and cats' eyes (doesn't the man who invented cats' eyes deserve a statue?). There are emergency call-outs and there is winter salting. Roads require a lot of work that we normally prefer not to think about. The A272 is a fairly

Shimmings Valley, scene of bypass?

Developments. The A272-A29 Billingshurst bypass was started in early 1998 and what it entails is discussed in Chapter 3. Another proposed improvement in the period to 2006 involves the A24/A272 Buck Barn junction, which is relatively minor. I would love to see the plans for the mooted Wisborough Green bypass, for I fail to see how that can be done within reasonable cost and without reasonable damage. The same goes for the long-expected relief road for Haywards Heath. The plans for these improvements were developed by the Local Highway Authority and were submitted to the Department of Transport. They were then laid down in the Transport Policy and Programme for 1995/96, and state among other things that the A272 is currently part of the primary route network, but that the Department of Transport has agreed that it will be de-primed when the A272 has been improved throughout the county, which would mean soon after the millennium. The County's consultation leaflet *Review of Strategic Road Network* of May 1995 corroborated this view for the A272 west of the A24. But you know even better than I do how slow and uncertain these processes often are. 'Twas in the spring of 1998 that the County Surveyor's office reported to me that 'the Government is awaiting the results of the recent consultation on *What Trunk Roads in England* before making a decision on the role of this section of the A272'. The County Council are still hoping to get this section 'removed from the Primary Route network and then effect signing changes so that it is used more as a local route'. It sounds contradictory. You improve the roads and then you hope that fewer people will make use of them. But we have to learn to live with the fact that traffic will continue to increase, whatever the authorities do.

19

Evidence. What sort of proof is there that the A272 was a secondary Pilgrims' Way? Scant, really, to be perfectly honest. I'll tell you what I have so far. (1) In the middle ages a popular name for inns along pilgrim ways was The Angel. Both Midhurst and Petworth have Angel hotels. They are not medieval hotels, but it's impossible to say how old their names are. Traditions die hard. The names may have survived even if the buildings haven't. And having two cases seems more than coincidental. Let's say that it's something.

And here is something else: (2) Wisborough Green has a mural dating from *c.*1275 with a portrait of St James of Compostela. He was the patron saint of pilgrims and the journey to Santiago da Compostela's grave in north-west Spain has for centuries been the most appealing pilgrimage of Europe. It still is remarkably popular. St James's appearance in Wisborough Green can hardly be a coincidence either, since it was usual for enthusiasts to combine pilgrimages. And then (3), reading J. Lindsey's history of Newick in East Sussex, I came across the sentence: 'The building we know as The Bull was built in 1510 and used as a resting place for pilgrims on their way between the shrines of St Thomas of Canterbury and St Swithun of Winchester.' The signpost in Newick demonstrates the traditional idea of a well-used connection between Winchester and Canterbury. And (4) the official guide to Uckfield says that the town was a centre of several routes, and then mentions 'one variant of the Pilgrims' Way between Canterbury and Winchester'. Plus there are one or two more dubious cases that I will come back to. Summing up, I can boast the views of a few fellow researchers, a mural and maybe two names. It's not much, but extravagantly, not to say exorbitantly, better than nothing.

*must have been more traffic between the two most important cities of England. In the course of the book I will get back a few times to this notion of a secondary Pilgrims' Road, and produce more **evidence** than I have up to now, even if it is a trifle flimsy. I still like the idea and it is difficult to give up on it. I hope to get more proof from readers' comments. Do write c/o the publisher if you have N E $_{W}$ S.*

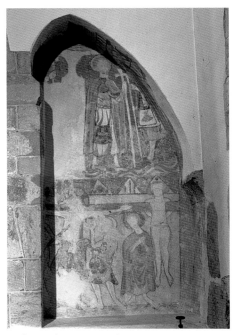

Wisborough Green mural

Let's follow this 'joke of a road', 'lovely lovely lane', 'the most historical road of England', 'the worst bloody road in the south', 'the bendy road', or just 'my road', as I have heard it described. Let's do England in short. England's Epitome, the A272. The Longest Lane in the Land.

I guess I am still too much of a teacher not to supply the following hints: respect the signs saying 'private', keep to the Country Code, and enjoy yourselves!

This weathervane used to grace a roof in Lodsworth WS

I would appreciate N E W S from all quarters.

normal three-digit A road and costs each of the County Councils roughly £6000 per mile every year, all in.

The standard width for a road of this type is 7.3 metres. The A272 varies a lot in this respect, but there are more narrow than wide stretches. According to the County Surveyors' figures the narrowest stretch is in Buxted, between the school and the station: 5.5 metres.

I mention this because it may have something to do with another thing we usually prefer not to think about: accidents. In this respect the A272 is again fairly normal, in spite of the fact that it is usually narrower than standard. Counting fatal, serious and slight mishaps together we have almost 200 accidents every year on its 90 miles. Fairly normal this may be, but too much it certainly is.❁

There are some eight or nine different ways of pronouncing the notorious combination -ough. Bough, cough, hiccough (hiccup), lough (with a k sound at the end or the Scots' ch), rough, though, through and thorough. Spelling is often a poor indication of the pronunciation. The reverse is also true. The vowel sound in 'they' is the same as the one in break, reign, weigh, vein, vain, pray, gauge etc. And I can't begin to give a list of possible spellings for the schwa, the non-committal uh sound in the first syllable of afield and the last syllables of Winchester and borough. And what about the longer and shorter vowel sounds of bad and bat?

Putting things together like this we see chaos, and that might reflect on placenames in this book. An unpleasant prospect. My solution is to use spelling in between brackets that English speaking persons would generally agree on. For example: double ee is normally pronounced as in tree, even if one can think of exceptions (breeches). If I thought you could have a problem with Dean, I would indicate [deen]. Greatham becomes [grettum]. With a name like Burpham one is at least tempted to say [burpum], but it's [burfum]. I wasn't so sure about the schwa, by the way. [burf'm] or [burf-m] may look more elegant or appropriate, but then I have a problem at the end of a word. [burfum] is clearer.

Things are difficult enough. A friend of mine is called Hurst [hurst]. Although the r is not pronounced, I can't leave it out, for the consonant r influences the preceding vowel. On the other hand I would be tempted to distinguish between Hurstpierpoint [hustpeerpoint} and [billingshurst]. And let us not argue about the fact that one doesn't pronounce a double l in Billingshurst. And let's not exaggerate either. I couldn't stand the sight of the first name [peetu]. Let's be tolerant. This is not an academic essay, but meant as a simple tool and a gesture by [peter] [bo-gart].

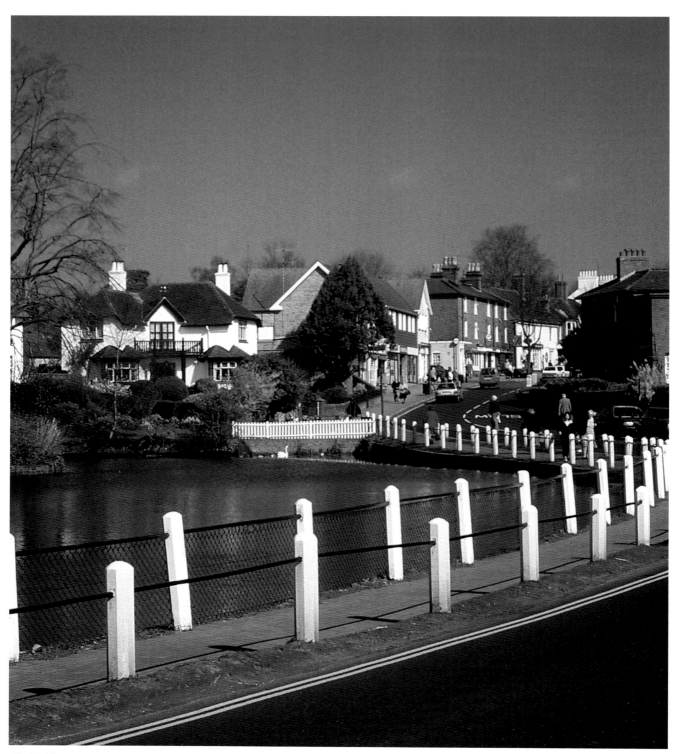

Lindfield

Chapter

1

To Haywards Heath

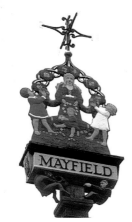

Mayfield village sign

Coade stone was an artificial stone, invented in the 1720's and after 1769 produced by the Coade family until 1840, when the firm was sold; the formula was subsequently lost, but later analysis showed that it consisted of sand, ground stoneware and china clay, all mixed and fired in a kiln. It was weatherproof, and sculpted detail kept its sharpness. For a few decades it was popular for decorative elements, objects like statues and even for light buildings.

Beacon. A warning system of beacons strung out on hilltops along the south coast of England was already being tried out in the 14thC, and had been perfected halfway through the 16th, so that the English were able to keep track of the Armada in 1588. The gap between beacons was usually six to eight miles and they consisted of metal braziers or cressets on poles. They were revived when Napoleon's invasion seemed imminent. But beacons are not restricted to the south coast, and are now often newly re-erected. They were lit on the occasion of the coronation of Queen Elizabeth in 1953 and on the fiftieth anniversary of the end of the Second World War.

Mayfield, just a few miles north-east of the beginning of the road, gets the prize for the most elaborate village sign. A good deal of the history of the place is on the pole. Among other interesting bits of information it says that Mayfield used to be a centre of the iron trade and that it has a local rhyme: Master Huggett and his man John – they did cast the first cannon. *In fact Huggett's Furnace was in Hadlow Down, but the name appears a number of times in the neighbourhood. It is rather close to Hogge, whom we will see in Buxted, and the claim may be legitimate. Mayfield doesn't need dubious claims to fame, however. It has real ones. It has been voted the tidiest (large) village a number of times, which is in accordance with another compliment, this time from Victorian poet Coventry Patmore, who called it 'the*

The beginning of the A272 can be approached from various directions. Crawley's Gatwick Airport is where you want to be if you wish to take a 727 to view the 272. If you come from the east you could stop at Sissinghurst Castle for its garden on the way or go through (not just around) the old town of Rye. ★ But the nicest way is that which takes in the village of **Brightling**. Strictly speaking this is just over seven miles east of the A272, but we might just as well begin with an exception to the rule, if there are not too many of them. Yes, why not? Brightling is worth it. In the early 19thC country squire John Fuller MP built a number of follies there. He was eminently suitable for the self-appointed task, having enough money and the right kind of madness. In fact he was usually called Mad Jack Fuller and was one of England's great eccentrics. ✳ But he was a benefactor as well: the big wall round Brightling Park was built to provide employment. In ascending order of uselessness the following objects came into being. (1) The observatory, now a private house. (2) The rotunda temple for drinking tea, gambling or bawdy parties. (3) The summerhouse, a **Coade stone** alcove or garden seat. (4) The hermit's tower, for which he couldn't find a hermit. And (5) the obelisk: always nice to have one, isn't it? But one of the best folly stories is the one about (6) the cone called Sugar Loaf. Fuller had wagered that the spire of Dallington church was visible from his house. He was probably drunk at the time. When he sobered up and could see for himself that it wasn't, he managed to win the bet by hurriedly putting together an imitation spire in a field between Brightling and Dallington. Pointing at it he could say: there it is. And this mock spire is still there along the B2096, and was even lived in for a time. Fuller was buried beneath a large pyramid beside Brightling church. Rumours spread that he was sitting there inside the pyramid with a bottle of Madeira and a roast chicken, so there was disappointment when it

Burwash [burish], 7 miles east of the A272, is a very pleasing village and the A265 has many lovely views of the Rother Valley and the obelisk of Brightling. In the centre is the Burwash map, consisting of 54 tiles with the map 'baked in', fading fast. Bateman's is a good Jacobean ironmaster's house and was the home of **Rudyard Kipling**, *who died there in 1936. The rooms are as he left them. The gardens go down to the river Dudwell, where a working water mill grinds corn for flour. A National Trust property.* ✤

Too far to the south for us is Herstmonceux Castle [hustmonsoo] with its modern Science Centre. Lovely castle, good 'hands on' science centre, but too far.

At **Chapel Cross** *an obelisk has been erected to the memory of two martyrs from*

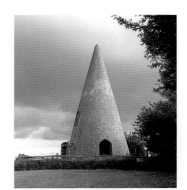

Brightling Sugar Loaf

sweetest village of England'. The founder of the Royal Exchange Sir Thomas Gresham was living here in the Old Palace when Queen Elizabeth I came to visit him. Another notable inhabitant was Gabriel Tomkins of the 18thC Mayfield Gang of smugglers, who for a time became the thief to catch other thieves when he was made customs officer. The impressive convent buildings harbour the tongs with which St Dunstan caught the devil's nose according to the local legend. Argos Hill, halfway towards Rotherfield and topped by a post mill, affords a good view of this pretty village.

Rotherfield. *The first woman doctor in England, and a feminist, Sophia Jex-Blake, died in this hilltop village in 1912. The large 13thC St Denys church contains a number of treasures for lovers of art history, the best*

was opened a few years ago and appeared to be empty. It is always sad to see the end of a myth. Most of these follies are strictly speaking on private property, but fairly easily accessible. The Fuller's Arms will give information on their occasional guided walks; April 1st is one day they favour. Follies on fool's day. ✪

The actual start of the A272 is on the A267, to be reached either from the Heathfield direction or from Mayfield. These two villages will be treated as lying south and north of the A272 respectively. But halfway between the two the A272 plunges into existence at what local people call Summer Hill Corner after a farm there. The local papers often refer to it as Summer Hill Junction because they have to report accidents there on a weekly basis, but officially the place is known as **Poundford**. Pound as in a small enclosure for cattle, and ford as in a water-crossing. Poundford is very rural and on a watershed. All the little tributaries of the Eastern Rother, the Cuckmere [**cook**mere], the Uck, the Ouse [**ooz**] and even, a few miles away, the river Medway spring from here. Which made this area pretty well ideal for the iron industry. We'll soon see the signs.

So down we go on the A272 and soon up again to start our journey. In summer the good views to the left are mostly obscured by hedges. The white object that can sometimes be seen in the distance looking back a bit towards the hills in the south is a windmill, the post mill at Cross in Hand. Windmills seem to have moved around a lot in Sussex. This one hails from Uckfield. ❊

Hadlow House on the right is where the hamlet of Hadlow used to be, but that has gradually and unobtrusively disappeared over the years. We find **Wilderness Wood** a bit further on the left. It's a family-owned and run working wood of about sixty acres, where

Rudyard Kipling (1865-1936) was born in Bombay, but lived much of his life in Sussex, which he first got to know staying with his uncle Burne-Jones in Rottingdean. *Puck of Pook's Hill* is perhaps the most enchanting of his books, full of love for the Sussex countryside and its magic trees, oak, ash and thorn. Kipling's poem *Sussex by the Sea* ends:

God gives all men all earth to love
But since man's heart is small,
Ordains for each one spot shall
 prove
Beloved over all.
Each to his choice, and I rejoice
The lot has fallen to me
In a fair ground – in a fair ground –
Yea, Sussex by the sea!

Brightling: Mad Jack Fuller's grave

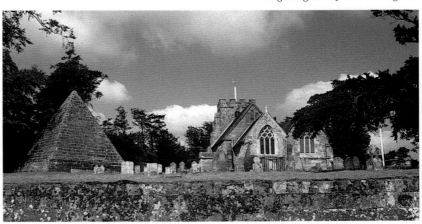

Warbleton, two from Cade Street and six others, who were burnt to death in Lewes by the Roman Catholics in 1557 'because they dared to worship God as the word of God directs'. The anger can still be felt. Here, as elsewhere, I noticed sheep doing lawnmower's work among the graves.

Cade Street, *further west, has taken up the old custom of providing a* **beacon**, *with a*

Sir Edward Coley Burne-Jones (1833-1898), uncle by marriage of Rudyard Kipling (see p. 25), mystico-romantic painter, a successor to the Pre-Raphaelites. He worked closely with his friend William Morris (particularly on tapestry and stained glass) but was not above lampooning Morris' enormous girth and ceaseless loquacity.

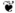

William Morris (1834-1896) all-round, not to say rotund, artist: poet, fabulist, painter, furniture designer, architect, printer, letterer and above all a designer of textiles. 'Topsy' to his friends. Prophet of the Arts and Crafts movement who declared: 'Have nothing in your house that you do not know to be useful or believe to be beautiful.' Inspired by socialist ideals, and dissatisfied with Victorian industrial products he founded a firm (eventually called Morris & Co) to provide better designs, executed by artisans, craftsmen working together as in medieval guilds. But such was the expense that he soon found himself 'ministering to the swinish luxury of the rich'. One of the houses he and his firm decorated was Standen, south of East Grinstead WS and just outside our limit, but well worth a visit as the whole ensemble is still intact and gives an insight into the life of the nouveau riche art patrons for whom the socialist worked.

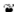

Oast: a kiln used to dry malt or hops. Oast-houses were an innovation imported from Flanders in the early 16thC. The characteristic white ventilation cowls turn in the wind to optimise the draught. This helps draw up the heat from the fire below through the hops that are spread on cloths. The main hopping area in England is Kent.

example being the very green east window by **Edward Burne-Jones** *and* **William Morris.** ☀

*C*rowborough *is mainly Victorian. It's the highest town in Sussex and often affords good views of the surrounding countryside. The lovely 'Cobblers' garden in Jarvis Brook is sometimes open to the public. There are some minor literary connections (the novelist Arthur Hutchinson died here and Franz Kafka's The*

brazier. Why not? And here is another bit of history. The name of the village was changed slightly from Cat to Cade after Jack Cade died here. Cade, you will remember from history lessons, was the leader of the (arguably) justifiable rebellion of 1450 that chased King Henry VI out of London. He has a monument here, unassuming, a sort of chimney over a wall, left, going east.

Castle was translated here by Edwin and Willa Muir), but the most notable link is with Sherlock Holmes, whose creator used to live here in Windlesham Manor, now a hotel. Sir Arthur Conan Doyle, by the way, had wanted to refuse to become a 'Sir', but eventually allowed himself to be persuaded. He made up for it by having Sherlock Holmes refuse a knighthood in one of the novels. Windlesham Manor

you can see how trees (mostly pine, beech and fir) are farmed sustainably, and how timber is used both traditionally and creatively. There are woodland trails for different seasons, quiz walks and all the mod cons that one might expect. Educational and simple at the same time.

The first village we get to is **Hadlow Down**. The first part of that appellation is from the Anglo-Saxon man's name Headda. The second part, often seen spelt as ley, ly or legh, means clearing. Down means hill, which is appropriate: the height is 480 feet. The history of the village is typical of a small **Wealden** community. In Tudor times it had a few ironworks; one of them dates back to the 14thC and belonged to the Huggett who also owned ironworks in Maresfield. Hadlow Down lies on a ridge and both sides of the ridge had springs that could be used for the water wheels. The iron industry made the village. But it wasn't until the 1830's that Hadlow Down, which was part of Mayfield and Buxted, became independent and got its own church. In 1913 this church was replaced by the one with the thin spire we see here.

Almost behind it a cross lies over a grave. In the centre of it is a maze. At first sight hardly anything apart from the date 1911 is legible, but when you get used to the lettering it appears to be the grave of Lt Col Francis Wheler 4th Viscount Hood, †1907, and of Edith his wife, †1911. The text round the maze reads: AND THERE SHALL BE NO MORE DEATH, NEITHER SORROW NOR CRYING, NEITHER SHALL THERE BE ANY MORE PAIN. In order to get into the centre of the maze, all four quarters are used along the broad paths – you go along the dikes, not the ditches, so to speak. You can't take a wrong turning: there is only one way to go. It's a unicursal maze of the type that was often used in the middle ages. I leave it to you to decipher the text at the foot of the cross.

*H*eathfield. *Some of the older inhabitants still pronounce the name of their village [heffel]. It had a market and Cuckoo Fair or Heffle Fair for more than six centuries. Heathfield Park houses the circular and battlemented Gibraltar Tower. It was built in 1793 to honour General Eliott, Lord Heathfield, who had defended Gibraltar some ten years earlier. But the Park is heavily guarded by six*

was ceremonially exorcised after Conan Doyle's death in 1930.

Ashdown Forest, whose southern tip just reaches Maresfield, is something of a misnomer. It is not so much a forest with trees as a wild heath; the original meaning of forest was (royal) 'hunting reserve'. In the 1820's William Cobbett had no qualms about calling it 'verily the most villainously ugly spot I ever saw in *England'. Generally speaking people had little idea what to do with areas of natural beauty in his time. Only shady characters appreciated Ashdown Forest. Conveniently situated halfway between London and the south coast, it provided a natural hideout for smugglers and their goods with its tree cover, hollows and often impassable roads. Not until the early 20thC did the heath inspire poets, when*

Hadlow Down, cross, detail

The most conspicuous building in the village is the New Inn, a typical late 19thC eclectic jumble of styles and materials. It's over 100 years old and replaced another and less interesting New Inn that was also 100 years old when it burned down in 1890. The inscription HOTEL is a relic from the days when the **pub** 'suffered from delusions of Victorian grandeur', as the owner told us; it never was and never will be an hotel. It never was a post office either. Yet the sign is there, temporarily they say. The old creamy interior earned the pub a place in the unofficial list of Classic Basic Unspoilt Pubs of Great Britain, with one star, and when we were there the owner was even more of an original than his pub.

Between Hadlow Down and Pound Green, where a little road branches off towards Rotherfield, you are up on a ridge with unobstructed views to either side. On your right are the North Downs and on your left are the South Downs. These views of both at the same time are always too rare.

Pound Green got its name from the combination of pound and green that is still there, with the beautiful old tree and triangular fence, on the left. The private house opposite used to be a cottage and **oast**-house, probably dating from the

Pub. There is a principle at work here. There are lots of nice-looking pubs along the road. Half of them have good restaurants. Some excellent. But I'm not going to mention them much. Partly because there are so many good ones. But there is something else. In most villages only the church and the pub are publicly accessible. There are more pubs than churches along the road. I go into churches and churchyards a lot and I tell you about them. I also go into pubs a lot and I don't tell you about them. This is slightly unfair, but churches, even for non-religious persons, simply are more significant. And you can always have a look inside, if only to take shelter (unless insurance companies have convinced the vicar that churches should normally be closed and you have to hunt around for the key – I hate that). I could maybe get free beers or free meals if I did recommend pubs specifically, but I just don't want to work that way. If there is something special about a pub I will tell you of course. Any other information can easily be found in specialist publications. But please go and have a drink or a meal in pubs along the road. Generally speaking, their seductiveness is not misleading.

Wealden means of The Weald. It's an old word meaning forest, and denoted the large woodland area in Sussex, bits of Surrey and bits of Kent, north of the South Downs. Besides Ashdown Forest and St Leonard's Forest only some patches now remain. When William Cobbett tried to explain it he said: 'This Weald is a bed of clay, in which nothing grows well but oak-trees.' Oaks, yes (Rudyard Kipling called them 'the Sussex weed'), but there were other trees as well, of course. Medieval industry, building, iron, glass, brick-making, etc. made short work of most of these woods.

unleashed guard dogs, as it says somewhere at the gate, so if you want to inspect the dilapidated condition of the folly from close up, forget it.✻ On the other side of the Park is Old Heathfield, whose main building beside the church is the quietly dignified 650-year-old pub. In 1994 a booklet called Heathfield and Waldron in history and legend *appeared, which deals with its variety of subject-matter in* *narrative verse! Interesting stuff, in which the Indian chieftain's daughter Pocahontas (a recent victim of Disneyfication) makes an appearance as a sort of Florence Nightingale. From Heathfield southwards stretches the Cuckoo Trail, cared for by, among others, Sustrans. Walkers, cyclists and horse-riders follow the old railway line from here to Polegate. In a few years' time this Trail will be extended*

Saxonbury Tower

Iron industry. The Wealdon iron industry, based on local iron ore, water and wood, has left its marks all over this area but often you have to be made aware of them before you notice them. The industry was already flourishing during the Roman occupation and had its heyday in the 16th and early 17thC. Ralph Hogge of Buxted made the first iron cannon in 1543 and Sussex guns and Sussex shot helped to defeat the Armada. Besides domestic firegrates and the like, Sussex iron was used for the railings of St Paul's Cathedral in London, for milestones and even for grave-'stones'. The industry brought wealth to a region that was ideally suited for the production of iron: ironstone and wood were abundant, and there were plenty of streams to drive the machinery and act as coolant. For hundreds of years it looked as if there would never be an end to the prosperity. But when timber for the furnaces finally became scarce and coal, discovered in the Midlands, proved to work better in the smelting process than the Sussex charcoal, the industry eventually moved north. See also the note on Hammerponds (page 42).

Ezra Pound agreed to spend a winter here as W. B. Yeats' secretary and fencing master. Today the feeling of wilderness and space in the Forest attracts many tourists and day-trippers in summer. The Forest Centre provides information and there is also a family-run Ashdown Forest Farm. Both are near Wych Cross, where the A22 and the A275 come together. There is even an Ashdown Llama Farm at **Forest Row***.*

But equally surprising, and more traditional, is the striking village hall of Forest Row. As with other things in this book, it is worth seeing, but maybe not worth going to see.

*J*ust on the edge of our seven mile limit, in the north-eastern corner of the Forest, is the **Saxonbury Tower** on the hill of the same name. It was built in the 1820's on the highest point of the Eridge estate by Henrietta

1830's. The house was restored in the 1930's and the top of the oast was later turned into the look-out lantern for an attic room.

Buxted is one of the names that indicate the character of the Weald: it means beech place. The village used to have a good ghost story. Nan Tuck, who had murdered her husband, escaped from the authorities and after her death haunted the old lane towards Rotherfield. Alas, she hasn't been sighted for donkey's years now, but there is still a Nan Tuck's Lane at Potter's Green. Another sad loss is the custom of Beating the Bounds on Ascension Day (see p. 40). But other elements of Buxted's past have remained. Most amazing about it is perhaps that it wasn't always where it is now. It moved! This happened in the 1830's and had to do with the lords of Buxted Park. The present house in the park was built in 1725, with the village quite near. Lord Liverpool, who owned the place from 1814 onwards, thought it was too near and wanted to enlarge his garden, following the fashion of the time. His solution was as simple as it was radical: the village was moved to its present position outside the grounds. Only St Margaret's church remains inside and can be reached through the park gate next to Hogge House, by public right of way. Moving a village for the sake of a landscape garden is not unique, by the way: the loveliest example is Milton Abbas in Dorset. But later in this book we shall also see an example in West Sussex: Parham, where something similar happened. Buxted Park House itself saw many famous and some royal faces when it was still a private house. In 1940 it was gutted by fire and the top storey was never replaced. The grounds beyond the customary ha-ha cover 312 acres, with two lakes. They are for the use of the hotel guests nowadays. Buxted Park is an expensive country house hotel that prides itself on its health programmes. If you do want to go there, note the modest front door with its drainpipes and frostwork on the half-columns. ✳

to London in the north and Eastbourne in the south. ✩

Cross in Hand is usually unhyphenated nowadays. It is supposed to have been a meeting place for crusaders who held crosses. That sounds like the sort of popular etymology that is invariably wrong, but in this case perhaps it isn't. There may have been an image of a hand holding a cross aloft to mark the

gathering point, and there are other place-names that indicate something similar, like Cross-at-Hand (quite near) and Cross o' th' Hand. Handcross (also quite near) and others usually denote crossroads and roadsigns. Not that Cross in Hand isn't at a crossroads: roads from London to Eastbourne, Winchester to Canterbury, and the old Lewes to Canterbury ridgeway met here. Its situation south of

*Abergavenny, whose initials are over the door. The inside consists of a stone staircase. The telescope form, the conical hat and the rhododendrons make it memorable. There are some other follies on this estate, but they are not readily accessible to the public.**

Just over the edge of our limit are the new **Groombridge Place** Gardens. They are on the border of Kent and East Sussex and I will

Groombridge Place grotto

Buxted Park will be coming up on the left, but first we go down under the railway line and see a nice-looking lodge with a monogram on the right. HH stands for Harrock House, which is up the drive and has a history that goes back to the early 13th century. Rebuilt in the 1650's, it was a private estate until 1969, when it was turned into a girls' school, but now it is a private house again.

This part of the A272 is the narrowest stretch of the whole 90 miles according to the County Surveyor's Office. Between Buxted station and the school it is said to be no more than 5.5 metres. Hard to believe, isn't it? Don't measure it yourself. I did (almost 7 metres at one point) and barely survived.

The view of Hogge House, at the corner of the entrance to Buxted Park on the left, is obscured by a big wall. You have to go into the street opposite to get a good view of the funny black hog above the date 1581 in the panel over the front door. Ralph Hogge's invention of casting cannon in one piece revolutionised the

iron industry and I gather that this was the first time in history that a finished product was exported to the continent, bringing wealth to Sussex. These cannons are said to have held the **Armada** at bay and Hogge's house looks a bit like a stronghold, which could be thought appropriate.

Armada (the Spanish word for 'armed fleet') became the name of Philip II's 'invincible' Spanish fleet that was supposed to invade and conquer England in 1588. Philip had spent years in preparation, confiscating foreign ships in Spanish and Portuguese harbours. Many of them were Dutch ships, since Philip had a bone to pick with Holland as well. Both our countries were trying to preserve their independence and freedom of religion against the same Roman Catholic enemy. Part of the plan was to ferry the Duke of Parma's army in the Low Countries over the Channel. England knew all about this and so had plenty of warning, but apprehension was still great. Preparations were often inadequate, since it was difficult to know what exactly was needed and especially where it was needed: the course of sailing ships was always uncertain. When the fleet finally came, the hostilities opened with skirmishes off the Sussex coast, and the defenders' iron cannons did a lot of damage to the Spanish ships. The Armada sailed up England's east coast in disarray and was finally vanquished mainly by the bad British weather.

London and midway between Winchester and Canterbury would have made Cross in Hand a good place for crusaders to gather.

Possingworth Park is along the road to Blackboys. It used to be one big estate with a priory in it, but it was sold off in individual bits a long time ago and the priory is a nursing home now. The hurricane of 1987 was particularly vicious for the park. Just to give you an

idea of the damage a big storm can do: tens of thousands of trees were lost here, many of them hundreds of years old, especially the sequoias round the lake. That sounds impressive and it is: Possingworth Park will probably never look the same again. To give another example of this type of influence on the landscape: the two storms of 1987 and 1990 cost Wakehurst Place near Ardingly more than 15,000 trees.

Exception. I am not going to make many exceptions to the general rule that I will say something about things I have found interesting up to six or seven miles north and south of the A272, and not beyond. In fact for some reason all the exceptions to this rule will be in chapter I. With a few exceptions of course!

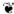

Early English, **Pointed** or **Lancet** is the 13thC style of the earliest period of English Gothic architecture, characterized by the pointed arch, slim ribs and lancet windows.

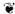

Sussex cap: country church towers in Sussex are sometimes capped by a low pyramidal roof.

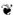

Parish registers are among the many possible sources of information about a village. They are usually kept in County Record Offices. Naturally they are mostly about religious affairs and quotable stories are few and far between.

*just have to make an **exception** in this case. I'll try to be brief. Ever since the new owner took over a few years ago the gardens have been made ready for public enjoyment in a most inventive and artistic way. This is high praise and well deserved. There are various gardens (Sculpture Garden, Drunken Garden, Oriental Garden et cetera), a collection of Sherlock Holmes memorabilia, a sanctuary for birds of prey and an Enchanted Forest with pools of water and excellent work by Ivan Hicks, whom we will meet in later chapters. The house is open for weddings and functions and there is a programme of all sorts of activities, from jousting to opera. All this in an environment that has inspired famous writers. Still developing, but already unique. Peter Greenaway's film* The Draughtsman's Contract *was shot here.*

Here is the entrance to Buxted Park. It is worth going into the grounds to see St Margaret's church with a stained glass picture of St Nicholas in the porch, if only for the feeling of authorised trespassing. Dedicated to the 11thC Queen of Scotland, it was built in 1250 in the **Early English** style. The old vestment chest is rare and the fine plaster work in the chancel contains a number of interesting elements that the little church guide tells you about. Have another look at the elegant white war memorial on your way back. Buxted's other church, St Mary's, was added to the village in 1885. **Parish registers** can sometimes yield quaint information. In Buxted there is the touching story of a young man in the 18thC whose beloved fell seriously ill. He took care of her until she died and then afterwards he laid himself down on his bed and found death a week later, heart-broken. Very sad of course. Let me make up for it by quoting from the same register (and the *Hidden Sussex* series) praising the talents of the 17thC parish clerk Richard Bassett, 'whose melody warbled forth as if he had been thumped on the back with a stone'.

We continue on our way west along Buxted Park. You may not have noticed a military pill-box that you passed earlier on the left in the grounds, but two similar pill-boxes are coming up soon for those who like that sort of thing. Leftovers from the Second World War. One is in a dip of the road at the bottom of a field on the left, another one a bit further away on the right there. In case you are wondering exactly what they are made of: more than twelve inches of concrete and then brick on the inside. The ceiling (eight foot high) is supported by a few thick walls in the middle of the interior. There are seven windows and one door in this hexagon. A number of **military**

Framfield lychgate

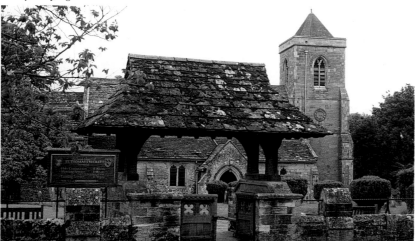

Opposite the entrance to Possingworth Park is the Long Barn Motor Museum, a very modest affair, even when it is open.

*If you happen to drive through **Framfield** have a look at the area near the church with the **Sussex cap**. The cottages just before you get to the churchyard are notable, as are the lychgate (half-stone, half-wood with benches) and the house with the extra turret that you can see*

*Moving westward from Groombridge we get to **Withyham** [widiam], with its historically important house Duckings and the quaintly situated church with the Sackville Chapel and its memorial to **Vita Sackville-West**. The Sackvilles moved their family seat to Knole in Kent late in the 16thC, but they were a Sussex family. Such major British sculptors as Flaxman and Nollekens left their mark here,*

defence works can with hindsight be classified as follies even if they are government buildings, but these pill-boxes are a bit too ugly and humourless to deserve the name.

The grandest entrance to Buxted Park used to be a bit further down the road in the corner of the estate, where the traffic lights are. The old drive ran straight to the house from there. You will see the sign **Cooper's Green**. The occupational surname Cooper (barrel maker) occurs some nine times in Sussex place-names, in various combinations. Even people who live around here often do not know for certain where exactly Cooper's Green is. Most of them seem to agree that the pub and church a few hundred yards to the north are part of Five Ash Down and that Cooper's Green is the triangle south of our road and north of Ringles Cross. It's not really a community, but part of Uckfield.

So we go straight over at the lights and on towards the A26 roundabout. The A272 turns left here and right again at the next roundabout in order to avoid Maresfield, but we don't want to avoid Maresfield at all. On the contrary. We go straight across the A26 roundabout and into the village. The bypass is only interesting for those who want to go somewhere. We want to be somewhere.

Maresfield is pronounced [maresfel] by most villagers. The Domesday Book refers to it as Mesewelle (owned by William the Conqueror's brother), which

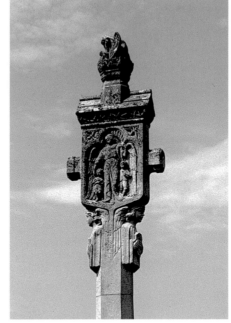

Buxted church war memorial

Military defence works. England has only rarely been seriously afraid of invasion, but since the south-east coast was the most obviously vulnerable, a number of defence measures were taken along the Kent, Sussex and even Hampshire coasts over the centuries. With hindsight most of them now look absurd. Martello towers are round, plump and reusable, which gives them a certain charm, but they were surely not worth the millions they cost. Pill-boxes, as at Buxted Park or at Southease, were less expensive. The biscuit was taken at Pett ES, where a canal was dug to keep out the French under Napoleon in 1804. Cobbett needed no hindsight to be indignant: 'as if those armies who had so often crossed the Rhine and the Danube, were to be kept back by a canal, made by Pitt, thirty feet wide at most!' The supreme example is from our own century: the Listening Devices, built at Greatstone-on-Sea in Kent in 1928. These consisted of a huge curved wall of concrete and a dish, meant as a sort of ear for acoustic reflection, in order to be able to hear every sound from the ships in the Channel. A great idea, and magnificently useless. A truly heroic failure.

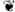

Vita Sackville-West (1892-1962) novelist, poet, biographer, and creator, with her husband Harold Nicolson, of one of the world's most famous gardens at Sissinghurst. In *The Land* she reminded us not to complain about rain:

> Now be you thankful, who in
> England dwell
> That to the starving trees
> and thirsty grass
> Even at summer's height
> come cloudy fleets
> Moist from the wastes
> of the Atlantic swell,
> To spill their rain, and pass
> While fields renew their sweets.

from the churchyard. Inside the church is a modern window depicting children at play.

Uckfield has been a crossroads of several routes since the middle ages, one of them being, as the town guide says, one variant of the Pilgrims' Way between Canterbury and Winchester. The signs of recent growth are everywhere. Diverting the A22 hasn't really solved the problems: traffic-jams are still not

uncommon in the sloping High Street. The churchyard has a Japanese memorial to a local missionary under an impressive cedar tree. Down near the railway crossing is Bridge Cottage, c. 1400, Uckfield's best known building. Beeches Farm gardens, a mile to the west, are no longer open to the public. If you should happen to find yourself at Ringles Cross just north of Uckfield, note the Thai restaurant in a

Norman architecture, from 1066 to the 12thC, is called Romanesque on the continent and this building style is characterised by thick walls and round arches, inherited from Roman building. It came not so much from Normandy as from the Romanised areas beyond, but was introduced in England in the wake of the Norman Conquest, hence Norman. There is a second meaning of 'Norman', which is indeed: from Normandy, the north-western part of France, which is where William the Conqueror came from in 1066. The chevron or zig-zag decorations along the arches and windows often seen in Norman churches are typical in Normandy (not to be confused with the dog-tooth decorations sometimes seen in the hollows of some of the ribs in a Gothic arch).

❦

Milestone. Milestones of the old Roman roads may have the distance from a town on them, but more often than not they only have the name of the ruling emperor. Some sixty have been found in Britain and most of them are in museums now. Turnpike roads, centuries later, were also usually marked by milestones, sometimes giving the distances from more than one town. They were erected by the Turnpike Trusts and after 1744 were legally required. Distances to and from London were measured from Sir Christopher Wren's church St Mary le Bow in the City, still often seen as the true centre of London (and so, to Londoners at least, as the true centre of the world). As a symbol for this St Mary le Bow, a bow of ribbon with a few bells (Bow Bells) beneath appeared together with the figure for the distance in miles. See page 15 of the Introduction. ❀

but the biggest monument is by Cibber, Dutch King William's sculptor. It shows a young boy on his death-bed, attended by his parents, all in white marble. A simple tablet commemorates Vita Sackville-West. When I was there a single long-stemmed rose was hanging over it, with a card attached saying 'Thank you for the beauty'. Her ashes are below in a crypt, contained in her ink-well, in the shape of a tiny Egyptian

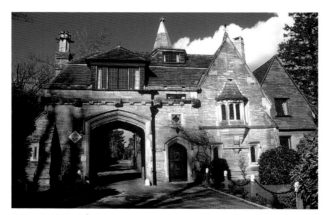

Maresfield Park lodge

sarcophagus. A writer ends up in her ink-well. There can be no more fitting way.

Most people know a lot about Ashdown Forest (without perhaps realising it) from the descriptions in Winnie-the-Pooh. *A. A. Milne lived in* **Hartfield** *in the north-east corner of the Forest. People come from London to go on tourist walks round beauty spots like Eeyore's Gloomy Place and Poohsticks Bridge.*

would mean marshy stream, but later references like Mer(e)sfeld make the meaning 'open field by the marsh' more likely – there are several pools about. The earliest settlement might date from 5000 years ago. There are clear traces of Roman ironworks. And again in the 16th and 17th centuries Maresfield was an important centre for iron, with hammers beating night and day, according to report. The evidence is still visible in things like iron tombstones and the Bow Bells **milestone**, to the left of the Chequers Inn. Going into Maresfield one passes a graveyard on the right. At the beginning of it are the sad remains of an ornamental lamp to commemorate the coronation in 1902 of Edward VII and Alexandra. What is to be done with a thing like that? Repair or remove. Let's give the parish council until 2002. ✭ The old churchyard further on has two lychgates, the second one slightly larger and better carved than the first. The church itself was restored in the **Gothic** style in 1375, but still incorporates a

converted barn, with the 'house altar' in the garden, the way they do things in Thailand.❦ All in all, I found precious little reason why Hilaire Belloc should have called this village Irkfield.

Near **Halland** *the Bentley Wildfowl and Motor Museum sounds a funny combination of attractions, but it works. The family name (not connected to Bentley cars) has been there since the 14thC and the estate was given*

to the county council in 1978. The wildfowl collection was already famous before it was opened to the public. In 1982 the cars came: more than 50 items, some on loan, and kept in pristine condition. Since the summer of 1996 the Sussex Guild of Craftsmen is represented here too, with demonstrations and exhibitions of their crafts and art-forms. For Bentley it's a creative addition to the attractions and for the

The Pooh Corner shop in Hartfield has an endearing range of goods related to Pooh, Christopher Robin, Piglet and Eeyore, and a map for a walk to the bridge where Poohsticks was played. I had a hard time dragging my wife Rita away from there. The lychgate at the church is overhung on the right by the projecting second floor of a cottage. There used to be a cottage on the left as well.

*I*n the south of Ashdown Forest is Barnsgate Manor, where the family have an almost 300-year-long tradition of growing grapes. Temple Grove in nearby **Heron's Ghyll** (a ghyll or gill is usually a wooded ravine), now a school, was the house of the Victorian poet Coventry Patmore. South of the village is a rather spectacular modern beacon for aircraft, one of the type we'll also see in Chapter 4.

Gothic and **Gothick.**

Gothic as an architectural period in Britain is divided into Early English (*c.*1190-1280), Decorated or Curvilinear (*c.*1280-1380), more ornate, especially in the window tracery and the elaborate rib patterns, and Perpendicular or Rectilinear (*c.*1350-1550) with very light, open structures and even more elaborate vaults. The building style is characterized by the pointed arch over doors and windows. Italian renaissance men disliked the 'pointed' style so much that they used their best derogatory term for it: 'gotico', meaning distasteful, barbaric, nonclassical, as the Goths had been when invading the west during the Great Migration of the 4th and 5th centuries AD.

Norman window that is at least a couple of centuries older. The rose window is pretty. Richard Bonner was rector of Maresfield until 1692 and the school still bears his name. Each year a deserving child under fourteen can win a Bonner Bible (not exceeding eight shillings in value, according to his will). The remarkable stair turret that you can see through the trees off Batts Bridge Road in winter belongs to the lovely old rectory, built by the Reverend John Butler in 1872. He assumed that as he had built the rectory himself, it was his to leave to his children, but the Church Commissioners told him that it was built on

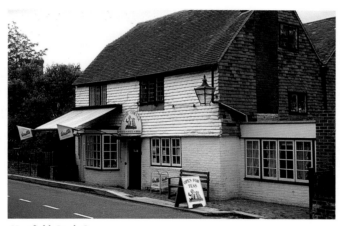

Hartfield, Pooh Corner

church land and would be needed for the next incumbent – after which they thanked him for his generous gift.

*I*n Maresfield Park the old manor house has known famous inhabitants (the Villiers Shelley family, to mention one name) and visitors – there is still a Duke

A few centuries later, during the Georgian era, a more flamboyant or bizarre version of the style became fashionable and is referred to as **Gothick** with an extra k. Victorian times saw a serious and elaborate Gothic Revival (as in the Houses of Parliament).

Later in this chapter we will see examples of the difference between Gothic and Gothick, when we are at Sheffield Park (p. 38).

Another meaning of the word Gothic is horrific. Gothic novels are 18th-19thC horror novels. For printers Gothic denotes the heavy sans serif letters used by the Victorians for thumping great advertisements. The typefaces popularly called Gothic (elongated, narrow and pointed like the architecture) are properly called black letter. They are different again from the Gothic letters that were used by Bishop Ulfilas (or Wulfila, 311-383), who is about the only person whose writings in the Gothic language have survived. As students of English language and literature we started by learning Gothic at our Dutch university. It wasn't too difficult though: it was all Bible texts.

Guild a permanent exhibition centre. The house, the adjacent buildings and the grounds, the many gardens and the children's amusements cater for a family outing of a few hours.

*R*aystede Centre for Animal Welfare can be found along the B2192 between Halland✳ and Ringmer.✳ In 1942 Mrs Raymonde-Hawkins founded a charity for sick and needy animals, with 49 acres of

grounds. Following that this Centre was opened in 1952 and ever since people have been able to come in daily to see the animals. Lots of them. There is a video explaining how the place works. They have a resident vet and even a crematorium. You can look upon it as a sort of minor zoo, but there is no entrance fee. How often does one find things like that nowadays? A surprising and sympathetic place. ✳

Fletching pump house

Piltdown Man. Ever since Charles Darwin's theory of evolution was published, scientists have tried to find missing links between ape and man. The first to claim success was the Dutchman Dubois. In the 1890's he dug up bones on the island of Java that were thought to prove the theory right, and so were called *Pithecanthropus erectus*, 'erect ape-man'.

Then in 1911 Charles Dawson, a lawyer, antiquary and amateur geologist, found some similar fossil bones in a siliceous layer near the village of Piltdown. He showed them to fellow researchers who confirmed their authenticity: another link between ape and man had been found and was suitably baptised *Eoanthropus Dawsoni*, 'Dawson's original man'. Some people were sceptical, since there appeared to be a discrepancy between the ape-like jaw fragments and the man-like skull fragments in the same set of bones. But doubts were dispelled when in the following years Dawson came up with other finds in the same area, like some more teeth, an ivory club and a similar pair of skull- and jawbones. Dawson died a happy man in 1916. For decades Piltdown Man – as Dawson's find was popularly called – looked increasingly anomalous and even embarrassing to ☞

*F*letching consists mainly of a row of cottages that look neatly pressed together and ironed, so that the wooden beams are nice and straight and at right angles. The village was renowned for the manufacture of arrowheads in the middle ages, as the name suggests (although the meaning Flecci or Fleece's people is more likely). Down the road to Piltdown is a nice wooden pump house with the village pump still in place. The very presentable old Early English church contains a mausoleum in which are the remains of Edward Gibbon, author of The Decline and Fall of the Roman Empire. But people also come here simply to see a parish church that is lovely and complete in almost every aspect. Note the rood screen and the well-preserved High Sheriff's tomb – he has even managed to preserve his nose. Note the bed on

of Wellington's cedar, planted where the great man first set foot in the village and there are still a number of oaks from the long avenue planted to commemorate Queen Victoria's visit. The Park was sold off in little bits in 1924 and gradually an affluent enclosed village within a village was developed. We will see this often in the course of the book. In this case the manor house, dairy house and coach house, buildings of the old estate, have also been turned into private residences and they still look handsome among the biggish modern houses in this villa village. The entrance lodge-cum-gateway, also private, is phenomenal for such a small community. Its siting at an angle to the roads, the view through it, the extraordinary mixture of roofs, chimneys and windows and the decorative animal heads make it into a proper period piece. Essentially, authentically English – is what it was. And then in early 1998 I was shocked to see that the entrance had been barred with an eyesore reminiscent of a horizontal barber's pole. How can people perpetrate such philistinism? Off to the saltmines with them! How can the local authorities allow these things? The blow almost made me teeter across the authentically English mini-roundabout, in order to calm down and have a drink in the authentically English Georgian Chequers Inn opposite. Six months later I went back to see if I could get used to it. It still looked like sacrilege to me. ✠

Horsted Keynes, Bluebell Railway station

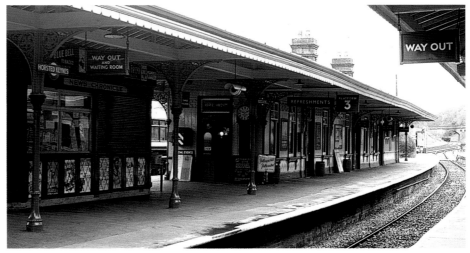

which he lies, as also the gravestone with the gloves nearby and the squint. The gate and lodge opposite the church, built by James Wyatt in a mildly Gothic style, used to represent the main entrance to Sheffield Park. Of course this was at the time when the A272 didn't pass the village by. Fetching Fletching.

The **Bluebell Railway** *was started in 1960 after the main line from London to Lewes* was dismantled. In principle it is still run by volunteers, but the regularity of the services is close to professional standards. It recreates the great days of steam and does so magnificently. The trains run through the relatively unspoilt Sussex landscape from Sheffield Park Station to Horsted Keynes and on to Kingscote, where you can get a vintage bus to East Grinstead – or the other way round. A connection to East*

The roads in Maresfield can still be busy, by the way, in spite of the bypass that was opened in 1990. People from Uckfield going north to the A22 find it more convenient to speed through the village. A direct slip road to Budlett's Common would make Maresfield breathe easily again. I should make some other remarks about the road at this point. The Maresfield bypass of the A272 consists of the A26 for the first bit and the A22 for the second bit. There is a common rule laid down by the Department of Transport that when two roads join to follow the same route then the lower road number will take precedence over the higher road number. So the A272 is overlapped by the A26 and A22 here. This overlapping of our 272 by other roads occurs a few more times for minor stretches, mainly in towns. It is nothing serious, our road can stand it. It only becomes slightly sickening near the end of the A272 where, unfortunately, it 'underlaps' other roads and things get messy, but we'll discuss that when we get there. One final remark about status. Until we reached Maresfield our road was just another country road. From Maresfield onwards it acquires a slightly higher classification which it retains to the end: the A272 becomes a Local Authority Primary Route. Impressive, huh?

Back onto the A272, just over the roundabout out of Maresfield, a funny-looking construction on the left may strike you as a jolly good folly tower, but it isn't. It was built in 1978 for the East Sussex County Fire Brigade's Training Centre and the peculiar shape is convenient for practising with ladders. As a true folly-lover I cannot help feeling let down somehow. Cheats!

We have a few houses here and there along the road towards Newick. Most of them make up the hamlet of **Piltdown**. The name denoted the hill of a man called Pileca (Pylkedown – Piltdown). It unexpectedly became world famous after the discovery of **Piltdown Man** in 1911. The local pub changed its name from The

☛ the palaeontological community, but it was not until the 1950's that a proper investigation was made with newly developed chemical tests. Fossils change. Nitrogen is lost, fluorine is gained. When this happens at a known rate the age of fossils can be determined with some accuracy, as with radio-carbon dating. Tests showed that one part of the primitive man of Piltdown was 50,000 years old, while another part of the same man was 500,000 years old. It was all a hoax.

For a long time after that it remained uncertain whether Charles Dawson had perpetrated the forgery or had himself been a victim. Who else in the area would have been sufficiently expert? Teilhard de Chardin was suspected, and even Sir Arthur Conan Doyle. But in May 1996 the palaeontologist Brian Gardiner managed to unmask the real culprit: a frustrated zoologist called Martin Hinton, long since dead of course. The proof was found in a trunk he had left. For anyone who has followed the case so far, it is hard to believe that this is the final word – and in fact it has not been universally accepted.

Some good must come out of a great story like this one. It did. The research required to unmask the hoax benefited general geology enormously. And the inn sign for the Piltdown Man pub would never have been as tongue-in-cheek funny as it is.

*I**sfield** [izvil] or [eye-field]: The **Lavender Line**, for steam and diesel railway enthusiasts, is not open and not much fun on workdays. A modest museum, gift shop and the Cinders Buffet are open at weekends.* ✳

*S**helley's Folly** in **Barcombe** sounds enticing. However, it is a normal biggish house, private, and is called the way it is because the poet Percy Bysshe Shelley built or bought it for his mistress and later had regrets. So, it was folly to have it, but it's not a folly. Barcombe used to be on a railway line. Dismantled now, but the station is still there, with the classic white railings and gates and the notice board saying that trespassing on the lines may be punished by a penalty of 40 shillings or one month's imprisonment for every such offence. The station is a restaurant next to the pub The Angler's Rest,*

Sheffield Park

Henry Moore (1898-1986) is considered England's greatest sculptor of the last century. His works have found homes all over the world, with a special collection at Much Hadham, Hertfordshire, where he had his studios. The architect Chermayeff commissioned a sculpture for his house in Halland, and Henry Moore designed what he called 'a mediator between the modern house and the ageless land'. Twenty years after he had carved it Henry Moore recalled how the landscape had inspired him. At first he thought of it as a 'kind of focal point for all the horizontals'. But later 'I became aware of the necessity of giving outdoor sculpture a far-seeing gaze. My figure looked out across a great sweep of the Downs, and her gaze gathered in the horizon. The sculpture ... had its own identity and did not *need* to be on Chermayeff's terrace, but it so to speak *enjoyed* being there, and I think it introduced a humanizing element.' (John Russell, *Henry Moore*). Fascinating, how alive this figure was for the artist. He liked the view of the Downs; so did she. The sculpture is in London's Tate Gallery now, a female figure with holes, all flowing lines like the South Downs (see p. 77).

Grinstead main line station is expected in the near future. ✳ *We'll come across a few other places in the A272 area where people have succeeded in keeping a few old trains running, but the Bluebell Railway definitely has most to offer and is open all year. No wonder it is always used for TV and films. Vintage little stations, engine shed, locomotives from Thomas the Tank Engine to a replica of Stephenson's Rocket, a whole museum devoted to the romantic age of railway travel. You can hire a train for parties, eat and drink (for instance in the 'Orient Express') and even have Bed and Breakfast in recently acquired Pullman coaches.*

Half a mile up the road on the right is the entrance to Sheffield Park gardens, where both **Capability Brown** and **Humphry Repton** worked.

Lamb to Piltdown Man and had a lovely sign. On 6 July 1994 the always exciting cycling Tour de France crossed the Channel and the route in this part of Sussex passed along Maresfield, through Piltdown, Newick and North Chailey, where it went south-west in the direction of Brighton. I remember how the commentators on Dutch TV, genuinely amazed, talked about the 'incredibly beautiful' villages and landscapes they had come through – they had never been in England before. The Piltdown Man pub made quite a day of it, from a champagne breakfast to all day meals, a large TV screen and a disco; off road parking for £5. Well, it didn't help them survive. In 1996 the pub was empty and for sale. The funny inn-sign was kept there, fortunately, but it was removed by new owners in 1997. How dare they – I was going to protest, but meanwhile the old sign is back again.

There is a road from Piltdown to Fletching, where the main entrance to the great Sheffield Park estate used to be. The best way to get to Sheffield Park now is to take the A275 to the north a few miles further on. The Park and the Bluebell Railway are up in the top section of this chapter, as belonging to things north of our road.

Barkham Manor, off to the left of the A272, was mentioned in the Domesday Book and valued at 20 shillings (see also p. 103). The present house dates from the mid-1830's and is the home of a modern vineyard. People are welcome and are in fact encouraged to view the winery where the whole process of wine-making is explained. For groups guided tours and tutored tasting can be organised as an outing, and the beamed and thatched barn is used for functions. Their white wines are among the best in the business, I hear, but I'm not sure what that means. Along the drive up to Barkham Manor Vineyard is a stone column on the right, a folly monument one might say, to indicate the spot where Piltdown Man was found. ☆

and the waiting-rooms are occupied by a shop. It's a quiet, out of the way and slightly melancholy place, with walks along the track and the river. ✳

Offham [oafum], just north of Lewes, has a pub called The Chalkpit on the A275. A bottle wall of some 20 yards, double here and there and with seats, forms part of the pub garden. Well done. But the main attraction outside is what is left of the actual chalk pit. The Ouse was used to transport the stuff. The difference in height between the chalk hills and the river down below is 400 feet. Loaded carts used to go down railway lines, their weight pulling up the empty carts. The track can still be seen diving under the A275 into a tunnel. Recently a few minor excavations behind the pub unearthed some more tunnels and things. Together with

The gardens at Sheffield Park

The bridge over the river Ouse brings us into **Newick**. It's a fairly easy name to explain: new is new and wic(k) means farm, or dwelling in general. Farming has always remained the major occupation of the people, as with most villages along the A272. In Newick other small industries were pottery and glove making. One of the cottages of Brett's Farm on the right served as a toll house until 1866 when the turnpike expired. It is still called Toll Gate House. Not that they collected from everybody: the locals justifiably hated the tolls and used a bypass lane south of here. Toll Gate House is easily recognised by its closeness to the road and by the most conspicuous of the present inhabitant's hobbies: topiary in the garden.

The village pump was erected to commemorate the Diamond Jubilee of Queen Victoria in 1897. For a long time it constituted the only way of getting water in the village, which may explain the notice not to use it for filling steam engines. Wouldn't it have been a good idea to get it working again for its centenary?✷ The village sign dates from the present Queen's Silver Jubilee in 1977. The village store at the end of the green is really on the wrong (right) side of the road, since almost all the customers live on the other side. A number of near-accidents happen every day and as long as they don't become real accidents this remains a lovely, spacious village green. It's dangerous enough on the wicket nearby: as early as 1737 a

the old lime kilns there the whole place could be turned into a minor show-ground for industrial archaeology.

*A distant view (from Halland) of the South Downs east of Lewes inspired **Henry Moore**'s Recumbent Figure (1938).*

Lewes, the county town, is just outside our limit, but is too important to leave out entirely. Its main tourist attractions are the

Norman Castle and the Anne of Cleves House. But above all Lewes is a regional centre with a beautiful shopping street running east to west. Some unexpected views to the south from the higher part of this street are lovely. As William Morris said of Lewes: '... on the whole it is set down better than any town I have seen in England.' On Cliff Hill in the east is the Martyrs' Memorial, an obelisk to seventeen

Lancelot 'Capability' Brown (1716-1783) is the most famous of landscape gardeners. He began his career at Stowe, Buckinghamshire, as an assistant to William Kent. Encouraged by Kent and Lord Cobham of Stowe he completed several minor commissions for other places before setting up on his own in 1751. His first great job was Croome Court. His success brought him invitations to work for a great number of major country seats, including Burghley House, Longleat, Blenheim Palace, Corsham Court, Alnwick and Tong Castles and Hampton Court, by royal appointment. Meanwhile his quick and imaginative assessments of the 'capabilities' of gardens to be turned into idealised landscapes 'fit for the Owner, the Poet and the Painter' earned him his nickname. Well over a hundred properties were thus 'improved' and made 'picturesque', in an impressive career that took Brown all over England. His efforts were universally appreciated. Almost universally. One man remarked to Capability Brown that he would like to die before Brown, '... because I should like to see heaven before you have improved it'.

Humphry Repton (1752-1818) is generally considered to be the successor to Capability Brown, some of whose designs he completed. One of the differences was that he brought flower beds back near the house. He had a special method of presenting his plans to his clients: he made water-colour impressions of the situation before and after his good offices, so that clients could lift a flap and compare and contrast. These views were assembled in folio volumes bound in red Morocco leather and hence called Red Books. Some two hundred of them survive.

Ninfield stocks and whipping post

Remnants. Pevensey has a tiny old courthouse/museum and Ninfield sports stocks in excellent condition: they are made of iron. Alfriston itself has a lock-up. At least ... A funny thing happened recently when researchers tried to find out about this little building. They were told that no records survive to establish its history, but the words dovecote, overnight accommodation and lock-up have all been used to describe it. Local authorities said that they had no idea what it was, but they were certain it wasn't a lock-up. Come again?

You should go and find out for yourselves perhaps. Alfriston is an unusually pretty village and has, of all things, a corkscrew museum!

Alfriston lock-up

Sheffield Park House, designed by James Wyatt, can only be seen in the distance, from the park. It has mostly been converted into flats which are private. So are the lodges that show Wyatt's architectural progress from Gothick to Gothic – at least, so it can be argued. The North Lodge was built in 1776 on the A275 (we'll see it in a minute) and is Georgian: more sedate in character: symmetrical, and with medieval motifs to make it look interesting. The East Lodge is the one we saw in the village of Fletching, opposite the church. It was built ten years later and is more ebullient: asymmetrical and romantic. Same place, same architect, ten years' difference. ✳ The gardens are run by the National Trust and are open to the public. They now look different from when they were first designed in the 18thC. The local hammerponds

cricketer was killed there. An accident of course.

The Bull Inn dates from 1510. Village tradition says that it used to be run by monks and served as a resting place for pilgrims, being almost exactly halfway between the two cathedral cities of Winchester and Canterbury. That also explains the names of these two on the signpost: Canterbury 63 and Winchester 68 miles. The inn-sign originally represented the Papal Bull. (This bull was the lead seal ('bulla') with the heads of the apostles Peter and Paul on it, affixed to letters or documents from the Pope of Rome. The other side had the name of the reigning Pope.) It is interesting to note that The Bull Inn was built at the beginning of the 16thC just after Pope Alexander VI of the Borgia family had died. The emblem of the Borgias was a bull, the animal. That makes the transition in meaning from a piece of parchment to the animal less amusing and bemusing. In the course of the ages this pub has also been known as The Hatch, The Crown and the Bull and Butcher. For some reason butchers were popular in Newick. At the beginning of this century there were no fewer than three.

The church has some very old Norman bits. It also boasts among other things an organ of 1889 that is still 'tonally intact, which is pretty unique', according to the vicar. Newick's most interesting building to my mind used to be the Tower House, but nowadays even this isn't everything it was. It was built by a local eccentric, an ex-butler who wanted to be able to overlook his former master's garden, Sheffield Park. He also wanted to watch the cricket matches in the village and the ships in the Channel. The house itself was three storeys high and on top of that he had a little tower room with a telescope. Unfortunately the whole was struck by lightning and the top had to be taken down, proving that you can be over-ambitious in life.

Protestant martyrs (remember Chapel Cross), who were burned during the reign of Queen Mary. Bonfire Night celebrations in Lewes still include the burning of an effigy of the Pope. ✳ *South of Lewes is* **Rodmell** *where Virginia Woolf (of the* **Bloomsbury Group**) *lived in Monk's House (now owned by the National Trust) until 1941. She drowned herself in the river there, before it ouses into the sea.*

Another area of interest that would be impossible to ignore completely, even if it is just over 7 miles from the A272 is south-east of Lewes. OK. Quickly then. From Lewes we'll follow the A27 eastwards. **Glynde** *Place manor house is fine, but more famous is* **Glyndebourne** *[rhymes with blindborn] Opera House to the north of it. An extraordinary new building, very chic.* **Firle Place** *is fine.* **Charleston**

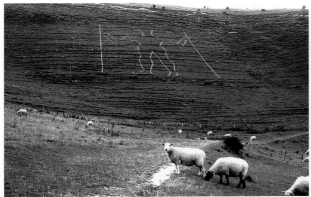

Wilmington Long Man and pub sign

One other striking building is one mile south of Newick: Pinnacle Lodge at the entrance to Newick Park. Since the gardens there are no longer open to the public few people see it nowadays.

Always on the look-out for Dutch connections I found the name of a Newick archaeologist: Blaauw. It means Blue. But an even better connection is that local lad Derek Bogaerde (later Dirk Bogarde) played his first roles on the stage in the village hall here. Dirk's father had immigrated from the Netherlands. The name Bogarde means Orchard, as also in the name of the American film star Humphrey Bogart. What can I say as a member of the extended family? A Boogaart can't do everything faultlessly. We Boogaarts are creative spellers.

Newick is twinned with the French village of Itteville in Essonne, which was mainly chosen for its proximity to Paris and its wealth of clubs and societies. The twinning association is very much alive: the French sometimes come over for Bonfire Night for instance. ✴

Half a mile west out of Newick the railway line from London to Lewes and the south coast used to have a station here, south of the A272, which explains the name Station Road. Just before we get there we cross an unseen magical line. It's

Bloomsbury Group. When they were at Charleston these artists were quite normal people on the one hand, delighting in the postman gossiping at the kitchen table. On the other they often lived in a world apart. Lytton Strachey wrote to Carrington in a letter: 'Typically, Maynard has insisted on... you'd never guess what: altering the time! So that the clocks are one hour in advance even of summer time, with curious consequences. For one thing, Jessie disapproves, won't have it, and has let the kitchen clock run down so that the servants have NO time. Then Clive is fitful on the subject, and insists upon always referring to the normal time; and altogether the confusion is extraordinary. How mad they all are! Maynard, though he sees what a rumpus it causes, persists. Vanessa is too feeble to put him down, and Clive is too tetchy to grin and bear it. The result is extremely Tchekhofesque. But luckily the atmosphere is entirely comic, instead of being fundamentally tragic as in Tchekhof. Everyone laughs and screams and passes on.'

The contrast between this free and easy living colony and the stodgily conservative neighbouring farmers is perhaps best expressed by an anecdote that is still told at Charleston Farmhouse today. It concerns the widow of Maynard Keynes, Lydia Lopokova, a former ballet dancer who used to sunbathe in the nude. She had been told that the farmers didn't appreciate seeing her completely naked, so as a compromise she sometimes wore a skirt, with nothing underneath. One day a farmer came by and in a panic reaction she quickly gathered her skirt up and covered herself from the waist upwards, not realising that now the lower half of her naked body was exposed. The farmer later commented that her skin looked like dark leather.

*Farmhouse is near **Berwick** church. Both of them are places of pilgrimage for lovers of the Bloomsbury Group of artists. **Drusillas Park** is a zoo that has a Junior Board of Directors and caters for young children in particular. The Clergy House in **Alfriston** (which used to be pronounced [allstun]), further south, was the first ever building acquired by the National Trust in 1896. Here and further east some fine*

*remnants of the old judiciary system can be admired. Down the river Cuckmere you eventually get to the Seven Sisters Country Park with its beautiful cliff walks along the South Downs Way to Beachy Head. Did you notice the hill figure on the way near **Litlington**? A white horse. Not the most famous hill figure in this neighbourhood. That would be the **Wilmington Long Man**. As a picture of a man or a woman it*

Beating the Bounds. As early as the 8thC parishes had processions in which the priest went round, noting and confirming the boundaries by striking certain points with rods, and sometimes beating boys with willow wands to make them remember. Scriptures were read at places like a Gospel Oak. It was a community festival, and part of the so-called Rogation Days, the three days before Ascension Day on which favours were asked from various saints. Cross Days was another term, since besides boughs and flowers crosses were also carried round the parish boundaries. After the Reformation, when the processions were officially banned, the festivities dwindled to just 'beating the bounds' on Ascension Day. It was very useful of course to preserve the memory of the boundaries in the days before good maps. Recent attempts to revive the old custom have often not been taken seriously. But in Chailey ES it has quickly grown into a community festival again.

❧

Sack road is a term of my own invention. For some reason I have always been vexed to see the quasi-French term cul de sac or cul-de-sac in Britain. It sounds both rude and uncouth, I think. We do not normally realise this, but the two main words, cul and sac, would appear prominently in a French dictionary of rude words if there was one. I'm sure the French have gleefully and insidiously tried to foist this on an unsuspecting English public, and you fell for it. A decent alternative is called for. Dead-end-street would be better, but it is a bit cumbersome. 'Sock road' would give one the right idea of having to come out the way one came in, but 'sack road' would convey the same message and at the same time have much of the sound of the original. Sack road. Sack street. What about it? Why not? ✳

may have inspired the creator of the gardens when he made the series of lakes. Capability Brown did them, but there is little left now that is obviously in his style. Later Humphry Repton worked in Sheffield Park too. Because of 20thC planting, it is now a beautiful setting for a great collection of trees rather than a landscaped garden. The little guide book is full of botanical terms. The summerhouses on the map are just

seats, alcoves. Spring and autumn are particularly attractive in this park and the National Trust cashes in on that by imposing a higher admission fee then – who are these people?

Further north on the A275 is this Wyatt North Lodge to Sheffield Park. People have tried to add to it in an 'appropriate style'. Always tricky, this. See what you think of it, if you pass that way. Still going north note how

the 0 Meridian of Greenwich. Personally I always have trouble realising that I can't bring time forwards or backwards by jumping across the line quickly and repeatedly and I tend to be mildly surprised to find that it's still the same day and date on the other side. But this is it: the dividing line between the eastern and western hemisphere. Or am I wrong in this as well? However that may be, the 0 Meridian is not indicated along our road. But there is something to be seen less than a mile away directly north of here, to be reached by going up the A275 and turning right again towards Fletching Common. You'll find Lane End Common car park on your left, and walking north from there for about 100 yards you may see the Meridian Stone monument along the path you come upon. Quite unspectacular. Quite nice.

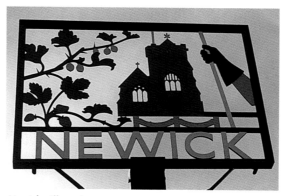

Newick village sign

So we cross the dismantled railway line a good mile south of Sheffield Park (where the Bluebell Line starts that makes use of the same track), and we are in **North Chailey**. Chailey parish consists of three villages. It used to be the centre of Sussex before the county was split up. Its name means gorse clearing. The ceremony of **Beating the Bounds** every year in May has here become a happy happening with lots of

may be the largest one in the world. Rodney Castleden, whose investigations took him to Newgrange in Ireland, Maes How in Orkney and the prehistoric temples of Malta, wrote the book The Wilmington Giant. *I can't summarise it better than by quoting the last sentence: 'For the Wilmington Giant now stands revealed as the oldest known god of these islands.' He may be right. Who knows? The genderless giant*

with the mysterious staves like ski sticks may be a Bronze Age god or an elaborate 18thC joke. There is a good car park from which to view it.

If you should find yourself in the neighbourhood of Ripe, where the novelist Malcolm Lowry lies buried, in between Lewes and Hailsham, go and have a look at the carved timber of Old Cottage in the village. It is exceptionally handsome craftsmanship.

*high **Danehill** church sits on its hill. Heaven Farm in Danehill is a sort of museum of Victorian farming housed in the original Victorian buildings. It is also the starting point for a nature trail and some attractive tours in the area between the river Ouse and the hilly boundary between East and West Sussex.*

Horsted Keynes *is pronounced [kanes]. Horsted means horse-place and it was* owned by a family that came from Cahagnes in French Normandy in the wake of William the Conqueror. (A descendant of this family was the famous 20thC economist John Maynard Keynes.) Since 1971 Horsted Keynes has been very appropriately twinned with Cahagnes. The village is perhaps best known for its cute little railway station on the Bluebell line, but there is more to be seen here. The North

North Chailey windmill

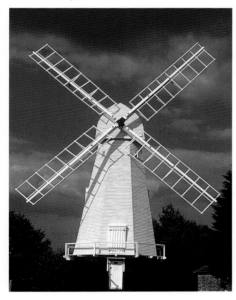

connected and unconnected elements. Let me quote from the 1996 programme: Maypole Dancing, Country Market, Novelty Dog Show, Historic Vehicles Display, Family Races and Children's Races, Tug o' war, Pantomime Horse Races, Displays, Dr Colin's Circus, Side-shows, Folk Musicians, Bounds Draw and Evening Barn Dance with Move The Foot. The Beating the Bounds race itself is 24 miles in relay, making use of runners, cyclists, canoes, dogs, horses, wheelbarrows et cetera. Village life *in optima forma*.

North Chailey is a part of the A272 where the ribbon development has provided a string of houses along the road without giving the idea that you are in a village. One B&B lady here tries to keep alive the legend of 'The White Lady', by telling her guests that at about 3 a.m. the cloaked figure of the lady of the Manor House is regularly seen by policemen and taxi drivers at roughly the spot where she was killed by a pony and trap. Some tourists love that sort of thing. And so do I to a certain extent. It's very English isn't it? So why not?

Fletching Common Meridian stone

Malcolm Lowry (1909-57) based *Ultramarine* and *Under the Volcano* on his years of alcoholic wandering. He wrote himself a short epitaph:

Malcolm Lowry,
Late of the Bowery,
His prose was flowery,
And often glowery.
He lived nightly,
And drank daily,
And died playing the ukelele.

Ripe, Old Cottage carvings

Back near the A272 again. The name *Wivelsfield [wilsfel] became famous because the first Donkey Derby was held here. The old community of Wivelsfield is now a hamlet west of the B2112 in a **sack road** that ends in a private estate. At the gate of Rose Cottage is the renewed village wellhead. The churchyard has some iron crosses and the south porch of the church shows a lion upside-down.*

The belfry chamber has two stones with texts, on one of which a few lines are upside down. There is Latin on the older one and both English and Latin on the other. All the Latin is OK, so probably the chiseller started in English on the second stone, realised that it should be Latin, turned the stone around and started anew in the style of the older one. He must have been a bit of a bungler. It's the type of

Vineyards have been planted in England ever since Roman times and have flourished intermittently, notably in more south-eastern parts of England shortly after the year 1000. William Cobbett saw a wealth of vines near Selborne HA. But talking about people who 'for mere fashion's sake' go into the wine business he said: 'They really deserve the contempt of mankind and the curses of their children.' Nevertheless, another heyday of wine-making started in Horam ES a few decades ago. And now, surprisingly, south-east England has some thirty vineyards open to the public.

Hammerponds: the loveliest relics of the Wealden iron industry. The charcoal of the Sussex woods and the iron-ore in the furnaces together made slag. Hammerponds were used for collecting water to turn the wheels that activate the hammers and bellows with which the iron was forged repeatedly to get rid of the slag and thus improve the quality of the product. There is often a chain of four or five of the ponds on different levels.

North Chailey war memorial

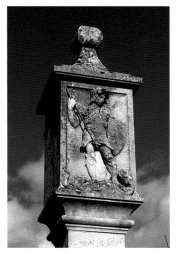

North Chailey Heritage Centre

American Indian Centre & Museum was in The Forge on the attractive village green, entrance by appointment. ❊ *Part of the Sussex Border Path leads down from the mainly Norman church to a chain of* **hammerponds**. *An excellent example of a Bolney stone grave stage 4 (see page 60) with 'diamond' decorations is just outside the door. The church itself contains the 13thC grave called 'the* **Crusader**'. *Crusaders were usually*

At the corner of the A275 south towards Lewes is one of those nice-looking pubs that have specialised as a restaurant, The King's Head. Turning north here up the A275 would take us to Sheffield Park and the Bluebell Railway line. Just after the A275 (on the right by the post office and almost invisible from the road) is a windmill-cum-rural-life-museum, open only a few afternoons a week in summer. Like so many others it has been moved, in this case from West Hoathly, and restored. It's a smock-mill (see page 68) and from the other side is a conspicuous landmark for Chailey Common, north of our road, a nature reserve of wet and dry bog, heather and gorse, open to the public all year round, with some rare specimens of flora and fauna.

More conspicuous on the south side of the A272 is Chailey Old Heritage School for handicapped children, or in other words, 'the Guild of Brave Poor Things', as the expression was when it was founded in 1903. The memorial along the road is in memory of 28 boys who served in the Great War. The motto 'Laetus Sorte Mea', happy with my fate, sounds a bit wry here. I could hardly believe my ears when I was told that all the buildings are post 1903. One of them, two-storeyed and half-timbered, definitely looks Tudor. The church bears the date 1923 and has a tower *and* a spire, both big and equally superfluous, since the church is only a school chapel. The place is not normally open to the public. People here are

stone that is only used inside, so nobody can have minded very much and most people couldn't read anyway. Funny. The word Armiger on the stones, by the way, denotes a sort of yeoman, allowed to carry a coat of arms.

In 1734 a man called Jacob Harris murdered three people in the Royal Oak Inn. He was hanged for his crime and the gibbet where his body was exposed, Jacob's Post, was later

supposed to have medicinal effects: gibbet wood is good for toothaches, people thought. So they cut pieces off, and only a small fragment of the original post is now on show in the Royal Oak pub, where they also have the history on the wall. The replica Post stands a few hundred yards further down the B2112, along the second drive on the right, in a field. The year 1734 is cut out of a rusty rooster that is fixed to the top.

buried wherever it was they died, but sometimes the heart was cut out and sent back home for a separate funeral. That's what must have happened in the case of this endearing effigy, only 27 inches long. ✳

West Hoathly *[hoath-lie] is a Saxon village with an 11thC church that has a narrow steeple and a curiosity in front: a completely stone-built lychgate. The village is the centre of*

Horsted Keynes, Bolney-type grave

a few attractions to different tastes. In the south and hard to find on private land is Big-on-Little, a natural sandstone outcrop that looks like a mushroom – a phenomenon that completely baffled William Cobbett. Close to the centre of the village is the museum called Priest House, in a 15thC building with a traditional cottage garden. It contains mainly domestic stuff: furniture, ironwork, needlework and

busy. There is a lot of commendable work to be done. ✳

Another mile and another boundary is crossed: we're in West Sussex now. Rock Lodge Vineyard on the right just before Scaynes Hill is one of the oldest (1961) and also one of the more unassuming modern **vineyards** in the business. They do red, white and rosé wines and pride themselves especially on their sparkling wines. People do not spend too much time here usually, but they are allowed to taste the wines before buying.

Scaynes Hill derives its name from a land-owning family of more than 400 years ago. Cyclists should not let themselves be deterred by names like this: it's a smooth climb. The village is part of the parish of Lindfield and most people live along the road off the A272 to the north. The church here houses a large embroidery, *The Gospel of St John*, that was made as a joint effort by the villagers (and by a few visiting foreigners) following a design by Polly Hope. The winter of 1998-1999 saw it finished, and there were suitable festivities. It is indeed quite an effort, containing over four million stitches. Communal works of art and devotion are rare these days, but personal contributions to the church are traditional around here. The church itself was built in 1858 to serve as both a school on weekdays and a church on Sundays. The system worked fine for a time, but eventually the school

Lindfield Road off the A272

It's not much to look at. We are almost on Ditchling Common here.

Ditchling *has always been a haunt for famous people. Especially since shortly before the first World War, when the artists **Eric Gill** and **Edward Johnston** formed an artists' colony in the village. Its influence can still be felt in the antiques and craft shops. Especially the Turner Dumbrell workshops north of the*

Crusaders. There were seven major crusades to free Jerusalem from Muslim rule. In England they were not so much a national movement as an opportunity for the fighting classes to show their skills in a good cause, and to learn new military techniques from friends and enemies encountered on the way. For instance, the Norman mound-and-stockade castles were gradually replaced by larger and better fortifications (with curtain walls and towers), such as Bodiam ES, modelled on the latest developments in the East. Confrontation with the East also contributed to the spirit of adventure and exploration. And, just as centuries later the Grand Tour (see p. 128) greatly enriched England's culture, so did surviving crusaders bring back knowledge of Eastern arts and sciences.

It is often claimed, wrongly, that effigies of dead crusaders in churches can be recognized by their crossed legs. This was a uniquely English fashion, and is thought to be a way of showing the knight *en garde*, ready to fight off death.

Edward Johnston (1872-1944), great letterer, is best remembered for designing the London Transport typeface. His teaching and example inspired Eric Gill (1882-1940), who not only designed the classic Gill typeface (see below), but was also a sculptor, printmaker, apostle of free love and Catholic. In 1929 Gill wrote: 'That state is a state of Slavery in which a man does what he likes to do in his spare time and in his working time that which is required of him. This state can only exist when what a man likes to do is to please himself. That state is a state of Freedom in which a man does what he likes to do in his working time and in his spare time that which is required of him. This state can only exist when what a man likes to do is to please God.'

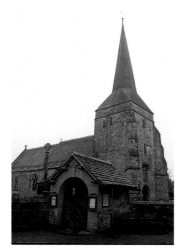

West Hoathly church and lychgate, in the pouring rain

Horsham slabs or Horsham stones are large, thick and square sandstone slabs. From the 14thC onwards they were used for floors and especially roofs, where they were usually laid in a pattern with the bigger ones lowest. They can look a bit heavy, but weather beautifully. Typical of, and indeed made in, Horsham WS. In the 19thC many pavements in Horsham were made with these stone slabs, some of which survive, for instance in the Causeway.❦

William Robinson (1838-1935) was Irish, but moved to London in 1861 where he became a gardener and a journalist. He can be credited with much that was new in gardening a hundred years ago and has been called 'the father of the modern garden'. His book *The Wild Garden* was published in 1870, 'wild' meaning an informal looking mixture of cultivated and wild species. His work is similar to Gertrude Jekyll's, but her influence was greater because he was also wild and headstrong in the expression of his ideas (e.g. he refused to use Latin names).

such. **Horsham slabs** on the roof and an iron slab outside at the front door. It is supposed to ward off witches. More things inside the house have the same function. The chap who lives there must feel very safe.

North of the village is Gravetye Manor [grave-tie], where **William Robinson** lived for more than fifty years and created his own private paradise of a garden in an incomparable setting. This is brochure language, but it's true. I was surprised to see the village stocks in the grounds. Gravetye Manor is now the sort of hotel where people come and stay who are not interested to hear what it costs. Mine was a quick visit.

Our present Queen Beatrix of the Netherlands spent some time in **Sharpthorne** when the royal family temporarily stayed in

had to move out. It went further down this road into what looks like a second, smaller church. History repeated itself, the school moved again and the Old School House is now an unusual private house. A mile or so down this road and to the left is a naturist site. Have they donated all their stitches to the church?

A bit further on is Freshfield Lock in the river Ouse with the 200-year-old picture postcard Sloop Inn, originally for bargees. Sloop, by the way, is a word the Dutch contributed to English, along with some other naval terms. Our influence on your language dates from the middle ages, because we have always traded and fought a lot. Our naval connections have given you terms like boom, deck, freebooter, furlough, schooner and yacht.

And so we come to the end of this stage and to **Haywards Heath**. It is still said that a highwayman called Hayward used to ply his trade on the heath here, which at least sounds romantic for a town with relatively few traditions. The fact is that since the 13thC there were a few farms round the manor of Heyworth (which means hedge enclosure). The Civil War in Sussex was started by a battle on the heath here in 1642, but that is more or less the full extent of the importance of the town in the past. On a county map of 1838 Haywards Heath is still missing. When the London to Brighton railway line was planned, neither Lindfield nor Cuckfield

Great Haywards Farmhouse, Haywards Heath

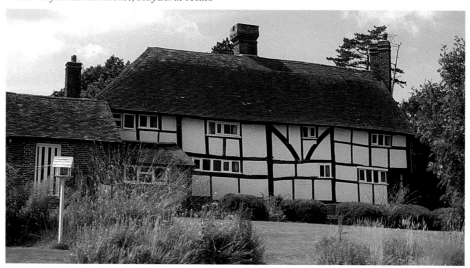

England during the Second World War. The Bluebell Railway ducks underneath the village of Sharpthorne into a longish tunnel, usually whistling loudly.

North of Weir Wood Reservoir and beyond our seven mile limit is **Standen**, one of the rare houses by the great arts and crafts architect **Philip Webb**, almost entirely decorated with Morris furnishings and papers. It is National Trust, but there still is a very private feel about it. I love the billiard room.

Ardingly [arding-lie] is best known for its show-ground. It is used for things like antiques fairs, but the main happening for the village is the South of England Show, which has grown into an event that attracts 100,000 visitors in three days in June. Just think of it. Everyone seems to know what to expect and

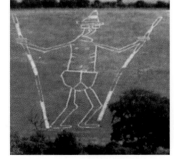

John Major, hill figure

really wanted it, so the station was built in between and a new town soon took off from there in 1841. Hilaire Belloc loved all of Sussex, but had problems with towns like Haywards Heath, which, he said in *The Four Men*, were 'not made for men, but rather for tourists or foreigners, or London people that had lost their way'. 'It's just a dormitory', a local historian said to me. Even the official guide to the town begins by explaining how well situated it is for going to other places. I asked the ladies of the local library (which doubles as a tourist office) what the beauties or attractions of Haywards Heath are and they registered mute amazement. I could hardly have caused more embarrassment. When I told them that I knew an architect who actually claimed he liked Haywards Heath they couldn't believe me. 'What's to like? It's a, just eh, well, it's a convenient town,' they said. But I'm not going to sell it short. It's a nice enough place with facilities like a shopping precinct, schools, parks, a leisure centre and its own theatre. There are 48 listed buildings, among

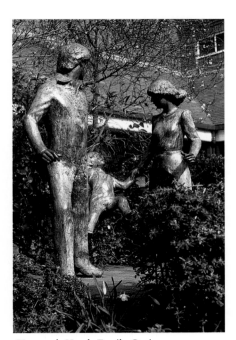

Haywards Heath, Family Outing

Hill figures. Cut in the turf of the South Downs above Plumpton Place there used to be a hill figure called Ditchling Cross, but it is no longer visible. A sad loss. Another hill figure around here that has now disappeared was laid out on the Downs in 1994. It was a huge caricature of PM John Major (500ft, 15 tons of crushed chalk), clad only in underpants and holding two surveyors' poles, much like the Long Man of Wilmington. This Grey Man of Ditchling was made (by Steve Bell and Simon English) as part of the 'nimby' ('not in my back yard') campaign called SCAR, South Coast Against Road-building. It was patronised by national celebrities, and directed against the improvement of the A27 between Lewes and Polegate. Fighting can be fun.

Philip Webb (1831-1915), lifelong friend and partner of William Morris, was painstaking and modest to a fault. 'I never begin to be satisfied until my work looks commonplace,' he once declared. Look at the care with which he chose the bricks at Standen to match the original Wealden farmhouse Webb preserved at its core. 'He tried to do for building what Browning attempted for poetry, to revitalize it by returning to contact with reality,' wrote his disciple Lethaby.

village centre try to carry on the artistic tradition. Ditchling's museum started relatively late, in April 1985. Besides the local stuff and works by Gill and Johnston it holds special exhibitions. Its emblem is the Wyvern or Wessex Dragon, a heraldic beast associated with King Alfred who owned Ditchling 1100 years ago. Terracotta wyverns (e.g. for rooftops) are still made by a tile factory in Burgess Hill.

Ditchling Beacon, a hill in the south, provides panoramic views, as might be expected. There is also an Iron Age fort, but you need to have an expert's eye to be able to distinguish it. I regretfully have to report the loss of two **hill figures** in this area.

North-east of this luscious village of Ditchling is Stoneywish Country Park with a number of ponds. The nature trail of

Tudor: In architectural terms the Tudor age (1485-1603) is divided into Early Tudor and Elizabethan. Early Tudor is characterised by the flattened pointed arch and the use of brick, as in Hampton Court. Elizabethan architecture shows the transition between late Gothic and renaissance in the adaptation of more and more renaissance ornaments from the continent, fitted to domestic architecture, notably larger symmetrical windows. Other characteristics are carved timber frames and leaded windows.

Pevsner, as the term is used in architectural circles, is short for the series of books called *The Buildings of England*, which appeared in some 40 volumes and were ordered by county, compiled by Nikolaus Pevsner (1902-1983) and a number of associates. There have been revisions, but since buildings are changed or lost with alarming speed it may be high time for a national project of complete revision in another form. A computer database CD-ROM for all of Pevsner has just been produced. Hooray. Keep it up to date and in all libraries please.

Sustrans (short for sustainable transport) is a Bristol-based charity that builds traffic-free routes for walkers and cyclists, though ramblers are not always keen on bikes. The idea was that by the year 2005 routes all over Britain will be linked together to form a National Cycle Network, passing through every area of the country. Traffic-calmed minor roads and cycle lanes in towns and cities will also be included, all in all some 5000 miles. Good luck to them, especially since they also try and combine these routes with sculpture trails. ✄

people always find it worthwhile. It is supposed to be an agricultural show and it is, but industry, commerce and entertainment have their place as well. On other days Ardingly is a quiet village with impressive Victorian public school buildings and, further west, a lovely big reservoir (90 acres), surrounded by wooded slopes, very quiet usually, and with excellent opportunities for water sports.

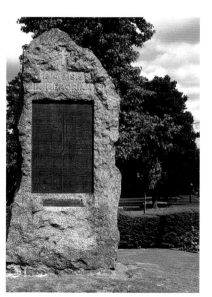

Haywards Heath, war memorial

Ditchling Common Country Park is east of Burgess Hill.

Burgess Hill *is in between Hassocks in the south and Haywards Heath in the north in more than one respect. Even if there are a few old houses it is generally regarded as a New Town, developed for commuters brought by the London to Brighton railway. There is a modern pedestrian shopping precinct and the Summer*

Lindfield *[linfield or even linfel]. On most maps Lindfield can't be distinguished from Haywards Heath, but it's a different parish. And a lovely one it is. It must be rare indeed to have so many fine houses of different periods and styles so close together:* **Tudor,** *Georgian, the lot.* **Pevsner** *called this 'without any doubt the finest village street in East Sussex'. Since the county border has changed and Lindfield is in*

them the oldest, Great Haywards Farmhouse. The treasures are there, but Haywards Heath tends to hide them a bit. The town is a modern administrative centre. The latest history book about it is even called 'The Metropolis of Mid Sussex'. So there you are. There are no fewer than four Town Walks. Asking for them can cause a bit of a panic since few people ever do, but they lead you along a number of pleasant places and are enjoyable. There is more beauty to Haywards Heath than the fact that you can get out of it easily.

Nature reserves see to it that there will always be open land in the directions of Cuckfield and Lindfield. Open and often wet. In fact, Franklands Village near the Scrase Valley Nature Reserve area in the east of Haywards Heath is built on the type of clay that can heave itself up sometimes by as much as a foot and make houses slide. As happened in early 1995, I was told.❋

We'll follow the A272 as it goes through the town, right through the High Street, which is called South Road. The first roundabout in Haywards Heath has an entrance to the Princess Royal Hospital. The big fat tower there is a very practical building, but the brickwork is a lot fancier than might be expected for a water tower. Built in

Festival in June is ambitious. The United Reformed Church (1860) in Junction Road is a sturdy piece of architecture. Dutch margarine manufacturers have their offices in Burgess Hill. Bedelands Farm Nature Reserve is just north of the town centre. The Burgess Hill and Haywards Heath area is a favourite for cyclists. It is very active during National Bike Week and there are a lot of supporters of **Sustrans.**

West Sussex now, the compliment doesn't sound right, but you know what he means. In the early nineties there was a pole at the north end of the pond, celebrating the fact that Lindfield was chosen as the best kept village in Sussex three consecutive times. Some of the houses are nearly 500 years old and they line the High Street all the way from the pond with the swans at the bottom to the 13th-14thC church near

the top of the village. Have a look at this church with its porch (two storeys) and its spire. It's a good example of the Perpendicular (see Gothic, page 33) style. Note the deep gutter. In one corner a gargoyle looks as if he has just sucked up the water from it through a gigantic straw. The war monument features St George and St Michael, both often associated with war, its victims and its victors. The church is light

Clayton, railway tunnel

style with the old hospital, a listed building, it is worth an extra look. The former St Francis Psychiatric Hospital, where the original **Gypsy Lee** died in 1911, was closed recently and now forms the West Wing of the Princess Royal. Seen from the B2112 to the south, these enormous brick buildings are quite impressive. The Priory near the second roundabout (Daisy Ashford who wrote *The Young Visiters* was educated here) used to consist of religious buildings but there are offices and club facilities now. The shopping precinct a bit further on is called 'Orchards'. It is adorned by John Ravera's 1985 sculpture called *Family Outing*. (It depicts a father and mother holding their child between them and swinging it forward. When the bushes in front of the sculpture aren't trimmed back enough, it looks as if the child is begging the cruel parents not to be tossed into the nettles, see p. 45.) Victoria Park follows on the left and a good view of a sloping churchyard is on the right. You will find the town sign at Star Corner, near the pub. The Halcyon bookshop there does second-hand upstairs. Which is good, for now one more requirement

*We are getting ever closer to **Brighton.** It is clearly outside our range, but one simply cannot come within a few miles of it and ignore it. I'll have to refer you to the margin for some of the attractions.*

Clayton church has paintings on the walls which date from c.1100. They were restored a few years ago, but don't expect bright colours. They are venerable but vague. Art

historians find them fascinating, but to non-experts they are less accessible.

The railway tunnel entrance where the A273 and the B2112 come together is generally called a folly. Living in the keeper's cottage, flanked by two castellated towers straddling the tracks, must be a singular experience. The tunnel has ventilation shafts in the direction of Brighton, so these little round towers that you

Gypsy Lee, Lucy Lee, was a famous Victorian fortune teller, consulted for over 30 years by royalty and celebrities. She used to live in a caravan at Devils Dyke near Poynings [**pun**nins]. Others later tried to cash in on her reputation, like Gypsy Rose Lee (Rose Louise Hovick, 1914-1970), an American striptease artist, whose choice of stage name was influenced by the popularity of the name Gypsy Lee. Lee is a common Gypsy name. Whether this Lucy Lee is the same person as the Mrs Lee who told fortunes at St Anne's Well Gardens in Hove is not entirely sure. Funny how quickly uncertainties can grow: less than 100 years later I can't seem to find out.

Brighton. Just a few things quickly then. Unsurpassed anywhere as a dazzling and exotic building is the Royal Pavilion. Restyled by John Nash in 1815 it looks like a palace in India (although Cobbett called it the Kremlin, but he didn't know much about the difference). Brightly illuminated in the evening it looks like whipped-cream-topped confectionery and may be the largest folly in Britain. It's magnificent inside as well. Quite near are two other tourist haunts: Brighton Pier with countless seaside amusements as only the English can devise and enjoy, and the area with narrow shopping streets called The Lanes. Just one more thing out of many: St Bartholomew's church in Ann Street. It has been called among other things Wagner's Folly (after the builder) since its dimensions are highly unusual. That is because they were based on those given in the bible for Noah's Ark. Note the pigeon holes in the façade, still in use, as you can see on the ground below. The nave is the tallest in the country and there are no chancels or aisles, so the inside space is undivided and simply awesome.✠

Graham Greene (1904-1991) started as a journalist, and wrote some important film criticism, as well as the screenplay for *The Third Man*. He roamed extensively all over the world and his large and varied output (novels, short stories, 'entertainments') almost invariably reflects his travels, his political views and his (RC) religion. He may well come to be regarded as England's greatest novelist of the last century.

His first great novel *Brighton Rock* (1938) paints a sometimes frightening picture of a seaside resort. About the holiday-makers: 'They had stood all the way from Victoria in crowded carriages, they would have had to wait in queues for lunch, at midnight half asleep they would rock back in trains an hour late to the cramped streets and the closed pubs and the weary walk home. With immense labour and immense patience they extricated from the long day the grain of pleasure: this sun, this music, the rattle of the miniature cars, the ghost train diving between the grinning skeletons under the Aquarium promenade, the sticks of Brighton Rock, the paper sailors "caps."'

But about Brighton itself: '...fresh and glittering air; the new silver paint sparkled on the piers, the cream houses ran away into the west like a pale Victorian water-colour; a race in miniature motors, a band playing, flower gardens in bloom below the front, an aeroplane advertising something for the health in pale vanishing clouds across the sky.' That's decidedly better.

I did an analysis of the popularity of authors on my secondary school once. The material comprised ten years. Greene was only the third most popular author (after Orwell and Steinbeck), but he was number one in terms of how many different titles were read. His best-read book was *The Third Man*, closely followed by *The Power and the Glory*.

and airy. Note the chancel aisles, the ceiling and the old and modern wood carvings.

Beside the church is the old Tiger Inn, where *that fascinating Quaker club called Benefit Friendly Society used to meet. The Parvise Museum for local interest is also nearby. The Old Brewery now houses the Wireless Museum. The octagonal slated roof behind the Red Lion pub is the cover of an old horse gin (hoist) that*

Haywards Heath, The Sergison Arms / The Dolphin

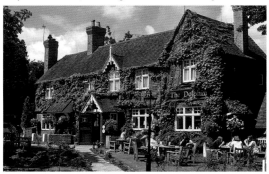

kind of name is that? It's a Philistine name. People have lost their sense of history again. There wasn't a dolphin in the Sergison Arms, was there?✺

Note the James Bradford Almshouses almost at the end of this chapter, also on the right, opposite Beech Hurst Gardens. I sometimes wonder if we shouldn't have Poor Houses for the culturally destitute.

Haywards Heath is twinned with Traunstein ('Traun Rock') in Bavaria, situated on a rock outcrop, with the river Traun on three sides. It is also twinned with Bondues, a little town near Lille.

was part of the Old Lindfield Brewery. All in all Lindfield is a perfectly beautiful and inalienably English village.

East of it, in **Walstead**, *is the lovely 16thC timbered East Mascalls house near the Ouse while Walstead Farm nearby has a front garden with rockwork and some charming examples of miniature architecture – the sort of thing anyone would like to see more often.*

for attractiveness in a town (a second-hand bookshop) has been fulfilled.✪ The war memorial (p. 46) is at Muster Green, where the Sussex militia used to gather. A bit further is the old 16thC pub Sergison Arms, named after the local landowners. A fine name, I should think. But in 1998 I was shocked to see that the lovely old pub had been rechristened The Dolphin. What

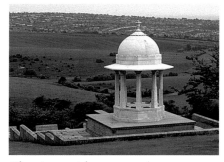

Chattri memorial

can see in this area are not follies but very practical.✳ *The windmills Jack and Jill are visible for miles around. Jack is the black tower mill (1866), Jill is the white post mill (1852). You can make circular walks up on the South Downs here.*

Brighton, *as I said, cannot be skipped. It is at the end of East Sussex and it is at the end of this chapter, as it should be. I would like*

to mention its best literary connection: **Graham Greene**'s Brighton Rock.

East of Brighton past Roedean school lies **Rottingdean**, *where Burne-Jones once lived. A salubrious walk north of Brighton will take you to the Chattri monument, a bright-white Indian war memorial for Sikh and Hindu soldiers, dated 1921. It's on the Sussex Border Path, over the A27 from* **Patcham**.

England,

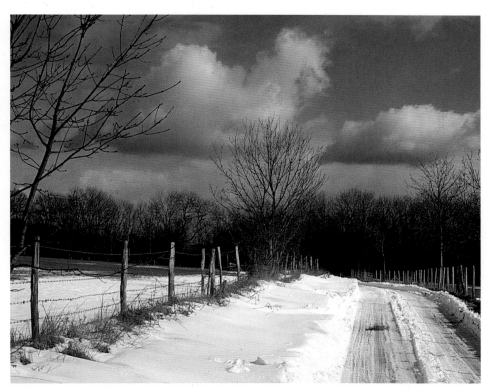

Near Henfield WS

your England

A wife's job is quite a pleasing mixture of crazy and kind behaviour. No, wait. These sentences in which the adjectives can easily be juggled around are dangerous. I had better put it in another way and start again. I'm fairly sure that I would have learned to love Britain if I had been on my own, but coming together with my wife Rita as I did from the first holiday onwards, made me appreciate the country all the more. We came in spite of Britain's reputation. When Dutch people think of England they assume it is cold, rainy and misty. Smog and Coronation Street terraced houses come to mind. And if England is nice and green in some places, then that's only because the weather is bad all the time.✳ For some reason the English enjoy confirming their country's reputation for bad weather. Which is largely unjustified.

But there are also serious, authentic reasons why tourists stay away from England. One is the high cost of getting there. (I am assuming now that the war between the ferries and the channel tunnel will only be temporary. I am afraid the competitors will soon come to their senses and stop fighting each other and start fighting their customers again, as they used to do.) And another reason is your prices. The high value of the pound in the last few years has made everything expensive for foreigners, and there is the curious phenomenon that a large number of products (cars, wine etc.) are for some reason more expensive than on the continent – something which I have often heard English people complain about, but is never satisfactorily explained. Take accommodation prices. Simply prohibitive for longer stays. So tourists tend to stay away. And most of you British people will probably say: fine, let's keep it that way.

Contrariwise, it must be said that you are really friendly to all tourists who do defy the disadvantages. And that is

49

one of the attractions of coming over here. There are countries where tourists are barely tolerated (France), and others where they are exploited. But the British are generally very kind to visitors. Good for you.

Another attraction is culture. Culture in general and architecture as the most readily accessible expression of it in particular. On the whole it is very pleasing indeed. I do not only mean little villages with cosy cottages and here and there a traditional church or a large country house. Their charm is easily recognised. But typical architecture is to be found in cities as well. Streets with multi-coloured doors and bow windows have a very British elegance and attractiveness to them. The problem lies with buildings that are un-British. International. Where most British architects are to blame is in failing to find a synthesis of modern needs like efficiency and economy on the one hand and traditionally British building qualities of character and loveliness on the other. In that respect I tend to agree with Prince Charles in his book and TV film *A Vision of Britain*. (Much to my surprise, for otherwise we can have little in common.) International architecture is so often graceless and barren. Isn't your isolation splendid any more?

Still, real ugliness is rare in Britain. Bill Bryson in his inspiring book *Notes from a Small Island* sometimes fulminates against it precisely because he loves Britain so much. It is the un-Britishness of taste and attitude that is offensive. Rita and I feel the same. This is about the way in which some modern shopping centres are worked into High Street architecture as well as graffiti; about neglecting maintenance of houses as well as building viaducts.

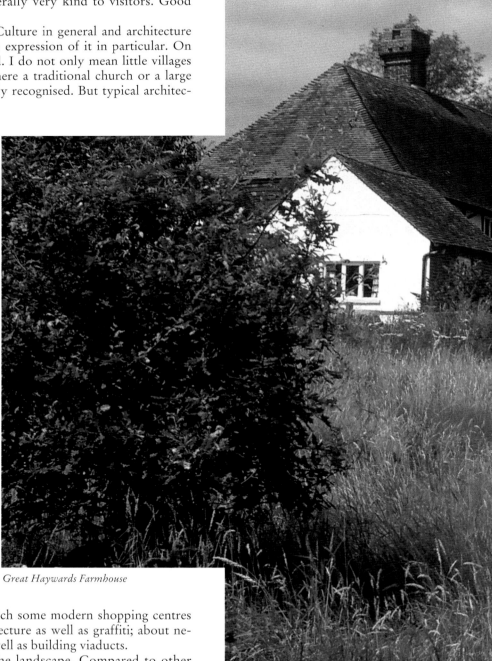

Great Haywards Farmhouse

Perhaps Britain's best asset is the landscape. Compared to other countries (France again) most of the English landscape remains virginally unspoilt. And what a landscape! Gentle hills. Fields, in

proportion with the undulations. Hedges, essential in this often dream-like setting. Centuries of ostensibly casual, maybe even subconscious, but consistent care make it all irresistibly lovely. Seldom really spectacular, but with a quality of timelessness. A gorgeous languor often hangs about it. Lush and pastoral. Sometimes even a muffled sexuality. Yes: a luscious, not to say lascivious landscape. Does one have to be a foreigner to see it?

I have great admiration for the people who develop and maintain footpaths and walkways. They provide the sort of attention that is needed. Farmers also care, more often than not. The only major mistake regarding landscape husbandry that Britain made in the past was allowing the powerline pylons in. Never again. They are as bad as the electricity lines in towns and villages. You are used to them, but they make things ugly. And when you come to think of it, they are terribly old-fashioned. Not to be tolerated in this century. It is a difficult but essential job to keep constant guard against further intrusions and encroachments. Against Power Brokers. Against the Planners of Plans, the Schemers of Schemes and the Greater Good Gurus.

Clearly, Britain is still incredibly rich. In human resources, in cultural aspects and in natural beauty. Take trees. Essential for the scenery. Awesome oaks in the woods, a row of poplars here and there, a willow at a stream, a yew tree in a churchyard, a lonely beech in a field, a cedar of Lebanon in a landscaped garden. All natural on the one hand, but lovingly planted, maintained and taken care of by ordinary people on the other. A lonely tree in a field isn't awkward for the farmer, an Englishman explained to me once. 'The tree is there because it is there. This is not a field with a tree in it. It is a tree surrounded by a field.' The British are the only people in the world who fully deserve the lush and languorous loveliness of their land: they have always contributed to its creation. Please, keep on caring.

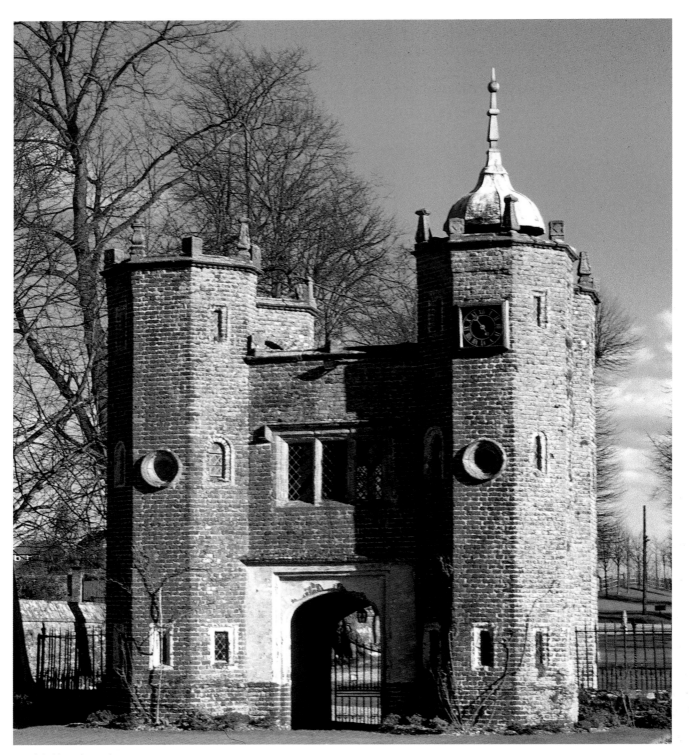

Cuckfield Park gatehouse

Chapter

2

Cuckfield
to
Billingshurst

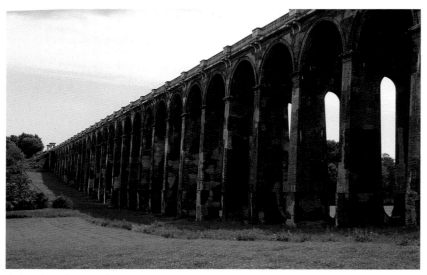

Balcombe railway viaduct

The area north-west of Haywards Heath contains some of the best gardens of Sussex normally open to the public: Borde Hill, Wakehurst, Nymans and Leonardslee.

Borde Hill gardens are only a mile north of the centre of the town and have been open since 1965. The house, late 16thC, still private, is owned by the Stephenson Clarke family. The gardens are tranquil and informal, with trees,

This second stage of our journey is almost the same length as the first. Seventeen miles. At the end of it we will have travelled from south of east London to south of west London, just thirty-six miles altogether. The second half of the distance contains some of the straightest stretches of the whole A272. It is almost as if we are paying tribute to the old Roman road at the beginning, east of Haywards Heath, and to the Roman road at the end, which runs right through our destination, Billingshurst.

We leave Haywards Heath and go past Butler's Green. That sounds a wonderful name and may conjure up images of frock-coated men frolicking, but its history is not spectacular: it is derived from the local Boteler family who had died out by 1600. Further west is the corner of Chownes Mead Lane, where you may see how topiary can get close to architecture: a fanciful series of arches graces the front of a house.

The roundabout is where the Cuckfield bypass begins. You could take the bypass next time, when you're in a big hurry. You could see a little stream that seems to come from nowhere and goes down some steps before it runs underneath the road. According to the relevant hydro-geological maps that can be studied in Haywards Heath library it is one of many headwaters of the river Adur [a-dur] (or sometimes as in adder) that rises on the right here, halfway towards the next roundabout. If only this were a nice, quiet place with a view of Cuckfield up on the hill... – but it isn't. The view is there, but cars keep whizzing past and we don't want to bypass Cuckfield anyway. On the contrary. ☆

Listed building. Buildings and other structures of importance, whether architecturally, historically or in general culturally speaking, are recorded on lists by the Secretary of State for the Environment. They are then supposed to be protected from being altered, removed or demolished. All buildings from before 1700 are included if they survive in anything like their original condition. Most 18thC and early 19thC buildings will also qualify more or less automatically. Beyond that selection is needed and the more modern the building the stricter the selection. There are three grades indicating the relative importance of listed buildings. Grade I, meaning: of exceptional importance; Grade II*: of particular importance and perhaps with outstanding features; and Grade II – of special interest. This last category may not seem vital, but even these buildings warrant every effort being made to preserve them. Local authorities produce Local Lists to protect buildings of local importance. Very commendable too.

Heaselands, one mile down the A273, used to be open to the public on a regular basis. They had beautiful flowering trees and shrubs and plants and different types of garden. They still do and it looks ideal for open days, but the creators of the gardens died and the family got security problems and little old ladies pulled out lots of plants and ... in short, it is all private again now. That's life.

Hurstpierpoint gets most of its name from the de Pierpoint family. One of these Pierpoints set fire to his servants. Yes. It is no longer common practice, fortunately. It happened at the house called Danny, one mile to the south. It is a very old estate that was already mentioned in the 13thC, but the house itself is late Elizabethan, in the familiar E-shape. When we visited it was being used as service

flowers and shrubs (at least one rose was created by the resident family themselves), all in lovely grounds, park-like with woodland and lakeside walks. There is a children's adventure playground as well.★

Another mile to the north brings us to another **listed building**, *Balcombe viaduct, a spectacular brick railway bridge for the London to Brighton Railway, dating from 1840 and crossing the Ouse valley with thirty-seven arches of almost one hundred feet high. Elongated oval openings lighten the structure. A photograph doesn't really do justice to the awesome experience of the perspective view through the holes and the cacophony of trains overhead. The twelve-and-a-half million bricks for it were brought up the river by barge. I read that there are as many bricks under the ground as*

Haywards Heath was a hamlet that quickly grew into a modern new town. **Cuckfield** is an old town that has retained the size of a village. After the Norman Conquest it was held by the Earls Warenne and was granted a charter as early as 1254. The pronunciation [**cook**field] is derived from the meaning of the word: cuckoo-field. *The Clearing where the Cuckoo Came* is also the title of a book of poetry about the village. Two minor 19thC literary characters had ties here. The novelist Henry Kingsley (brother of Charles, of *The Water Babies*) lived and died here (1876) and must have found the village very quiet after his adventures in Australia and as a war correspondent. And Harrison Ainsworth stayed at Cuckfield Park and used the house as a model for the first of his thirty-nine novels: *Rookwood* (1834), a romance immortalizing the highwayman Dick Turpin.

The High Street in the centre proudly shows a great variety of houses with front gardens. Halfway on the west side is Tower House, so called because behind the house and attached to it is a very sturdy round grey tower. It used to have an observatory on top, built by an amateur astronomer, Mr Knott, in the 1850's, but the glass dome had already been taken off before the Great War. It is good to see the tower still in use though. Going back down on the same side is the Victorian Queen's Hall. Inside this community centre are the names of the men who left their homes to fight in the Great War of 1914-1918. Fortunately they didn't all die in Europe, but just look at the list. There are almost 500 of them. What a sacrifice for the village that must have been. The exigencies of war are rarely brought home to you more clearly. The museum in this same building is open only a few mornings a week and also by appointment. Most of the exhibits are of local interest, like the whipping post, but one of the drawers that was opened for me contained objects related to a moment of international history. Or rather **prehistory**.

Prehistory. In 1822 Dr Gideon Mantell, a Lewes physician, visited a patient in Cuckfield. His wife went for a walk in the meantime and found two huge old teeth in the quarry just north of Cuckfield. They seemed interesting enough for the doctor to show them at an international conference, where an expert on South America identified them as belonging to the Iguana Lizard – but of an outrageous size. Later they were found to be prehistoric. All of which goes some way towards justifying the local claim that the first intimation scientists had of the existence of dinosaurs came from teeth that were discovered in England. In Cuckfield, if you please.✻

Defensive works. It would be difficult to overestimate the fear Sussex people of around 1800 had of Napoleon invading the country. A diary of 1803 mentions plans to evacuate women and children to places nearer London. Richard Weeke, the town's surgeon in those days, decided that Napoleon would perhaps not attack Hurstpierpoint if he saw it fortified. So he built a sturdy little lookout tower and provided some walls with castellations to deter the French. Needless to say Napoleon gave up his plans. Weeke's Folly is listed grade II.

Hurstpierpoint, Weeke's Folly

flats. And the staff were safe, I'm pleased to say. Nobody had tried to set fire to them for a long time. But the old habit may be the reason why the name Hurstpierpoint is often shortened to Hurst: I too would want to get rid of the family name in a hurry. Hurst is an attractive village where the Victorian novelist Harrison Ainsworth wrote some of his most popular books. Quite unexpectedly I came across private **defensive works** *in Hurst, down West Furlong Lane.*

The parish church can boast some famous architects: Barry (of the Houses of Parliament) and Scott (of the Albert Memorial) are among its builders. The stone spire and the lychgate are both worth an extra glance in passing. The other spire you can see north-east of Hurstpierpoint belongs to the college chapel.

Bosses are the nodal points where the ribs of a vaulted ceiling meet. These keystones provided ample opportunities for medieval carvers in wood or stone for embellishment in the form of emblems, symbols, faces, figures or just general grotesqueries.

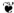

Brasses are effigies of the dead engraved on 'brass' plates, usually fixed to a slab, and laid flat on the floor of a church or on the top of a tomb-chest. A few very late ones were fixed on walls. The custom of using these plates was probably developed in the Low Countries in the early 13thC, with large rectangular sheets, often decorated with floral patterns. Only in England did people cut out the shapes of the persons represented. The brass, an alloy known as latten, was hammered into thin sheets, and engraved with a burin. The early medieval brasses are deeply and vigorously cut, but as time goes on the cutting becomes shallower and more elaborate. By the 17thC (when brasses were right out of fashion) the few that were made looked more like prints than brasses. The technique was occasionally revived by the Victorians who also experimented with coloured enamels, used on the finest medieval examples but almost always worn away.

More brasses survive in England than the rest of Europe put together. People often like to take copies of the images by putting paper over them and then rubbing with crayon (properly, cobblers' heelball). The London Brass Rubbing Centre at St-Martin-in-the-Fields has a collection of 70 British and European brasses in replica. They are mainly knights and priests and a few women, but there are also fragments with animals and children. You can study and rub them, for a fee.

there are above ground, which in itself is an amazing thought. It would be even more amazing to think that there were these same arches under the ground as well. No wonder it's a listed building.

*To get to **Wakehurst Place**, an Elizabethan sandstone house famous for its gardens, you have to nip back into chapter 1 territory briefly, north of Ardingly. The gardens are*

At the bottom of Cuckfield's High Street one can go further south past the old grammar school towards the church. There are two lychgates, or maybe I should say two-and-a-half. Note the cottages in the corner of the churchyard. There is a quaint wooden rail memorial (a graveboard – low, horizontal, supported by wooden uprights) just outside the church and a monument to the victims of the Boer War. All part of an unusually large churchyard with good views of the South Downs. And if you have never paid attention to this before, mark the motley mixture of memorials. The church itself gradually grew out of a chapel in the 13th and 14th centuries and was refurbished in 1855. It contains a number of venerable objects, memorials and **brasses**, but the reason why it sticks in the mind is the ceiling. It is a unique combination: a 15thC framework with **bosses**, with panels painted by a local artist in 1865. ✳

Cuckfield church ceiling

owned by the National Trust and managed by the Royal Botanical Gardens, Kew, so they are under the auspices of the Ministry of Agriculture. 'Kew in the country.' My standard question of how many visitors they attracted per year was answered rather pompously by the remark that the management were not allowed to divulge these figures to the general public. Which is nonsense. The gardens themselves are

South-east of the centre of the village near the drinking trough is a lane leading up to Ockenden Manor and one notices a unit of four houses. These started life as Poor Law House and have had an interesting history of public use for military volunteers as well as for tramps and even as a pub called The Bull, until it was split up and converted into private flats. It still looks like one big house. So it's not only the large country houses that are sold off in parts nowadays. Ockenden Manor itself (the

Even these 'minor' boarding schools and their chapels look exactly as you see them in films, by the way.

Washbrooks Farm on the B2117 out of Hurst is one of many farms that opened their gates to the public when times became a bit rough for them. This one still farms 300 acres and receives school parties and private parties with small children for a few pleasant

hours among the animals. One of the barns has been renovated to make a tea-room.

*Two miles south of the A272 along the A23 to Brighton is **Hickstead** Show Jumping Ground. It's a nationally and even internationally famous centre for riding. Big, big business. And only business. They have consistently had too much business to talk to me or answer my letters.*

nice and friendly, though it's a goodish walk if you go all the way along the ponds and lakes and have a look at the various birches, red-woods and pines.

Near Gatwick Airport is **Crawley**, *the county's main industrial centre. It hides its old charms well inside a ring of round-abouts.* ✪ *The largest Saxon church in England, at nearby* **Worth**, *with its beautiful churchyard, is*

Twineham church, Quakers' corner

name is **Old English**, and means Occa's woodland pasture) belonged to the Burrell family for a few centuries (we shall meet them again later on), but it is now an hotel.

Cuckfield Park was built by an iron-master called Bowyer in the reign of Elizabeth I and was owned by the Sergison family [**sa**-gison] for a few hundred years. It was a school until the end of the 1980's and was open to the public, but now it is privately owned. The gate-house you can see from the road is pretty exceptional. In fact the only thing like it that I know of is at Hever Castle in Kent. It was the focal point at the beginning of a long avenue of redwood lime trees (and still is partly so) which used to run all the way to the Sergison Arms pub we saw in Haywards Heath. Henry Kingsley called it 'the finest lime avenue of its length in England'. There is a strange custom related to this gatehouse. Anyone of the family who died in the house was left underneath it until the midnight before interment and then they were taken to the cemetery by torch light, past the Doomtree, which used to drop a branch whenever the death of a male heir was imminent. The park itself, a stunningly beautiful private garden now, was called 'the dearly loved haunt of Shelley' (Kingsley again), and its main feature is a series of hammerponds. According to the head gardener Walter de la Mare found his death in one of these lakes in 1956, but quite why he told me this I can't think, as de la Mare never seems to have been to Cuckfield. He died in his bed in London, though I feel certain that if he had had the choice... The last of this se-ries of hammerponds is at a mill south of the road to Ansty. This mill, by the way, could also be a very romantic spot if people cared to make it one.

To the west from here is **Twineham** *[twine-um]. It is a normal parish church, but the churchyard has a corner just inside the gate where Quakers have been buried. The grass is usually high there because the hay is a form of rent. The church itself is built of Tudor brick and has Horsham slabs on the roof. Peaceful and rural and you wouldn't think you were so close to the London-Brighton road.*

The fact that just over a mile away to the west of Twineham is a village with the rhyming name of Wineham can hardly be a co-incidence. Twineham is supposed to mean 'at two streams'. Not unlikely, since it lies in be-tween two headwaters of the Adur. Wineham is pronounced the same as Wyndham [wine-um] (a place near Lurgashall WS) which means Winda's water meadow. South of the Adur in

Old English. To most people Shakespeare's English (*c.* 1600) is Old English. Linguistically speaking it isn't. Old English is the English language as it was from the end of the 7thC up to 1150. There were several dialects, but Old English grammars are based on early West Saxon, as it was used in Wessex and also in Sussex, or in other words in the area of the A272 (when people call the A272 a historic road they usually don't know the half of it!). Old English literature was mainly historical and religious, the best-known poem being *Beowulf.* It is over three thousand lines long and praises the Scandinavian hero Beowulf who vanquishes the mon-ster Grendel, and the monster Grendel's mother. After Old English came Middle English, which ends with Geoffrey Chaucer. If I were to read aloud a poem of his in the way it was pronounced in his day and age, you wouldn't recognise the sounds as belonging to your own language. You might think it was Dutch. Middle English turns into early Modern English around 1400. So Shakespeare is modern English.

Handcross: the gardens at Nymans

George Bernard Shaw (1856-1950), Dublin-born Fabian socialist, opinionator, polemicist, food faddist, bicyclist, knickerbocker wearer, playwright compared to Shakespeare by his contemporaries, critic of music, then of the theatre, then of anything at all; oracle.

He was awarded the Nobel Prize in 1925, as a mark, he said, of the world's gratitude that he had published nothing that year.

Shaw's play *Pygmalion*, on which *My Fair Lady* was based, showed Shaw's interest in phonetics. He had very particular and (to my mind) sound ideas about spelling and the inefficiency of what he called 'Dr. Johnson's Alphabet'. He even left most of his estate to be spent on research into spelling reform. All to no avail, unfortunately.

We leave Cuckfield in a south-westerly direction and go over the roundabout. All in all it is a grand little place. It is twinned with Aumale in Normandy, a village known for its good market square and dairy products, and with Karlstadt, north of Würzburg on the river Main, close to Naturpark Spessart.

Ansty is pronounced either [an-**stie**] or [**an**-stie]. It is a beautiful Old English name meaning one-path, usually a steep path to a hill-top. Most of the village is hidden behind trees and it must be the best concealed community along our road. So there is more than what you see at the mini-roundabout, but the place is much too small for all the traffic that speeds through it. It is high time the link road

Wineham is Wyndham Farm. That name might denote the same man Winda, and the spelling might have been adapted to its neighbour.

However that may be, **Wineham** is chiefly known for Mercers, the good-looking house where **George Bernard Shaw** used to live, now private. But there is another pretty building that does welcome visitors: the Royal Oak pub. The building is 600 years old and has been

a pub for the last 200, the present landlord being the fifth generation of one and the same family of publicans here. The outside is less special than the inside with all its nooks and crannies. If you're over 5 ft 8 you won't be able to stand up in some places. Few honest English country pubs can be better.

Henfield *means the field of the cocks. The name stems from the time when 'hen' still*

unfortunately too close to the motorway. But both places are just over seven miles from our road, so perhaps I shouldn't even have mentioned them.

Nymans *Gardens, a National Trust property near Handcross, suffered much from the great storm of 1987 and is still in transition. The Pinetum for example was completely flattened and it will take years upon years for it to*

return to former glory. But most of the garden is ready for inspection again and living up to its reputation as one of the most beautiful in the country. There are a number of enclosed gardens, linked by grassy paths, and a variety of buildings, including a temple, a romantic gazebo-cum-dovecote and even an Italian loggia. The wing of the old house that you can see looks hundreds of years older than it in

The Bayeux Tapestry. You may have seen it in schoolbooks, but unless you go to Bayeux you can't really imagine how big the real thing is – between 19 and 20 inches high and 231 feet long. It tells the history of the Norman Conquest with 626 human figures, 190 horses, 35 dogs and 506 other animals; to obviate confusion there is explanatory text in Latin. The pub-sign at Ansty (designed with some artistic licence) shows the scene when William the Conqueror is warned of King Harold's movements shortly before the battle. William is holding the Papal banner, to indicate that Pope Alexander II supported him.

between the A23 and Burgess Hill is completed, so that 'only' the east-west traffic will go through. Two striking signs here. The Ansty Cross pub shows a colourful scene from the **Bayeux Tapestry** outside, but no one inside could tell me why. And the village sign opposite has the word ANSTY printed on one side and ANSTYE on the other. Tch, tch. No wonder these villagers hide among the trees, I thought. But further enquiry elicited the following information: Anstye was the older spelling and then suddenly the relevant authorities decided that it should be Ansty without the 'e'. A lot of villagers didn't much like that and when the village sign was put up in 1977 both spellings were used to please everybody. It was painted by James Forsyth who lived nearby, author of the poetry book on Cuckfield.✳

Continuing gently downhill towards the A23 the last building on the right is another erstwhile private estate: Gravenhurst, once owned by Vicomte de Stern and his son Lord Wandsworth, on the right just before the A23. It was a school for the blind called Farney Close for a time, but now it is Bolney Court, a private school. Things keep changing.

Some AA maps colour the A272 green after this point, to indicate that our

Ansty, village sign (above) and inn-sign (right)

The Bayeux Tapestry was commissioned by the Conqueror's half-brother Odo, Bishop of Bayeux, so it tells the story from a resolutely Norman point of view, though it was probably made in England. There has always been a strong tradition of embroidery here. This book mentions Scaynes Hill (ES), Wisborough Green (WS) and the Test Valley (HA) tapestries.✳ In Portsmouth (HA) the D-Day Museum features the Overlord Embroidery about the famous military operation of 1944, so the theme is the same as Bayeux's, but the invasion goes in the opposite direction. It's very colourful and 272 ft long. 272 – where have I heard that number before?

meant 'cock'. Anyway, a nice rural name for a busy little town on the A281, a typical local centre for shopping, banks and so forth. But there is also a museum, in the Village Hall, with lots of local stuff. The Cat and Canary House near the church is in pristine condition. This represents a good example of the problems of believing what people tell you. Or not. Guidebooks that take themselves very seriously

do not give you a story. Other, more readable books tell you that the series of black wrought iron cats below the eaves is there probably to scare off birds, or maybe it was a form of protest against the killing of a canary by the vicar's cat. Both reasons are just about acceptable. But in another book (Hardiman Scott's Secret Sussex*) a few pages are dedicated to an explanation. The cats were used as a way of*

Bolney: a prince among lychgates

Bolney stones. This type of grave is characterised by two longish stones lying lengthwise, with the text on the side and two uprights at either end. The oldest stones have sunk the furthest, but not quite disappeared from view. That is Stage 1, according to the Sussex Family History Group, who told me what they were called. The earliest readable date is 1660. Stages 2 and 3 are higher, often with diamond-shaped decorations at the ends of the horizontal stones. Stage 4, with flat decorated stones at either end, is the most recent stage and can be found elsewhere too (at Ardingly, for instance). These Stage 4 stones look like graveboards, of which we saw an example in Cuckfield. The diamond style is peculiar to Bolney, I am told, and this period of waywardness in the people of Bolney lasted one hundred years and apparently ended when other villages started to take up the custom. You will remember the solitary good example at Horsted Keynes. The people of Bolney are all right again now.

fact is, or was, rather. It was built by the Messel family after the First World War, but burnt out in 1947 and ever since this has been a great-looking ruin.

*Just over a mile north of Nymans is **High Beeches** gardens, with woodland- and water-gardens in an early 20thC landscaped layout. You had better check their opening times on www.highbeeches.com before going.*

road is a Primary Route between the A23 and the A3 at Petersfield. Ah well, let them have their fun.

After having crossed the A23 you'll find **Bolney** on the right up a little lane. The older spelling Boulney gives an indication of the correct pronunciation [bo**u**lni]. The last syllable of the name suggests that the place must have been an island in marshy country: Bolla's island. The village should go down in legend and song because of what can be seen round the church. Park the car 100 yards off the A272 at the Eight Bells pub and cross the road towards the church. The most obvious sight here is the lychgate. Hey, a prince among lychgates! It replaced an older one and was dedicated to Henry and Augusta Huth [hooth] by their son in 1905. He put in a coffin stone or corpse table, although by then these were hardly ever used. That is the sort of altar, flanked by elegant little gates, the place where the dead body was put to rest before the holy ground of the churchyard could be entered. It is designed to be the right height for the coffin bearers to rest their load. AMDG stands for Ad Maiorem Dei Gloriam – to the greater glory of God. Note the semicircular space in front of it, the traditional Sussex materials and the mill-stones worked into the path. Nearer the church itself you'll find something you may have seen before and will see again: the grass borders are edged with tablets commemorating people who have been cremated, from 1971 on – surprisingly avant-garde. The slabs with the names of the deceased are in front of the actual urns. Another thing you may have seen before is that the footstones have often

revenge by an eccentric man who could pull a wire fed through a hole in the wall. The wire had these iron cats and a lot of large scallop shells affixed to it and whenever the guilty vicar came near, it was pulled vigorously and an awful racket ensued. The story demonstrates the right sort of smalltownishness and pettiness to give it credibility. The hole in the wall can be found round to the left. It is called the Zulu

hole: this chap had learned Zulu tactics in Africa. But the main thing about all this is: it is a beautiful black and white cottage, early 16thC, and if I hadn't read the story I wouldn't have been curious to see it (and I'm glad I did see it) and I wouldn't have seen much of Henfield either, perhaps. Which would also have been a pity, if only because of the following item.

*G*oing south-east along the B2114 back towards Cuckfield and Haywards Heath you get to **Staplefield** with its giant cricket green. Some of these villages seem to have no other purpose in life than to be a beautifully sited cricket field with a good pub. Not that I'm complaining, mind you. It's a noble cause. And we are all aware that there is more to life than cricket, however unfortunate that may be.

*S*laugham [slaffum] is a gem in summer. It's the picture in many people's minds when they think of an English village. You come to it along old-fashioned country roads. There is only one street, a sack street, with gates at the end. Cottages with hollyhocks and roses. Renoir would have loved it. A good-looking pub. A little green on the other side of the road. A well-carved lychgate in front of a typical

Bolney stones

been placed against the headstones, to save labour mowing grass. There is a sundial at the entrance to the church. Churchyards often gladden the heart of the seeker after whimsy. Bolney's is quite remarkable. The best collection of **Bolney stones** is to be found here, naturally – what on earth or in heaven are the 'diamonds' for? And then I also have some disappointments. What are locally known as Plague Graves are not so, for in fact the death rate hardly changed at all through the awful plague years in the 17thC. And no exceptionally long graves have been found in spite of local legends about two giants (Henry Blaker and Henry Lintott, both of the first half of the 18thC). Nowadays I suppose a regular Dutch volleyball team would be seen as giants.

*C*oming back from the churchyard note the rather awkwardly placed stocks in front of the pub. They were made in 1994 by a local lad, just for fun. And just for this pub, there are imprints of **Eight Bells** to be seen in the cement.

*N*orth of Bolney, which consists of one road mainly, is the pub called Bolney Stage. On the outside you can still see that it used to be two cottages. One of the beams inside is carved with the date 1613. There are Old Tudor Tearooms, but the best attraction is the priest hole in one of the chimneys, where the local clergyman could hide from the Roundheads when the hunt for priests was on again.

A bit further along the same road, on the left, is Wykehurst Place, a private house (now owned by a Dutchman), which has been used a number of times as decorative background for (horror) films.

Eight Bells as a name for a pub is exceptional in that the number of bells is high. Pubs are often named for the number of bells in the church tower nearby, as in Bolney. To mention a few in Sussex: there are Six Bells pubs in Billingshurst, Chiddingly and Northiam, and Five Bells pubs in Pulborough and Chailey. We have Bell Inns in Bexhill and Rye, The Bell in Outwood and The Old Bell in Rye.

Henfield, Cat and Canary House

*T*he Henfield Tavern, at the corner of Church Street has a landlord who is an avid reader and every day he writes down a different quotation, culled from a dictionary, on a movable notice board outside the pub. One day I was there I read: 'Never, no never did nature say one thing and wisdom say another. Edmund Burke.' Philosophy in Henfield, in broad daylight. Keep it up, please!

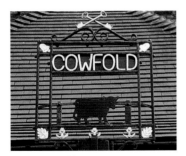

Cowfold, village sign

Lychgates (or lichgates) are 'corpse gates', lich meaning (dead) body. They are roofed gates at the church-yard entrance. According to medieval custom a corpse was carried towards the church and met by the priest 'at the Churche style'. That is where the religious service began and some shelter was useful. The body was laid down on the portable parish bier, or a special permanent bier (called corpse table or coffin stone) was provided.

Some lychgates are centuries old, but their great popularity with vicars was in Victorian times. We'll see a non-religious sort of lychgate at Easebourne WS. Another, modern one graces the entrance to a remembrance garden in Keymer near Hassocks WS. There is a type that pivots in the centre, often called tapsell gate in Sussex. Some good lychgates near our road are at Framfield ES, West Hoathly WS (stone), Pulborough WS and Hartfield ES, which is half under the projecting room of a cottage. In Hursley HA the lychgate is attached to Lychgate Cottage. Some lychgates are nicely carved, like the one at Slaugham WS, or have nicely curved beams, like Hurstpierpoint WS. Some of them consist of a wider plus a narrower gate, as at Cuckfield WS and East Meon HA. They are usually a pleasant sight to behold. But the prize for the most elaborate one unequivocally and irrevocably goes to Bolney WS.

parish church. Behind it is a field and you can take a walk to a lake and the remains of Slaugham Place, the old Manor House. In winter you have a good view of the arches from afar. The originally Norman church has a number of memorials to the Covert family, lords of the manor here, while outside behind the choir is a memorial with some famous names and confusing family relations. Iron crosses as well.

Cowfold, the Nelond brass

*South of Henfield is **Small Dole** where the Sussex Wildlife Trust has found a home in Woods Mill, a converted 18thC water mill. They organise workshops and outings all year round, and you can even get a fishing net to use in the ponds along the nature trail. Tottington Manor, which is quite near here, was the Headquarters for the Auxiliary Units of the 'Secret Sussex Resistance' during the Second*

Slaugham is one place where one would enjoy seeing a bright red telephone kiosk, but here it is white. And if you should have a vague idea that something is missing here, you are correct. Some form of ugliness is missing: there are no overhead electricity wires, since many years ago a Colonel Warren paid to have them put underground. He deserves a small statue, doesn't he? Slaugham is to be enjoyed at leisure.

Continuing west along the A272 from Bolney you'll see Bolney Chapel Road on the left. Providence Chapel there was built in 1858, with a little graveyard on the corner. The congregation consisted of Calvinistic Independents of the Baptist denomination, if that means anything to anyone, and lasted until the early 1970's. It is a private house now. You could sneak into the graveyard from the corner, but frankly there is not much point. ★

A few easy-going miles further there is an interesting-looking house on the right. It was a school for dyslexic children at one time, but now it's private again. We are approaching **Cowfold**. Coming into **Cowfold** (yes, a note) I realise how deep we are in the heart of the country, surrounded by animals. North of us lies Horsham, south of us is Henfield. Coneyhurst is to the west and to the east lies Cuck(oo)field, all at the same distance. Cowfold in the middle, whose name is also self-explanatory. How delightfully rural all these names are. Still, Cowfold has three small industrial estates. It has always looked like little more than an elaborate crossroads, but it does have a comprehensive and

World War as you may find described in a nostalgic book of that name, published more than fifty years later.

*Just over 7 miles from the A272 are the ruins of the old castle of **Bramber** – a bit pathetic considering the town's historical importance. Very little is left of it and of the fame of the town. But it came up in the news in 1974, when the Parish Council tried to save on its electricity*

*The two main entrance gates to Lydhurst House in **Warninglid** are enlivened by signs that say:* No Footpath or Bridleway - No Unauthorised or Foreign-made Vehicles. *They were meant in earnest when they were put up. They probably still are. How English can one get?*

Here we may illustrate how difficult it often is to define the word folly. The

drive up to the east entrance to this private estate starts by going over an elegant bridge with nice curves on the sides, fanciful and more elaborate than strictly necessary. But that doesn't mean much. Decorations on a building do not a folly make. But in this case the bridge didn't have to be there at all. How then did they cross the water before the bridge was built? Simple: there was no water. Until 1975 this was farm-

Cowfold WS is not the village described by Mark Rutherford in his book about Nonconformism, *The Revolution in Tanner's Lane*, written in 1887. The name was sacrilegeously used as an alias for Ampthill in Bedfordshire.

Another literary connection is made by Hilaire Belloc in *The Four Men* where they reach Little Cowfold and he jokingly quotes the poet Virgil as saying 'Propria quæ Cowfold Carmen Cervisia Ludus', which means that Song, Beer and Play are characteristic of Cowfold.

If song, beer and play also contribute to the community spirit it is no wonder that Cowfold won a few prizes as a village. The only mystery to me is that it can one year win a prize as a small village and another year as a large village. I'm sure that if I asked around I would hear a logical explanation. Better not, perhaps.

spirited village life, centred round the green on the one side, where cricket and **stoolball** are played, and the church with the **lychgates** on the other side. Eating and drinking can be done in between, as you can see. Note the Village Hall, a third centre and a splendidly Victorian affair, dated 1896. Also note the Horsham slab roof on the restaurant near the first roundabout. Normally the church itself is closed because of vandalism and you have to find the vicar along the A281 north to get in. Fortunately only very few churches in Sussex and Hampshire give in to the hooligans in this way. Inside this mainly 14thC church the most important attraction is the famous Nelond brass, made for Prior Thomas Nelond shortly after his death in 1429 or 1432, which lies under a red carpet locked to the floor. It measures 10'2" by 4'8" (the effigy itself is 5'10"), which makes it one of the largest brasses in England. Exactly why it was placed here is unknown. ✳

A notice board under the north-east lychgate explains the system of church marks, which originated in Saxon times and meant that the fences round the perimeter were marked by the people who had contributed to it. On the occasion of the 750th anniversary of the church the old custom was

Cowfold, shields

Stoolball as a sport dates from the late middle ages. There is a 15thC report from Devon of milkmaids playing it and using their milking stools as wickets, which must serve to explain the name. The so-called *Instructions for Parish Priests* of 1450 strongly advised against the game being played in churchyards. It is similar to cricket and rounders. The ball is bowled underarm, the bat is like a table tennis bat and the wicket still is a sort of stool, one foot square, mounted on a stake 4'8" high. A player can be out 'body before wicket'. A game for summer evenings. During the 18thC its popularity waned and it was supplanted by cricket in most counties. Nowadays it is thought of as a game for girls, mainly played in Sussex. In Newick ES, Cowfold WS and Billingshurst WS for instance the greens are shared by cricket and stoolball.✳

bill by turning off the street lighting for three days. It worked: £11.59 was saved. But the bill for the extra work involved was just over £20. So they had three days in the dark that cost them £8.41. There is a lot to be learned in life.✳

*Definitely too far away to the south is the Gothic chapel of **Lancing** College, exceptionally tall and beautiful, and a well-known landmark near the A27.*

Steyning [stenning] is a fascinating and varied market town, but unfortunately it is just beyond our limit as well. A pity, if only because of one of the finest Norman churches in England. ☆ *But I am pleased that we can just include Wappingthorn Farm along the B2135 Horsham Road north of Steyning. The farm buildings themselves are as weird as any you will ever see, and behind them is the 1928*

Alfred, Lord Tennyson (1809-1892) was appointed Poet Laureate in 1850 and made a peer in 1884. He built a house, Aldworth, at Black Down WS in 1868, and lived there until his death. High and exposed, it had wonderful views, but no road to it. Tennyson agonised over having a porch and bathroom; eventually the latter was included, over the former, and was so successful that the poet took to having three baths a day.

Aldworth seems like a suitably elevated home for Tennyson, far from the madding crowd. But he wasn't all that high-and-mighty. Carlyle mentioned his 'bright, laughing hazel eyes ... clothes cynically loose, free and easy ... voice ... fit for loud laughter and piercing wail, and all that may lie between' and said: 'I do not meet, in these late decades, such company over a pipe.'

Tennyson liked his pipe and port. Henry James's lack of interest in smoking counted against him, but for children Tennyson delighted in inverting his pipe into a bowl of soapy water, and blowing magically opaque bubbles.

He dedicated his last poems to his wife Emily and their happiness here:

> There on the top of the down,
> The wild heather round me, and
> over me June's high blue,
> When I looked at the bracken so
> bright and the heather so brown
> I thought to myself I would offer
> this book to you,
> This, and my love together...

❧

Clock. The Clock House itself lies further back. In 1914 it was built from recycled materials, such as old timbers from Dutch windmills, by Barry Parker (of the Arts and Crafts firm Parker and Unwin) as a model farm, and it did have a big clock then. The turret was damaged during the last war and not rebuilt.

land. Then the pond was made and the hump-backed bridge was made. Purely decorative and unnecessary. And here we enter the world of folly in its broadest definition. A landscape building, created to inspire pleasure. Stand on the bridge, lean over the parapet, watch the Brobdingnagian goldfish underneath and think about it. I myself prefer a narrower definition of 'folly'.

Cowfold tomb: Father Time

helter-skelter water tower, octagonal with a summerhouse on top, to be reached by a staircase on the outside. It's lived in by a friendly modern hermit.✤

*Just east of the A24 one of the highest points of the South Downs is the Iron Age circular rampart called **Chanctonbury Ring**, also the site of a Romano-British temple. This is where Charles Goring of the nearby Wiston estate*

*The Warninglid village sign with its Germanic-looking hero, the cottages, the un-English modern church (1935, why like this?), the notice boards at the entrances to the estate and the big carp make Warninglid an enjoyable village. It must have improved a lot since **Lord Tennyson** lived here and hated it.*

*A few miles north of Cowfold are the **Leonardslee** gardens. Founded by the*

restored at least temporarily, and in 1981 the then landowners repaired the fence again. Well done. Meanwhile, there are some charming reliefs on the gravestones near the church door.✤

The monastery called **Parkminster**, south of Cowfold and marked by a 200 ft high spire, is the largest in England and has a decidedly medieval atmosphere, even if it dates from 1877. Nice people, but it is not the sort of place where you go for a family outing.

Back to Cowfold itself and the two little roundabouts and our road to the west. The Margaret Cottages, named after the kind lady who converted the old workhouse into these homes in the 1920's, are the first ones on the left-hand side of the road after the second roundabout. They could be said to have two fronts, since from the A272 as well as from the churchyard you see front doors. One or two have old

planted a ring of beech trees in 1760, when he was nineteen. A second Chanctonbury Ring, as it were. Since then this botanical 'folly' has been an eyecatcher for miles around. Sixty-eight (!) years later Charles Goring wrote:

> *How oft around thy Ring, sweet Hill,*
> *A Boy, I used to play,*
> *And form my plans to plant thy top*
> *On some auspicious day!*

Loder family, who developed their own rhododendron Loderi, *the gardens are situated in a dramatic landscape with steep slopes along the seemingly endless chain of old hammerponds. One of them is called Engine Pond because the pump house there supplied water for the estate. There is a rock garden and there are some animals, including some that children will be delighted to recognise as wallabies. The azaleas,*

camellias, magnolias and rhododendrons in this setting make Leonardslee one of the great gardens of England. ✽

ooks on the Weald of Sussex always tell you about the iron industry and hammerponds (see chapter 1 of this book), but decent examples of hammerponds are not easy to find outside the large private and public gardens. A good one is halfway along the lovely little road

Cowfold firemark

firemarks. A bit further the houses lie back a little and then a tiny white shop comes forward unexpectedly. This building is supposed to be the smallest detached freehold in Sussex. I was told it used to be the grainstore of the local priory. ✽

ear the first road south towards Partridge Green is the Clock House. From our road you can see outside stairs up to a viewing platform and a little lantern. Worth a look in passing. This is a modification of what used to be a watertower. No **clock** to be seen here, but these are only preliminary buildings. The clockless Clock House advertises itself loudly, but is private nonetheless.

n to Pope's Oak. ✳ The next large estate south of the A272 is **West Grinstead**, also bordering the A24. Grinstead [grinsted] means green place. There were two Grinsteads in Sussex and to distinguish them they were called East and West. East Grinstead is some twenty miles to the north-east. The entrance to West Grinstead Park from the A272 now gives as its name Popes Oak Farm, in homage to Alexander Pope. He was good friends with the owners of the place at the time when the main house used to be where the moat is indicated on the OS map. That house didn't survive the 18thC and then a new one was built by John Nash, slightly to the north-east. This was pulled down after the Second World War, when Canadian soldiers finished off the ruining of it. Early in the 1990's the present owners decided to build again. They used towers and bricks left

Wappingthorn, water-tower

ere the big storm of 16 October 1987 hit disproportionately hard and the famous ring of trees at Chanctonbury has looked a bit of a mess ever since. You may be pleased to hear that restoration has taken place however, and we are all waiting for the young trees to grow to maturity. Wilfrid Scawen Blunt would be particularly pleased to hear it. He loved the place. He was convinced that the correct name

Firemarks are relics of the time when insurance companies had their own fire brigades. They only extinguished the fires of those houses that were insured with them. The houses could be recognised by the companies' individual firemarks. Of course by the time it had been established which fire brigade was supposed to put out the fire, the house had usually burned down. Which is why we now have a system of local authority fire brigades. ✽

❧

Parkminster. They told me they have had a remarkable influx of novices in this monastery recently, giving a total of some 20 monks – still absurdly few compared to the size of the place. And the whole place is in trouble. The building was severely damaged by the hurricane in 1987 and to give just one example: the rooftiles must be replaced. Each tile costs £3 and literally miles of them are needed. The main building and the square with the cells for the contemplative hermits cover 30 acres. The cells are built into the surrounding garden wall and look big enough to house small families, by the way. I'm sorry if I have made you curious to see it. It's not really a place you can visit. Women aren't allowed in anyway. Yes, I know we are in the 21stC. Don't tell me. Tell them.

Ordnance Survey (OS) maps were originally military (ordnance = artillery). It all started with a survey of Scotland as part of pacification operations after the Jacobite uprising of 1745-6. But the main work began after the then Master-General of the Ordnance authorised the acquisition of a theodolite in 1791. The first official OS map was of Kent (1801), 1:63,630, or 1 inch to 1 mile, and it became a popular series. Most counties were mapped in the first few decades of the 19thC. Very detailed town maps (1:500 scale, 127 inches to 1 mile) were introduced as early as 1855. London was mapped at 1:1056. Britain went metric in the 1940's (!). OS was way ahead of its time. In 1943 work was begun on National Grid sheet lines, 1:1250. By 1993 some 57,000 maps had been produced, each covering 500 square metres or 25 ha. 1:2500 National Grid mapping was started in 1948 and finished in the early 1980's. The most popular series (apart from the green Pathfinders) is the 204 sheets of cyclamen-coloured Landranger maps (1:50,000; 2 cm to 1 km) that everyone uses to pinpoint locations.

Pope's Oak, West Grinstead

from Slaugham to Horsham in **St Leonard's Forest**✛, *north of Lower Beeding,* **Ordnance Survey** *map TQ220290. The overflow on the south side of the road, the steps and the little waterfall look as if they could be used again any day. A few miles north is Colgate, whose pub, the Dragon, reminds us of the monster that infested St Leonard's Forest until the saint himself slew it. Nearby is the Holmbush estate, where a sham hermitage is reflected in the water of a small lake. Difficult to find, perhaps, but worth it for follyologists, especially in spring, when the odoriferous azaleas and rhododendrons are blooming. I'm not entirely sure if it is on private land.*

*S*t Leonard's Forest is no longer infested by *dragons and is not really a forest either. The largest river in Sussex, the Arun, rises here.*

over from the old stables for the construction of a new house, connecting it to another old part by a glass corridor: a clever piece of modern architecture. The result may look a bit of a jumble at first, but it makes a beautiful home. A little arch in the garden between the main parts of the house was inspired by drawings of an entrance gate of the original manor house. A pure pious portal. In 1995 the lawn was adorned with a pavilion. Twelve mosaic tableaux are fitted inside, representing the story of **Alexander Pope**'s poem *The Rape of the Lock*. This was based on the story of a family feud told to Pope by his host John Caryll in 1712. From this pavilion you have a good view of the oak tree under which the poet allowed himself to be inspired for this lengthy, lofty, lasting work of art. The oak can also be seen from the public footpath that leads through the park. The owner of all this modern beauty claimed he didn't care about history, but that is not borne out by his actions, fortunately. A few other families live on this private estate.

There are two churches nearby. One is the Catholic church where **Hilaire Belloc** lies buried (see p. 13), near the south-east corner of the old West Grinstead Park.✡ The other one is south of the village of West Grinstead and was built by William de Braose after the Norman Conquest to replace the Saxon church. The pews inside are marked by the names of surrounding farms and houses, because that is where the heads of the families used to sit. The wives and children were seated at the back of the church. This is the early 19thC we're talking about. I thought I'd better tell you, since it is hard to get the key to this church, which is in a remote, peaceful spot on the river Adur. Its vicar is never in.✳

was Chanclebury Ring and he might very well have been right if there ever had been either a Chancleton or a Chanclebury. He wrote a poem called Chanclebury Ring, *which soon becomes an effusion of love for the Sussex Weald in general ('Dear checker-work of woods'). It begins:*

Say what you will, there is not in the world
A nobler sight than from this upper down.

Horsham *may have a rural name (horse-settlement), but it is very much a town. There are few people left who pronounce the name as it used to sound: [horsum]. Today it is [hor-shum], although with an appeal to people's snobbery one might still get the correct pronunciation back, perhaps. Anyway. Probably founded by the Braose family, Horsham began to grow as a market town in the 13thC and* *developed into the metropolis of the Weald, among other things because the county court and gaol were here. Hangings could attract as many as 3,000 spectators on 'Horsham Hang Fair', the last one being in 1844. The developments of c. 1990 have turned Horsham from a traffic-congested town into a very pleasant place indeed. You can still drive a car right into the centre, but there are large pedestrian areas*

One mile down the A24 on the right are the remains of the old Knepp Castle. Knepp is supposed to mean knob or knoll, but there is not much evidence of that, apart from the mound on which the ruin stands. In theory the word could also come from Old English *cneapp*, meaning assistant: 'the king's helper's castle' would make sense. The old castle was important once, and owned by the powerful de Braose family. In 1789 William Burrell inherited the estate and spent the rest of his life collecting books and prints for a definitive work on the history of Sussex.

Horsham, The Causeway

Sullington *is where A. J. Cronin (1896-1981), surprisingly popular in the Nether-lands, wrote The Citadel. At Manor Farm is an enormous **tithe barn**, maybe the last of its kind in West Sussex. Most tithe barns are medieval, but this one is probably later. You need the farmer's permission to see it properly. The local road a bit further on runs between the church and the churchyard. The lychgate is not on the same* *side of the road as the church, which is exceptional. Inside the church are some modern windows, by Jane Gray and Annie Goodman.*

*The **Storrington** Conservation Society has published a number of leaflets describing rural walks near here. To produce these things is simple enough and the example of this old market town could and should be followed more often.*

Alexander Pope (1688-1744), England's greatest classical poet, played an important part in the development of landscape gardening. In the fourth of his *Moral Essays*, dedicated to the Earl of Burlington, the great arbiter of Georgian taste, he condemns the 'Vanity of Expence in People of Wealth and Quality'. Instead of being led by the 'false Taste of Magnificence' one must always follow Nature 'even in works of Luxury and Elegance.'

'Tis Use alone that sanctifies
Expense,
And Splendour borrows all her
rays from Sense.

In architecture and gardening 'all must be adapted to the Genius and Use of the Place, and the Beauties not forced into it, but resulting from it', maxims that Pope did not always practise in his own garden and richly encrusted grotto at Twickenham.

Hilaire Belloc (1870-1953), immortal for his *Cautionary Tales* and *A Bad Child's Book of Beasts,* was also a poet, novelist, historian, travel writer, biographer, and (briefly) an MP. 'He is such a geographer as I wish many historians were,' wrote Edward Thomas, 'such a poet as all geographers ought to be, and hardly any other has been.' Belloc lived for almost fifty years in Shipley by the white mill and much of his topographical writing is about his beloved Sussex. Time was not as precious then as it is now, but *The Four Men – a farrago* is still a good read for Sussex people.

Tithe barn. Tithe means tenth and barn means barley-store. One tenth part of the agricultural produce of a parish was due in payment to the church authorities, mostly in support of the parish priest. The tithes were stored in these barley-houses.

Toll houses, where toll collectors plied their unpopular business in the days of the turnpike roads, were for the sake of convenience often built right at the edge of the road, where they have mostly fallen prey to subsequent road-widening schemes. They were plain and usually quite functional (windows overlooking both sides of the road), but some of them show some light-heartedness or imagination. There is a round one on the A27 south-west of Lewes and another dressed up as a castle on the A280 at the foot of the South Downs north-west of Worthing. Look out for them if you find yourself in that area.

❧

Windmills. While watermills were introduced by the Romans, windmills were only invented a thousand years later and came to Britain *c.*1300. There are three main types of windmill. In post-mills, the oldest kind, the whole body revolves around an oak post. Tower-mills are built in brick or stone and only the cap on top turns into the wind. Smock-mills are similar but made of wood, tapering and weatherboarded, looking like a (white) smock. Dutch people tend to think that windmills are an exclusively Dutch phenomenon, but there are a surprising number of them in the south of England.

Parham Wendy House

as well. The sacrifices made for this progress can be judged from the lone spire against the backdrop of the Sun Alliance offices in the centre. It definitely makes a weird impression and inspired a special leaflet, which is available at the tourist office. It is called The Strange Story of St Mark's, *and explains How A Church Spire Came To Have An Office Building Wrapped Around It.*

Knepp Castle

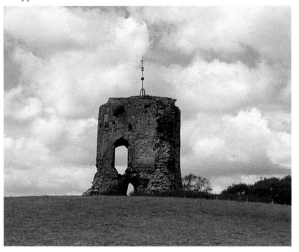

The Carfax is the odd-shaped 'square' in the centre of Horsham. Oxford and other places have Carfaxes as well. It's a good name, derived from an old French version (carrefourgs) of the word Crossroads – don't let Horsham sceptics confuse you. The Carfax is a lovely space with some notable buildings. In one corner the Sun Alliance offices dominate the scene. They are of the kind that makes you

Illness prevented him from ever publishing, but the Burrell Collection is still both useful and famous. At this stage the castle was much as it is today, a ruined chunk of the Norman keep standing on a **motte** crowned by a showy little weathervane. Burrell's son had a new Knepp Castle built by John Nash in 1809, but that was destroyed by fire and nowadays there is yet another Knepp Castle, built after 1904 in the style of the previous one. You can't see this from our road, but it's on the left after the A24. It looks a bit drab, but its siting beside the lake, Kneppmill Pond, is lovely. It is owned by the Burrell family to this day and so is still private.

Knepp Castle Estate, after Parkminster Monastery, the Clock House and West Grinstead Park is the fourth location in a row that is not really open to the public. I am sorry about that, but I think mentioning them as I do is better than trying to conceal their existence. And I can promise you that this sequence is unique for this book. You wouldn't prefer not to know about them, would you?

West of here is another great estate: Parham. The house was built in 1577; the village here had disappeared by the late 18thC and was ultimately rebuilt half a mile to the west, thus improving the view and making room for the deer park. Only the church remains in the grounds, as at Buxted ES. The house still breathes the atmosphere of an Elizabethan mansion. There are some good

portraits, a few surprising objects, and a major collection of needlework, of assorted styles and ages, much appreciated by connoisseurs. The Long Gallery is deeply satisfying, both as a room and as a showcase for embroideries and other jewels of craftsmanship. In the garden you'll find a brick maze in the grass. Tracing the right route on the notice board is difficult enough if you observe the rules. You might also

think that Horsham is developing its own style of architecture. It would be nice to see more of that, as long as it is compatible with more traditional English elements. It seems to be virtually impossible to combine good traditions in building with modern needs. A good example is the blue Swan Walk Shopping Centre, which starts in another corner of Carfax. Inside, both the modern Swan Mosaic and Lorne McKean's bronze sculpture of three swans landing on water will probably be universally admired. But what is your view of the way in which this modern bit of shopping precinct architecture as a whole comes out into the square? Horsham people seem to have got used to it pretty quickly. Have a look at the blue public notice board in the Carfax. That too was commissioned as a work of art. But the most spectacular and

Shipley, Mrs Shipley

A mile away from the A24 we see a cross-roads where the two side-roads do not exactly come together. This happens more often of course for reasons of traffic-regulation; in fact we just passed this situation when crossing the A24. But this southward road to Shipley is a different case. The house here used to be a **toll house** and the road from the north continued straight on past it (see p. 14). The local people used to avoid paying tolls by bypassing this house a few yards to the east and this latter track they made is now the official road. The phenomenon is best seen coming from Shipley: the old road goes straight on past the house and the new one curves to the right.

Shipley, where the **Knights Templar** built a church, is a shortened form of sheep-ley, meaning sheep's clearing. Hilaire Belloc lived here from 1906 until his death in 1953 in a 15thC house beside the **windmill** that he owned. The windmill dates from 1879 and was restored as a memorial to Belloc after his death. It is a smock-mill and sometimes referred to as Mrs Shipley. Unfortunately it is not often open to the public. However, it's the largest in Sussex, it's in good working order, it displays educational material and it has an enthusiastic miller, so a visit is recommended. Above the door is a tablet saying 'Let this be a memorial to Hilaire Belloc who garnered a harvest of wisdom and sympathy for young and old.'

have a look at the statue inside the Alcove or Temple: a classical nude in a mannerist pose, representing Rose Klein, first wife of the sculptor Ivan Mestrovic (1883-1962). And don't forget the Wendy House for children, in the far end of one of the garden walls. It's empty, but endearing. (It may be time for someone to write a book on Wendy Houses.) House and grounds are open to the public a few days a week.

I was going to go on and tell you about Offham and Burpham's literary connections next, but it may be time to explain about these things quickly. Lots of writers have ties with the area seven miles north or south of the A272. I only mention them if I knew about them before I started this book, and I only make notes about them if I have read them. I dislike name dropping. So I shan't mention Michael Fairless

Knights Templar: a military order founded in 1118 to safeguard pilgrims to Jerusalem. It quickly amassed enormous wealth and property in France, England, Cyprus and elsewhere, and in due course developed customs and rituals of an esoteric character. Eventually the order's independence was seen as insolence, and its wealth proved irresistible. The Knights were accused of heresy and sorcery, and the order was suppressed, with great cruelty, at the instigation of Philip IV of France.

Templar churches were always circular, based on the Temple in Jerusalem from which the Knights took their name. There is still one standing in London.

Motte: mound or artificial hill. A motte-and-bailey castle was a sort of fortress or castle introduced by the Normans, built at first mainly in wood and later in stone. The strongest part was the motte where the lord lived in a tower house or keep. The word **bailey** is used for the forecourt as well as the external wall, which usually consisted of a palisaded rampart and a ditch. Not much more than a dry ditch round a hill is to be seen if these haven't been re-used. An example can be found going out of Horsham just before the A264 roundabout on the right along the road to Rusper. But you will find lots of them indicated on Ordnance Survey maps.

Motte and bailey

Angela Conner, The Rising Universe

Mervyn Peake (1911-1968), artist and fantasist, may have based the castle of Gormenghast in his *Titus Groan* trilogy on Arundel. 'Beneath the downpour and the sunbeams, the Castle, hollow as a tongueless bell, its corroded shell dripping or gleaming with the ephemeral weather, arose in immemorial defiance of the changing airs and skies.'

Horsham, Piries Place ✳

D. H. Lawrence (David Herbert, 1885-1930): In *The Rainbow*, Ursula revels in 'the river winding bright through the patterned plain to seaward, Arundel Castle a shadowy bulk, the rolling of the high, smooth downs, making a high, smooth land under heaven, acknowledging only the heavens in their great, sunglowing strength ...'

controversial (!) work of art in Horsham is The Rising Universe *by Angela Conner, 1996, a huge golden water-globe inspired by Shelley's poem* Mont Blanc *(1816) down West Street. Do go and see it, and I hope for you it is working properly.*

William Pirie *(pronounced to rhyme with weary) was the headmaster of Collyers school from 1822 to 1868. He used to go around*

with a donkey and cart, and a life-size sculpture of this scene (also by Lorne McKean) can be enjoyed at the site where he built fifteen cottages. Children love sitting in the bronze cart and on his bronze lap at Piries Place, to the east of the Carfax.

Notice those green 'bells' to keep cars off *the pavement in front of the Crown Pub. They were put there in 1994, concrete cores*

The 12thC church at Shipley, built by the Templars, is now the parish church of St Mary. Its greatest treasure was a little shrine for relics, covered with gilt and enamelled copper, made in the 13thC in Limoges, France. Art historians loved it. Too much perhaps, for it was stolen in 1976 and now you can only see a copy. More readily appreciable is a stained glass window made by artist Margaret Traherne (famous for windows in Coventry and Liverpool) in 1984. The subject-matter is very much secular, as was the occasion: to celebrate the 50th anniversary of the Scouting movement. But well, why not? Be Prepared for Baden Powell. If you don't know your Scout Law any more, this is your chance to learn it again. Have a look. ✳ In the churchyard the composer John Ireland lies buried. The walk down the short path towards the river Adur from Shipley church is rewarded by peaceful views of the mill and the countryside.

On the other side of our road from Shipley is **Dragons Green**. The more romantic explanation of that name is of course related to the dragon legend of St Leonard's Forest. The more realistic explanation is that a family called Dragon owned land there in the 13thC. A few hundred yards north of the A272 is the pub called the George and Dragon. I suppose the question why this pub is not called the Leonard and Dragon must be considered foolish and foreign, but its name is not what is special about it. In the front garden of this pub is, quite unusually, a large standing cross on a tombstone. It is for Walter Budd, whose father was the publican 100 years ago. Walter was treated as the village idiot and after a minor incident drowned himself in 1893. His parents expressed

(real name Margaret Fairless Barber), nor Francis Thompson, nor Alice Meynell nor Viola Meynell, although I should have heard of Alice. Modern writers are even more of an unknown quantity. So I am not saying anything about, say, Rachel Cusk. But I do, with pleasure, mention the villages of Offham and Burpham, south of Parham, with connections with two literary mavericks: **John Cowper Powys** *and*

Mervyn Peake. *One can't help thinking that their taste for medieval mysteries must have been fed by their surroundings.*

Two other villages now, for your own tranquility of mind, on the river Arun. On the eastern side we have the unconditionally picturesque **Amberley**. The Pearl of Sussex it has been called, and not without reason. The cottages are a harmony of thatch, stone and brick.

covered by iron shells. The design, I was told, dates from the 1880's and came from Ontario; the ring in the top was meant for fastening horses. Come to think of it, there are similar ones to be seen in villages nearby.

North Street is a bit out of the centre *nowadays. Middle Street is between East Street and West Street. Towards the south is South Street. Life can be simple. South Street*

continues into The Causeway, easily the most beautiful street around. It's a broad sack street with a medley of architectural styles and closed off at the end by St Mary's church, essentially medieval. The churchyard has a modest Muslim grave. Beyond it you are in open country.

The Horsham Museum is at the start of The *Causeway. Its collection was installed in an ordinary house with different shapes and*

William Penn (1644-1718): Quaker leader who suffered persecution and imprisonment for his beliefs. In 1682 he sailed for America where a treaty with the Red Indians resulted in the foundation of Penn-sylvania, named after his father. In Steyning, Thakeham and at the Blue Idol in Coneyhurst Penn events are still held regularly by Quakers.

their resentment on the tombstone. Though the tone was mild, the vicar thought such a monument would reflect badly on the village and refused to have it in the churchyard. So the parents defiantly placed it in their pub garden where it is much more poignant.

Back towards the road for what is the longest straight stretch in the whole of the A272. **Coolham** [coolum] means homestead or village of a man called Cola. It is only a crossroads, really. A pub, a petrol station and a village hall. But they do have a neat war memorial to the airmen of the nearby Advance Landing Ground Airfield, used in Operation Overlord in 1944. They came from various countries, but the monument is especially for British and Polish casualties.

The next bit of road is straight again until it veers off to the right. At that point a track leads to the left and to the Blue Idol. The guardians used to do Bed and Breakfast in this Meeting House of the Society of Friends, or Quakers. Blue Idol is a curious name. Some say that it comes from the shutters being blue and the place having been idle for a long time. Unlikely. There are other explanations. The latest and perhaps the best is that the colour of the clothes these Quakers used to wear was blue, and idol suggested a different sort of worship. However that may be, it's a lovely 17thC cottage, where **William Penn** used to attend the services in the room with the gallery on the right-hand side. Quakers still meet here on Sundays.

Coneyhurst means what it says: the hurst (wooded hill or copse) where rabbits, conies, come. Again there is not much more here than a crossroads, and Coneyhurst is more of a collective noun for the houses and farms in the area than

John Cowper Powys (1872-1963) spent much of his life writing and lecturing in America, far from the Wales and Sussex he loved so much. 'It was not my country, this warm, mellow, gracious, tender-soiled Sussex, just as they were not my people, these blue-eyed South-Saxons, but there was something about the place that was profoundly English; more English, in the narrowest sense of the word, than any other county in the kingdom.' Didn't I tell you this road was England Epitomised? Powys is a wonderful writer for those who have patience. It took me a week's holiday in Glastonbury to recover from reading his great mystical novel *A Glastonbury Romance.*

Dragons Green

The church and chuchyard sport some fine pieces of craftsmanship. Note the pub sign. It can sometimes seem a breach of intimacy to go into the pub of a small community and disturb the local people, but here they are quite used to it. Amberley also has castle ruins and to the north is Amberley Wild Brooks nature reserve. North of that is the village of Greatham [grettum] where D. H. Lawrence finished his novel

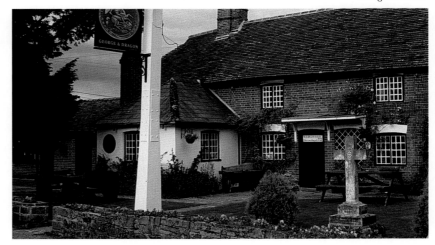

Billingsgate was London's chief mooring for fishing vessels by the early middle ages. Geoffrey of Monmouth (12thC) said that it was built in the 4thC BC by Beli(n), a king of the Britons, but Geoffrey was a romantic and often wrong. The gate may have been rebuilt, for as early as 1598 Stow's *Survey of London* said 'It seemeth to me not to be so ancient, but rather to have taken that name of some later owner of the place, haply named Beling or Biling.' From the mid-17thC onwards 'billingsgate' denoted the use of foul-mouthed abusive language, as by the fishwives in the market there.

Saxon or **Anglo-Saxon** denotes the art and architecture of the Angles and Saxons (from 410 AD until the Norman Conquest), who had invaded England. Not much is left beyond some fragments of stumpy sculpture and some scattered bits of church architecture, usually pieces of rough herringbone bond walls. Saxon churches often consisted of two relatively high rectangular rooms, dark with solid walls and tiny windows high up. Few Saxon churches are so little spoilt. St Nicholas in Worth WS, near Crawley (just beyond this book's reach) is a fine example.

Percy Bysshe Shelley (1792-1822), spectacularly romantic poet and radical, was sent down from Oxford for atheism. He married the 16-year-old Harriet Westbrook but left her three years later for Mary Wollstonecraft Godwin, author of *Frankenstein,* whom he married after Harriet drowned herself. He drowned too, near Leghorn; his body was only identified by the volume of Keats's poems he kept always in his pocket.

*sizes of rooms. That makes it highly endearing. One room is devoted to the poet **Percy Bysshe Shelley**. The museum doubles as a Tourist Office and you can get a Town Trail as well as Shelley's Horsham Heritage Trail. Do go into the garden and have a good look round.*

A *few more details. Behind the council offices just north of the centre is a huge modern brick sundial on the ground. It is a* work of art called The Sungod, *by the Sussex artist John Skelton, and the motto sounds very Horshamite to me:* I count not the hours unless they be happy. ❋ *That part of Horsham Park was designed with disabled people in mind: there is a variety of smells for the blind for instance.*

A *nd then always the question aimed at measuring the quality of a town: are there* the name of a proper village.

The road from here to Billingshurst is intersected by the railway line between Crawley (and Horsham) in the north-east and Littlehampton in the south. Just beyond it on the right is Rowfold Grange, where Major General Renton, who was on Montgomery's staff in the Second World War, used to entertain the likes of the

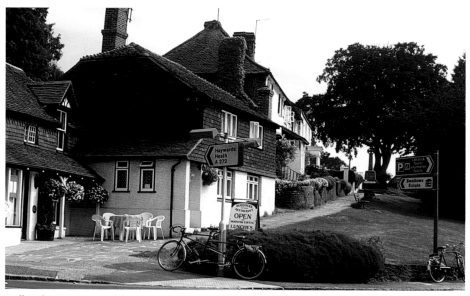
Billingshurst Green, with bicycles

The Rainbow, *and he wrote about it in* England, my England. *The Wey South Path and the South Downs Way, both major footpaths, come together here. The **Amberley Museum** advertises itself as The Museum that Works! It used to be called the Chalk Pits Museum, but it wasn't about chalk pits. It was and still is about industrial history, with exhibits that can show you how things are put together and function,* *technically speaking, but nothing too difficult. You might perhaps expect a wheelwright's shop or a kiln, but the variety is unexpected and thrilling: a telephone exchange, a locomotive workshop, a printing works and somebody who makes clay pipes; and everything is brilliantly explained. The museum attracts close to 100,000 visitors per year. There are leaflets in several languages, and yes, Dutch is one of them.*

second-hand bookshops in Horsham? Yes, there are. Two good ones. Go and see for yourself, before this book finds its way into their stock.

As Cobbett said: 'This is a very nice, solid, country town. Very clean'. There were Dutch people living in Horsham as early as the 15thC. No wonder I felt at home here.

I'm sorry I haven't been able to find out for certain why Tower Hill in the south is called *Tower Hill. Do you happen to know? If so, please tell me.*✳

The excellent lodge you can see at the A24-B2237 roundabout in the north-west belongs to Warnham Court, now a school✳. Warnham itself remains a very pretty village. West of Horsham is **Broadbridge Heath** where Shelley was born, of Sussex land-owning stock, in Field Place.✳

Private estates. The A272 used to be graced by many private estates in former ages, usually owned by members of the nobility. Some of them have been in the hands of the same family for centuries, e.g. Knepp Castle at the A272/A24, owned by generations of Burrells. But in most cases the resident family eventually couldn't hold on and found themselves forced to sell out. Some estates became nursing homes or hospitals, like Bordean House near Petersfield HA. Others became schools, like Gravenhurst/Bolney Court WS. A lot of them were split up and sold in little parcels, like Maresfield ES and Hawkhurst Court, Wisborough Green WS. Some have been acquired by the National Trust and are open to the public, like Hinton Ampner and Petworth. New uses include hotels (Lainston House in Sparsholt HA and Buxted Park ES) and even vineyards (Barkham Manor ES). The Cowdray Estate WS still belongs to the Cowdrays, while Crawley Court HA is owned by a communications firm. Fortunately some of them have new private owners who keep the place as a whole as much as they can, with good stewardship. Most estates remain 'private'.

Saudi Arabian Royal Family, or so all the neighbours say. You wouldn't have guessed that, looking at it nowadays, when the house and the outbuildings (a music room even) have all become private homes. **Private estates** get broken up more often than not, nowadays.

We are getting to the end of our second stage: **Billingshurst**. This hurst was where the Billingas lived, Billa's people, whoever he was. The Billingas may have partly moved to London later and settled near **Billingsgate** – there are more streets with 'Billing' in London. Another explanation says that it was named for a man Belinus, a Roman surveyor, responsible for the construction of the road. Less likely (if only for the combination of Latin and **Saxon**)✳, but sure, the Roman Road called Stane Street (stone street) has always been vitally important to the village. Running between the major Roman settlements of Chichester and London it carried troops, and later trade.✳ In the early 19thC Billingshurst was on the only inland water route from London to the south and by 1859 there was the railway as well. Add the A272 to the picture and there you have Billingshurst: a crossroads town that needs a bypass. Well, work on the north-south Billingshurst bypass started in February 1998, and it must be said that once these people get started they really do apply themselves. Things become messy in no time. Our road A272 is not seriously affected. The planning application for this Western Bypass includes among other things 555 new houses, extra recreational land and a cycle path, while associated planning benefits comprise things like an all-weather pitch and a pool for the new school plus improvements in the village centre. One can see the headlines: Bypass Benefits Boost Billingshurst.✳

William Cobbett called it a 'pretty village' and it still is in many ways. The village green along the

Billingshurst, Ye Olde Six Bells

On the other side of the Arun, a natural boundary, is Bury. It is on this side of the A29, it is true, but a typically A29/Stane Street village and so we will discuss it in Chapter 3.

The village of **Thakeham** [Thackum] lives up to the meaning of the word: thatch settlement. You wouldn't want to drive through it in a hurry. The church has a table tomb in the chancel. Notice the view outside and the triple-

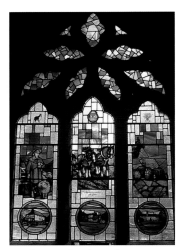

Southwater church window

Wilfrid Scawen Blunt (1840-1922) 'the chief public nuisance of his time' agitated mightily in the cause of the 'nations lying under the British yoke', particularly Ireland, Egypt and India. He saw himself, though, as an old-fashioned squire and poet, and till the end of his life vociferously preferred driving a four-in-hand to a motor car.

When Ezra Pound organized a delegation to visit the older poet in 1913, Blunt admitted not being sure at first 'whether they were a deputation of poets or horse-breeders'. But he did give them roasted peacock for dinner.

Gertrude Jekyll [jeekil] (1843-1932) author, artist, photographer and great garden designer, famous for planting in the cottage garden tradition and for her eye for colour. Her collaboration with **Sir Edwin Lutyens** (1869-1944) (who called her Bumps) was crucial to the success of each. Lutyens liked gardens to have a central idea, often a built feature, and his designs often use brick-lined oblong ponds, many steps, straight, paved paths and pergolas with brick uprights.

South-west of Horsham is Christ's Hospital. In 1904 E. V. Lucas (Highways and Byways in Sussex) called Christ's Hospital 'an arrogant red-brick town'. It's surprisingly huge, this Bluecoat School. Over 800 pupils work and live here. It used to be a charity school, founded by Edward VI in London in 1552, the word hospital being derived from the hospitality of the monks. These buildings, alien to the landscape, date from the turn of the 20thC. The school has its own museum, arts centre, sports centre and even a 500-seat theatre, often open to outsiders. If you get the chance, go and see the chapel with the murals (started in 1912) by Frank Brangwyn. Among his 'heroes of the faith' the printer William Caxton and a few others cut surprising figures, as you can see on the opposite page.※

Causeway is smaller than might be expected. Behind it is the parish church. It is entered through the heavy tower, with the **broach spire** on top, covered with wooden shingles. The timepiece mechanism is a half-size replica of London's Big Ben. (That may sound as if it goes twice as fast or produces only half the melodies, but it doesn't.) Some genuine Roman bricks have been incorporated in the church walls. The handsome 15thC **wagon roof** has some nice bosses and there are two **squints**, not very large, but tunnel-like. Note the **Sussex marble** used as paving stones in the porch and on the south path. The people of Billingshurst have always been an independent-minded lot, which shows in matters of religion and of politics: in the Unitarian chapel, the Women's Hall and the Mothers' Garden, which was founded by the suffragette sisters Edith and Ellen Beck in 1923. There are over 80 timber-framed buildings in Billingshurst. The Dickensian pub called Ye Olde Six Bells Inn in South Street with its Horsham stone slab roof for one; and Great Daux near the station is also among the

Pulborough, Old Place

finest. Like so many towns in the south of England (Horsham, Chichester) it has a North Street, a South Street, an East Street and a West Street in principle, only here the North Street is also the High Street. It's the business and shopping

*seated stocks and whipping-post. Little Thakeham, which is off the B2139 north of Storrington, is a minor example of a house designed by the dynamic duo **Lutyens** and **Jekyll**. It's now a hotel and had come highly recommended, but I found the place full of upmarketness (in the usual sense of needlessly expensive) and snobbery. As the house and garden can only be enjoyed by hotel guests, I'm not in a position to report how much of Bumps' and Ned's work survives.※*

West Chiltington *Museum is open when you want it to be and not surprisingly contains mainly local village stuff. St Mary's church is at the end of a little sack street and you'll see the stocks and whipping post, newly restored. The church dates from the 11th-12thC and contains a series of 12-13thC murals. Faded*

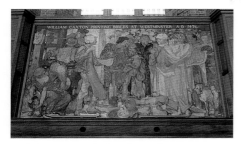

Christ's Hospital, chapel mural

*Southwater Country Park is good for informal recreation like a nice undulating walk. This is the landscape that used to inspire a poetical champion of Sussex, **Wilfrid Scawen Blunt**, who lived nearby. The parish church is worth seeing for its modern windows, mainly by Harold Thompson. A good number of them on the south side show pictures of rural life, people going about their business, while on*

Christ's Hospital, chapel

Broach spire. Usually a church tower is square. An octagonal spire sometimes starts from this square base, the broaches being the wedges of masonry in the corners. As a variant to this the 'splayed-foot' spire splays out the four cardinal faces near their base, to cover the corners, while oblique (or intermediate) faces taper away to the point. So what starts off as a pyramid continues into an octagonal spire.

Wagon (or **waggon**) **roof** is a semi-cylindrical roof, often panelled and/or plastered. Also known as barrel roof or cradle-roof.

Squints are openings cut slantwise through masonry in order to give a view of the altar in a church for those who would otherwise not be able to see it. Sometimes this was just because of the way the church was built, but in other cases squints were used by people who had a contagious disease, or wanted to keep their distance, or were at a subsidiary altar. The longest I have ever seen in an English church was in Melbourne in Derbyshire: about 13 feet! No wonder they give it a stylish name: hagioscope.

Sussex marble or winkle stone, officially Paludina Limestone, is not a true marble but consists of winkle-like fossil shells and is found between the layers of clay. The colour is a bluish grey. It is used for paving, gravestones, fonts, fireplaces and decoration in general and has found its way to places like Westminster Abbey, York Minster and Salisbury and Canterbury Cathedrals. It is also and perhaps better known as Petworth marble, not only because it is found nearby, but also because it is much used in Petworth House and in the town.

area, with a little extra precinct developing north and to the west. The friendly library also serves as a tourist office. You can find a copy of *A Walk around Billingshurst* here. This historical trail makes a nice, easy walk. The library is near the post office. Parking there is free and Billingshurst is the sort of place where you should never have to pay to park your car. The bookshop near the local supermarket, sadly closed in 2004, had a second-hand department upstairs. One of the books you could buy was *Billingshurst to Burgundy by Bike*, written by a local resident, Edward Enfield. Two charity shops here still sell second-hand books.

One mile north of Billingshurst towards the left is an art gallery that specialises in 19th-20thC watercolours and paintings. Before that on the right along the A29 is Summers Place, which used to be spelt Somers, first recorded in the 13thC. The present Gothic mansion was built in 1881, became a convent school and in 1984 was taken over by Sotheby's. In a way this is the ideal solution for the problem of what to do with mansions like this. These are now the largest fine art auction rooms outside London, with a

of course, but still full of life. The squint in this church must be one of the longest in the country: it's a tunnel, some 9 to 10 foot long (try to measure it yourself).

Pulborough Brooks Nature Reserve is at Wiggonholt, over a mile to the south, and is a lowland wet grass habitat, rich in birds and butterflies. Excursions and talks are arranged. Pulborough as a village has stretched itself

disproportionately towards the east, the centre being the crossroads area of Stane Street. North-west of here is Old Place and a bit further on is an old motte-and-bailey castle. The parish church is north of the crossroads on a hill and heralded by steps that lead up to a proud lychgate with a pyramidal roof covered in Horsham slabs. Yes. It dates from this century, but is a copy of the original medieval one (13th-

Southwater church window, Christ's Hospital school

Victorian: 'Victorian architecture was dominated by the 'Battle of the Styles', between a romantic neo-Gothic that stood for a revived religion and a renewed chivalry, and a heavy late-Georgian classicism that stood for the established order,' wrote Joan Evans in 1966, when all the fun and folly of the Victorians were just beginning to be reassessed. In fact the Victorian mania for decoration and stuck-on style made for many more than just the two styles: a jobbing architect would be able to offer buildings strictly faithful to the styles of 'Henry VII, Francis I, Elizabeth etc. down to the time of Louis XIV.' At the same time a new architecture of engineering was developed to take full advantage of the properties of cast iron and plate glass.

Victorian also means prudish. It stands for stifling moral probity, especially in sexual matters, with table legs covered for decency. One hundred years on, the English as a people are still Victorian. In my foreigner's eyes most of you are both prudish and priggish, and can be relied upon to deny the same. 'Me? A prude? Never!' 'A prig? Moi?'

the other side a sort of history of nearby Christ's Hospital school is depicted: six windows showing a variety of scenes. The villagers must feel very much at home in this church. When they get in that is, for the door is normally locked. The insurance company's money proves more important than Christian hospitality.

Newbuildings Place, south-west of here and nearly back on the A272, is the name of the house owned by Wilfrid Scawen Blunt. He entertained Ezra Pound, W. B. Yeats, Hilaire Belloc and others of their ilk. For a number of years it used to be open in summer by appointment, but it has changed hands again and is now a very private place. I didn't know. My application was turned down by the resident countess. I wouldn't have been surprised if her name had been Blunt, but it wasn't.

restaurant, a garden and what have you. Don't come near this **Victorian** building outside business hours: man-eating dogs patrol the place. ✳

Few people will select Billingshurst as the ideal place for their honeymoon, and I won't blame them. But it is a good halting-place in our journey and a convenient centre from which to explore the neighbourhood. ✳

Arundel, Hiorne Tower

14thC). Pulborough's bridges are described on p. 82, in the section describing sites south of the road.

Tucked away in the south-western corner of the map of this chapter is **Arundel**. Too far to the south for us, but a major attraction for the historically minded. The Castle, seat of the Duke of Norfolk, Earl Marshal and premier peer of the realm, is superb. In the park is Hiorne Tower, now newly restored. Francis Hiorne built it to ingratiate himself with the then Duke of Norfolk, hoping that he might work on the restoration of the castle. The duke was suitably impressed, but Hiorne died before he could start on the commission. The relative uselessness of the tower, its triangular shape and the story behind it would make it a folly in most people's book. ✳

When in 1948 the first-ever open air exhibition of its kind was held in Battersea Park, London, it included a handful of native artists – most notably Henry Moore, who more or less inspired it all and whose *Three standing figures* are still to be seen there. It is remarkable that it wasn't until then that the value of having sculptures outdoors was recognised, since many sculptures have intrinsic landscape qualities as we saw with Moore's recumbent figure for a house in Halland (p. 32). In 1949 Sonsbeek near Arnhem (NL) followed suit with an open air exhibition and one year later there was one at Middelheim near Antwerp (B). Middelheim soon became permanent, Arnhem followed and in 1977 Britain got its first sculpture park at Bretton Hall near Leeds, with many excellent Henry Moores, I might add.

Outdoor art is in. Sculpture parks are booming. Museums have created open spaces for outdoor sculptures and some artists, Ian Hamilton Finlay for one, have created landscape environments for their work. Portland in Dorset has the first sculpture quarry in England, Tout Quarry, where Portland stone is used, which is the finest of carving stones, they say. More and more often cycle paths are combined with sculpture trails: an excellent initiative by Sustrans, the bicycle-promoting people (p. 46). Some of the sculptures may serve a dual purpose, as seats or drinking fountains and as works of art. The Cuckoo Trail, south of Heathfield ES, also has sculptures. All self-respecting towns and cities have sculpture trails these days. Winchester is one of many. Sculpture trails seem to breed.

We are lucky in the area of the A272. Groombridge Place Gardens is rich in outdoor art and there are regular exhibitions of open air sculptures at Ockley (Hannah Peschar's) and Goodwood. There are sculptures at the Queen Elizabeth Country Park, at The Garden Gallery at Broughton and at Roche Court, further west in Wiltshire. When Henry Moore starts a trend, it makes an impression. Wow.

Sculpture Parks

Blessed are the Peacemakers

It was getting late in the afternoon and I hadn't bothered to book a Bed and Breakfast in advance. But I had been along this road before and I knew that there was one coming, with signs for free-range eggs. Well, I was free-ranging as it were and this wasn't the holiday season strictly speaking, so I was fairly confident they would have a room for me. I saw the signs, rode up to the house and put my bicycle against the porch. It had windows with a number of oldish stickers on them. The one with CND I found especially endearing. What was happening with the Campaign for Nuclear Disarmament nowadays? I rang the bell and a lady answered. Yes, they had rooms for B&B and I had better take the double room, since it was nice and close to the shower. They didn't expect anyone else. We went in and started chatting. What was I doing cycling? I explained about my project of researching

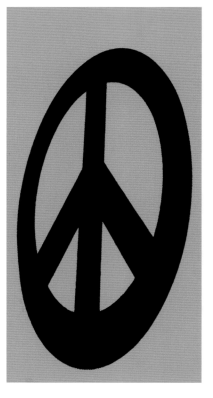

for a book on the A272 and told her where I had come from that morning. Ah yes, she knew the place, that was near where she and her husband used to go skinny-dipping when they were younger. Skinny-dipping? I had thought that it was an American English term. No, she said, it was English all right, though very few English people ever did it. I told her my wife and I were as fond of skinny-dipping as the next couple in Holland and we smiled at each other. We had established a bond. I asked her if she was still active in the CND. Not really. Not since she had come back from Greenham Common.

I was interested. Greenham Common, if you'll remember, was one of the places where the government wanted to deploy nuclear missiles round about 1980. Protesting women put up tents near the entrance gates to the airbase and the camp got a lot of attention. Normal house-wives left their families

for what they considered a greater cause and stayed there for days, weeks and even months in poor conditions. The place looked a bit like a badly organised gypsy camp. We were there in summer and I couldn't bear thinking about what it would be like in winter. I was a teacher at the time and wanted to collect material for discussions on nuclear missiles. Being male I wasn't allowed in the camp, but Rita was cordially received and we were both suitably impressed by the idealism of these women. We didn't get much in the way of brochures or pamphlets, however.

It reminded me of the time when my school asked me to pick up material for a project we had on energy. There was this broad national debate about nuclear power (the eventual outcome of which was highly disappointing for those in favour). My school took part, and since I was going to London anyway, could I please bring back whatever I could get on the subject? For the arguments 'pro' it was simple. A brand new government building along the banks of the Thames, thick carpets, lovely displays, several beautifully smiling lady-receptionists. Of course, anything I wanted, splendid books and brochures, colour print, glossy paper, everything free of charge. For the arguments 'against' it was difficult. A dilapidated house on a corner in a back street in north London somewhere, a shabby but surprisingly cheerful volunteer, wooden floors, rickety book-cases with stacks of black-and-white leaflets that I could buy, so that they could make a little profit. There was no comparison of course: they had my sympathy. As did the women of Greenham Common. Don't they deserve a national monument? I think they do.

I felt very much related to my landlady of that evening. Clare. A reluctant farmer's wife, she described herself as. At dusk we were in the back yard, leaning over the fence, looking at her husband's hens and ducks and other animals, and talking about the pros and cons of free-range farming. It was a beautiful evening. It will always be a beautiful evening in my memory. And the next morning I enjoyed the best eggs I had had in years for my breakfast. ☆

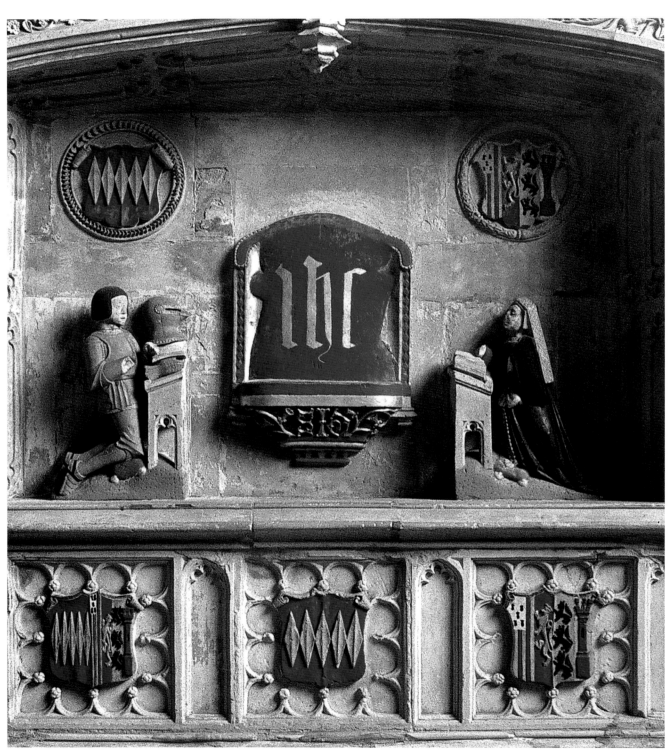

Petworth church, Dawtrey monument

Chapter

3

Newbridge to Petworth

The Limeburners

Limeburning. Lime from cliff quarries was usually brought up by barges and burned in many local kilns. It was used by farmers as a sort of fertiliser, to sweeten acid soil. But lime has also been used for building purposes since Roman times. Chalk when burnt at about 900° becomes quicklime. Add some water and you get slaked lime. Add an excess of water and you can use it for mortar and plastering. Today the use of lime for mortar has been almost entirely superseded by cement, but as sticky stuff lime still has many specialist purposes.

*Where Stane Street (A29) fades into Surrey, at **Ockley**, a Dutch lady called Hannah Peschar has created a grand sculpture garden in grounds designed by Anthony Paul. For once you may disbelieve me when I say that it is over our limit – just follow the signs.*

*Books on Sussex will often tell you of a peculiar religious sect, officially called the Society of Dependants but popularly known as the Cokelers. The name is supposed to derive from their teetotal habit of drinking cocoa. In **Loxwood**'s Spy Lane I looked for a Cokelers' Chapel. Well, the building is still there, but since the mid-1980's it has been used by another religious group, the Emmanuel Fellowship, who have a Pentecostal background – which didn't mean very much to me, I'm afraid. The Cokelers were started in 1850 by*

This third stage of our journey is only half as long as the second. After the relatively long straight stretches of the road east of Billingshurst we come to a tortuous bit across the river Arun and through the remains of an old forest. Naturally this chapter will be shorter, but quantity is compensated for by quality.

Starting out westwards from Billingshurst one can see a little tower on a hill three miles away to the south-west. That's the Toat Monument, described at the bottom of this page. Just before you get to the river Arun you can turn left or right. Left is to a pub called The Limeburners Arms, a few hundred yards away. The sign outside looks nicely educational, but is simplistic and makes a mockery of the process of **limeburning**, I was told. The road to the right, a bit nearer to the bridge, leads to a gallery. If you follow it past the fishing pitches and keep right, you will eventually see this art gallery off to the left in a modern wooden building, close to the A29 north of Billingshurst near Sotheby's. I mentioned them in the previous chapter.

The bridge between Billingshurst and Wisborough Green is called **Newbridge** or New Bridge. The present bridge of 1814 replaces one that had been there since the 12thC. Which goes to show that our A272 was already a route of some importance by that time. In fact there are two bridges, one for the river Arun and one for the **Wey and Arun Canal**. In winter it is sometimes hard to see which

Newbridge

is. Newbridge used to be a busy centre of waterway traffic. This was where the Arun Navigation from the south stopped and boats had to turn round. The Wey and Arun canal, built in the 1810's, was a huge success for only a few

*The slender **Toat** Monument near Codmore Hill is not a monument to a man called Toat, but a folly on a hill called Toat. The Old English word tot [toat] means look-out point, and that's what it is. The tower itself is octagonal, has four storeys and still manages to look small. It was erected in 1827 to commemorate Samuel Drinkald who had been thrown from his horse here four years*

John Sirgood. They were almost masochistically harsh on themselves and marriage was discouraged. By the end of the 19thC they owned a number of chapels, some shops and the first taxi service in the area. Branches were founded in Germany and America. Considering their superficially unattractive way of life they lasted a surprisingly long time, but they are almost finished now. In the last few years a number of

quiet Cokeler burials have taken place behind the chapel, in unmarked graves as is the custom. In fact, all in all there were seven Cokelers left in England in 1995. One lived in Loxwood, and he was really too frail to tell me much. A few years ago they had had contact with a German branch, but otherwise there were no longer any activities, nor any property. They literally died out.

Wey and Arun Canal. Almost 200 years ago Lord Egremont of Petworth launched the initiative for the canal, in a bid to connect London with Portsmouth and Chichester by inland waterways, and it was built between 1813 and 1816. ('Building' a canal is a funny way of putting it, but anyway.) It was 23 miles long, 25 feet wide and only three feet deep. There were three aqueducts and 26 locks and it all worked well. But with the coming of the railways traffic on water declined and in 1871 the canal was formally abandoned. Interest was only revived 99 years later. The Wey and Arun Canal Trust has been doing excellent work to try to get the canal in working order again and make it part of a scheme of over 2000 miles of inland waterways from the Sussex coast to north Yorkshire. This southern stretch would rate among the most scenic of course. Four times a year they issue a bulletin. You don't think of these things when you're just driving over a bridge, do you? And by the way: the President of the Wey and Arun Canal Trust is ... Lord Egremont of Petworth.

decades, before the railways took over a lot of the freight traffic. Waterways were sometimes complicated. South of here the canal used to cross the river Arun at a place called Orfold Lock. It is now a brickwork puzzle. There is a confusion of bricks, arches, holes, curving walls, the casements for a dry canal and for a waterwheel. Even an expert cannot entirely explain all the details. I know, for I heard the best of them try. The Wey and Arun Trust still have a lot of work cut out for them here. Orfold Lock, for what it is worth, can be reached by the public footpath that is indicated at Newbridge. Further south still, at Hardham, a short cut in the route of the Arun used to go through a low tunnel. All sorts of aspects of the river Arun are discussed in a book called *Along the Arun* by John Adamson. Which goes to show that the whole area is to waterway historians as important as the Bluebell Line is to railway enthusiasts. Gosh, and we were just crossing a bridge between two villages.

Turning up the B2133 after Newbridge takes you to Newpound Common and Fishers Farm Park: an animal farm mainly for children, but one of the bigger attractions of its sort, with all the usual facilities, plus campsite and cottages.

The name **Wisborough Green** consists of several parts and must be the most descriptive one along the road. The first syllable denotes a marshy meadow, quite logical so close to the river. The second part, borough, indicates either a mound (and sure enough, the church is on a hill) or a fortified place. The third part is even more obvious: the village consists of a green lined with houses, one could say. In older texts you can sometimes find just 'Green'. Or even West-borough

Toat Monument and guardians

previously. If you are not afraid of large animals you can get quite close, but you had better ask permission. ✶

Pulborough *(see also Chapter 2) is where the rivers Chilt and Stor from the east and the Rother from the west join the Arun. It's an ideal place for bridge-buffs, and I don't mean card-players. Across the Arun south of the crossroads the old and the new bridges on the A29*

Glass. The Wealden glass industry, exploiting the sand and the woodland materials for its furnaces, began to develop in the 13thC, when French, Flemish and Dutch settlers brought new techniques. By 1240 Wealden glass was being used at Westminster Abbey. Wisborough Green and Kirdford became well-known centres for glass.

Halfway through the 16thC French Protestant refugees called Huguenots came to this area and they continued the tradition of glass blowing until 1616, when ironmasters and shipbuilders managed to claim the woods for themselves through an Act of Parliament.

Glebe was land that was kept and used for the good of the priest of the place. In the main it was prime land next to or close to where he lived. Glebes, tithe barns and in fact a great many of the perks of a priest's job disappeared in the course of the years when the church lost some (if not all) of its clout in most folk's lives.

Stopham, bridge

One of the local pubs here is called the Sir Roger Tichborne, after the baronet whose disappearance at sea led to the famous case of the Tichborne Claimant. In 1866 a man in Australia answered advertisements placed by Sir Roger's distraught mother, and arrived to claim back his portion. The mother was willing to accept him as her lost son, but the rest of the family demurred. The subsequent trial lasted most of a year and it was established that the claimant was one Arthur Orton, the son of a Wapping butcher. He was sentenced to 14 years' hard labour for perjury. That's life. We will see more of the Tichbornes in chapter 6.

*Part of **Plaistow** [plasto] is just a housing estate. Another part is a peaceful out-of-the-way English village with a school, a stores-cum-post-office, a pond and a green lined with trees*

Green (Cobbett in *Rural Rides*), but that is clearly a misunderstanding.

Agriculture of course has always been the main business here, but Wisborough Green has a history of two other occupations. One was charcoal burning, the other was the **glass** industry, a souvenir of which can be seen in a little window in the south wall of the church. Dutch and Dutch-speaking people had a hand in this glass business too. One of the success stories here was a Flemish artisan in Wisborough Green in the 1560's. Besides windows he made bottles, jugs and drinking glasses in the Venetian style and did very well out of it. His name sounds French: Quarre or Carré. Another name from that period is definitely Dutch: Bongars. Must be an ancestor of mine.

St Peter Ad Vincula (In Chains) is the name of the remarkable church on the hill at the entrance to the village – fragments of the apostle's chains were supposed to have been kept here at one time. Its earliest parts date from the 12thC and like many others it has a wonderful uninterrupted list of vicars from the 13thC onwards. The tower was probably built from within the church in the 14thC. The thickness of some walls and the asymmetrical position of the tower have led to speculation that the building also had a defensive function, thus favouring the meaning 'fortified place' for the 'borough' part of Wisborough. To the right of the chancel opening is a mural that dates from *c.*1275. This was discovered by accident when a stone thrown in a fight dislodged some plaster infilling. Even fights can lead to discoveries. It is only a small painting, but two elements are remarkable. One is the crucifixion: Jesus

are side by side. Further south under Hardham the roadbridge and the footbridge are side by side. In the direction of Fittleworth to the left of the A283 there are two bridges side by side again, but the funny-looking one has a funny function: it is a casing for water pipes from Hardham pumping station, conveying water from the Rother over the Arun and then taking it to Crawley. So it's a bridge to take river

rather than houses. If you are wondering (as some books do) what the few steps from the road to the water are for: the green used to be the site of a cattle market. People fetched water via the steps, away from the ramp on the right where the animals drank.

Remembering **Kirdford** one thinks of red brick cottages, hollyhocks and roses. And maybe chocolate boxes. Even in winter one can

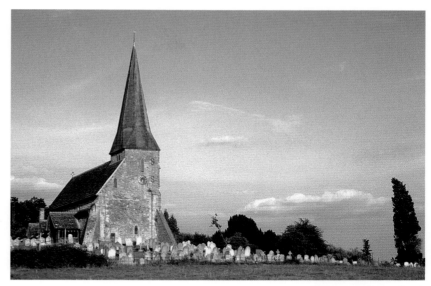

Wisborough Green church

and the thieves are hanging from the same beam (the thief on the left has been hidden by later construction). Unique in art history, as far as Rita knows, and she has a **collection** of pictures of the crucifixion. The other thing about it is the portrait of **St James of Compostela**, which I mentioned in the Introduction. His appearance in Wisborough Green might indicate that this church was on a minor pilgrims' route to Canterbury, where pilgrims would gather before going on towards Compostela in Spain. The big altar stone is worth a second look. During the Reformation it was hidden by the villagers who were afraid that iconoclasts would harm it. They hid it so well that it was lost for a few centuries – it was used in Loxwood vicarage as a kitchen chimney breast and only discovered when the vicarage was demolished in 1901. But the most colourful and modern feature in the church is the embroidery. It was meant to mark Queen Elizabeth's Silver Jubilee (1977) and the design was by a local artist, Patrick Gierth. More than 80 villagers helped with over three quarters of a million stitches, and the work was finished in 1984. It is all about life in Wisborough Green. Of course. Why not? Note the smock-mill, numbered 2 in the centre panel, and Hawkhurst Court's connection with Dieppe 1942 (see page 88). The church used to have a lovely colour brochure. Buy it before they run out again.

Outside in front of the church are a few things one might expect: a tithe barn on **glebe** land and a pond. The name of the pub, The Three Crowns, may be connected to the Benedictine Order, since this pub probably replaced an inn called The

water across river water. There are a few railway bridges of course. But the most beautiful bridge is the medieval one (most probably 1423) further west, side by side with the smooth new bridge on the A283 one mile out of Pulborough, between the pub and Stopham House. It is certainly worth getting out of the car for and walking across it, meditating on how rare and lovely it is with its passing places

and what a nuisance it must have been to modern traffic until 1986. Bridges, bridges, bridges. There is an inconspicuous dry bridge across a dry branch of the Rother south of Stopham House and further on is Stopham bridge beyond Fittleworth bridge and so on, but enough is sufficient.

Just south of Pulborough along a little road parallel to the A29 the local church is full of

St James the Elder was one of the twelve apostles and he was beheaded in Jerusalem in the year 44 AD. His remains were later taken to (Santiago de) Compostela in north-west Spain. From the 10thC Compostela became the third most famous place of pilgrimage in Christendom, after Rome and Jerusalem. The various routes through France joined on the other side of the Pyrenees and are used to this day. People who have travelled to Santiago (St Iago = St Jacobus = St James) on foot wear a shell, the 'coquille St Jacques'.

English pilgrims used to meet in Canterbury before crossing the Channel to join the continental routes.

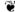

Collection. The idea behind the collection was that every period of art history would be reflected in this theme, together with people's views of Christ on the cross. But it doesn't quite work that way. And another disadvantage is that it can be quite difficult to go into a bookshop and ask for pictures of crucifixions without getting a funny look.

Kirdford: Degradation of Drunkenness

Hardham murals. Hardham may be unique in the extent and age of its murals but there are many other remains of medieval paintwork in parish churches. Sadly, most are venerable but vague, as I said about Clayton, and only art historians will appreciate them fully. None of them are in the condition they should be seen in: colourful, lively and instructive. Why not repaint one of them, so that we have a better idea of what they were like? Since the Hardham murals are the most complete, why not select them for the experiment? One art historian I know will indignantly reply that that would ruin them for ever. Well, my answer to that is: why not paint the same figures on removable panels then, wood or canvas, and put them up in front of the murals? On a smaller scale this has been done in the Lady Chapel of Winchester Cathedral. Panels are fastened over the original murals, and the copies were painted on, with stones and joints and all, by Professor Tristram in 1937. If it could be done in Winchester, it can be done in Hardham church. Wouldn't it be an ideal project for art colleges in collaboration with technical colleges? There are plenty of them in the area that might be interested.

How about it?

see that it must be heartening in summer. On the vicarage wall near the road junction a tablet expounds the Degradation of Drunkenness. Please read it, if you have the time. It is as nicely overdone as one would wish. The local publican can't be very happy with the overt warning against overdoing it in her line of business, even if it only raises smiles nowadays. Under the village sign, also in the centre, is a tablet with 'The Story of Kirdford', on which of course the last 400 years take up half the space of the total 4000. As could be expected the village has changed over from hunting to farming in the course of all these years, but the spates of glass working, Sussex marble quarrying, iron industry and other details are interesting. A church window shows some remnants of this old glass business. Nowadays there are a lot

Benedictine, which may have been run as a pilgrim hostel by the vicar, according to an old church guide. Further down the road the generous green is in every way the centre of the village. It's a nine acre triangle, surrounded by magnificent chestnut trees in two colours, white and red. Looking at them now you may wonder why there is an irregular sequence. Well, that wasn't exactly the idea. When the trees were planted about a hundred years ago, the workers started off in the morning doing the red and white trees alternately. Work progressed nicely. But at lunchtime they went and had a few drinks at The Cricketers' Arms and after that they didn't see things too clearly any more and mistakes began to occur – as I was told by the publican who was told by the vicar who was told by the previous vicar and so on. Nowadays the irregular pattern is further confused by young saplings. The green is used for cricket as well as stoolball, which makes the name of the pub The Cricketers' Arms sound like favouritism. But having said that, could one ever have a pub called The Stoolballers' Arms?

On leaving the village another relatively little-known religious sect manifests itself among the houses on the left: the Zoar Chapel. Zoar was the biblical place of refuge for Lot and his daughters after the destruction of Sodom and Gomorrah. In a way this is another sign of the corporate spirit of the villagers who clubbed together to pay for the construction of the chapel in 1753. Nearly a quarter of a millennium later the place is still in active use and there are similar chapels in Kirdford and Plaistow. Just before you get to the chapel an old graveyard beckons, also on the left. One row of headstones displays some beautiful carvings with lots of symbols, but you will probably need to look twice before you can appreciate them. If you should feel the urge to clean them up, don't fight it too long. Some people will say that these things should be left to look mouldy, simply because they should

paintings that have received a great deal more attention since they were called 'Byzantium in Sussex'. These **Hardham murals** *date from the early 12thC and are very special in that the whole two-tier scheme has been preserved; it is elaborately explained in the church guide. An anchorite or hermit used to live in a wattle-and-daub hut against the church wall and there was a squint through the chancel wall for a*

view of the altar especially for him.

Further south along the A29 the village of Bury [beri] has some nice houses. The first one you get to on the right dates from 1910 and is where the novelist **John Galsworthy** *spent the last years of his life. Through the windows you will now see elderly people shuffling towards the dining-room. A bit further on is the general stores, which is peculiarly decorated with*

of apple orchards in the neighbourhood. Attractive idea, the tablet. Attractive village.

I *am happy to report that very little has changed at* **Ebernoe** *[ebbernoe] since Hardiman Scott followed a cricket match there and wrote about it in* Secret Sussex, *in 1949. I spent a few hours in similar fashion and was amazed to learn that the other team didn't have a home ground. Which shows how little I*

know. But Ebernoe home ground is also peculiar. The public road forms part of the actual cricket pitch and I had driven along it before I realised I was interrupting the game. Bloody foreigner. I was still welcome, though, and I specially loved the sounds of the match: muffled talking from the pavilion, teacups tinkling and boots on the wooden floor. Restrained shouts of encouragement and commiseration, lazy

look old, but I tend to think that it's a pity to lose what is underneath. Have a look.

To the west of Wisborough Green is **Idehurst** where an eccentric playwright used to live: **Neil Lyons.** The road towards the south goes to Cold Harbour. The name means shelter. Coldharbours were roadside constructions, sometimes derelict houses, to protect travellers. Could Stella Gibbons have had Cold Harbour Farm in mind when she situated **Cold Comfort Farm** in Sussex? There are several farms of that name.

Signs for 'PTP' in this area stand for Paintball Tactics Petworth. At Brownings Farm, one mile south of Kirdford, you can take part in this almost military sport in which you shoot paint-balls at your opponents. That may sound childish, and in a way it is, but it is also exciting, I am told. Did you know there is a European Paintball Sports Federation?

Strood Green can hardly be called even a hamlet. Strood means scrubland, marshy land overgrown with brushwood. The variations in spelling are Stroud and Strode, and it also became

Bury, at the Arun

bizarre carved heads. The craftsman must have had my favourite kind of madness. 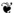 *Next to it is a plan of the village, with drawings of the most important buildings: an excellent idea that it would be nice to see followed elsewhere. But Bury's best bit is the modest path straight on beyond the church. It leads to where the ferry used to be and affords tranquil views of the other side of the river Arun, in the direction of*

Amberley. A beauty spot.

J*ust continue south and then south-west along the A29. As with Arundel in the last chapter, I feel I have to make an exception to the rule and say something about nearby* **Slindon**. *Not only because it is an exceptional village. It is. But also because my own favourite folly is there, beautifully situated, overlooking a cornfield north-west of the village, backed by*

John Galsworthy (1867-1933) is mainly remembered for *The Forsyte Saga*, a sequence of novels that gave a brilliant picture of Victorian and Edwardian manners, but he was another of our Nobel prizewinners, and his play *Justice* changed the penal code. He knew the Downs well, and they appear in this racing scene in *Swan Song*: 'Whether or not the character of Englishmen in general is based on chalk, it is undeniably present in the systems of our jockeys and trainers. Living for the most part on Downs, drinking a good deal of water, and concerned with the joints of horses, they are almost professionally calcareous, and at times distinguished by bony noses and chains.' Galsworthy's ashes were scattered on Bury Hill.

Neil Lyons (1880-1940) South African-born journalist. He also wrote novels and four plays, including *Arthur's* about a coffee stall. 'There is a warmth at coffee-stalls, and good cheer and money's worth,' he declared. 'We know that the greatest of all gospels, tolerance, is practised there as nowhere else.'

Lyons' eccentric lifestyle as a homosexual with a hobby of waggoning must often have surprised the locals. He lived all over Sussex and kept in touch with the Bloomsburyites at Charleston.

❦

Cold Comfort Farm 'was crouched on a bleak hillside, whence its fields, fanged with flints, dropped steeply to the village of Howling a mile away.' The novels of gloomy and elementally passionate rural life that Stella Gibbons was satirizing have all sunk without any trace except this great parody. *Cold Comfort Farm* is still a wonderful read. Gibbons put stars in the margin like a guidebook to point readers towards the passages of 'fine' writing.

Nature reserve. The Mens is almost 400 acres of unenclosed deciduous woodland, probably 7000 years old. The soil is mainly clay and sandstone, but there is also Paludina Limestone, a.k.a. Petworth or Sussex marble. Oak and beech are the most common trees, but there are 41 other species. 194 different types of flowering plants have been counted, 10 ferns and horsetails, 69 mosses, 29 liverworts, 366 different sorts of fungi (yes, do you want them subdivided?) and 76 lichens. Insect and arachnid types have been counted, amphibia and reptilia, 47 species of birds and 27 sorts of mammals.

So now you know. There are plenty of nature reserves along the A272, and just for once I felt like pointing out their richness and variety. Most of them provide leaflets with information about the nature and descriptions of walks.

Petworth, church

Pytta is not a name recorded in Old English, but there is a Petwick in Berkshire and a Pitney in Somerset that are hard to explain without the existence of such a name. Peota and Peohta are very close to Pytta of course. In Dorset Petrichesham came from Peohtric and became Petersham. ✒

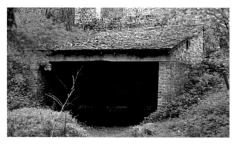

Ebernoe, brick kiln

applause and now and then pock! Bat on ball, leather on willow. If you can find Ebernoe in the woods, the best time to be there must be when cricket is being played.

South of Ebernoe, on the Common, are the remains of 18thC brickworks, the spot having been chosen to be close to the fuel all around. Kiln, claypit, moulding shed, pug mill, drying racks: they are all there and interesting

a family name. Strood Green is not much more than some private houses before you get to the next area of interest, which is coming up on the left.

The Mens is a **nature reserve** owned by the Sussex Wildlife Trust. The name comes from an Old English word (gemaennes) which denotes joint or common property. It still is common property in a way. There is a car park for it along the road to Hawkhurst Court and the good-looking Crimbourne Farm.

A number of houses on our route in this chapter are worth a second look (some of them hidden by trees in summer), perhaps the biggest one being Hawkhurst Court. Built in the 19thC as a country home it was sold by the Mitford family, of whom the novelist Nancy Mitford was one, in 1938. During the Second World War the Canadian Army Second Division Headquarters were established here and it was here that the Dieppe Raid was planned in August 1942. It was also an hotel and a school. After 1982 the school staff houses became private, the main house was divided into four flats and the estate of Hawkhurst Court now harbours almost 30 families.

Westwards on the A272. Once you are out from under the trees Petworth heaves into sight in the distance. **Petworth** is the end of this short stage. Worth means enclosure, farm, village or estate: in short, valuable property; Pet may be from the name **Pytta** or Peota. So it's Peota's estate. And valuable it is. Coming up to it on the A272 you have a choice at the first mini-roundabout. To the right are the car parks of Petworth Park. Left is the road into the town. This is the first proof of the dichotomy of this place: Petworth is two things. On the one hand the house and the park, or what is nowadays called the Leconfield Estate [lecconfield]. And on the other hand the town, which has been called a miniature city. Let's go left into town first. Mind the traffic on this narrow bit of road. Have a look at the

trees and marked on the Ordnance Survey maps as The Folly, which is rare in itself. The realisation of what pure folly-building means can hit you here like a collapsing ruin. Or epiphany. This folly is officially called the Nore Folly (built c.1770?) after the hill on which it stands, and it is as mysterious, pointless and unique as you might wish. The explanations one sometimes sees are tenuous guesses at best, and

I for one hope it will remain mysterious forever. You have to follow paths over the local farmer's land to get close to it.

The village of Slindon belongs almost entirely to the National Trust. Nothing very spectacular there, all in the best English good taste. In Dyers Lane a bow-fronted lock-up rises amongst the rhubarb plants. Round the corner a thatched crimson railway carriage is in

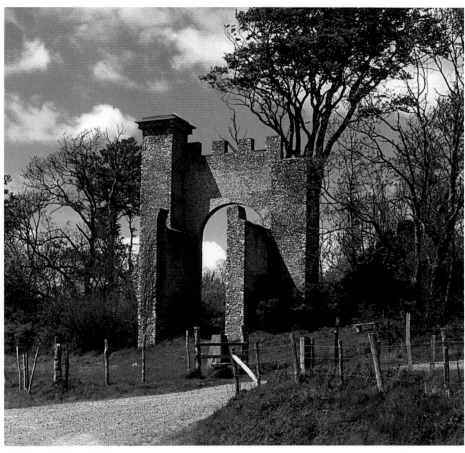

Slindon, the Nore Folly

lovely buildings on the left only after you have parked your vehicle in the town centre and can walk about with some safety. Petworth is to be enjoyed on foot. ✪

The town has remained virtually unchanged over the centuries. It is old and has many lovely buildings. Quite amazingly, only three of them have known architects. The streets are often narrow. Traffic has always been a problem. The streets

the grounds of Church House in Church Hill. A little fountain elsewhere looks somewhat pathetic. But it is a highly seductive village. One of the entrances to Slindon Park (also National Trust) is formed by a lodge and castellated gateway along the A27.

Back to Bury. Hidden Sussex supplied directions to a spot for incurable romantics near the village of West Burton, off the A29 to the

west. You'll see a footpath indicated a few hundred yards north of the sign for the village. Take it and go straight on over two stiles for a memorial and a seat. Relatives of Fred and Winifred Hughes have placed a bench here with an inscription, so that people can enjoy the view of South View Farm where the Hughes family still lives. The memorial stone for the father reads: FRED...WHO WORKED THESE FIELDS

☛ Peohtric could be Peohta's strip of land or Peohta's ridge. Other combinations that have been recorded are Peohtgils, Peohthun and also Peohthelm.

Peohta is Old English for Pict. The Picts came from Scotland. They may have been there long before the Celts came and their language may not even have belonged to the great Indo-European family. The word Pict itself may be a description rather than a name. The Romans called these people Picts, meaning 'painted' (think of 'picture'), because of their tattoos.

In Old English words beginning with a 'p' are relatively rare. But there are many ('hundreds', *British Place-names* says) Scottish place-names of which the first syllable is Pit, Pet or Pett. The meaning of this word or element has given rise to some pretty wild speculation amongst academics. In fact the truth is not known. Words with 'pet' and the word Peohta (the Saxons' version of the Romans' Pict) itself could be related, confused or merged. My guesses can be as good as the next man's. And as wild. Was Peohta used as a nickname? Not unlikely. I am a great believer in ignorance and humour as creators of language. Could there have been a lost Pict or even a few isolated pockets of Picts (Pictspockets) that settled in this southern part of England? They would have been conspicuous and could easily have had places named after them. It might account for Dorset's Petersham, as well as Petworth WS and Petersfield HA in that case. There is also a Picts Lane near Cowfold.

Now, linguisticians may frown on all this because their first idea might be that it can't be all right. But evidence that it is all wrong cannot possibly be adduced either.

How nice it is to speculate with impunity when you do not really know much about these things.

Bricks. The Dutch tend to think that they introduced bricklaying to Britain. There are two reasons for this. After the period of Roman tile-shaped bricks (which soon fell into disuse), England built with timber or stone. Holland did not have stone, but we had enough clay to make bricks. Bricks were among our few 'natural resources', so to speak. We exported them, to begin with maybe mainly as ballast for ships. Britain was among the first of the recipient countries. As they were a success we began to export bricks as well as brickmakers and bricklayers to Britain, hence names like Michael Fflemynge and Baldwin Dutchman in this trade around 1400.

The second wave of influence concerned brick gables and façades. Our renaissance designs used red brickwork with ornaments picked out in imported stone, if we could afford it. We had patternbooks to provide suggestions for such effects, and they were introduced and used in Britain from the last years of Elizabeth I onwards. One of the earliest Dutch curved gables was for Kew Palace (called the Dutch House) in 1631. English architects visited Holland to bring back expertise. During the reign of William and Mary the Dutch influence was even stronger of course. No wonder we feel at home with that brick architecture.

One particular aspect of the use of bricks however is typically English. The firing in brick kilns such as the one in Ebernoe results in uneven temperatures and therefore different colours in the bricks. The side that is very near to the fire will get flared. Sometimes it becomes nearly black and vitrified, and is much darker than the opposite side. You can get dark headers and dark stretchers. In Tudor times they used the different colours, particularly headers, to make patterns in the wall, often diapers. ☛

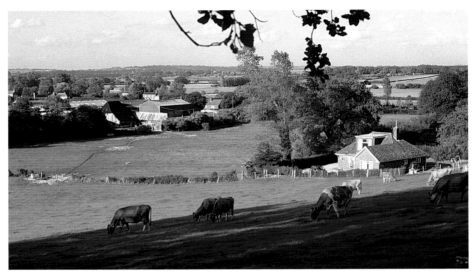

West Burton from the family monument

of Petworth were never suited to cope with 21stC traffic. Five major county roads come together here. Tractors and unloading lorries invariably cause jams. At one stage people were so desperate that plans for a bypass right underneath Petworth Park were seriously considered. The alternatives aren't obvious, it must be said.

The tourist office in Golden Square provides an excellent little Town Guide, a model of useful and reliable information, with some walks. There is more to Petworth than its seventeen antique shops. Note the flamboyant bust of my fellow countryman King William III on the north face of the Town Hall (William Cobbett thought this was Charles II, but was told it was Sir William Wyndham; today the experts agree that it's William III. Why he is there is still a question.) Walk up cobbled Lombard Street which used to have an open drain down the middle. St Mary the Virgin is the parish church. Inside, the woodcarving and the galleries under the blue ceiling are pleasing, and I like the 16thC Dawtrey Tomb with the little Michelin Men angels over it. As a building the church doesn't charm everybody, but that may be mainly because you can see that people have been working on it from the middle ages to this century. The most famous architect involved was Sir Charles Barry, who later built the Houses of Parliament in London.

West Burton, Coke's House

AND LOVED THEM, HE BUILT THE FARM YOU SEE, AND NEVER WANTED ANY MORE, ONLY TO BE FREE. *For the mother:* WINIFRED... WHO YOU COULD PUT YOUR ARMS AROUND. *I'm a sucker for this sort of thing.*

West Burton itself consists almost entirely of pretty cottages. One large residence (Coke's [cook] House) lies hidden behind a wall on the right-hand side of the road and the

to both experts and laymen, since some information about **bricks** *was provided a few years ago. It's not too hard to find. You could see it as a walk in the very ancient and wild woods, with something to look out for. Park by the church.* ☞ *This church was in the national news in early September 1996, when it acquired a musical machine that can produce 3000 hymns for the parishioners to sing to – no organist is*

William III

He put a spire on the tower, but that was taken down again in 1949, after which a new top was designed in 1953. And so it goes on. Barry also designed the blue neo-gothic iron lamp standard, often called 'obelisk', funnily enough, there between North Street and East Street (picture p. 95). By the way, on an architectural walking tour through the town (led by local historian Peter Jerrome – catch him if you can) I heard that there had been a West Street as well, but it was bought up by one of the Dukes of Northumberland who didn't want ordinary people in or near his park.

In a bend of Park Road there is one house that has a front with **mathematical tiles**. Be careful if you want to have a look on foot.

At the beginning of Bartons Lane the Coach House bears a notice board that tries to tell you the difference between wright and rong. Please read it. It's as good an example of the Victorian mentality as any. Very English. Bartons Lane was the old road to the east. It must be the most pleasantly surprising town lane in the country. After only 100 yards one walks into a lovely view of Shimmings Valley. Where the footpath turns right the old track continues straight on down and up again beyond the little bridge. That is the old road and this view gives you the best idea of what the A272 must have looked like for hundreds of years. There is a bench a bit further on the right, where you can sit. On the opposite side of the valley, on the left, a medieval field system can be made out. Enjoy the view. A few years ago there was talk of the Petworth bypass going right through all this beauty.

Mathematical tiles

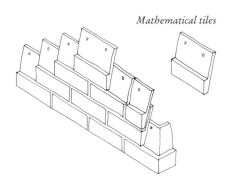

side entrance to it in this wall looks surprisingly Italian. Slowly wending your way further west (note how the hedges have been shorn) you'll see the signs for the Roman Villa of Bignor.

Bignor *Roman Villa is beautifully situated at the foot of the South Downs. In Roman times it was a luxurious house just off Stane Street. It consisted of various rooms on all sides of a squareish garden. The 4thC mosaics rank*

☞ We've been seeing colour patterns in brick walls everywhere in Britain, ever since the process was explained to us. I suppose you have known about this all the time. And it must be said that patterns within brickwork have become more common ever since the Victorians developed the technique of making polychromatic bricks, using chemicals. Still, it's very English, to us.

The term diapers, by the way, comes from the fact that the decorations often looked like the cloth patterns from Flemish Ieper (or Ypers) (d'Ypres – diapers).

🐛

Mathematical tiles (also called brick tiles) are usually hung on timber frames and often combined with bow windows. The deceit dates from the 18thC, and was probably in part a tax dodge: there was a special tax on brick houses between 1784 and 1850. But they had some other advantages, as Andrew Plumridge points out in his book *Brickwork*: for the fashion-conscious 'brick tiles were a way of applying a "face-lift", especially to buildings of less durable materials. They were also a means of weatherproofing and fire-proofing vulnerable timber structures. However, brick tiles were not cheap; the considerable care required for their manufacture and the specialist labour needed to erect them made them an expensive addition to a house.'

Set in what resembles a normal brick bond, they look quite convincingly like bricks, even when glazed, and you must have seen them often without realising. You can identify them by looking carefully at the space between the 'bricks', too narrow, too regular, not filled in. The town walk of Lewes has a few good examples to show en route.

Attraction. One of the most re-markable aspects of tourism in this part of England is the reluctance with which people are encouraged to come and visit. The tourist offices are more than friendly to those who do come, but splendid little towns like Petworth and Midhurst do not really advertise themselves and do not seem to want to make things too easy for tourists.

Condition of the roads. In his *Travel in England* Thomas Burke mentions that in 1703 Prince George of Denmark came to visit Petworth from London, which as you know from the milestone in New Street is 49 miles away. The whole journey lasted fourteen hours. The great de-lays were near the end, when the last nine miles took six hours. Every mile at least one of the carriages in the entourage was overturned or got stuck in the mire. Burke quotes from an account by a follower: 'Even the royal chariot would have fared no better than the rest, had it not been for relays of peasants who poised and kept it erect by strength of arm.'

Petworth: Bartons Lane in summer

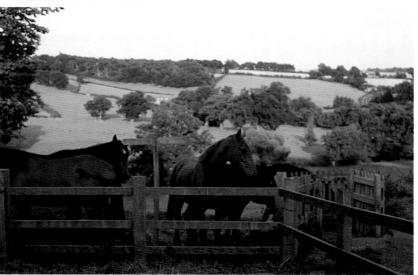

needed any more. Look at the polychrome brickwork here, the effect aided and abetted by the yellow lines: a form of lichen. Read the no-tice board. Follow the path into this nature re-serve and take a side-track to the left. Good luck. And I hope we'll see you back. ✱

Little **London** at Ebernoe is the address of the British School of Ballooning. They ply their trade nearby. You can book balloon

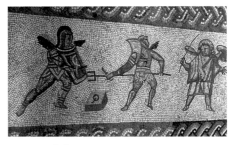

Bignor, Gladiator mosaic

Modern man does drum up evil choices for himself. Still and all, it is a far cry from the **condition of the roads** round Petworth in former times.

For a while a surprising **attraction** in Petworth was the Doll House Museum. It was based on the collection of Ms Helen Zetter and moved here from London in order to provide more space and parking facilities. Well, it was in the town's car park, so they were all right there. Over 100 doll houses and over 2000 little people to inhabit them were on show, plus some miniature replicas of real buildings. But... everything was moved again, to Royston, Hertfordshire. It was a perfectly endear-ing, modest little attraction and now it's gone. Why do these things happen?

Another recent enrichment is the Petworth Cottage Museum in the High Street. One of the ordinary houses here has been restored and furnished in the style of the beginning of the 20thC, based on what was known of the occupants at that time. In theory we know these things. In practice we bang our heads and feel cramped. A useful and enjoyable experience.

Just a few more things. While walking about did you see the medieval-looking tower on the 19thC Roman Catholic church in Angel Street, with its much too thin green spire? And did you note the quality of the wall around Petworth Park (some 12 miles!) and other walls around here? French prisoners of war built most of the walls in Petworth and Chichester in the 18thC and they did an excellent job. It's one of the reasons why William Cobbett wrote about Petworth: 'a nice market town ... solid and clean, every-thing of the building kind has an air of great strength and produces the agreable

among the best in the country. Most famous are the Medusa head, Ganymede and an endearing group of baby gladiators. Ever since they were accidentally turned up by a farmer's plough in 1811 they have been taken good care of by his descendants. The set-up now is imaginative and instructive. It's not the largest Romano-British site in Sussex: that would be the palace of Cogidubnus in Fishbourne, but there is a quiet

Bignor, Medusa mosaic

flights with or without champagne and you can learn how to fly. On summer evenings one can often see balloons over Wisborough Green or Petworth.

One mile east of **Northchapel** is Midhurst Beacon that to the unsuspecting traveller looks like a flying saucer just after its landing. Built c. 1980 to guide aircraft, it produces radio signals rather than strong lights. The village

Sutton rectory had something interesting about it, I had read, so I went there. The information turned out to be wrong. Or rather, the people I talked to denied all knowledge of it. Very annoying of course, so I vowed that every single fact in this book would be checked by me personally. But it can't be done. The entry on Bignor that we just had e.g. consists of more than 30 statements/facts. I can't check everything. 35,000 visitors is a rounded off figure. The assistant who gave it to me said they counted visitors every year. He could have been lying. I trusted him. You'll have to trust me. The thing about Sutton is that it is lovely driving along in the middle of nowhere.

❧

idea of durability.'

Only two of the antique shops have a second-hand books section. If I do have a fault to find with Petworth it is that this is too meagre. The modern bookshop is near the car park. *

Just over one mile south of Petworth on the A285 is Coultershaw Beam Pump, installed over 200 years ago to provide Petworth House and town with water from the Rother. It was in service until about 1960, has become a Scheduled Ancient Monument and is open to the public at certain times. The Sussex Industrial Archaeology Society have done their utmost to explain how it all worked.

Petworth House has been owned by the inter-related families of Percy, Seymour and Wyndham since the 12thC, but the only medieval parts left are the cellars and the chapel. The house we see now has a quiet dignity and dates from the end of the 17thC. It was built by Charles Seymour, the 6th Duke of Somerset of the Egremont family [eggremont] that has lived here ever since. He was nicknamed the Proud Duke.

The National Trust has run Petworth House since it was given to them in 1947, but a few of the family still live there. Coming from the car park you would do well to go to the iron fence on the right just before you reach the house. You'll have a view of the massive front of the building and you'll be able to see how a ha-ha works. Note the wide tunnel for vehicles and animals there. Very inconspicuous in another courtyard is the entrance to a little building unfortunately not open to the public. Some 25 feet in diameter and divided into three separate

Little London as a place-name was often used by drovers on their way between London and the Welsh borders. All along the Welsh Road, the cattle route to London, one finds names like London End, London Street, London Farm and Little London. But they are near Ebernoe, Heathfield and Ardingly too.

Petworth: Bartons Lane in winter

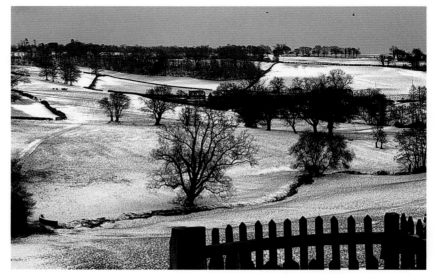

small-scale charm about the place and it is certainly worth a detour. 35,000 people do it every year. Don't forget to enjoy the turf maze. *

Charlotte Smith was born near Bignor. Every book on Sussex says she deserves to be read more than she in fact is. OK boys. We'll meet her again on page 122.

Places like **Sutton**, Barlavington and Sutton End can only be reached via the sort of

Joseph Mallord William Turner (1775-1851), spent a great deal of time at Petworth as the guest of Lord Egremont, who was famously generous. (Another painter, Haydon, exclaimed 'The very flies at Petworth seem to know there is room for their existence, that the windows are theirs.') Turner's manners did not soften here, however. 'He was extremely obstinate,' wrote one biographer. 'At Petworth a discussion ensued between Lord Egremont and Turner as to whether carrots could float in water. I suppose Turner had introduced some in one of the Petworth pictures.

'Carrots don't swim.'

'They do.'

'They don't.'

'They do.'

Lord Egremont rings the bell, and calls for a bucket of water and some carrots. The water is brought, the carrots are thrown in. The obstinate painter is right; they *do* swim after all.'

Rose of Jersey, another inmate, remembers Turner 'trudging down the avenue' at Petworth. 'An umbrella invariably accompanied him; rain or sunshine, storm or calm, there was that old faded article tucked under his arm. Now, the umbrella answered a double purpose, for by some contrivance the stick could be separated from the other parts; this then formed a fishing-rod, being hollow, with several joints running one into the other. I have seen him sitting patiently for hours by the side of a piece of water belonging to the property, his piscatory propensities keeping up his excitement, though perhaps without a single nibble; yet it must not be understood that he was always unlucky, for when fortune favoured him in securing any of the finny tribe, it was not long before we were made acquainted with his success, at which he appeared as much pleased as a boy from school.'

Northchapel, beacon

itself has hidden its modern houses well. People who know about these things say that the area round the green looks just like a Surrey village. The Stores along the High Street used to be a Cokelers' shop.

*J*ust over a mile to the north-east from here is the lovely lake of Shillinglee Park, which is mostly private. The Deer Tower here, a sort of castle keep with round castellated towers on the

chambers, with a circular passage around two thirds of the perimeter, it is a magnificent example of an **icehouse**.

The west front of the house is imposingly long, over 320 ft, but otherwise kept very simple and relatively unadorned. Inside is another matter. Sumptuous. Even Dr Johnson thought the furniture magnificent (1782). Buy the guidebook and go in. Various rooms and staircases are to be seen. The Carved Room for instance where most of the exquisite lime-wood carving is by the master in his field, Grinling Gibbons – born and bred in my country, in Rotterdam, by the way. And we shouldn't underestimate John Selden's work in wood here. The North Gallery is where the Proud Duke brought together his art collection. It's a unique room full of sculptures and paintings. Again I am partial to Dutch artists. I counted more than twenty different Dutch and Flemish masters. A collection any Dutch museum would be proud of. Big names like Cuyp, Hals, Hobbema, Rembrandt, Rubens, Ruysdael, Van der Weyden and of course a number of works by Anthony van Dyck, pupil of Rubens and court painter to Charles I. There are classical sculptures, one attributed to Praxiteles,

Burton Park church monument

single-track lanes that are typical of this part of England. Try them some time, if you have little experience of them.

*F*ittleworth's best story is about the Swan Inn and taken from a newspaper article dating from the turn of the last century. It describes how people discovered that the nude lady astride the swan on the sign of the pub looked remarkably like Queen Victoria – not exactly

the lady one associates with riding swans naked. The sign was subsequently chastened somewhat and hung up inside. It is still there in the stairwell. The picturesqueness of sandstone Fittleworth made the Swan Inn a haunt for artists at that time. The composer of Land of Hope and Glory, Elgar, often found inspiration here. The lovely Artist's Room has a number of paintings in the wainscoting. The room looks

Petworth church, the Dawtrey monument (detail)

and more modern ones. And again the name John Flaxman stands out. But the artist most connected with Petworth is England's greatest painter, **Turner**, a constant visitor in the first decades of the 19thC. Most of his interiors of the house and views of the park are in the Tate Gallery in London, but there are a few here.

Another artist's name that is indissolubly linked to Petworth is that of Capability Brown (see p. 37), who designed the Park that was to inspire Turner. And others. Perhaps the biggest achievement is the serpentine lake, which is fed by springs in the north-west corner of the park, the water coming through a mile of underground brick culverts. The northern part of the park has views to both the North Downs and the South Downs and in the north-west corner is an eyecatcher and prospect tower called The Monument or Upperton Monument, designed by Sir John Soane in 1815. It's a private house, but you can go up to it: the deer are considerably more nervous about you than you could be about them. Petworth Park has a herd of fallow deer of over one thousand head, the largest in Britain.

Most people will know the Doric Temple and the Ionic Rotunda along the path between the car park and the House. In winter

Petworth 'obelisk'

Icehouses. The first records of icehouses come from Mesopotamia, 4000 years ago. Chinese poets talk about icepits in the 11thC BC. India had them too and they occur everywhere really, but in Britain they hardly became popular until the 17thC. Ice was used for making cold confections in the kitchen, for cooling drinks and for storage, but also for medical purposes.

Icehouses were built near mansions to provide ice all year round and they were usually located near the water where the ice could be collected in winter. They were often built in or on top of slopes, which allowed them to form part of the landscape or be combined with garden buildings like temples. Height helped with the drainage, and an open situation against damp. The ice well itself is usually a few yards deep and layers of ice and snow, pounded into a hard mass, alternated with straw. The main trick is to prevent air from circulating. That's why they often had two or three doors for one entrance. A 1994 survey by Ron Martin for Sussex Industrial History shows 96 icehouses in Sussex. Some places (Uppark, Goodwood) have two icehouses. The one at Petworth has three pits. I would have loved to discuss this one further with you, but I didn't get permission to see it, as explained in the larger note on conservation societies. I still shiver to think of it. I couldn't have been colder if I had been inside the icehouse for years.

In Holland the efficacy of an icehouse was put to the test a few years ago. It was quite an exciting project and a goodish number of people participated, each of whom was issued with a key. They were naturally proud of what they were doing and showed the icehouse outside and inside to friends and relatives. And they all came regularly to check on things. Which was exactly why it didn't work.

stylish, a bit posh even. All in all a fine inn, in a quiet village near the river Rother, with views of the South Downs nearby.

South-west of Fittleworth is a scary-looking Gothic 19thC castle called Coates. It is private and rarely open nowadays. ☆

*The little church at St Michaels, **Burton Park**, is one of those places where you are not quite sure if you are not trespassing.*

Probably not. There is not really a village called Burton here. There is a Burton House and then a Burton Mill, which has a nature trail near the pond. There is also a Burton church. which was restored in 1636. There are lots of monuments, texts and paintings, and a unique little brass showing a lady in a tabard, a heraldic costume.

Burton can be found east of the A285, just over two miles south of Petworth. I'm not

Petworth Park, Upperton Monument

four corners and an extra square bit, served two purposes. It was an observation tower for the deerkeeper and an eyecatcher for the House. For some reason folly-books find fault with it, calling it ugly and inadequate. It does look a bit stark at first, but since the estate was broken up the present owner has been working hard on it and has turned it into a lovely home. It can now be rented out.

Petworth Park, folly

Pegasus Bridge is in fact two bridges, over the river Orne and the canal, north-east of Caen. They achieved undying fame at the end of the Second World War. The Allied forces were ready for D-Day. The British 6th Airborne Division was supposed to land in Normandy east of the American troops and very early in the night, but the plan required the prior destruction of most of the bridges in the area, while a few others had to be saved. Pegasus Bridge between Ranville and Bénouville, was to be secured in advance and kept intact. Complete surprise, achieved by total silence, was imperative if the operation was to succeed. So the decision was taken to fly in using gliders. Big Horsa gliders did a number of practice runs in the dark in England, to see if they could land smoothly. Then on June 6th at 00.16 hrs six of them with some 300 men on board indeed landed in France, in between the two bridges, as the very first Allied troops to arrive on D-Day. This feat was later called the best bit of flying in the whole of the war. Within five minutes the bridges were captured from the surprised Germans and shortly afterwards the Allied troops landed to start their invasion.

the Doric Temple can even be seen through the trees from a great distance: it is straight ahead coming up to Petworth on the A272. And also The Monument can be found in most books. But pleasingly eremitic is the little folly in the south-western corner of the park. It looks like a sort of castellated gate lodge and is dated 1844. The inside is nothing special: it has obviously been used by animals. There are two rooms, separated by a feeding trough. It is in relatively wild grounds, and only frequented by deer. Wet winter weather will warrant wearing wellies.

It would be good to realise that when Capability Brown planted all these clusters of trees they were still young, and now after almost 250 years some of them are at the peak of their beauty. But the park looks emptier now than it normally would. The storms of 1987 and 1990 hastened the demise of many trees and damaged the majority, so that it became necessary to replace them. Close to 40,000 new young trees have been planted. Impressive figures again.

Perhaps the best thing about Petworth Park is that on lovely summer evenings you can stroll through it for free. Go to one of the gates in the south for instance and just walk in.

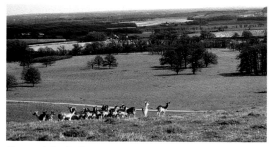

Petworth Park, deer

Petworth is twinned with Ranville, a village in French Normandy, where the 6th British Airborne Division landed on 6 June 1944. There is a little monument and a small museum, devoted to a famous military operation at the end of the war: **Pegasus Bridge**.

sure if Burton and West Burton are related, but West Burton is south-east of here. Not that that means a lot in Sussex. Lower Beeding is on a height, Upper Beeding is the lowest point of Sussex. There are more of these peculiarities. It is often extra confusing for non-English people who already have trouble understanding that in a name like Hadlow Down down means up. Linguistically this is called corruption.

In his celebration of Sussex called The Four Men – a Farrago, Hilaire Belloc blames this kind of special Sussex perversity on Adam and Eve, who gave names to all the places of the earth. 'And the best manner (thought Adam) so to establish by names this good peculiar place, this Eden which is Sussex still, was to make her names of a sort that should give fools to think.' I think I think too much.

Conservation Societies

At Petworth House I rang the bell and asked them if I could see the icehouse in the courtyard. No, it was not open to the public. But, I said, I'm doing this book on the A272 and would like at least some kind of description. It was freezing. There was a snowstorm. Someone told me to wait, outside. After fifteen minutes they came back and told me to go away. More than a year later I tried again, this time backed up by the expert who had been inside to describe the icehouse for them in an article. No, they said, we couldn't go in since the icehouse was dangerous. It's not that, the expert told me, but that's their best reason. Nice people, all of them in the National Trust, but inflexible and too powerful for their own good.

Conservation societies need not be arrogant. With the Landmark Trust you know where you are. They rescue buildings in distress and then try and give them a new life, perhaps as a holiday home. They produce an excellent catalogue of buildings that you can rent, from cottages to castles. A bit expensive perhaps, but it's in a good cause and the holiday homes are invariably exceptional and loveable buildings. An example in the area of the A272 is Fox Hall at Charlton WS (p. 108).

There are other national conservation societies, such as the Georgian Group and English Heritage, and there are lots of local groups. Architecture of a special nature gets special attention from only a few organisations. One is The Folly Fellowship, which deserves its own note (p. 171), and another is SAVE Britain's Heritage. In 1987 SAVE produced a superb report called *Pavilions in Peril*, which oozes sympathy with beautiful and eccentric buildings that are threatened in some way. The awesome Racton Monument near Chichester, as fine a ruin as any millionaire could wish to rescue, is in it of course, and so is the old bathhouse at Warnford Park, now called summerhouse. This last one has been lovingly restored and is now lived in. So the system works and there is hope for other buildings.

SECTION ICEHOUSE PETWORTH

PLAN ICEHOUSE PETWORTH

After taking a second look I decided that there would be at least half an hour of sunshine left for someone sitting at the one and only little white table outside the tea-room. 'Good,' I thought, 'a nice spot, not too hot, not too cold, in a corner, ideal.' I went in and waited quietly behind and beside the lady who was just receiving her order of food – a promising plateful. I ordered mine, got it and paid. Balancing the tray with the large glass of milk, keeping a sharp look-out for uneven bits of floor, I was concentrating so much on getting outside safely that I was startled to see that one of the chairs round the little table was occupied, by the lady who had been before me at the counter. I was turning away again, slightly indignant, when I thought: 'Ah well, why not?' So I asked her if I could join her. 'Fine with me,' she said. She was obviously enjoying the sunshine. She hadn't started on her lunch yet. We both took our first bite at the same time and after a while I asked her, 'Do you live locally?'

Well, she lived only a mile or so away and there wasn't much she could tell me about the place. Nice enough, convenient, a good place to go to now and again for shopping or a meal. Not that she needed much, because she tried to be as independent as possible. She had a small farm. She could bake her own bread and eat it with her own preserves on it. She

grew all sorts of things and she could trade with other farmers: her products and services like baby-sitting. A simple life, but all right.

She lived alone, a divorcee. All very sad and she still wasn't over it quite. But she did have her animals, especially her old dog for company. And she had her hobbies. She loved fixing old furniture, buying, repairing, polishing – a good trade. In fact she was thinking of making it her livelihood. Make a fresh start in life after the failure of her marriage. Yes, she did have the friends she needed here in the area. And further afield. She even had friends in the Netherlands, but she hadn't been there yet. No, it wasn't so much that she was lonely here. But the farm was becoming more and more difficult to survive on and perhaps, no probably it was much better to sell out and move some place further away in the west somewhere. Everything was cheaper there and there were better chances to start a repair shop for antiques.

I told her about a friend of mine who had always been good with his hands and who had always wanted to start an antiques repair business in Dorset somewhere, after he had finished with his teaching job at a secondary school near London. It had never come to that, because he had begun to develop some form of arthritis and so now it was too late. But that shouldn't discourage her, of course. On the contrary. The sooner she could do what she wanted to do, the better.

I asked her if starting out again on her own wasn't a daunting prospect. No, she was tough enough, she said. She had come from Wales originally and much later in life she would maybe go back there. She wasn't ready for that yet. For now a new start in the west, in Devon or Cornwall, seemed ideal. Well, what's keeping you then, I asked. It was the dog. He was old and probably had only a year or two to live, if that. He wouldn't easily get used to a new environment and she was not prepared to let him suffer more than absolutely necessary. But weren't her own feelings and decisions more important than waiting for the death of the dog? Well, in short, no.

She was silent. I thought about it for some time. A shadow began creeping up the legs of our little table. We both finished our meals, smiled at each other and got up. We were certain that we would never see each other again. We shook hands. If this had been in my country I would have kissed her.

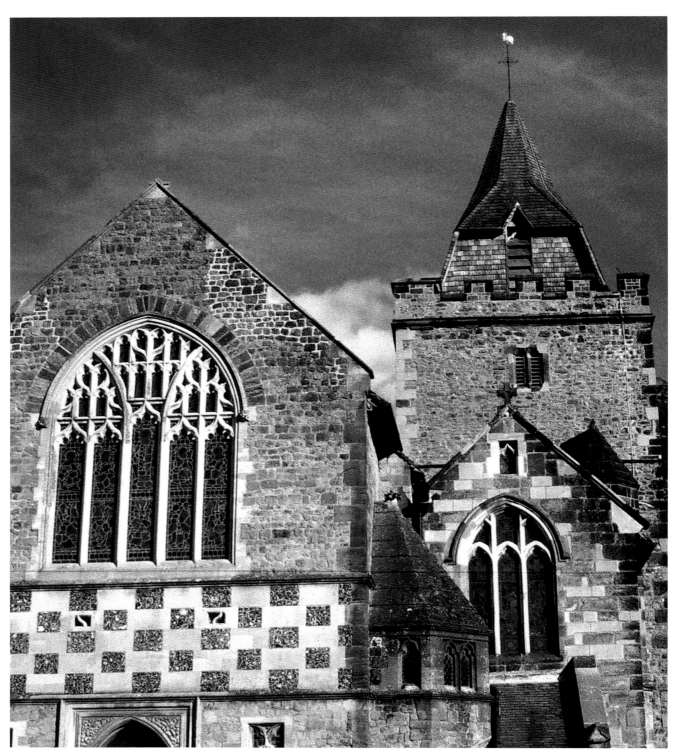

Midhurst church

Chapter

4

Tillington to Midhurst

The Light of the World caused controversy from its first appearance in 1854, the year after the Pre-Raphaelite Brotherhood had been dissolved. Holman Hunt had been a founding Brother, but here he appeared to be overturning all the Brotherhood's ideals of clarity and naturalism. Where Ruskin called *The Light of the World* 'one of the very noblest works of sacred art ever produced in this or any other age', Carlyle was horrified by the apostasy and denounced it as 'mere papistical fantasy'. 'Do you suppose,' he demanded the cowering painter, 'that Jesus walked about bedizened in priestly robes and a crown, and with yon jewels on his breast, and a gilt aureole around his head? Don't you see that you're helping to make people believe what you know to be false, what you don't believe yourself?' In fact Hunt had undergone a spiritual conversion while painting the picture, and it went on to have a greater impact on believers than any other painting of the period. In 1903 it was sent on a tour of the colonies, travelling to Canada, South Africa, Australia and New Zealand. It was said that four-fifths of the population of Australasia saw it.

Tillington church window

North of Tillington the road climbs to Upperton, a nice and quiet place that has another little entrance to Petworth Park. You are approaching a wooded ridge there with views to the South Downs looking back, and a bit further on views of the North Downs appear where the trees are not in the way. Upperton Monument can be seen on the right over the wall. It's a private house. Between

The fourth stage of our journey, to Midhurst, is the shortest. Again this doesn't mean that it is less charming. Places like Petworth and Midhurst take so much time to explore because they are so English and fascinating. From Petworth to Midhurst is some seven miles. The A272 is 90 miles. We have seven stages. Three long ones are nearly 20 miles each, four short ones nearly 10 miles. The order is: long, long, short, short, short, long, short (my Morse code for A272). Naturally this is reflected in the respective lengths of the chapters. Petworth is almost in the middle of the 90 miles. Somewhere between Petworth and Halfway Bridge (halfway to Midhurst) is our own halfway point.

Leaving Petworth, always going westwards, we come to **Tillington**. It is remarkable that we had to wait this long to come across a village along the road whose name ends in '-ton'. It is the most common syllable as an ending to English place-names. It is short for town and developed from Old English tun [toon], meaning enclosure, often farmstead, often estate or manor. Tillington means: the

Upperton and the Monument is a little road to the west. Straight on where it turns south is the private house called Pitshill. There are lots of lovely footpaths and bridleways here. Some of them go further west to a village called River. This name means 'at the hill brow' rather than what one would expect, so it does make sense. But it is a bit like the Upperton Monument in not being a monument but an

Tillington church

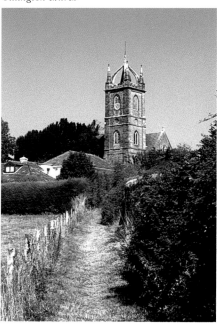

*In this chapter and the next the South Downs come closest to the A272. It takes only a few miles down the A285 to reach the first viewpoint over the valley of the Rother at **Duncton Down**. On the way there, south of Duncton village, you'll pass a lovely gate with welcoming open arms. If you look at it while driving you'll miss the bend in the road. It is one of the entrances to Seaford College, which*

is a public school that has only recently turned co-educational. Pupils must feel very privileged in the spacious and beautiful grounds that used to be the private estate called Lavington Park. Duncton's church bell is Dutch in origin. The name Duncton may sound familiar to you. William Horwood lives not far away and his epic novels about animals in the 'Duncton' series are 'loosely' connected

eyecatcher or gazebo, and like Pitshill Tower in hardly being a tower. They must be further examples of Sussex perversity. ★

The owner of Pitshill flatly refused me access to the Belvedere. (He didn't know I had already seen it; I didn't know I had been trespassing.) He declared it out of bounds, following publication of photographs of it in the local press. Vandals came to find it

and damaged the tower considerably. At least, that is what the owner says. When you see the inside of it, it is difficult to make out whether the deteriorated condition is due to vandalism or neglect by the owner himself. I could tell you to go and see for yourself, but it has always been difficult enough to find and under the circumstances you would obviously be trespassing as well, so I don't really recommend it.

farmstead of the man Tulla (and his people).

Tillington church, 12thC, is one of the first views one sees from the road over the wall of Petworth Park on the right. The lofty tower with its highly exceptional and graceful Scots Crown (the curving arms supporting the weather-vane) dates from 1807 and inspired Turner. Quite rightly. Inside is an excellent Pre-Raphaelite stained glass window based on William Holman Hunt's painting *The Light of the World*. Tillington is part of the Petworth Estate and has some nice buildings to show for it. E. V. Lucas, essayist, beloved friend of Belloc and author of the classic *Highways and Byways of Sussex* (1904), lived in one of them.

Another farm that has opened its gates to the public (left of our road) is Noah's Farmyard, but there are fewer types of animals than the name suggests. It is aimed at three- to eight-year-old children. School parties tend to stay a few hours. It has been open since the end of the 1980's – in winter without the shop and with half the animals. There is a ten minute nature trail to the river Rother. Noah's Farmyard is on Grittenham Farm, which has been a working farm ever since its mention in the **Domesday Book** (when it was held by one Robert) but don't expect to see evidence of the fact in the buildings. The present-day farmer is one of the stoutest castigators of the A272: 'the worst bloody road in the south of England'. ♣

Half a mile further is Netherlands Farm on the left. To my disappointment the name has nothing to do with The Netherlands. Generations of farmers here have never had connections with my country. One explanation for the name is 'adder-infested land', as in

to this part of Sussex. Nature in the hills nearby must be a continual source of inspiration for the writer. The view of Duncton Down is to the north. Petworth can be seen and much else of course.

East Lavington and Woolavington are in the same parish. Only local people distinguish between the neighbourhoods. They are silent places, hushed, like on the eastern side of

Domesday Book became the name of the survey of his new domain that William the Conqueror commissioned twenty years after the invasion. Every acre of land, woodland, meadow and pasture, every plough, mill and fishpond, every villager and cottager, every slave and freeman and every relevant animal was recorded and the value of the possessions established. To the natives it all looked like a final reckoning and the inescapability of the scheme led to its nickname Domesday Book (in reference to the Day of Judgement). Most names of manors and villages are mentioned here for the first time in writing. Let me give an example that we came across in Chapter 1: Barkham. The entry reads as follows. 'Warner holds 3 virgates in BARKHAM from the count [the virgate was about thirty acres]. It answers for as much. Earl Godwin held it from King Edward as a manor, as a freehold. Land for 3 ploughs. In lordship 1 plough; 4 villagers and 5 smallholders with 2 ploughs. Meadow, 6 acres; from woodland and grazing 9 pigs. Value before 1066, later and now 20s.'

Duncton Down

Henry Edward Manning (1808-1892) came to East Lavington as curate in January 1833, succeeded to the living in May and married the daughter of the previous incumbent in November. He joined the Roman Catholic church in 1851, became a cardinal in 1875, and founded Westminster Cathedral. If there is such a thing as an ecclesiastical statesman, he was it.

Pitshill Belvedere

It is sad to reflect that newspaper articles and books like this one can indirectly cause damage to pieces of architectural heritage. It is equally sad to reflect that both owners and custodians are unable or unwilling to distinguish between vandals and decent people. What can one say? Private property is private property, and owners have the right and the duty to protect it. On the other hand: even private things could often be accessible, and the public has rights and duties as well. Vandals operate outside this system. They are strictly forbidden to read this book.

On the other side of the little stream west of River is **Lodsworth***. It made me realise that I was surreptitiously becoming blasé about all these pretty villages with all their pretty houses and cottages. If I ever became*

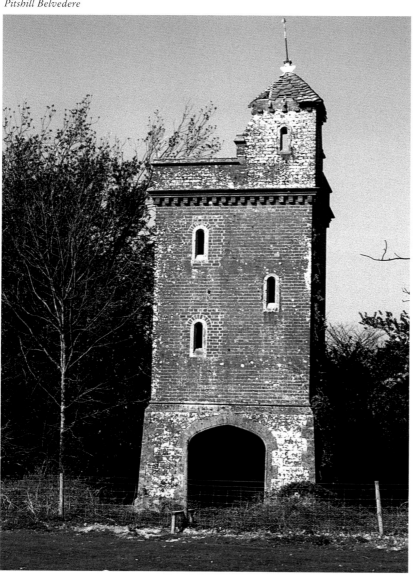

East Sussex's **Netherfield**. But I think it must be topographically derived from the low-lying land near the rivers Rother and Lod, where the farm actually is. The names for this farm and for my country have exactly the same meaning then.

Halfway between Petworth and Midhurst is the eponymous **Halfway Bridge**. Bridge as in bridge over the lovely little Lod. The road here looks fairly straight and broad and new. And it is all of these things. We actually have a few yards of four lanes here! This is the broadest stretch of the whole A272 as an independent road, and one of its meanders was straightened here recently, where the old road used to run round the Halfway Bridge Inn on the other side. It's a good thing traditional English pubs usually have entrances on more than one side. The spot behind the inn used to be called 'Beggars Corner', since this was where beggars waited for scraps to be thrown from the coaches. The next bit of road used to be so steep that the inn had

the A285. I may be wrong, but I would expect people to be devoutly conservative. If you should want to go there: you are not supposed to go through the grounds of Seaford College, attractive as that may be. And I'll tell you something else. The College has an extremely rare thing in the churchyard: the grave of a cardinal's wife. Cardinals do not have wives, but the exception was 19thC Cardinal

rich enough to have a house in the country in England then this is the area I would most like to choose. Why not? Near the middle of the A272 between Petworth and Midhurst. Lovely lanes, muffled villages, beautiful countryside. Plethoric. The Hobbits' Shire land.✳

Yes, Lodsworth is an attractive village too. Rita calls it Lotsworth. One house on a corner, with a dark and light pattern of bricks,

was the home of E. H. Shepard, the illustrator of Winnie-the-Pooh *and* The Wind in the Willows. *Of course it is a nice village, or he wouldn't have died here, so to speak. From near the church there are good views of the adjacent wooded valley, I had been told. True, especially in winter. Immediately behind the lychgate I noticed two little stones with inscriptions:* SOWN IN CORRUPTION – RAISED IN

The Halfway Bridge pub

an extra pair of horses to draw the coaches over the hill. Good pub. I wish they wouldn't advertise so loudly.✪

The A272 lies close to the western Rother here. We go west, following the river valley upstream; the Rother itself goes east.

Half a mile to the south is **Selham** bridge across the Rother, where in the early 19thC a band of smugglers left an excise officer hanging in the water, tied to a tree by his hair. Gosh, how many stories there are! And I mention only a small percentage of the complete collection. Anyway, the house called Hurlands to the right of the elevated Three Moles pub has some interesting brickwork and the church, with its Saxon and Norman features, sports a few monsters and snakes in the chancel arch. But we are getting too far south. Back to the road and Halfway Bridge. And westwards for a small stretch of road with banks on either side. This A272 does manifest itself in varied settings. A bit further on to the left is (South) Ambersham. Historically speaking this is interesting, since a bit of **Hampshire** used to be in Sussex here. For hundreds of years a very narrow strip of land from Ambersham straight to the north beyond Blackdown used to belong to Hampshire, ecclesiastically and politically speaking.

A house on the right, an old gatekeeper's lodge, (where one of the roads to Lodsworth branches off) sports remarkable paintwork. You'll see a lot more of the same orangey-yellow colours shortly. In fact yellow doors and windows can be seen for miles around, in and near Easebourne and Midhurst. It's the characteristic colour of the Cowdray Estate properties, and this custom of highly distinctive colouring is a genuine leftover from feudal times. Green-coloured houses in the area also belong to the Cowdray Estate. The difference is one of class. Can one find this sort of thing anywhere else but here, I wonder.

Netherfield. This name probably comes from 'naeddre field'. Naeddre is Old English for adder. I can point out one of the little tricks of etymology here. The word for adder used to be nadder, but 'a nadder' became 'an adder'. Exactly the same happened in Dutch, where 'een nadder' became 'een adder'. Both languages also have examples of the opposite: in English e.g. 'an ewt', has become 'a newt' over the ages. Explanations like that can be fairly straightforward; but Netherfield may have nothing to do with adders, who prefer drier ground.

It has always seemed ironic to me that the word 'etymology' is based on the Greek word 'etumos' which means 'truth', when there is often so much speculation in this field. We do our best, but unfortunately the study of linguistics is not considered as important as it used to be.

Manning who was rector here when this school chapel was the village church. The grave itself is otherwise unremarkable.

Further west is *Graffham [short vowels, the h is silent], with two good pubs and a sack road to the parish church. Up on Graffham Down are some barrows near that celebrated footpath called South Downs Way. You can easily lose your way in the woods further west*

towards the A286 and beyond: it's a tortuous tangle and you are not likely to find help. That's exactly the attraction of the area.

Cocking *is a flinty village where the colours of the Cowdray estate are obvious here and there. It was already old at the time of William I, who brought monks here to build and till the land, but with the exception of parts of the church (a bit awkward to get to)*

Hampshire. Not until the beginning of the last century was this long strip of land only a few hundred yards wide fully integrated into Sussex. Whole theories have been developed as to why this bit of Hampshire should have been in the middle of West Sussex, some as wonderful as they were faulty. But trying to explain them would take us too far. We can't do *everything* within the framework of this book.

Hunting. Apparently it was not uncommon for the servants to chase the deer in the direction of the queen so that she could have an easy shot. Or even simpler: the animals were driven into an enclosure. *The Progresses and Public Processions of Queen Elizabeth* (J. Nichols, 1823) quotes a report of 1591: a 'delicate bowre' was built for the queen and musicians were playing nicely when she was provided with a crossbow 'to shoote the deere, about some thirtie in number, put into a paddock, of which number she killed three or four and the Countess of Kildare one. Then rode her Grace to Cowdray to dinner, and about six of the clocke in the evening, from a turret, sawe sixteen bucks ... pulled down with greyhounds.'

Barrows are large mounds over the remains of the dead. They were mainly for influential people or chieftains. Their bodies were either buried whole or they were cremated first. The first barrow types date from around 3000 BC and they were 'long' and simple. Later barrows were raised over chambers and passages, built with huge flat stones, which often were family mausoleums. From 2000 BC onwards new immigrants began to build the round barrows that we can see here and there throughout Britain, sometimes constructed with elaborate encircling ditches and banks. Valuable tools and weapons were often buried with the bodies.

Sint Nicolaas (or Sinterklaas, or just Sint) in Dutch tradition is a Spanish bishop, though in fact he is based on St Nicholas of Myra in Asia Minor, now Turkey, who died on 6 December 342. Various legends have accrued to his name. In one story ☛

INCORRUPTION, *and* : SOWN IN DISHONOUR – RAISED IN GLORY. *Is this about illegitimacy? Poor bastards.* ✲

The church itself, devoted to someone we know in Holland as **Sint Nicolaas,** *has two striking stained glass windows. I hesitate to describe the* Christ on the Cross *by Carl Edwards. Words like crew-cut, body-builder, gay and diapers come to mind. No fun or*

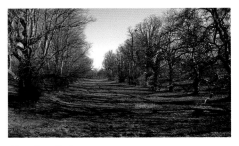

Cowdray Park, avenue

St Nicholas window

Just a bit further on the right is Benbow Pond.✲ You can often see duck here moving upon the face of the waters. The netting is to keep them away from the water lilies underneath. We also have the so-called Queen Elizabeth Oak here in Cowdray Park. What is left of it stands off to the left near the pond, halfway to the horizon – but you are not really supposed to go there. It was named for Elizabeth I, who was sometimes entertained at Cowdray. It is stunted, hollow and cracked, but alive.✳ What happened was that nobody wanted to make things too difficult for the queen when she was out **hunting**. It could hardly be called hunting, perhaps, as one can read in a contemporary report.

After Benbow Pond you'll find the golf course of Cowdray Park also on the right. Do you think that is a **barrow** on top of the natural hill? So did I, but I'm told it isn't. Also on the right you can see one of several avenues of trees that used to lead up to the ruins of Cowdray House on the left. There is no better descriptive word for these old trees than 'gnarled'; it's a beautiful lane. On the other side of the road the continuation of this route is less clear, but a lot has happened since Cowdray House became Cowdray Ruins. These avenues (The Race is the name for another one of them a bit further on) are supposed to be part of the 1750's landscaping, in the manner of Capability Brown. Well, I would have thought that Brown wasn't all that fond of straight

nothing is left of the old days, not even any field system.✴

Some six to seven miles south of Midhurst down the A286 is a whole cluster of attractions, some of them nationally famous.

We start at **Singleton**, again a modest village of flint and brick cottages, and first continue south-west one mile (past Chilsdown Vineyard on the right) to **West**

Dean.✲ *The present flint-faced manor house here on the left dates from 1804 (architect James Wyatt) and was bought by Willie James in 1891. It is now called West Dean College and houses a school with residential courses for artists and artisans.* ☆ *A few rooms have retained their original splendour. James was fabulously rich and redesigned the garden, which is now open to the public and run by the Edward*

irreverence intended by anyone, but it is safer to say something about the other window – St Nicholas, the patron saint of children. This gorgeously coloured stained glass (by A. E. Bass), near the children's corner in the church, depicts some of the legends pertaining to this saint. I was chuffed to see him here. At home Sint Nicolaas is the key figure of a wealth of our national customs.

Going north from Lodsworth along the attractive road towards Blackdown we pass the Lickfold Inn, timber-framed with herring-bone brick filling. Spot the terracotta Tudor rose. Also notice the bridge that runs parallel to the road for a number of yards on the right-hand side. It's the type of footbridge that comes in handy when the road is flooded. A clapper bridge, it is often called. There is

Easebourne, near Benbow Pond: Queen Elizabeth Oak left of centre

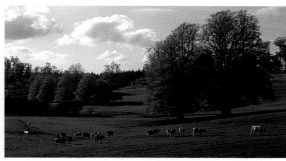

avenues, but why not? Some other features in Cowdray Park, like the ha-ha, wooded hilltops and wooded edges to horizons certainly are reminiscent of him. He may have made the 'barrow'. After all, he did work at nearby Petworth at the beginning of his career (early 1750's). But no written evidence of Brown's presence at Cowdray has been found.

Only a few yards further on there is a good view of the Cowdray ruins and Midhurst over the farmer's gate on the left. In the background are the South Downs. We'll have a closer look at these ruins later. The green fields near them are used for cricket, stoolball and especially polo. Cowdray is internationally famous for this rich man's sport, which you might describe as horse hockey. Prince Charles and the other royals are regulars here. You don't have to be rich to watch the games, which are often exciting. The car park costs between £5 and £10. So go on foot and there will be no charge. Matches are played every

Of course I would have loved to reproduce this picture here. René Magritte called it *La Reproduction Interdite*, usually translated as *Reproduction Forbidden*. It shows Edward James in half-length, seen from behind. He is standing in front of a mirror on a mantelpiece, and the reflection should show James's face and front, but it shows him from behind again. On the mantelpiece is a book by Edgar Allan Poe. The painting was sold in 1981 and is now in Rotterdam. The cost of reproducing any painting in a book depends on a number of factors. On the cover is more expensive than inside, colour is more expensive than black and white, large is more expensive than small, and the more books are printed the more expensive it all is. Having *La Reproduction Interdite* here would cost around £130 in what are called repro-rights and copyrights. This is so much more, extra, than other pictures, that we can safely give the painting two titles: *Reproduction Forbidden* and *Reproduction Forbidding*.

Let me make a promise: any reader who has some useful information for me about any aspect of this book will get a picture of *Reproduction Forbidden*.

Reproduction Forbidden: a portrait of Edward James by René Magritte

James Foundation – Edward was Willie's son. The grounds contain several types of garden and a parkland walk that leads to an arboretum. Note the beech stump in the Water Garden. Some rustic summerhouses, a gazebo and a 300ft-long pergola are to be seen, but lovers of flowers, plants and trees will find the garden more interesting than folly-fans. There was still an unfinished look about the place

☞ he brought some children back to life after they had been killed and pickled in a tub by an evil publican. The ship or anchor symbolises another legend of rescue: Nicholas saved three shipwrecked men or boys, unjustly accused of theft, which made him patron saint of sailors and of boats. In another story he anonymously gave money for the dowry of three poor girls, who would otherwise have become prostitutes or, in another version, been killed. The three golden balls that symbolise his money somehow became associated with pawnshops and with bakeries. A versatile saint, with a reputation as a giver of gifts to children. Our Dutch Sint Nicolaas is generous too. He comes to Holland from Spain by steamboat every year, shortly before his feast-day of 6 December. He is always accompanied by a number of black servants (our idea of Spanish Moors), almost all of whom are called Piet [peet] or Zwarte Piet (Black Peter) and he rides a grey horse over the roofs of the houses in order to be able to drop presents down the chimneys. Children put carrots for the grey in their shoes beside the chimney and sing a great variety of special songs. If you haven't been good, which he knows by consulting his large notebook, Sint takes you with him to Spain when he returns, in the gunny sack in which he brought the presents for well-behaved children. Presents are always accompanied by unserious, often satirical pieces of poetry. Special kinds of sweets are in the shops at that time and so on. Some Dutch customs round Sint Nicolaas, not least that of gift-giving, were taken over by other countries in the late 18thC, especially through the Dutch in New York (formerly New Amsterdam), only the festivities were transferred to a few weeks later, and so you have your tradition of Santa Claus at Christmas.

Lurgashall, pub sign

Edward James (1907-1984) was named after his godfather King Edward VII, who often came to West Dean to visit Edward's mother, his illegitimate daughter. (I know it is often thought that Edward James was Edward VII's son, but I saw Edward James on TV once, saying that the illegitimacy had occurred one generation earlier, so I have to go along with that). James inherited a fortune at an early age and spent money in style. He was the first to patronise surrealist painters like Salvador Dalí and Magritte. He also was a poet and a first-class eccentric. His Monkton House, not far from the family residence West Dean, was a surrealist dream or nightmare, in striking purple colours. In 1964 he formed the Edward James Foundation and in 1971 his West Dean House was opened as a college for arts and crafts. Together with his head gardener Ivan Hicks he created surrealist gardens in Italy. (Ivan Hicks' later work includes Stansted Park near Rowland's Castle ES and Groombridge Place in Kent). Edward James soon found England too restrictive for his tastes and moved to Mexico, though he kept coming back. In Xilitla he had an artistic paradise built for himself, full of vividly colourful follies. According to recent reports it is now more or less rotting away in the jungle. One of my ambitions in life is to see it.

*another one not far east from here between Ebernoe and Balls Cross. Off to the right is what many would consider an ideal rural village, **Lurgashall**. The triangular green in the middle is the cricket pitch and there is not much more to the village than what you can see from there: such as cottages of different architectural parentage; a post office – general store and a 15thC inn, Noah's Ark (notice how*

Lurgashall

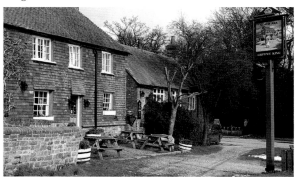

the Ark looks brick-built on the sign). The church that Tennyson used to come down to on Sundays is reached by a shady path. The main body of the building is 11thC (the tower is later) and there is a stained glass window showing people in modern dress. But its most remarkable feature is outside: a sort of wooden gallery along the south wall. It probably started life as a shelter for people staying over for a

weekend afternoon in summer, but also on weekdays. The programme usually shows fixtures for two out of three days in some months.

But first we come to **Easebourne**, which is pronounced [ɛzbɔrn] or even [ɛzbˈn] and means Esa's stream. Coming into Easebourne there are a few things to notice. On the left is a group of buildings that clearly belong together. They are what is loosely termed 'the priory', the vicarage, the church and then a house. The oldest parts of the whole priory complex date from the early 11thC, but it became a convent for Augustinian nuns in about 1248. The reputation of the nuns was such that the **Dissolution of the Monasteries** halfway through the 16thC cannot be considered altogether a bad idea. In principle the whole building still looks the same as it did then. On the left were living quarters with the 'dorter' (dormitory) on the second floor and behind that was the square cloister, which can still be seen from the vicarage, now more or less in the middle. The Refectory Hall is used for functions nowadays. The church on the right must be very rare in that one of the main entrances is now beside the altar. But there used to be five entrances. You can't miss the 16thC monument to Lord Montagu inside and you mustn't. Quite colourful.

*last time we went, but that was only temporary, I trust.�帛 Monkton House, on the Downs five miles to the north-west, built by Lutyens for Mr and Mrs Willie James and later transformed into startling surrealism by **Edward James**, was sold in 1986 and is now private. So, sadly, it can't be inspected, admired or abhorred according to one's taste and education in architecture.*

*At **Charlton**, east of Singleton, you may see an octagonal thatched building on staddle-stones: a grainstore.✻ More interesting is Fox Hall, a **Palladian** hunting lodge, designed by **Lord Burlington** in 1730. This became the focal point of the Charlton Hunt, which was founded in the 1760's and lasting until 1815, attended by the most high-spirited of noblemen. The building seems to have been*

second church service, but was being used as the village school as early as 1622. North-west of the village on the road to Blackdown is Lurgashall Winery, in 17th- and 19thC farm buildings. A pleasing place, and they sell other local drinkables and eatables besides wine.

Black Down (or Blackdown) is the highest point in Sussex (918 ft) and seems to have escaped from Surrey, so close is it to the county

Easebourne, bypass bridge

On the other side of the road the thing that looks like a lychgate is a private bypass bridge. It had something to do with busy horse traffic here. The inscription still raises eyebrows: in what way 'dangerous', one wonders, and for whom? The other yellow-marked buildings beyond it are the offices of the Cowdray Estate, one of the largest in Sussex. All in all this is a highly distinctive corner of the world. Exceptional, but unmistakably and exclusively English.

The village of Easebourne itself has lost some of its importance. But the fresh air still makes this area salubrious. It was considered good for TB patients and a specialised hospital was built on the hill north-west of Easebourne, named after Edward VII, who opened it himself. Nowadays it is a general hospital, largely private. The gardens are by Gertrude Jekyll.

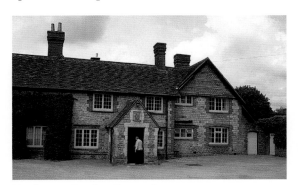

Easebourne, Cowdray Estate colours

The best approach to **Cowdray Ruins** is via the causeway behind the Tourist Information Office in Midhurst, but Cowdray belongs to Easebourne. The Tudor mansion was built

Dissolution of the Monasteries (1536-1539). Henry VIII (who was often seen at Cowdray WS – royalty still is) had quarrelled with the Church, mainly over his marriage, and established an independent Church of England, with himself at its head. The single most destructive period in the history of British art followed. Iconoclasm triumphed. Only a handful of the demolishable medieval art treasures survived. Henry VIII assaulted the monasteries and priories, confiscating their lands and holdings. In moveable goods alone (plate, vestments, jewels) he became £1,400,000 richer. Phew. Then there were the properties and the revenues from land, mines, quarries, mills, fisheries, timber and other sources. Yes, he did become wealthy and had a lot to spend. He bought loyalties with it, and later built Nonsuch.

Palladian means in the manner of the North Italian architect Andrea Palladio (1508-1580), a style based on the Roman architectural writer Vitruvius (*c*. 30 BC). His cool but dramatic classicism, used for churches and public buildings in Venice and Vicenza, as well as grandiose summer villas built for the Venetian nobility near the Brenta canal, became a major inspiration to later architects, particularly in Britain. His earliest disciple here was Inigo Jones (1573-1625), who mainly worked in London. Later, in the 1720's, **Lord Burlington** (1694-1753) who had studied Palladio's buildings in Italy and had bought many of his drawings, launched a Palladian revival, whose classical severity influenced English country house design for the next century. The most famous of the handful of buildings he himself designed is Chiswick House, just by the M4 in West London.

used for their illicit and illegal cavortings. Very foxy. The outside of Fox Hall is rather plain and it is small, but it is nowadays rented out by the Landmark Trust for holidays. Apart from this building the only thing in Charlton to remind one of the famous Hunt is the name of the pub. What used to be The Fox became The Fox Goes Free and is now The Charlton Fox. West Dean also has a related pub name:

The Fox and Hounds.

South of Singleton is the **Weald and Downland Open Air Museum**. All sorts of vernacular rural buildings like farms, barns, sheds, shops, workshops, mills and what have you, are gathered together here, most of them from Sussex, Surrey and Kent, and usually because their existence in their original sites was threatened. Machinery and tools are kept

Flint is exceptional as a building material for a stately home, but this area knows a number of villages that are built with flint, and apart from making a refreshing change, they look both beautiful and robust. Whether entire nodules are set in mortar or they are knapped and the dark inside is presented, together with the white stone dressings of corners and edges, flint produces an attractive effect of contrast. The latter pattern is called flushwork. I think it is lovely, and again I am tempted to quote from David Arscott's *In Praise of Sussex*, this time a few lines of his mock-heroic poem *A Hymn to Flint*:

> Knapped and squared,
> Round, unprepared
> And roughly layered:
> Gift of the chalk for those
> who're skint,
> Thy praises I shall never stint
> Oh various, lightsome,
> steel-hard flint!

Chesterton (Gilbert Keith, 1874-1936) journalist, critic, poet, hagiographer, Catholic and creator of the benevolent priest-detective Father Brown. 'A legendary figure,' says the DNB, 'with flapping hat, cloak and sword-stick; absent-minded, high-spirited, and good natured almost to weakness; but rock-like in maintaining his ideas.' His most famous poem, I am glad to say, is called *The Rolling English Road*.

Fleming. You may have wondered before why I mentioned Flemings like Van Dyck and Rubens with considerable pride, and why I hailed them as fellow countrymen. Well, this is because at the time they lived, the early 17thC, Flanders was an integral part of the Netherlands. So these people were fellow countrymen of my ancestors. And I am proud to be proud of them.

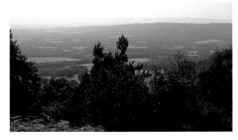

Black Down: Green Sussex fading into blue

boundary. *Tennyson loved the place and lived there at Aldworth House for twenty-four years. David Arscott's book* In Praise of Sussex *quotes exactly the right sentiment from* Lines to a Friend ✤:

> *You came, and look'd, and loved the view*
> *Long known and loved by me,*
> *Green Sussex fading into blue*
> *With one grey glimpse of sea.*

during the 1530's to replace a house of about 1300, when the lords of the manor in Midhurst wanted to leave the cramped and busy castle on Ann's Hill in Midhurst and moved to a hazel copse or hazel hedge (in French 'coudraye': Cowdray), a few hundred yards away on the other side of the Rother. 'Loveliest and perfectest of all ancient mansions' said **Walpole**. 'I should like to stay here four-and-twenty hours,' declared Dr. Johnson. 'We see here how our ancestors lived.' Ancestors, however, had incurred a **curse** and Cowdray burnt down in 1793. Ever since then the battlemented ruins of this piece of pure Tudor architecture have attracted all sorts of visitors to view the vestiges of vanished vainglory. William Cobbett saw the ruins at Cowdray thirty-two years after the fire and was clearly impressed. A tourist attraction. The present Lord Cowdray lives in the present Cowdray House in a secluded corner north-east of the ruins.

You are supposed to get your ticket for entrance to these theatrical ruins at the Round House. Walk down the causeway from the car park. Halfway, somewhere away on the right, is an icehouse dating from *c.*1750, set against St Ann's Hill. Reaching the river Rother you'll see a path to the right that was a favourite with Elizabeth I. But round to the left is the Round House, which is octagonal, with a pointed roof. Actually, this used to be a water tower or conduit house. There was a big water tank inside. The roof is complicated, with a sort of dip in the middle running all the way round – which was a clever way of collecting rainwater.

Easebourne-Midhurst handshake

intact and the old crafts and techniques are demonstrated almost continually by resident craftsmen. Buy the guidebook, it is highly informative and enlightening. This is one of the major tourist attractions in the south of England.✤

To the south is the heart of the **Goodwood** Estate, a 14,000 acre property and the home of the dukes of Richmond and Gordon for more than three centuries. The present house was built by James Wyatt between 1800 and 1806. In order to improve the view from the house the then Duke of Richmond had the road from Chichester to Petworth moved further east. The house is highly unusual in that it looks as if it is all made of **flint**. The ground floor is open to the public and the many treasures include a collection of Sèvres porcelain

There are views of Surrey (e.g. Leith Hill) and from the lie of the land – a steep fall to the south – one might expect a comprehensive view of Sussex, but there are often trees in the way now. Lovely old trees. On windless days of summer sunshine one hears Vivaldi concertos in one's head, or a slow melodious Beatles song, as the case may be. The widest view to the south and east has a memorial bench and a plaque explaining what you can see on a clear day. That must be what is called the Temple of the Winds. I had heard it described as a configuration of trees on top of Blackdown with a seat, but had trouble identifying it. But here, as in other cases, the hunt for it was more pleasant and more meaningful than the thing itself. The Arun gap allows a view of the sea, 25 miles away as the seagull

Cowdray ruins

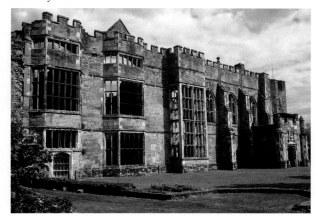

There is a fine bridge over the Rother between Easebourne and Midhurst. Seeing the water gush forth here one can hardly understand why there isn't a watermill any more. From the footpath you can see a stone relief on the side of the bridge: two hands clasped together, symbolic of the friendship and collaboration between the two towns. Complementary. It should be realised perhaps that for centuries Easebourne was more important than Midhurst. Now the roles have been reversed and it's a nice thought that they are seen congratulating each other. Complimentary.

Midhurst (in which the [h] is often silent) means middle wood, probably because of its position midway between North and South Downs. Apt. 'No other spot has so much to offer; a quaint country town, gabled and venerable, unmodernised and unambitious, with a river, a Tudor ruin, a park of deer, heather commons, immense woods, and the Downs only three miles distant. Sussex has no more contented town,' wrote E. V. Lucas in *Highways and Byways in Sussex*.

and paintings by the Englishman Stubbs, the Italian Canaletto and the **Fleming** Van Dyck. The private Carné's Seat, or Banqueting Hall is visible in the distance outside.

With Goodwood we are in the heart of the South Downs. Those 'colossal contours that express the best quality of England because they are at the same time soft and strong', as **G. K. Chesterton** said. It may sound

a bit as if he was talking about toilet paper but he was right. The Downs are everywhere, and Goodwood is everywhere. There is a Goodwood Park Hotel, there is a camping site and a caravan site. There is a golf course. There is an airfield with a Flying School and there is a racetrack for cars. If you pay enough you can make use of everything. If some of it sounds expensive, I can only assure you: it is.

Horace Walpole (1717-1797), son of the first Prime Minister, Robert Walpole, aesthete, novelist and prodigious letter writer, undertook the Grand Tour in the company of the poet Gray. As a decorator, at his 'little Gothic castle' at Strawberry Hill, Twickenham, and as a novelist with *The Castle of Otranto*, he created the fashion for the Gothic taste. His letters, written with an eye to publication, remain a delight and a wide-ranging source of information about the great houses and gardens of the time, most of which he had visited. Walpole also coined the word serendipity, which is an apt term for the ability to find follies.

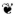

Curse. This one came either from the sub-prioress of the local convent at the time of the Dissolution, or from an abbot who may have transferred the curse to the resident family. Or from both. The origin of the curse may be doubtful, but the message was unambiguous: the family of Sir Anthony Browne would perish by fire and water. These curses can be a bit slow to work sometimes. Time passed. Guy Fawkes was a servant in the house, but he managed to curb his inclinations. Time passed. Horace Walpole came to visit. He didn't like Sussex much ('Sussex is a great damper of curiosity'), but Cowdray was his 'greatest pleasure'. And time passed. Dr Johnson came and expressed his appreciation of the house as well. Time still passed. But when the curse did take effect it hit hard. After almost 250 years some workmen left a fire unattended and it swept through every corner: the house was gutted. This was in September 1793. A week later the last male heir of the family tried to shoot the rapids on the river Rhine in Switzerland and drowned. So there you are. Fire and water. These clerical curses are not to be trifled with.

H. G. Wells (Herbert George, 1866-1946) first won acclaim for one of the great pioneering works of science fiction, *The Time Machine* (1895). His career in letters – which included scientific text-books, short stories, 'discussion' novels, as well as social and fantasy novels, and memoirs – made him a plausible rival to Defoe as the most prolific writer in English, and to Shaw as a fount of sweeping and sometimes belligerent pronouncements on the great issues of the day.

Despite his mother's unhappy time below the stairs at Uppark, Wells declared that 'it is the country house that has opened the way to human equality, not in the form of a democracy of insurgent proletarians, but as a world of universal gentlefolk no longer in need of a servile substratum. It was the experimental cellule of the coming Modern State.'

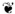

The Pilgrim Fathers were the 102 English, Scottish and Dutch Dissenters who sailed to America from Rotterdam and then Plymouth on the *Mayflower* in 1620. They played a major part in the colonisation of New England. The Dissenters, often called Puritans, had made themselves increasingly unpopular because of their fanaticism, and considered themselves missionaries to the New World.

Curfew Gardens. There is a little story attached to them. One day a traveller had got lost near Midhurst. He was just getting desperate when he heard the ringing of this bell. The sound directed him into safety. Out of gratitude he donated a plot of land to the town on condition that this bell rang out every evening at eight. So Curfew Gardens represent a nice bit of English folklore.

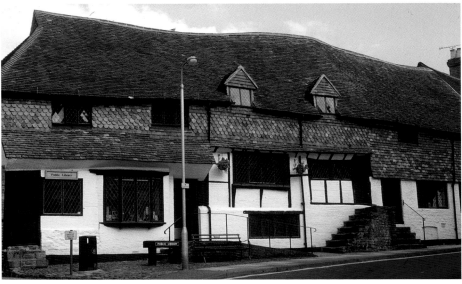

Midhurst library, Knockhundred Row

No deer today, but the town is still an architectural feast. Shortly after 1066 a castle was built on St Ann's Hill. In the 12thC Midhurst began to develop as a market town at the foot of this castle. It continued to prosper modestly, had a good spell in Georgian times and finally grew bigger than Easebourne. Again, this town is best explored on foot and we'll follow it roughly as the A272 goes. Parking is behind the Tourist Information Centre (TIC). Note the lovely new sundial. This is North Street, wide enough to be a market place.

Opposite the TIC is the grammar school where **H. G. Wells** was first a pupil and then a teacher (he also worked at the local chemist's and disguised Midhurst as Wimblehurst in *Tono-Bungay*). The Angel Hotel looks 19thC, but is older, probably 16thC. It is thought that it got its name from the **Pilgrim Fathers** on their way to Plymouth in 1620. Apparently they called every inn they stayed at 'Angel'. These Pilgrim Fathers must have followed the example of the real pilgrims of a few centuries earlier who liked the idea of having Angel hotels, Angels as guardians and for guidance on their way. 'The Angel's entrance lies yawning to engulf your highly respectable cyclists,' Wells wrote in *The Wheels of Chance*. In the

The famous racecourse is set in a natural amphitheatre at the top of the Downs; it is indubitably the loveliest sports-ground or field in England. Glorious Goodwood, as it is usually referred to, has regularly been visited by royalty ever since the first race was run in 1801. It has all the facilities for the rich and famous, but you can have fish and chips as well.

The latest addition to the Goodwood attractions is Sculpture at Goodwood, north-east of Goodwood House. An open-air venue with grassy lanes, lawns, beech, birch and thuya trees, and many firs. Sculptures by contemporary British artists – some of them daring enough to ask small or large fortunes for their work. Occasionally they publish a posh-looking magazine. Very modern

flies, and if you use binoculars you can see ships coming in on the finest days. The Temple of the Winds on Black Down is a longish walk away from the car parks. The TIC in the Haslemere museum sells a little map of the area, with explanations.

Haslemere is seven miles north of Easebourne and just over the Surrey border. Tucked away among the hills and

woods and further blessed with many beautiful buildings it has always been a tourist haunt, as two handsome Georgian hotels in the High Street bear witness. The French musician Arnold Dolmetsch settled here. The Town Hall looks older than it is (1814) and the parish church has stained glass windows for both Tennyson and his fellow local poet Gerard Manley Hopkins. Tolle House is a

Knockhundred Row. The most widely accepted etymological explanation is that the lord of the manor could summon 100 men to his service by knocking on 100 doors. Why then in this street specifically is uncertain. More logical might be that some animals were sold in groups of one hundred here, by a knock of the hammer, as in auctions. The name Sheep Lane nearby might point in that direction. But how often were things sold by the hundreds? Could the name be connected to the old use of 'hundred' for an area of land? (see p. 115).

❧

Dolmetsch: Arnold Dolmetsch 'made and revived the playing of almost every instrument of the 15thC to 18thC,' says the *Oxford Companion to Music*, adding for good measure 'as well as some earlier ones; and he trained every member of the family to make and play them.' The most influential revival was perhaps that of the recorder, which had slipped into complete obscurity. Dolmetsch studied in Belgium as well as London, where he was inspired by the collections in the British Museum. His workshops were in Haslemere and the annual festival he founded, is still going strong and is still run by the Dolmetsch Foundation.

same book he also mentions the nearby 'little shop flourishing cheerfully the cheerful sign of a teapot, and exhibiting a brilliant array of tobaccos, sweets, and children's toys in the window'. The cheerful sign is still there and very little has changed, as you can see. Wells used to lodge there. But 'ye olde tea shoppe' that you can go in now was renewed in the early 1990's. The enormous white teapot in the window is as new as that. And during these recent alterations a mural was discovered that is estimated to be 400 years old. You can see it while having lunch there. Sit down and think. It's small and perhaps not very spectacular, but if this was found here, what other things might be found?

We turn left into **Knockhundred Row.** Explanations of this quaint name have never been entirely satisfactory. New suggestions are welcome; I'd like to hear them. Near the bend in the road were two bookshops of which the second-hand one was sympathetic. Have a look at the enormous painting of Cowdray-House-before-the-fire over the staircase there. That it can stay in this place unharmed is pretty English, I'd say. 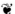 In the corner to the left of the library are the so-called **Curfew Gardens.** The next building is tile-hung and was converted into a library. Have you ever seen a more scrumptious library? If it's open do go in. The inside is wonderful as well.

We get to the Market Place (note Wells's Chemist's on the right) and to the parish church. In 1943 the main window behind the altar was destroyed by bombing. After the war the window was replaced by stained glass (by Claud Kinder) representing the two warriors St Michael and St George with members of the armed forces and civilians. A picture of the street outside, complete with war memorial, also forms part of this window. Outside again have a quick look at the peculiar form of the church spire. The churchyard entrance has a lychgate with two

Midhurst church, east window

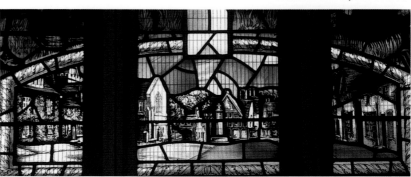

sculptures/objects in lovely surroundings with an unexpected view of Chichester Cathedral into the bargain. An illustrated leaflet leads you along a trail. In fine weather it's a park to rival Belgian Middelheim near Antwerp or Dutch Kröller Müller near Arnhem. ☆

*Overlooking it all is a hill: **The Trundle.** What is left of a Stone Age camp at the top is surrounded by an Iron Age fort.*

Lock-up – a miniature, provisional prison. Sometimes in the form of a strong-room, as part of an existing building, but also and more interestingly as a specially built cell. From the late middle ages until the 19thC lock-ups were used to put away people for the night, like a drunk who made a nuisance of himself or a criminal before he could be brought before a magistrate. Sussex and Hampshire have surprisingly few of them left. In the 1990's the Village Lock-up Association was founded, which aimed to produce a National Directory of Lock-ups. While they were at it they also worked on an inventory of stocks, pillories, gallows, gibbets, whipping posts, pounds and pinfolds plus other punishment and detention devices in the country. They include among other things branks, bull rings, cages, cucking stools, ducking stools, jougs, stangs and tumbrels. Are you still there?

Apart from some isolated cases elsewhere, including the Netherlands, lock-ups seem to be very British. The research into these things certainly is very English.

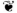

William Blake (1757-1827), poet, artist, maker of books, radical and visionary, was inveigled to Felpham near Bognor Regis by his friends to keep him from the distractions of politics in London. At first it was a great success:

> Away to sweet Felpham, for
> Heaven is there;
> The Ladder of Angels descends
> thro' the air;
> On the turret its spiral does softly
> descend,
> Thro' the village then winds, at
> my cot it does end.

Blake got into trouble, however, for pushing a soldier out of his garden, and was tried for sedition. Despite his acquittal, his natural suspiciousness grew and became more bitter.

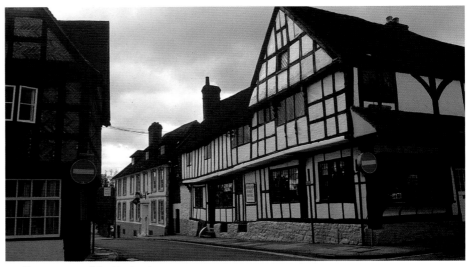

Midhurst, corner of the Market Square

seats on either side, lengthwise, making it look rather like a bus-stop. The churchyard itself has an unexpected annexe across the road round the corner, but most of the graves are unremarkable.

Locked up under the staircase of The Old Town Hall, on the church side, are the town's stocks. This space is not a genuine **lock-up**, however – it was never used to lock miscreants away temporarily. Between the church and the Old Town Hall one can go up St Ann's Hill, past some buildings with Cowdray colours. This site of the old castle has been done up a bit recently and now gives a good impression of what it must have been like. One can clearly see the outlines of the former castle, or fortified manor. St Ann's Hill was once Tan Hill, by the way, where the ancient fire god and sun god Tan was worshipped. The name change may be seen as a good example of how Christianization happened.

Back at the Old Town Hall see how the Spread Eagle has spread its wings over quite a few buildings. Note the Old Market Hall and other fine pieces of architecture. One fancy restaurant used to be run by a Dutch couple (Maxine's just was the finest restaurant along the whole of the A272 – either that or I am biased). Further down South Street is South Pond and the Spread Eagle Hotel proper,

South Downs. All of this is in the middle of the South Downs and we can't go back north to our road without saying a few words about the attractions of the Downs and Chichester. The Downs are especially suitable for walking. There are countless places to leave the car, from which you can start walks from one viewpoint to another. There are opportunities for riding for all ages and abilities,

and there is even llama trekking. Chichester TIC is the best place to ask for brochures. ✳

*Chichester is the county town of West Sussex and has always been important, from its foundation right through Roman times and the days when things were divided into **hundreds** and **rapes**. It has survived with an ideally ordered town plan and has a wealth of attractions, from its 900-year-old cathedral*

good group of almshouses (paid for by tolls) in Petworth Road. The Educational Museum is the home of an Egyptian mummy among other things, and also houses the tourist office. All round Haslemere, from Black Down in the south to the Devil's Punch Bowl in the north are footpaths, bridleways, nature trails and viewpoints. The town fully deserves all the tourists it gets.

I had noticed **Henley** *on the map, two miles north of Easebourne. I tried to look it up in the usual guides and books, but found nothing. No mention of it anywhere. Poor, unsung Henley, I thought. It made me curious. What sort of place could it be? So I went there and was surprised to see that entrance into the village is actually discouraged. You are not supposed to go there 'Except for Access'. Funny*

Hundreds. In early Saxon times the land and the people were divided into 'hundreds', which were units or families comprising roughly one hundred times 120 acres, the land required to maintain one free family. Hundreds were subdivided into tithings of ten households, each responsible for the behaviour of all. The men regularly came together in what is called a moot, under the chairmanship of a hundred reeve. The meeting place was often called moot as well. It was the beginning of local government. The hundred reeves, the local officials, answered to the shire reeves. From the 8thC onwards shire reeves were appointed as the king's representatives. The local leader below the reeve was often also called 'ealdorman', meaning older-parent-chief, in which you recognize the word alderman. Shire-reeve was later shortened to sheriff.

which partly dates back to 1430 – host to royalty and described by Hilaire Belloc in *The Four Men* as 'that oldest and most revered of all the prime inns of this world'. Of course it would be the proper place to stay for people who appreciate all this lovely old English architecture, but I'm afraid it is a bit too expensive for the likes of me.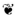

Not everything is old in Midhurst. The Grange Centre, in sharp contrast to most of the town, is a modern community centre for sports, conferences, day-care and leisure. There is also a new Roman Catholic church of startlingly modern design in the Bepton Road. The old Catholic church was over in Easebourne, and is now the village hall. The congregation moved to a building on Rumbold's Hill behind the Wheatsheaf pub, which is now used as function rooms (but it still looks like a church, doesn't it? Only the bell on top is missing). And in 1957 this new Catholic church was built, fortunately at some distance from the town centre. On the way there you pass a little cluster of shops on the corner of Grange Road. There used to be an honesty-box. With no-one around you just put the money in a box. It is comforting to see that this sort of thing is still possible in England. Don't forget West Street: it's handsomer than one photograph can show. Ah well, there is so much here. It doesn't take long to get to like this place with its olde worlde atmosphere.

On the southern edge of the town in the direction of Dunford (Cocking Causeway) an obelisk rises

Midhurst, West Street

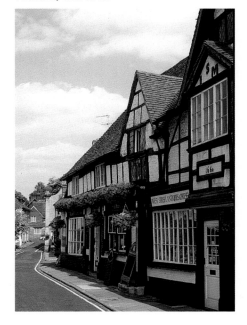

and elaborate market cross to the picturesque harbour. From the inside of St Mary's Hospital to the Pallant House and Guildhall museums. John Keats was inspired by Chichester and started The Eve of St Agnes *and* The Eve of St Mark *there, after having seen a stained glass window in a chapel in the grounds of Stansted.* **William Blake** *was tried for sedition in Chichester (he was acquitted).*

Rapes. In Sussex the hundreds (units of 100 families) were grouped together in 'rapes', probably meaning roped-off areas. William the Conqueror perfected an organised system of rapes and eventually there were six of them. From east to west Hastings, Pevensey and Lewes in East Sussex; Bramber, Arundel and Chichester in West Sussex. From the coastal capitals with their castles these rapes stretched northwards. They each had their own ports on the coast or on navigable rivers, and their main churches. William de Warenne was granted Lewes and William de Braose got Bramber, in recognition of their support at the Battle of Hastings. They were granted land elsewhere as well (in Scotland the French name Brix developed via English Braose into (Robert the) Bruce. Their names and those of their descendants occur a number of times on these pages.

Tomb. It is of Richard Fitzalan, 14th Earl of Arundel (b. 1346), and his lady. The two stone effigies date from *c.* 1400. Quite unusually, and very endearingly, they are holding hands.

A friend of mine drew my attention to the curious history of a poem by Philip Larkin, who was so moved by the husband and wife that he wrote the beautiful *An Arundel Tomb* in 1956. There is emotion, rare for Larkin, and a famous last line: 'What will survive of us is love.' Larkin himself seems to have had doubts about the implication. At the end of the manuscript he wrote: 'Love isn't stronger than death just because statues hold hands for 600 years.' On second reading one may also see some subtle ambiguities. And one thing is wrong. In a letter to a friend Larkin wrote: '... in fact I've got the hands the wrong way round, and it should be "right-hand gauntlet", not left-hand.' But there is more. After Pevsner had described the tomb (in 1965) he got a letter from Canon Lowther Clarke. Clarke had done research and discovered that (a) there had originally been two tombs, which had been in Lewes for a few hundred years before being moved to Chichester and (b) these two were only put together, and the hands joined, in 1844 by a Victorian restorer (E. Richardson). Larkin cannot have known. The poem is overtaken by history. And so on third reading one can determine if it suffers much from the new knowledge. Surprisingly enough it doesn't. On the contrary perhaps. Certain words and phrases ('... lie ... faithfulness ... stationary voyage ... altered people ... attitude ... untruth ... stone fidelity' and the like) have acquired double meanings.

For some people, quite absurdly, the poem has become even better than the poet can have meant it to be.

An Arundel Tomb is printed opposite.

sign, when you think of it. Let's say: don't go into Henley unless you have some business there. My business was trying to get some lunch at the pub. It was closed, and there was nothing more I could do, for the public house is the only thing public. The rest is private and obviously these people want to guard their privacy jealously. Understandably. It's an idyllic place in summer. Just take my word for it.

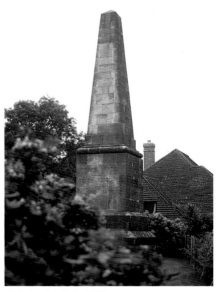
Cobden Obelisk, Midhurst

from fuzzy flowers. It is devoted to FREE TRADE, PEACE and GOODWILL AMONG NATIONS. It was erected in 1868 for Richard Cobden, who was a local boy and became a political celebrity, famous for his Anti-Corn Law League in the 1840's. Of course a town like this has known colourful inhabitants. Like Mathew Burnett, a.k.a. 'the hermit', who worked nights and slept in the daytime because of a traumatic experience with fire in his youth, which must have been awkward for his bicycle repair business. Or Frank Tatchell, the vicar, who went to Japan seven times and round the world four times and wrote a book *The Happy Traveller*, one of the best travel books ever written, as the critics said at the time. But this A272 book is not the place to go into these things much.

Two smallish second-hand bookshops is not much for a town of Midhurst's potential. It's a start, but more could be done. Bookshops would fit in perfectly. Midhurst would make an ideal second Hay-on-Wye. But maybe it is nice enough as it is. Rural, but stylish. 'This is a one-horse town,' a local saddler said to me. If that were really true he would soon be out of business.

Midhurst is twinned with two towns on the continent. Nogent-le-Rotrou in France lies at the foot of a hill dominated by the St Jean Castle of about 1300 and the 13thC Notre Dame church. Baiersbronn, in the German Black Forest, has an 11thC Minster church, but is mainly known for its wholesome air and for winter sports. The foreign twins are twinned too, in a rare triple alliance.

Oh, and don't forget to see the John Piper tapestry in the cathedral, and the special **tomb**. *In the Chichester area are such widely divergent lures as the Portfield Mechanical Music and Doll Collection, Fishbourne Roman Palace and Museum, Tangmere Military Aviation Museum and unforgettable Bosham [bozzum] with its quayside and shallow sea and its Saxon church (depicted in the Bayeux tapestry because King Harold sailed from here to Normandy). Stansted Park, which I just mentioned, is not too far away to the west, past the awesome folly called Racton Monument. The house is open, but alas is no longer the home of a unique surrealist walled garden called 'Garden in Mind', designed and cared for by Ivan Hicks, who used to work with Edward James.* ✴

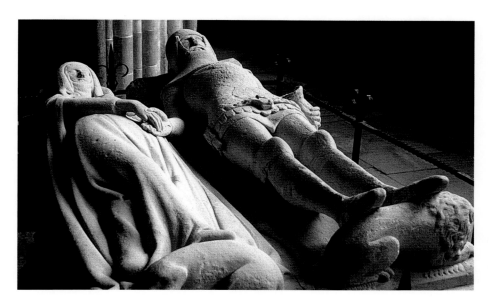

An Arundel Tomb by Philip Larkin

Side by side, their faces blurred,
The earl and countess lie in stone,
Their proper habits vaguely shown
As jointed armour, stiffened pleat,
And that faint hint of the absurd –
The little dogs under their feet.

Such plainness of the pre-baroque
Hardly involves the eye, until
It meets his left-hand gauntlet, still
Clasped empty in the other; and
One sees, with a sharp tender shock,
His hand withdrawn, holding her hand.

They would not think to lie so long.
Such faithfulness in effigy
Was just a detail friends would see:
A sculptor's sweet commissioned grace
Thrown off in helping to prolong
The Latin names around the base.

They would not guess how early in
Their supine stationary voyage
The air would change to soundless damage,
Turn the old tenantry away;

How soon succeeding eyes begin
To look, not read. Rigidly they

Persisted, linked, through lengths and
 breadths
Of time. Snow fell, undated. Light
Each summer thronged the glass.
 A bright
Litter of birdcalls strewed the same
Bone-riddled ground. And up the paths
The endless altered people came,

Washing at their identity.
Now, helpless in the hollow of
An unarmorial age, a trough
Of smoke in slow suspended skeins
Above their scrap of history,
Only an attitude remains:

Time has transfigured them into
Untruth. The stone fidelity
They hardly meant has come to be
Their final blazon, and to prove
Our almost-instinct almost true:
What will survive of us is love.

Manners maketh man

My favourite short story is Roald Dahl's 'The Landlady'. I am not going to tell you what it is about, but those who know it will recognise that I always feel slightly apprehensive when I start looking for a Bed & Breakfast place at the end of the day. It's not as if the memory of watery cabbage, rapacious landladies and a powerful smell of kippers in the living-room is my own. My experience with B&Bs is favourable on the whole. But there is almost always something wrong with them. Usually it's the shower. No two are the same. Instructions are usually incomprehensible. They are too hot, too cold or too measly - it's like waiting for dew to come down sometimes. Have you ever actually recognised a shower in England? (British plumbing in general is bad. Taps you can't get your hands under. Water comes out squirting in various directions. Cold and hot with no possibility of mixing them. Why is that?)

Other horrors in B&Bs are for example the plastic undersheets you sometimes see when the landlady has had an unfortunate experience with bed-wetters: they crackle and make you sweaty. And 'cafetières', so that much of the coffee is undrinkable, because it isn't filtered properly. Why on earth have they become trendy? A curse on cafetières! But as I said, on the whole B&Bs are good. And I say this fully realising that they are in fact second choice to me. When Rita and I started travelling round Britain in our holidays, we had a tent for several nights in a row, and sometimes we went to a hotel. On my teacher's salary we could afford two- or even three-star hotels in the early seventies. My salary has just followed the general trend of the economic situation, but hotel prices have gone up disproportionately and nowadays we can't afford hotels at all.

So we have had to resort to B&Bs. With few regrets on the whole. B&Bs are more personal than hotels. But sometimes I wish I were rich. When I see how Hilaire Belloc in *The Four Men* describes The Spread Eagle in Midhurst as 'that oldest and most revered of all the prime inns of this world' and I see that the place is still there and evidently functioning, still host to royalty perhaps, then I am sorry I don't even dare to go in. There are more places where no ploughman can afford the

Ploughman's Lunch, but this one is special. They say. Ah well. I must comfort myself with the thought that I might not be allowed in anyway, since I suffer mildly from a disease that I have come to call SAD. Sartorial Acumen Deficiency. Sad, really. My clothes are clean, decent and sometimes colourful, but never chic. I don't wear jackets or ties. I don't own a tie. To most British people this seems incomprehensible.

Once I stayed overnight in a hotel and wanted to go into the dining-room in the evening, for dinner. I was stopped at the door. *Excuse me sir, but you are not wearing a tie.* I know. *But you can't go in unless you wear a tie, sir.* Why? *House rule, sir, I'm sorry.* But I am a guest at this hotel. *I'm sorry, sir, we could lend you a tie, sir.* My wife isn't wearing a tie either. *She doesn't have to, sir, I'm sorry.* You are discriminating. *I know, sir, I'm sorry.* Do you happen to know if it's legal what you are doing? *Yes, sir, house rules, I'm sorry, sir.* And all the time I could see he wasn't sorry.

Saying something pompous like 'Suffering from Sartorial Acumen Deficiency' instead of 'underdressed' or 'casually dressed' expresses exactly the way I feel about hotels nowadays. They are beyond me because they have raised their standards beyond the budgets and manners of normal, decent people without an expense account. I fear it will be a long time before I become a regular guest again in any hotel. Or maybe I should say: they must needs abide until the female bovines have effectuated domiciliary ingress.

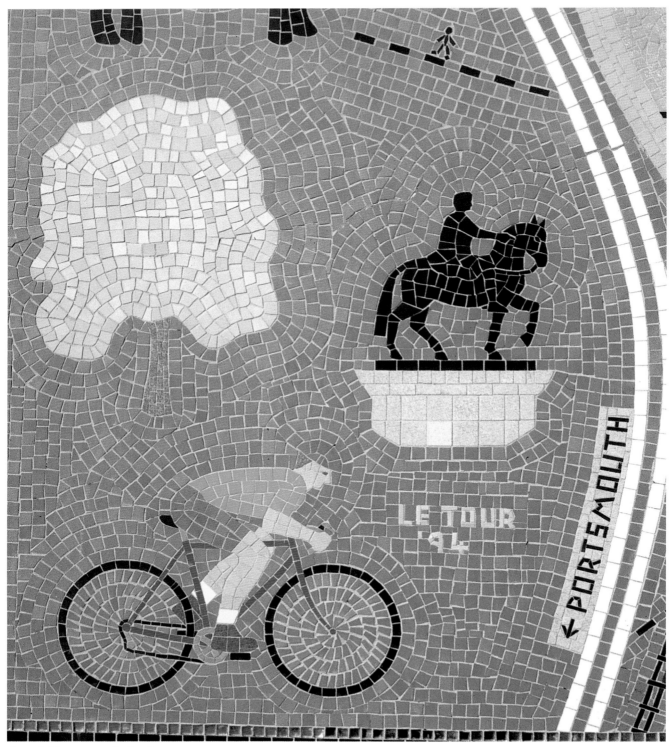

Petersfield, town mosaic, detail

Chapter

5

Midhurst to Petersfield

Woolbeding, Tulip Folly

Commons were an integral part of the system of husbandry in Saxon times, when villages held their crops and livestock in common. A common was undivided land where the livestock was grazed. It might in fact have been owned by the lord of the manor in Norman times, but villagers could all use whatever was growing there to feed animals and have any wood for fencing, burning and so on. It was mainly poorer land further from the centre than the privately owned plots, which explains why the word is now associated with unenclosed or waste land.

Charlotte Smith (1749-1806): now largely forgotten, her wildly melancholy poetry and Gothic novels were highly regarded by contemporaries including Scott, Cowper and Wordsworth. Sussex often appears in her work, and especially the Arun, 'dear to the lover's, and the mourner's heart/And ever sacred to the sons of song!' Her own life fully justified the tragic tone and need for romantic escapism: her first child died when the second was born and she was only seventeen; her husband was in debtor's prison and so on. A daughter of Sussex who deserves a modern champion.

*A*roundabout way of getting from *Easebourne to Midhurst is via Wulfbaed's People:* **Woolbeding** *[the e is long in the local pronunciation]. An idyllic route, especially for walkers or cyclists. The playwright Thomas Otway and the novelist* **Charlotte Smith** *both lived here. And the Rev. Francis Bourdillon, while we are at it: he wrote some very Victorian religious books. An inspiring place.* ☆ *Woolbeding House may look promising to mentally acquisitive people, but it is private. In the early 1990's a little new folly was built in the gardens (only visible from afar). To be called Tulip Folly perhaps, since it was built to commemorate a tulip tree, reputedly the largest in Europe, which hadn't survived the storm of 1987. Woolbeding Farm shows a simple form of decoration: little bits of flint have been pushed into the mortar*

The road westwards out of Midhurst is quiet. Again, as in the previous stage, we follow the river Rother. Some of the villages here were built along the water north of the A272 and have their **commons** south of the road: Stedham, Iping and Trotton. ★ This Rother, often called 'western Rother' to distinguish it from the eastern Rother near the beginning of the A272, comes from a number of tributaries north of our destination in this Chapter 5: Petersfield. Just before it gets to Petersfield it turns sharply east and rothers on eastwards until it joins the Arun south-east of Petworth. So we have two stages of our journey in the valley of this river and we cross it a few times, but other than that we seldom actually see it.

H. G. Wells did this bit of our road in the opposite direction, from Petersfield to Midhurst. He was on a bicycle and reported that this stretch 'goes up and down like a switchback' (a roller coaster). But he was exaggerating. And I suspect that his bike was not as good as mine.

The first few villages west of Midhurst are parishes that border on the A272, but are not really visible from the road. As almost all of the buildings are off to the right and you can hardly even see them, they are discussed in the upper section of these pages as if they really belonged to the area north of the road.

Leaving Midhurst ✳ one also says good-bye to the Cowdray estate: on the right is an old toll house in the distinctive estate colours. The heather south of Iping (on the south side of the A272) is a quite refreshing sight and if you should want to see a number of **tumuli** together you could do worse than exploring Iping and Stedham Common. In fact it is very pleasant to stretch one's legs here. There is a convenient car park at this Local Nature Reserve, one of the few areas of open heathland left in West Sussex. Near the bend in the Elsted road in between the two commons, half a mile south of the A272, a good cluster of three barrows is easily

Didling, at the Shepherds' Church

*T*he road at the foot of the South Downs *going west from Cocking (A286) leads through pleasant countryside with quiet villages and a lonely church with sheep. West of* **Bepton** *is a tower near a Cowdray Estate farm (yellow colour) whose purpose is not immediately apparent. It is a Victorian water tower, but with more decorative elements than one would expect on a purely functional building.*

between the bricks. It's the sort of thing you wouldn't notice unless someone makes you aware of it. A few houses in Midhurst have been played with in the same way – and you'll see it more often once you know about it. Going back to the A272 have a quick look at the old bridge over the Rother.✪

We continue west for some other balmy little villages at other medieval bridges,

most of them built by monks. Stedham's name means either the water meadow where stallions grazed or Stedda's settlement. The Old English name Stedda is supposed to be connected with the word steed (just as other old names like Hengist and Horsa are linked to horses) and horses are still important here. With its school, shop, church and pub it comes close to a model village. For that it would naturally also need to

identifiable. The narrow footpath there maybe shouldn't go right over the top of them because it wears them down, but it does.

At the corner of the little road north to Chithurst is The Forge Studio, the workshop of sculptor John Stickings. His ideas about sculpting are much the same as Henry Moore's and Barbara Hepworth's, but he usually works on a smaller scale. His work deserves bigger and better material, if I may say so. I became quite enamoured with one little piece in which the grain of the dark wood ingeniously accentuated the hole in the centre and the graceful curves all around. In short: you won't find the little object there any more.✳

The busiest old bridge over the Rother is at Trotton and this is one we have to cross. Be prepared to apply the brakes when you go down to the river, for this bridge is narrow and there are traffic lights. Just before you get to these lights you can see a pub high up on the left. Part of it used to be a Chinese restaurant. The combination is very similar to the pub-cum-Thai-restaurant at Stedham that was just north of the road a mile back, discussed in the north section of this chapter. It may be rare, but it works well. There used to be a smithy at this

Iping Common, tumuli

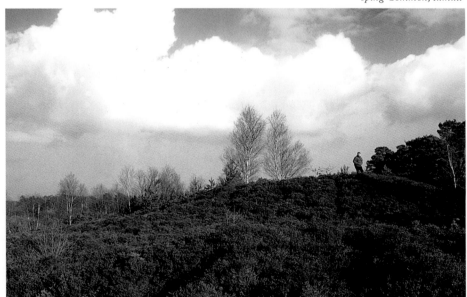

Old English names, men's names followed by an indication of their possessions, often grew into village names or even town names. In fact more place-names come from men's names than from any other source. Usually these personal names ended in -a. In Old English the suffix -ing meant 'son of', or 'descendant of'. Plural for that was -ingas, which came to mean 'people of' or 'tribe of'. In place-names this survives as -ing or -ings. In a minority of cases women's names were used. It may seem surprising that they were used at all, but in Saxon times women had a higher status than they had in the later middle ages. Particular natural features of the surrounding countryside, (hills, rivers, forests, trees, plants or even animals) are another primary source for place-names. Military structures, trade and industry, by contrast, contribute relatively few names. Fanciful names, often with a dash of humour (e.g. World's End) are unfortunately exceptional, and are later than Old English.

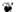

Settlement is the most frequent explanation for place-names ending in 'ham'. Homestead or village could also be correct interpretations for Old English 'ham'. So Stedham could mean the settlement of Stedda. But in some specific cases names ending in -ham can be derived from Old English 'hamm' meaning meadow or pasture enclosure, in particular a water meadow on a bend of the river. In Stedham the Rother has such a bend. So either explanation would make sense, but here the more exceptional one is to be preferred.

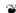

Tumuli [tiu-miu-lie] is plural of tumulus, a word often used on maps to denote an ancient burial mound, or barrow. See Barrows (p. 106).

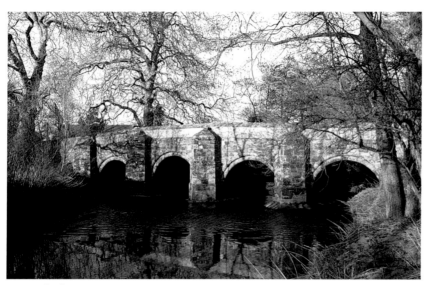

Trotton bridge

Thomas Otway (1652-1685) was born in Milland and lived at Trotton and Woolbeding before being sent to Winchester and Oxford. Like Shakespeare he moved to London and became first an actor and then a playwright. He also served in the army in Holland, but patronage eluded him and he died destitute. Still, *Venice Preserved* seems to have been the most performed play in English outside Shakespeare over the centuries. The Victorians loved to quote its beautiful expressions of friendship loyal unto death, but glossed over the sado-masochistic sub-plot.

Nonconformist chapels. What a lot of them there are! I'm sure the phenomenon is not exclusive to Sussex, but now that we are about to leave the county, or these two counties, I should say, it might be a good idea to remember places like Bolney Providence Chapel, the Quakers in Coneyhurst, the Cokelers in the Loxwood area and Zoar in ☞

have at least one colourful character in its history and it has: the 19thC Sir Charles Taylor. They say that his horses refused to draw the hearse with his coffin and the villagers had to carry him themselves. Stedham has an unusually large manor house, as seen from the river. The Hamilton Arms pub is in School Lane quite near the A272 again. It houses a Thai restaurant where you eat surrounded by specimens of

junction too. Smithy and bridge are indications of the importance of the road.

So on we go to **Trotton**. Not named for a man's estate this time, but related to the crossing of the river. Before there was this bridge – and it's a late medieval one – there used to be stepping stones to cross the water. The name Trotton is partly related to the verb 'to tread' and means the enclosure or farmstead at the stepping stones for 'treading' over the river – so almost literally Trot-town. Stepping stones, by the way, may chiefly be associated with Japanese gardens nowadays, but they came in useful hereabouts as well, until more expensive bridges could be built. Another primitive way of getting across a stream was by putting a (flattened) tree from one bank to the other where this was practical. A few miles south of Trotton we have an example: the place called tree-ford became Treyford. When the bushes haven't been cut back it is difficult to get a good view of Trotton bridge, but it is another lovely one.

Wells described Trotton as 'consisting apparently of a desolation, a broken sign-post and a decrepit stone-breaker,' but it is better of course. There are a 16th-18thC manor house, a few farms and a church. And the church, just over the bridge on the right, is well worth looking at. In fact it is no exaggeration to say that it is renowned. The murals on the west wall are clearer than most, but some details take a bit of explaining – you had better consult the leaflet. One of the brasses is the oldest one of a woman (1310). Thomas de Camoys, a hero of Agincourt who died in 1419, built both the bridge and the church. Of course his

South of **Didling** is the little church of St Andrew's, built in the Early English style in the 13thC. The font is Saxon and the wooden pews look very old too. Although there is no electric light, there does seem to be a security camera. It is called the Shepherds' Church and yes, there usually are sheep about. ✳

The next village is **Treyford** [trefford]. The original 13thC church had already

disappeared by 1849 when a new church was built with a new churchyard. It was called the Cathedral of the Downs (one of three churches with that epithet), but was demolished in 1951, leaving the village with two churchyards but no church. The ruins are flanked by private properties and can only be reached by climbing up a bank. Not worth it. They are mentioned in a book called Great British Ruins, *but can't be*

*Thai craftsmanship and there is even a minia-
ture shop; everything also in support of a Trust
Fund for Thai children. The churchyard has
two remarkable yew trees. One was split right
down the middle at some time in its history and
both halves have continued to grow strongly.
The other yew is even more impressive. It was
planted when the church was built, as was the
custom thereabouts, in 1040. It shows signs of*

*heavy surgery, but after nearly a thousand
years you would need some surgery too. The
church body itself was moved slightly to the left
in 1850, as can be seen when you look at the
tower. Things like that never cease to amaze
me. Well, they must have had their reasons.*

I*ping [I-pin] was named after Ippa's people.
A doctor's private garden has a Chinese
bridge, a very simple affair, unadorned. If you*

☞ Wisborough Green. There must
be dozens of them around, larger
and smaller communities, officially
and unofficially recognised.

Allow me to present the example
of Horsham about 100 years ago and
enumerate the churches: Church of
St Mary (Church of England),
Roman Catholic church, Unitarian
and Free Christian Baptists,
Particular Baptists in Rehoboth
chapel, Jireh Strict Baptists, General
Baptist New Connection church,
Plymouth Brethren, Independent
Congregationalists, Wesleyan
Methodists, Primitive Methodists,
Providence chapel, Quakers,
Presbyterians, Railway Mission
chapel and the Mormons' Church of
the Latter Day Saints. Plus the
Salvation Army of course. Most of
them are still extant.

This century has added the fol-
lowing: Horsham Swedenborgian
New Church, Church of the Four-
square Gospel, Christian Scientists
and the Kingdom Hall of the
Jehovah's Witnesses, while the
Fellowship Hall of the former
Primitive Methodists became the
United Apostolic Faith Church and
later the Pentecostal Church. What
is lacking are Buddhists of course
and other followers of the world's
great religions like Hindus and
Muslims. They are still to come,
probably. Or already there, only I
haven't seen them. Needless to say
they all have the true faith.

For a devout agnostic like me the
list is impressive. These noncon-
formist chapels are all gradually
dying out, is what people have been
saying for the last 100 years. And
people have mostly been right. New
uses are sought for churches and
chapels. On the other hand, new
variations of worship seem to crop
up, like house meetings. This may
sound a bit like Tupperware parties
or the vicar in the role of the Avon
lady, but the intimacy is appreciated
by a growing number of believers.

family table tomb deserves a place of honour, and it certainly gets one here. They
must have been convinced that for centuries to come no family in Trotton could
ever become more important. In everybody's way for eternity. The Camoys are in-
deed unforgettable. There is also a memorial to **Thomas Otway** whose father was
curate here. Note also the colourful hassocks – the early 1990's seem to have
inspired a burst of hassock embroidery in some churches. The shed behind the
church has nice windows; in another setting it would look follyesque. William
Cobbett felt that in order to build this 'good and commodious and capacious
church' the workers must have been terribly exploited. He wondered why they
didn't complain and remarked that the wrong sort of people always profited. Yes,
well. It shouldn't inhibit our enjoyment of things now.

G*oing north near* **Fyning** *[Fie-ning] I found Gospel Hall halfway up the hill. It
is now a private house, but from the 19thC until the 1950's it was a chapel.*
One of many **nonconformist
chapels** and one of a number
of Gospel Halls, few of which
are still active.

A*lso north of the road are
the houses of* **Terwick**
Common. Terwick church is
one mile from Trotton in the
fields south of the A272, and
it makes a pretty picture. The
strip between the church and
the road was given to the

Terwick Common church, lupinless

*called great by any standards in their present
condition. Treyford's nicest curiosity is the sign-
post to Harting, which has an extra little roof
built over St Christopher's outstretched arm,
pointing round the bend (see p. 6). It was made
of painted wood by Grailley Hewitt in 1926.* ❋
C*ontinuing westward we come to* **Elsted.**
*There are some churches with very low
wooden bell-towers in this area, but here the*

*church has no tower at all. The bell simply
hangs over the lower section of the church roof,
suspended from the higher section. The church
is surprisingly light inside. The window over the
font is probably a leper's window, through
which a leper could follow the service of Mass.
The little church is Saxon and its list of vicars
goes back to 1086. There is a large quilt in the
chancel, to commemorate 900 years of recorded*

St George was – if he ever existed – a martyr of high military rank in the early days of Christendom, and is therefore patron saint of knights, of England, of warriors and more recently of Scouts. He is usually shown in armour, either with a white banner with red cross, or slaying a dragon, symbol of evil, at his feet with a lance. According to legend he once saved a princess from a dragon.

St Michael looks very similar to St George, especially when the devil is pictured as a dragon too, but as leader of the angel force St Michael has wings.

War memorials. Most villages and towns in Sussex and Hampshire have them. They are all different, and I always find them moving, however simple or small they may be. We have them at home too, of course; the Netherlands managed to remain neutral in the Great War but were occupied by the Germans from 1940 to 1945 and suffered greatly. War memorials are often found near the church (lychgates sometimes double as war memorials, as in Clayton WS). The most striking one near the A272 area is at Alton HA, which is a beehive cairn.

Alton war memorial

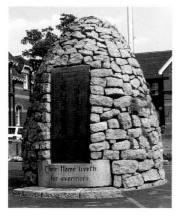

Rogate war memorial

lean over the bridge across the Rother and try to count the cutwaters, one side seems to have four and the other five. Is this the most important discovery one can make here? Almost. The church tower is entirely open on the inside. That's rare too. A modest little village, purely residential. Almost invisible. One would think that Wells's Invisible Man would feel at home here, but when 'this singular person fell out of

National Trust in the 1920's on condition that the lupins there would always be preserved. There were precious few of them left when I last inspected it, so they had better take care.✳ And before we go on I must give you examples here of how much a place-name can teach us about a place. Popular etymology has it that the name Fyning may be derived from 'vinery', meaning where wine is grown. This in itself is not impossible on this south-facing slope, but more likely it is a variation of the word 'fynnyng' for a place where wood is cut. Terwick [terik] may not be too pleased to be reminded of the origins of its name. It means turd farm (turd wick), the farm where turds are gathered. Manure could be used for fertilising, heating and building. In the middle ages all sorts of things came in handy that nowadays would be regarded as slightly distasteful. Urine for instance was collected to make saltpetre, which was used for gunpowder and for tanning. Anyway...

Half a mile to the west is **Rogate**. Rogate must have been a passage or gate into the woodland where the roe-deer were. A charming minutia from the past I can pass on is that at some time in the middle ages the rights to Rogate manor were rented out by John Bohun to Sir Thomas Parnel at the price of one rose per year. William Cobbett was very indignant about the low wages the able-bodied men of Rogate were earning in 1825. His visit to this area of Sussex made him think hard

history. A wealth of flora and fauna round the church is depicted, and the borders show the Downs through the four seasons. The kneelers are evidence of an active group of needle-working parishioners.

South of here the Downs rise up steeply, with features such as Beacon Hill and, along the South Downs Way, the Devil's Jumps, a cluster of Bronze Age barrows.

In the Rother valley is another group of villages, called Harting: East, West and South. Of the three, South Harting takes the biscuit. Better: the village positively tastes of strawberries and cream. The main street is worth a leisurely stroll up and down. Near the end, smiled down upon by the South Downs, is the church. At the gate are the combined village stocks and whipping post and beyond it is the

infinity into Iping village, with whitebound head and monstrous goggle eyes,' he got a very poor reception from the locals.

Chithurst is Citta's wooded hill. Citta also gave his name to places like Chiddingly (ES). The church is romantically situated on a height above the river. The big house there with the angry dogs and projecting first floor is the old manor house. This hillock may have

been a mound on which a pagan temple was sited. Not unlikely, for there is an Iron Age hill fort that encloses 17 acres, partly stone-clad, in Hammer Wood, half a mile away to the north of Chithurst. On the way there on the left you will pass the site of a Buddhist temple. A what? Yes, a Buddhist temple. Why not? Ever since 1956 people have tried to establish a Buddhist monastic order in Britain. In 1979 they bought

about social reforms. He must have seen good reasons here. But today it is a part of the county much like any other. Two pubs for one village seems a bit overdone, but it may serve as a reminder that there are more pubs than churches along the road. Rogate's **war memorial** not unusually shows **St George** (this time not accompanied by **St Michael**), slaying the dragon at the centre of the pillar. The memorial was done (well done) by Sir Ninian Comper and William Gough in 1920. The church itself was enlarged and the tower moved west in 1874. What that entailed can be appreciated from the timber framework inside.

Rogate may be a relatively large village for the area, but it is still a small place. So the sight of a sort of extra neighbourhood to the left along the road when you thought you had already left the village behind you is a bit surprising. But these houses are not all of them new. Some have recently been done up.✳

In the woods north of Rogate **P. G. Wodehouse** sometimes stayed at Rogate Lodge. He must have known the area well. He took no fewer than eight names from the area around Emsworth on the other side of the South Downs, most of them connected to Blandings Castle.

The Rogate Common area hereabouts offers good opportunities for forest walks. One mile north of Rogate is an official picnic site. The terrain is a bit steep here and there, but very suitable for those who want solitude. Ask Wodehouse – he used to walk his dogs there.

A quiet, smooth stretch of road follows. Half a mile short of the actual county boundary the Sussex Border Path crosses the A272 and a road on the left to the Hartings goes over the Rother at **Durford** bridge. It is a lovely quiet spot. The bridge is old, like Trotton and

war memorial in the shape of an elongated cross, created by Eric Gill. The church itself has a copper spire, unique in Sussex, that is as brightly green as it should be. The roof inside merits a good look. There is also a surprising collection of colourful modern hassocks, with subject-matters other than religious – and why not?✳ Two literary connections. Alexander Pope used to visit friends in this village and the

P. G. Wodehouse (Sir Pelham Grenville, 1881-1975). Only months before Wodehouse made his naïve and notorious wartime broadcasts from Berlin, Hilaire Belloc declared in his introduction to *Weekend Wodehouse* (1940): 'Whether the now famous P. G. Wodehouse will remain upon that level for as many generations as he deserves, depends, alas, upon what happens to England. For my part I would like to make it a test of that very thing – "What happens to England." If in, say, fifty years Jeeves and any other of that great company – but in particular Jeeves – shall have faded, then what we have so long called England will no longer be.' I fully agree. Wodehouse is a genius of a novelist. Because he is light-hearted and the world he writes about never seems to change, his literary talent is sometimes underestimated. But some of his characters are household words (Jeeves, Wooster, and, who knows, Gussie Fink-Nottle in some households) and there are 92 books of imcomparable Englishness. I have got them all at last, but I'm always on the lookout for hardbacks to replace Penguins. First editions have become collectors' items.

The P. G. Wodehouse Society (UK) was founded in 1997 and I'm pleased to say that I am a member. ✳

Chithurst stupa

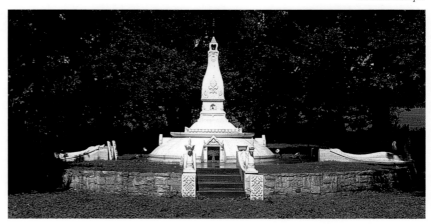

Anthony Trollope (1815-1882). Inventor of the pillar box, I'm told, writer of travel books and enduringly popular novels of life in Ireland, in the cathedral close, and in the world of politics. He 'determined to be good' in Harting, but 'of course, his old temper could still flare up. One day the gardener came running into the house to say that a man whom Trollope had employed to repair his fences had gathered up some of the fallen apples. The gardener wanted to summon the village constable. Trollope rushed from his library and found the man under a tree munching a purloined apple. "Who allowed you to take some of my apples?" Trollope roared. "I had nothing but bread and it's better with an apple," was the pert reply. Trollope rushed back into the kitchen, cut what could only be called Homeric slices of cheese and ham and hurried back, handed them to the man and commanded: "Eat and be better." "It was," the rector said, "just what he would have done as a Winchester boy fifty years ago, and a Winchester boy he was at heart to the end of his life."'

Grand Tour. 'According to the law of custom and perhaps of reason,' wrote Gibbon circumspectly, 'foreign travel completes the education of an English gentleman.' The alternative was dire, and one young man was offered £500 a year to go abroad rather than be ruined at a university.

The Grand Tour might easily take two or three years, most of which would be spent in Italy, where the nobility at an impressionable age acquired an appreciation of antiquity and classical landscapes, of the arts, of ruins and the architecture of the Ancients. They might run the risk of Catholicism and vice as well. They returned with artistic bric-à-brac of all kinds and, in many cases, developed a predilection for follies.

Chithurst House and called the place Cittaviveka. Cittaviveka – The Serene Heart – sounds like a good name for a place called Citta's hurst. These are seriously peaceful people. And only one mile away from the A272 road. What a road!

The hill fort is usually called Roman Hill Fort by the locals and is surrounded by land that has been donated to the Buddhist

community. From all sides when you get near you will find signs saying: QUIET AREA, PLEASE DO NOT ENTER. *But you needn't be too sorry, for there is very little left to see of the hill fort anyway.*

A few miles north of all these villages is **Linch** *(north of Redford), difficult to identify precisely, since the word is missing on most maps. Woodmansgreen Farm south of the*

others, and a scenic place for anglers. If you want to do some fishing yourself you have to apply for membership (temporary) of the local angling society.

About the name Durford: old English 'deor' means (wild) animal or, specifically, deer. Dur-ford is where they crossed the river. The ruins of Durford Abbey have dwindled into such insignificance that they are rightly not mentioned in guidebooks anymore.

The last place in Sussex to be mentioned is **Durleighmarsh**. The word is made up of three elements: animals, clearing and marsh. But there is hardly enough of Durleighmarsh to warrant any name.

After that we enter Hampshire. Nowadays the sign says: HAMPSHIRE – JANE AUSTEN COUNTRY, cashing in on the temporary wave of popularity caused by recent TV and film productions of Jane Austen's work. The sign used to read: HAMPSHIRE – FOR QUALITY OF LIFE (if it was there and if it was legible, which

Durleighmarsh bridge

wasn't always the case), and when I passed it I felt heartened. Or rather, so soon after being reminded of P. G. Wodehouse, I felt as if I had been served with some Buck-U-Uppo. But on we go. Proceed to the T-junction, turn left and you are in Sheet.

There is a little bit of a problem here as to where exactly the A272 is. The new

workaholic civil servant and novelist **Anthony Trollope** *spent his last years here. Though officially in retirement, he found time to write his last four novels at South Harting, starting at 5.30 every morning and standing at his desk.*

Is there nothing of interest north of the crossroads in this village? Not really. A Victorian wellhead with inscription is all. Is that a squint on the right-hand side? Of course not, it can't

be. No, nothing of interest.✳

Uppark as a name is self-explanatory. The house is high and isolated on the crest of the South Downs. In the grounds north-east of the house is the ruined Vandalian Tower, a folly built in 1774. Its creator, Matthew Fetherstonhaugh died in that same year, when his son Harry was on his **Grand Tour.** *Vandalia was the name of a projected new American*

little church looks a bit like some farms in the far south of Holland in that the buildings are grouped round a courtyard in the middle. The remarkable octagonal construction inside the quadrangle is used for drying hay. Peculiar late 16thC building style. Have a quick look if you are in the area. Once again, but not for the last time: it is worth seeing, but hardly worth going to see. ✳

London to Portsmouth A3 road bypasses Petersfield on the western side and a road between Sheet and Steep that starts at the next roundabout is supposed to cater for traffic on the A272 that wants to bypass the town, by going to the A3 in the north, turning left there and then again turning right to continue west of Petersfield. The old route went right through the town obviously. One map prematurely identified the bit between Sheet and Steep as the A272, but in 1995 Hampshire's county surveyor's office told me that this was to be called a sliproad of the A3 and that the A272 still went through Petersfield. If only these people were reliable.

Uppark, Vandalian Tower

Stuart: covers several styles over the course of the 17th century. The relatively sober Palladianism of Inigo Jones was followed after the Restoration by the English Baroque of Wren. Both of these styles were influenced by Italy, but domestic architecture often also has a touch of Dutch Palladianism, not least in the use of red brick. Uppark, for instance, looks strikingly Dutch to us, as the façade is similar to our first classical building, the Mauritshuis in The Hague, of 1633. Under William and Mary, the Dutch influence on houses and gardens was even more in vogue, as the royal couple brought Dutch designers with them.

I t is quite possible by the way for a road of one and the same name to follow two slightly different routes. In fact this is what happens to the A272 in Haywards Heath and Petworth, where in the towns a one-way system causes the two directions to part ways for a bit. In Petersfield we have the same, and this too remains relatively well-ordered. Later on in Winchester the authorities have made a right mess of things, but we'll discuss that when we get to it.

S heet means corner or nook, which could apply to the bend in the course of the headwaters of the river Rother as well as to the position of the village in a corner of Petersfield parish. In spite of the fact that Sheet is in the middle of a configuration of roads, a railway and a river, it manages to exude an atmosphere of tranquillity and even opulence. The centre of the village with the huge tree in the middle of the green, the white-washed cottages down the road, often Georgian, with their doors in different colours, the church, the vicarage, the pub and the shop

Uppark

colony and the tower was built to mark Harry's 21st birthday, which for your true folly-builder is as good a reason as any. You can get the occasional glimpse of the tower from afar. The resident Uppark family would like to consider that part of the park private, they told me.

T *he house was built by the architect Talman (some say: of Dutch origin) in the late 17thC, when William and Mary were on the*

*throne. That accounts for the **Stuart** design and the red bricks looking Dutch, which often means to English people that it has the charm of a doll's house. In 1747 the Fetherstonhaugh family bought it and after a few hundred years of colourful history (which included Emma Hamilton dancing on the tables) they still live here. H. G. Wells, whose mother was an unsuccessful housekeeper here for twelve years,*

Petersfield. One of England's oldest New Towns, created at the end of the 12thC. Only the parish church, St Peter, may be older. Why this church should have been built in the middle of nowhere, on open land (= St Peter's field), is not known for sure. But Petersfield is situated near spurs of the North Downs and the South Downs, between Portsmouth and London. And also between Winchester and the South Downs route and between Winchester and Canterbury. The traffic that there must have been makes an early settlement likely. High ground, valleys with little streams, predominantly clay, crossroads: why not a settlement? The old place-name 'The Borough' (as applied to the high ground west of the town) could mean fortification and also suggests an Old English settlement. And as to nomenclature: it wouldn't be the first time that a particular saint was chosen for the dedication of the church because his name resembled and could easily replace the existing heathen name. Maybe it was called Peohthere's field. After a lost Pict perhaps? As in Petworth?

Middlemarch was the publishing sensation of the day, but its gestation could not have been more peaceful. 'Imagine me seated near a window opening under a verandah,' wrote George Eliot, 'with flower-beds and lawn and pretty hills in sight, my feet on a warm water-bottle, and my writing on my knees... At four, when the tea comes in, I begin to read aloud. About 6 or 1/2 past we walk on to the commons and see the great sky over our head. At eight we are usually in the house again, and fill our evening with physics, chemistry, or other wisdom if our heads are at par; if not, we take to folly, in the shape of Alfred de Musset's poems.'

Between Woodmansgreen and Liphook is a tourist attraction which was set up for specialist enthusiasts, but has acquired general charm: the **Hollycombe Steam Collection***. Run by volunteers for more than 25 years now, they have gathered together all sorts of fairground attractions that are operated by steam. Like a Carousel, a Big Wheel, a Razzle Dazzle and so on, plus things like steam-rollers and of course*

Petersfield, Sheep Street & The Spain

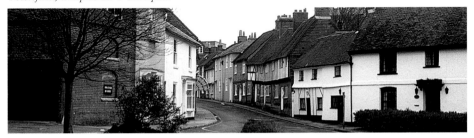

make an engaging whole. Nowadays nobody sees Sheet who doesn't specifically want to see it, and that is precisely how the villagers want it to be.

We come to **Petersfield**, whose name (see note) looks deceptively easy. Whatever its beginnings, it grew up as a market town, while the staple occupation in the region was farming. In the market square you can still see where the animals were tethered to the railings until the 1960's. Sheep were sold in Sheep Street, horses in The Spain (named for Spanish traders), also the centre for cloth and wool and dyeing. Petersfield has always been a stopping off place for travellers,

Uppark: The Urn

disguised it as 'Bladesover' in Tono-Bungay *and when he stayed there things must have quietened down considerably, since he wrote about 'the insignificant ebbing trickle of upstairs life'. It has been National Trust property since 1954. The ground floor and basement are open to the public, but the number of visitors is restricted somewhat to prevent overcrowding. All to the good, for the house is popular with visitors.*

railways, three of them. Unfortunately the place is often closed; even in summer. Ask your local Tourist Information Centre.

Liphook itself, on the edge of our 7 mile limit and just over the Surrey border, is mainly known for being a halting-place on the A3. The Square in the centre, where all the roads converge and the large hotel still attest to this function. Bohunt Manor in the south-west

Perhaps especially so in these years after the big fire of 1989, which caused very extensive damage. In fact, however much I enjoyed the house and the gardens, I must say I was most impressed by the exhibition in the Visitors' Centre about the fire and the subsequent restoration.

The servants' tunnels are a relatively rare feature, but those who have read The Time Machine *will be reminded of the*

has been given to the World Wildlife Fund. The gardens, a waterfowl sanctuary with a sizeable lake, are open to the public. The meaning of the name Liphook remains mysterious, by the way. Nothing to do with angling. ☆

George Eliot wrote **Middlemarch** *a few miles north-east, at Shottermill near Haslemere. She and her companion George Lewes came here for seclusion, but could not resist a visit from Tennyson ('one of the hill folk,' Eliot called him). For a couple living in sin it was a great honour. Tennyson read Guenevere to them aloud, and Eliot cried.*

West of Liphook on both sides of the new A3 is old **Woolmer Forest** *where thousands of acres of prime woodland have been turned into Danger Areas with rifle ranges and other military excitements. It is called*

William III

and there are some attractive houses as well as pubs and hotels. Nothing that scales the heights of architectural excellence, but Sheep Street with 16th-17thC houses and The Spain, mainly Georgian, have their own pleasing character. As do some other streets. The High Street for instance has some fine edifices, but you have to look up to the upper floors, as is quite normal in English shopping streets where the ground floors are by their nature commercial and loud and have completely lost their English character – more's the pity. The Square in the centre is dominated by the statue of a Dutchman. **King William III** on his horse was cast in lead and was at one time gilded. Just imagine this huge thing reflecting the sunlight in bright and shining gold. It was made by John Cheere in 1753, commissioned by Sir William Jolliffe who had no special connection with his namesake, but admired him as a symbol of liberty,

William III (1650-1702), Prince of the Dutch Royal House of Orange and Commander-in-chief in Holland, had married Princess Mary, daughter of James II. This Catholic king made himself impossible in England and fled to France. Politics, trade and vanity persuaded William and Mary to come over for what was termed the Glorious Revolution. In 1689 they were crowned King and Queen. James II tried to fight back later, but was defeated at the Battle of the Boyne in Ireland, which is why William III is still the hero of the Protestant 'Orange Men' there. My apologies for this Dutch contribution to Irish troubles. Mary was charming and popular, but died in 1694. William ruled on alone and did a decent job.

There are several equestrian statues of William III, based on the famous one of Marcus Aurelius in Rome. There is one in St James's Square in London for instance. The one in Hull, still gilded, has the inscription OUR GREAT DELIVERER. William in Petersfield looks very much like it, but since his removal from Jolliffe's house in St Peter's Road to The Square he has a much superior, dominant setting. It used to be gilded, but I read that the statue was tarred and feathered once during an election and that took off the gold.

Edward Gibbon (1737-1794) soldier MP and author of the *Decline and Fall of the Roman Empire*, which some say is the greatest work of history in English. He was grossly fat, a dandy who did not believe in exercise. Once as he was leaving Sheffield Park after a stay of some months, (Samuel Rogers remembered) the servants could not find his hat. "Bless me," said Gibbon, "I certainly left it in the hall on my arrival here." He had not stirred out of doors during the whole of the visit'.

Morlocks in that story: the labouring classes living and working underground, in tunnels and caves.

The gardens may or may not have been designed by Capability Brown, but what is certain is that around 1810 Humphry Repton did a great deal of remodelling both inside and outside. It was probably Repton who added the remarkable white game-larder, the dairy and

the hillock with the big urn. The so-called Gothick seat may well be a bit older.

Edward Gibbon lived at the Manor House in **Buriton** *[beriton]. St Mary's church, beautifully situated at the pond and very dark on first coming in, is relatively large because it used to serve Petersfield as well. There is a surprising number of tall houses for a small village. Buriton has dedicated a Literary Walk to*

Petersfield, The Market Inn

Teddy bears were named after President Teddy Roosevelt. While out hunting he refused to shoot a bear cub, and a newspaper cartoon of the incident was called Teddy's Bear. Around the same time, 1902-1903, bears first appeared in toy shops in both Germany and the USA. They have never looked back. The Petersfield Teddy Bear Museum started in 1984 and is the first in the world. They are not so much interested in the monetary value of bears (though they do sell them) as in their emotional value. Either that or I have completely fallen for their sales-talk. There are facilities for your teddy bear to take a picnic in the basement.

East Marden, rustic well with square wheel

Longmoor Camp now, and it goes without saying that it is not open to the public. What you can see when you drive through on the A3 is mainly a long fence. That is not there to keep people out or in, I was told, but to protect the deer. These woods used to belong to Lord Woolmer as part of his estate and were private property until the beginning of this century, when they were handed over to the Ministry of

Petersfield, R.C. church

patriotism and the Protestant succession. William III. Not bad for a Dutchman, eh?✳

Note the Victorian toilets and the painting within a painting on The Market Inn. Walking in the direction of the church you will find **Flora Twort**'s gallery opposite the west tower. This local artist made many watercolours, pastels and drawings of Petersfield and when she died in 1985 she left her works and her cottage to Hampshire. Her art is on show in changing exhibitions. The gallery is one of a fine row of cottages there at the churchyard. A nice, quiet corner of the town. And very English.

St Peter's is one of many victims of the 'revamping' movements that periodically hit churchyards. A regrettable practice, on the whole. Here the headstones (with one notable exception) have been placed side by side along the path as if they are trying to keep back the onslaught of the aggressive lawns. The church itself was called very interesting by Pevsner because of its early change in plan. Today we mainly notice the way the aisles embrace the west tower. Inside, the great chancel arches are impressive, with their zigzag decoration, typical of Norman architecture. A work by John Flaxman stands out and the pulpit with its wood carving is an excellent period piece. I picked up one of the available Hymn Books and looked up Nr 272. It ended with: AND GO REJOICING ON OUR WAY, RENEWED WITH STRENGTH DIVINE. Amen to that.

A different church altogether is the Italianate Roman Catholic church in Station Road, with its deep red bricks, its green copper cupola. It is just over one hundred years old, and a lot

W. H. Hudson, the self-taught field naturalist from Argentina.

There is another group of villages that I haven't mentioned so far because they are a bit further away to the south-east: the upland downland settlements called the Mardens, North, West, East and Up Marden [marn]. North Marden, home of a school started in 1927 by the controversial 20thC philosopher and

Defence. I know that one has to provide land for the army to practise, but I do wish it need not have been here. Didn't Lord Woolmer have some grounds in Wales or better still Scotland, where there is plenty of empty space for all these exercises in hostility?

*A few miles south of Liphook is **Milland**, pronounced stressing the second syllable: [miland]. The Working Tree is the workshop*

emptier inside than continental R.C. churches would be.

Petersfield has a number of bookshops, but the second-hand section in the one in Chapel Street is a delight, eminently bebrowsable. They used to have an 'annex' in Station Street (that's a masonic building in between). This Petersfield Bookshop was already famous before the war, and had been co-founded by Flora Twort. It was where she met **Nevil Shute**. The two became great friends, although she did reject his proposal of marriage.

Have a look at the windows of the Turnpike Gallery on your way to Petersfield's most endearing attraction: the Bear Museum in Dragon Street. All about **teddy bears**. They came into being in the early 20thy and the oldest English bear (1912) is on display here. And lots of others of course. Follow the Bear Trail. See the Teddy Bears' Picnic. Buy The Daily Teddygraph. And if something is wrong with your own bear, just bring it to the Bear Hospital.

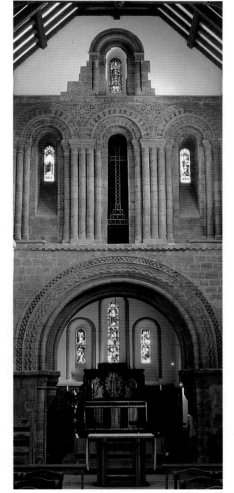

Petersfield, St Peter's church

Flora Caroline Twort (1893-1985) is a typical local artist, although she didn't come to Petersfield until she was 24 and had exhibitions at the Royal Academy in London. Her subject-matter was local. Church Path, Heath Pond and of course the Market in all its aspects, with all the different characters of the village about their daily business.

Nevil Shute Norway (1899-1960) was an aeronautical engineer who inherited his talent for novel-writing from both parents. A number of his books (*A Town called Alice*, *On the Beach*, *Pied Piper*) have become well-known and have been filmed. He is not one of the literary greats, but a highly entertaining storyteller. He wasn't the most popular writer with my secondary school pupils, but in terms of how many different titles of one author were read Shute ranked third, together with Shakespeare (and behind Graham Greene and John Steinbeck). I was surprised to learn that he isn't one of the most read novelists in England.

W. H. Hudson (1841-1922) wrote no fewer than twenty-three books (including *Green Mansions*, *Far Away and Long Ago*, and *A Shepherd's Life*) and founded the Royal Society for the Protection of Birds. Brought up on the pampas of Argentina, he came to Britain after his health collapsed in his early teens. 'He possessed an absolute freedom of spirit and detachment combined with great sensitiveness and receptivity, and an almost mystical sense of natural beauty,' says the DNB. His uncompromisingly modern memorial by Jacob Epstein, in Hyde Park, caused a scandal. Now it is a quiet duckpond.

nuclear weapons activist (and our third winner of the Nobel Prize for Literature already on this road) Bertrand Russell, has one of those very rare tiny early Norman churches consisting of one single room: a nave rounded off with an apse. In East Marden the principle is the same, but the church is rectangular. The village well here, complete with all the trimmings, is in good working order, sitting on the crossroads. A

lovely sight. The plea inside the structure, DO NOT WRECK ME, *evidently helps. This is one of the rare occasions where one can see a square wheel. In Up Marden's church the painting of St Christopher can just be made out on the wall. The children's section is large enough to take a whole school class, and I suppose it often does. The biggest village of the quartet, West Marden, has no church.*

Ivy Folly. In the late 1980's the cartoonist and painter Gerald Scarfe made a television documentary about follies. One of the locations he visited was Brightling, for Mad Jack Fuller's 'erections'. As you will have read in Chapter 1, Fuller's tomb in the village churchyard is in the shape of a pyramid. A pyramid? Why not a camel then, Scarfe thought. So in order to provide the pictures of this pyramid tomb with some suitable atmosphere, Scarfe decided to ride a camel on the little green plot beside the church. The vicar had no objections, a camel was hired and 'Scarfe's Follies' contains some footage of Gerald on a camel in front of this pyramid in an East Sussex village. The camel's name was Ivy.

As a personal touch Scarfe decided to build a folly of his own. It started as a round tower, but eventually it turned into the shape of a camel. Those who have seen the programme may remember Bob Geldof applying for the job of hermit, to live inside the circular body of Ivy. It was all good fun and today the sight of a camel at the edge of a field near a house in Milland is truly exhilarating. A pure and genuine folly.

Physic Garden. Close to the botanic garden, but specialising in medicinal herbs. Kew Physic Garden was the original name (1760) of what later became the Royal Botanic Garden at Kew. One of the oldest is Chelsea Physic Garden (1673), which still exists. Physic gardens were often created especially for students of botany and medicine in the 17thC, and usually consisted of long and narrow beds, laid out in geometric patterns, so that students could examine the plants from up close. Quite logically the plants would be arranged according to their purpose, not only medicinal, but also culinary or for dyeing.

and showroom of woodturner Donald Dennis. ✳ *Some of the items in the shop could easily be considered art. Milland Place was famous for its foreign royal guests in the 19thC, but burned down in 1901 and is now rebuilt as a hotel. Local people say they used to play in tunnels dug right through the hills here by monks, but the tunnel entrances seem to have been lost. Even the entrance to the hotel itself is difficult.*

Ivy Folly, Milland

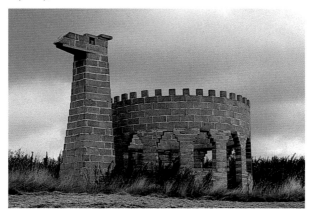

It looks forbidding. Equally hard to find without trespassing is another of Milland's surprises. At the edge of a field in the grounds of a private house not far from the village is one of England's most recent and most inspiring follies: Ivy Folly, in the shape of a camel. It can be seen from the bank just outside the gate to this house (Burrows), exactly two thirds of a mile east of Milland crossroads, as the camel trots. ✳

Petersfield is a local centre and so has plenty of shops. Folly Market on the corner of the High Street and College Street, is an arcade crammed with tiny shops selling a great variety of goods and products. ✳ It is near Folly Lane, whose name is still an enigma, local historians told me to my surprise. In the same area (High Street) is the **Physic Garden**, an old walled burgage plot laid out in imitation of a 17thC garden. Entrance is free but perhaps you need to be a bit of an expert really to enjoy this one. It is used as a study collection of medicinal herbs of the period.

One of the best things to happen to Petersfield was that 18thC farmers got fed up with their cattle drowning in the marsh and they separated land from water, creating a large pond in the area called The Heath south-east of the town centre. It made things easier for the cows. A lovely lake: 22 acres of water, surrounded by 69 acres of other natural beauty. There is a group of 21 Bronze Age barrows (*c.* 1500 BC) and tools up to 7000 years old (used by hunter-gatherers) have been found. The town is very fortunate to have all this so close to its centre.

The **Queen Elizabeth Country Park** *is best reached from the A3, where you can park at the elaborate Visitors' Centre, but there is also an entrance at the Buriton end. The park is a workplace for farmers and foresters in some places, and the 1400 acres offer a broad range of activities and events for all the family. Special events are organised for all seasons: spinning, riding, cycling, plant- and bird-watching,* *mountain-bikes and hang-glides, music and dancing, parties and barbecuing, lectures and walks, even in the dark. They have got it all here. And it must be said: the landscape is dramatic and the woods are beautiful. In autumn sunshine you feel you are quite near Tolkien's Lothlorien.*

Another country park, a few miles to the south, is **Staunton***, set in ancient*

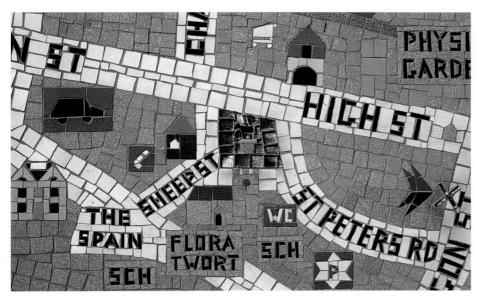

Petersfield, town mosaic, detail

The Heath is excellent for romantic evening walks or mucking about with boats on the lake. Also good for outdoor sports, tennis and cricket of course, close to the Leisure Centre.

Petersfield is ready to enjoy a new phase in its history since the opening of the bypass for both the A3 and the A272. This happened in 1994. To celebrate the occasion a playful map of the town was commissioned from Rosalind Wates and set into a wall in Dragon Street. Another major event for the town in that year was the visit of the circus called Tour de France. Yes, here too. Can you imagine the caravan of close to 200 cyclists and a few hundred cars thundering through

Chalton, Red Lion pub

parkland, with an ornamental farm and gardens. They also have some nice follies, but I won't go into that, since they are just outside our seven miles' reach. The Staunton Way, a Long Distance (twelve miles) footpath between Queen Elizabeth Country Park and Langstone Harbour passes by here.

In between these two country parks is the tiny village of **Chalton**, whose Red Lion pub is one of the oldest and most Dickensian in the three counties that we travel through. You get an excellent view of it from the church opposite, which is otherwise not really remarkable. ※

If you went back to Petersfield from here, you would pass a genuinely spurious Dickensian inn, the setting for a crucial scene in Nicholas Nickleby. **Dickens** knew the South Downs well. He was born nearby, in Portsmouth.

Charles Dickens (1812-70). Novelist, journalist, actor-manager, philanthropist. 'One of the greatest of creative writers: popular and fecund but yet profound, serious and wonderfully resourceful,' said the great critic F. R. Leavis in 1970. He was right. When Nicholas and Smike reach the pub near Petersfield (now a cottage opposite the current pub), they are exhausted after their long journey. Another writer might have said, 'they broke their journey at an inn'. Not Dickens:

'Thus, twilight had already closed in, when they turned off the path to the door of a road-side inn, yet twelve miles short of Portsmouth.

"Twelve miles," said Nicholas, leaning with both hands on his stick, and looking doubtfully at Smike.

"Twelve long miles," repeated the landlord.

"Is it a good road?" inquired Nicholas.

"Very bad," said the landlord. As of course, being a landlord, he would say.

"I want to get on," observed Nicholas, hesitating. "I scarcely know what to do."

"Don't let me influence you," rejoined the landlord. "I wouldn't go on if it was me."

"Wouldn't you?" asked Nicholas, with the same uncertainty.

"Not if I knew when I was well off," said the landlord. And having said it he pulled up his apron, put his hands into his pockets, and, taking a step or two outside the door, looked down the dark road with an assumption of great indifference.'

All too often 'Dickensian' is synonymous with exaggerated, caricatural, melodramatic writing: entertaining, yes, but trivial. 'The adult mind doesn't as a rule find in Dickens a challenge to an unusual and sustained seriousness,' wrote one critic in 1948 who should already have known better. Step forward, F. R. Leavis.

135

Woods in this area are far on the western edge of the Weald. Most of the Weald was used for fuel in the past, for the iron, brick and glass industries, as we have seen. But of course the trees have always been used for other purposes as well. In principle this is still going on, the difference being that today they are intentionally planted and grown.

Most of the trees that are grown here purely for timber are sweet chestnuts or Spanish chestnuts, and they are mainly for fencing. But there are other uses too. When they are two to three years old they are good for walking sticks (one end is bent by steaming). They can be split and used for hoops. Leave them for twelve to fourteen years and they grow into big poles. Cutting takes place from November until the end of March, since in that period they are dry inside and will give forty or fifty years' service. If you leave the cutting until after March the sap inside will begin a rotting process. You can see a lot of old tree trunks with new sprouts around here.

Petersfield Heath pond

Some of the woods here, south and south-east of Milland, are grown for industrial purposes and in winter the silence is occasionally disturbed by jarring sounds of machinery cutting wood. It's the sticks in more ways than one. But a nice and lonely place otherwise.

Liss consists of two villages. West Liss is the nicer and older part, East Liss largely being the result of the coming of the railway in 1859

Butser Hill Farm

(but it does have a little sculpture by Eric Gill above the porch door of the church). One mile to the east is Rake on the former A3, now the London Road B2070, where The Flying Bull pub has a bar which is half in West Sussex and half in Hampshire. It must be ideal for the ceremony of the Beating of the Bounds if it were to be held: to have a pub en route that you cannot but go right through.

Swan Street, the High Street, Dragon Street and on to Sussex Road? Well, that's what they did. It got a mention on the mosaic.

If eventually something good is done with the Grange Farm and abattoir area and if eventually something is done about the distressing lack of cheesecake in the lunchrooms and restaurants, Petersfield will be an almost perfect English country town. ✳

Petersfield has been twinned with Barentin in Normandy, France, since October 1992. Barentin is known for its enormous railway viaduct, the 17thC Aurore fountain, and the sculpture collection in the streets, the squares and the park. It is also twinned with Warendorf, east of Münster in Germany. This is another old market town, with colourful gabled houses and the official German Equitation Centre.

*West of Chalton is the new site of **Butser Ancient Farm**. As the name indicates it used to be on nearby Butser [but-ser] Hill, but it has crossed the road southward, so to speak. Not a very large place, and not even a very impressive place either, but exceptional in a number of respects. The claim of being absolutely unique doesn't hold anymore, but there are not many of these sites in Western Europe where* *you'll find the combination of so many studies into Iron Age husbandry, covering animals, fields, customs, buildings, plants, fences and so on. It is a sort of open air research laboratory, and has been since 1972. You can walk around, but there are also 'hands on' activities. Some ten thousand people a year visit it, half of them school children. Gosh, what a variety of things you can do along this road!*

The way you English treat your language is often amusing as well as amazing. I think primary school teachers have a lot to answer for. Let me explain. Towards the end of the 18thC usage guides began to appear, e.g. by the Winchester born and bred Bishop Robert Lowth and the American Murray. They suggested that to recklessly split an infinitive was unwise. And that refined people didn't use prepositions to end a sentence with. There were more of these (mis)conceptions, a bit silly and pedantic really. But they were subsequently taken as gospel by generations of schoolteachers and have become distressingly authoritative. Splitting infinitives

FRISKING THE HADDOCK

is considered ugly or even ungrammatical. Which is nonsense. It can be a powerful way of expression, as the latest edition of the Oxford English Dictionary recently admitted in a rare bout of grammatical renewal. And what is wrong with a preposition at the end of a sentence? Only that you have been taught that it shouldn't be there. This man Lowth wasn't even insistent about these suggestions, by the way. They should have been received with indulgent smiles and largely ignored, but their application has become virtually ineradicable.

The problem is that the language is not really allowed to develop in England. Spelling changes in Dutch cause an uproar in the Netherlands, and questions may be raised in parliament. But we do get them now and then. In England things largely have come to a standstill.

True Victorian conservatism works in more ways than you may realise. Isn't it pedantic to spell 'an hotel', 'an historical' or even 'an hospitable roof'? You do pronounce the h nowadays, don't you? Have these words not become English yet? Personally I have never understood why George Bernard Shaw, who really loved the language and put forward some sensible proposals (like leaving out the apostrophe in 'won't': 'wont'), has never been taken seriously, except by some linguists. Maybe because of the joke one of his fans sent him: that 'fish' might be spelt 'ghoti' (f = 'gh' as in 'enough', i = 'o' as in 'women' and sh = 'ti' as in 'motion').

I'm not advocating phonetic spelling by the way; that is the other extreme.

You used to have a sensible, logical rule regarding the 'plural s' and the genitive 'apostrophe s'. Apostrophe s denoted possession or relation, plural s was for plurals. But nowadays I see things like 'the Crosby's' and a book title like 'Fair Do's'. You are confusing yourselves. I have no say here, but 'the Crosbys' looks fine to me. It's just a matter of getting used to it. A hyphen might often help, as in no-one or to-ing and fro-ing. And, speaking of hyphens, compound words like place-name, summer-house, lamp-post and so on (etcetera? et cetera? etc.? &c.?) are spelt in different ways so often (even in dictionaries) that the most frequently occurring mistake should perhaps be made the official spelling. This is how grammar often works in other languages. The only thing one can say about this phenomenon is that it is clear that there is a tendency to shorten and connect things. We had a summer house once, we now have a summer-house and some of us already have a summerhouse.

Admittedly, you have a problem in that British English is not the only accepted form of English. American English is another one of many kinds of English, and may be the largest. The ideal would be for linguists from various English-speaking communities to get together and discuss what they have in common and try to arrive at some sensible agreements. Avoid the situation where dictionaries contradict each other. That sort of thing. I would be happy to represent the non-native speakers. We could try to get rid of silliness and confusion. Languages are difficult enough and full

of ambiguities anyway. Can anyone tell me what a 'wicket' is in cricket? Which wicket? Exactly.

You will probably find these remarks chaotic, irrelevant or even worse: foreign. A language can't be logical. Right. (Rite? Write? Wright?) But you could do yourselves a few favours. It can't be good for anyone that Cross in Hand can be spelt Cross-in-Hand. Going north-east from Petersfield on the A3 one sees right behind each other two signs for the same place: Griggs Green and Griggsgreen. There are countless similar examples. You will know more than I (than me, than I do). It's high time that some institution got the authority to say to everybody: 'Listen, we are not going to stand this nonsense any longer. This is what we will do.' Again I would be happy to represent the foreign interest in these matters. I only want to help. We should at least get rid of some of the illogicalities of the past. Differences in the spelling of place names (place-names, placenames) in previous centuries were excusable. Communication was rarer. The

same Sussex village was recorded as Barffham, Bergham, Bercam and Bargeham between the 16th and the 19thC. But that is no reason not to be able to choose between Bargham and Barpham in the 20thC. Any idea how it is pronounced?

So as I said, languages are difficult. A minor problem for foreigners is that as soon as they make a joke, a pun or whatever, they are immediately and circumstantially informed of the error of their ways. Creativity and jocularity are frowned on. Talking about 'ghoti', I myself like the taste of fish, but I'm nervous about bones. When my wife Rita gets the chance she very sweetly watches out for them. A friend of ours cooked some fish for us once, and Rita asked him if she could first 'frisk the haddock' for bones. She was told you couldn't 'frisk a haddock' and she couldn't have meant that. Could she? Yes she could and she did. She meant exactly that. Attagirl. As a foreigner I would like to say what I mean and to make jokes, however poorly. On behalf of my wife I reserve the right to frisk the haddock.

Farringdon churchyard

Chapter

6

Stroud to Winchester

Edward Thomas (1878-1917) published his first book at the age of 19 and garnered quite a reputation as a critic and nature writer. He only started to write poetry in 1913, with the encouragement of Robert Frost, who said 'Thomas was writing as good poetry as anybody alive, but in prose form. I told him to write it in verse form in exactly the same cadence. That's all there was to it...' Thomas was killed at the Battle of Arras in 1917, and so is remembered as one of the War Poets, though his subject is almost always the landscape of England, recalled in precise detail. 'Yes, I remember Adlestrop...'

Edward Thomas lived in Steep and the White Horse Inn, now usually referred to as 'The Pub with No Name', still honours him. His book *The South Country* is a poetic evocation but mentions no place-names. About the South Country's hospitality he says: 'For it is a good foster-mother, ample-bosomed, mild and homely.' The White Horse Inn (an isolated pub near Froxfield) features in the poem *Up in the Wind*, which begins with the startling lines:

I could wring the old thing's
neck that put it there!
A public-house!

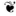

Price. You might be interested to know what people had to pay. Journey time from Petersfield to Winchester: almost two-and-a-half hours. Single fares:

inside	5s-0d
back part	3s-0d
seat behind driver	4s-3d
box seat	6s-6d

Dogs cost 1/-, no other animals allowed. Ten pounds of luggage was carried free, but parcels were charged as follows: 3lb was 3d, 3-10lb was 6d, 10-28lb was 1/-. Nothing over 28lb was carried. You always paid the same charges, even if you didn't go the full distance.

Langrish churchyard

North of Petersfield is the village of **Steep**, associated with the poet *Edward Thomas*. *The place-name is self-explanatory and the area is sometimes called Little Switzerland. Ashford Hangers is a National Nature Reserve here, mostly hanger woodland and views. A hanger is a wooded slope. If you want to experience a mountainous stretch of road follow the signs for Froxfield. The views*

This is going to be one of the longer stages of our journey, leading to a climax with the county town of Hampshire and former capital of England: Winchester. In a way this is the last stage, leading to the highlight of our journey, and what comes after in Chapter 7 is a sort of happy freewheeling to a final standstill west of Winchester. We will cover a lot of ground with relatively few and relatively small settlements on the way. Left and right of us are some jewels in the crown, but for the rest it seems as if long stretches of road are made free in order to empty the mind and prepare ourselves for Winchester.

Leaving Petersfield by going underneath the new A3 we are in **Stroud**, pronounced [strood]. Just as in the case of the Gloucestershire Stroud [strowd] the name means marshy land overgrown with brushwood. Stroud has always been related to the parish of Langrish, but belongs to Petersfield now. In 1907 a Roman villa was excavated here south-west of Finchmead Lane (the courtyard enclosed about 1.5 acres), but the site has been filled in again to protect and preserve it. A few posts mark the site, but I can safely say that it is not worth looking for. Apart from the Seven Stars Inn, which is directly on our road and has become a quality restaurant, everything in Stroud is private.

Butser Hill [but-ser] still has three walking trails of varying distances plus the South Downs Way, and is a favoured meeting place for hang-gliders, but the hill is quieter since Butser Ancient Farm moved away to the southeast. What will future archaeologists think when they excavate the remains of a 20thC prehistoric farm?★ The new location of Butser Hill Farm on the eastern side of the A3 means

that it was dealt with in Chapter 5 (p. 136). On the western side of the road here is the village of Clanfield. If you should go through it, have a look at the well, which is covered by a big square thatched roof. The church tower beside it sports two wheels in the open bell cages.

West of Butser is **East Meon** *[meeon]. The Saxon Meonware people were Jutish settlers originally, from the Rhineland. East Meon*

*could be better – there are trees in the way –
but it is good to reflect on the fact that in earlier
times coaches and all sorts of vehicles had to
climb up this same Stoner Hill on their way
from Petersfield to Winchester. That is, if they
followed the old track in the direction of
Alresford.*

*Some day, I think, there will be people enough
In Froxfield to pick all the blackberries*

*Out of the hedges of Green Lane, the straight
Broad lane where now September hides herself
In bracken and blackberry, harebell and
dwarf-gorse.*

(from The Lane*).*

There is an Edward Thomas Memorial
Stone on the Shoulder of Mutton Hill.
*Steep church (which sells picture postcards of its
kneelers) has two modern Edward Thomas*

Langrish is the next parish. It means either long rush-bed, or tall rushes. Rushes
grew in a tributary of the western Rother. There is little to be seen from the
road and you would think: ah well, just another village. And it *is* just another vil-
lage. But it does get the prize for the best book on a village along the road: *Some
Aspects of Langrish Life through the Ages*, by Evelyn Hickox. The larger picture
she gives is gripping stuff, but there is room for fascinating details too. We should
have time for one or two trivia. Intriguing from my point of view are a few remarks
on travel in the middle ages. Let me quote some lines: 'Most people walked; some
on pilgrimages walked very long distances. A Palmer always carried a piece of
palm, having visited the Holy Land. Great Palmers Copse, north-east of Cold Hill
and God's Pool, behind Ramsdean House, may indicate that pilgrims sometimes
passed this way.' Aha! Pilgrims on the alternative Pilgrims' road between
Winchester and Petersfield, as I suggested?✳ I must confess that I was pleased to
see this reference, but it is not much in the way of hard evidence, is it? A second
quotation also concerns travel: the Langrish Coach this time. A service between
Petersfield and Winchester started in 1855. 'Children 2-10 years were half **price**,
but those under two had to pay full fare – perhaps to discourage their parents!' Yes,
that would be understandable at least, in those faraway days without walkmans or
disposable nappies.

Devil's Pleasure is to come soon, on
our right, but before we get to
Langrish village green on the left, a clus-
ter of farm buildings come into view.
One of them is Manor Farm Dovecote.
Built *c.* 1500 it is the most complete of

*is an adorable village on a river, or rather baby
river: the Meon rises only a mile from here. The
regularity of its plan suggests that it was for-
mally laid out, complete with a little market
place, in the early 12thC. In the street opposite
the entrance to the church the well has been
covered up with cement. The wellhead is still
there between the almshouses and the pub. See
how beautifully the church is placed against the*

Devil in place-names in Hampshire
and Sussex is far from uncommon.
In Sussex we have a Devil's Bog, a
Devil's Brook, a Devil's Ditch, a
Devil's Dyke and a Devil's Road.
There are Devil's Humps and
Devil's Jumps. Some of these names
have legends attached to them. And
some of them are to be taken even
less seriously than others. The
Devil's Road for example is the
stretch of Stane Street that runs
through Billingshurst, and got its
name because it was felt to be excep-
tional in having been made of flint
and in running unnaturally straight.
Hampshire has examples of prehis-
toric earthworks having been called
'Giant's' until Christian times, and
then Giant was changed to Devil,
like Devil's Ditch and Devil's Dyke.
The problem with the name Devil's
Dyke near Brighton (some say it's a
hill fort, others say it's a dug hol-
low) is that the word dyke has two
meanings. One is channel or ditch
(such as the one that according to
legend the devil wanted to dig in
order to inundate England), and the
other is embankment or wall to pre-
vent inundations. This dichotomy is
clearly the devil's work.

Clanfield, well and church

Redwood trees in general are trees of a reddish colour, often tropical. By redwoods nowadays we usually mean the tall Californian timber type trees called *Sequoiadendron Giganteum* and *Sequoia Sempervirens* (the latter name suggesting that they live forever). They can indeed live for hundreds of years or even a few thousand. One of the reasons is that the combination of the wood and the loose-fitting bark is fire-resistant. In the USA there are some with arches cut out of the trunk big enough to drive your car right through. Redwoods are often described as the largest of all living things. California has a Sequoia Park, but the oldest known living redwood is in Yosemite Park: 2,700 years old. In England redwoods, often called Wellingtonia, were introduced in the early 18thC, but they are still fairly rare, unfortunately. Occasionally you see an isolated one, as at Privett church, and in Brockwood Park (p. 147) it looks as if they grow in the wild, but they are park trees. If you have never actually touched a redwood with your hands, you should. They usually feel peculiarly spongy and warm.✪

❧

Churches Preservation Trust, formerly the Redundant Churches Fund, was set up to preserve churches or even parts of churches that are no longer needed for regular worship, but are of historic or architectural interest. What happens to redundant churches? Well, in round figures, since 1970 over 700 have found some alternative use. 300 have been demolished and 300 are preserved by this trust. This latter group of churches is usually closed at all times, but the keys to most of them are relatively easy to get hold of. Check the notice boards.

memorial windows in the south wall, at eye level, done by Laurence Whistler. They consist of plain engraved glass of which both sides have been used: a subtle and dignified tribute. And a rare one.

Steep also hosts a school with an international reputation: Bedales [*beedales*]. **J. H. Badley**, *its founder, was far ahead of his time. Residential co-education was new, as was a*

the three medieval dovecotes in Hampshire. There used to be two large houses in Langrish. Langrish House, now a hotel and restaurant off the road to the south, and Bordean House, more of which anon. There is not much else. A miniature green, some nice farms and a Victorian church. The chain and anchor around a cross over one of the graves is very well done, considering that it is hewn out of stone. Here too, as so often in Sussex, the churchyard offers a lovely view.

Leaving Langrish the road wends and winds its way up through the trees. On the left is Limekiln Cottage. It is private, but on both sides of the road here, if

East Meon, the church

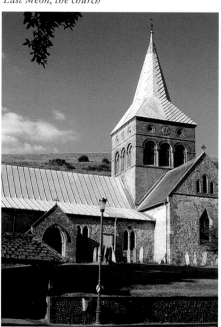

serious commitment not just to academic subjects but also to arts and crafts, rural skills and work out of doors. Being non-denominational was nothing short of revolutionary. Pupils here play musical instruments and make bread. They swim, play tennis, act, etch, tend sheep and build barns. There is a school gallery. It must be an honour to study in the distinguished timbered Library and Hall. If I had children I

East Meon, the font

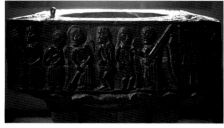

you look carefully, you can see where chalk was dug out of the hill and then burned to make lime. Careful in two respects, for the slopes are extremely steep. Which may also account for the appearance of another of those old names connected with the devil, of which England seems to have a greater portion than any other country. This time the area is called Devil's Pleasure, but God knows exactly why.

hill, beyond the lychgate. The church is Norman (though now with a lead-covered spire) and huge for the size of the village. Inside, the black marble font is very similar to Winchester's, and dates from the mid-12thC. There are six others in the country, all beautifully carved. They come from the Walloon town of Tournai (Doornik). The leaflet available in the church explains about them.

would try and get them admitted there.

*T*he pub called The Harrow Inn, near the A3 off the road to Sheet, has two snug rooms only, unconnected to each other except from behind the bar, the arrangement of so many pubs in the old days. The room on the left contains a disproportionately large fireplace and a so-called 'library'. A two-smile pub. A pub as they used to be. ❋

*H*awkley is the centre for a Literary Walk with William Cobbett as its theme. The surrounding landscape is often so enchanting that guidebooks forget to look at the village itself. The church with its Rhineland helm may not be old (1865), but it has a number of attractive features. The path through the lychgate with its seats leads past a few yew trees, one of which is so weary that it has laid itself down.

Oxenbourne, Giant Cottage

*B*ordean House, a bit further on the left, was built in 1611 for Sir Roger Langrishe, whose family can be traced back to the 13thC. Four different ghosts and their stories are, or rather were, connected with it. We don't really have time for them, but there will be one later this chapter, I promise. Today Bordean House is a **Sue Ryder** Home. Behind the gate to the 17-acre estate are two lodges. They are called East and West and they are side by side, defying the adage that never the twain shall meet.

*O*ne mile further, just before a left turn towards Bereleigh, the large cornfield is used for scrambling in summer: on a good day hundreds of vans bring spectators and motor-cyclists to the marked-out tracks. The sound is that of a swarm of gargantuan, irate gnats. A bit further on, similar marks can be seen on the hill behind the petrol station at West Meon Hut.

*B*ut first on the right we have the church of **Privett** (a botanical name), maintained by the **Churches Preservation Trust**. It has a surprisingly tall stone spire, a bit like Salisbury Cathedral, a real landmark in this deeply rural part of the Hampshire countryside. Go under the well-carved lychgate to see some fine sculpture (including David with his harp) on the outside of the north wall. Note the tall **redwood tree** on the other side of the

Privett church

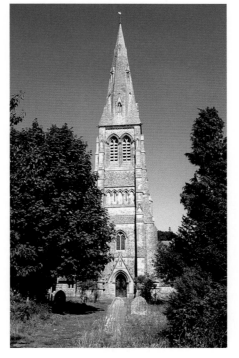

*I*f you go to East Meon via Oxenbourne, note the face in the wall of Giant Cottage. For the others there is a picture here. How simple it sometimes is to create something nice.

*W*hat you can see on the map south of the village on the South Downs Way: HMS Mercury sounds like a stranded ship, but is a Royal Navy communications school. Southwest is Old Winchester Hill, the site of a 7,000-

J. H. Badley lived to be 102. Though his work continues a tradition of holistic education that had been started in England and Germany one generation earlier, his contribution is the most long lasting.

He told his pupils that his three favourite quotations were:

O let me learn to do what is possible (Goethe).

I am come that they might have life and that they might have it more abundantly (Jesus Christ).

Labour, Art Worship, Love, these make men's lives.

(His pupils were not sure who said this first, but suspected it was Ruskin, whose speeches first inspired Badley in 1884).

Sue Ryder, Lady Ryder of Warsaw, set up the Sue Ryder Foundation in 1953 as a memorial to the millions who died in the world wars and to aid victims of illness and persecution. Today there are over 80 Sue Ryder Homes in 15 countries, 24 in Britain. Bordean House is a palliative care unit, which means that the nursing is concentrated on general help and relief rather than cure. Close to 500 shops in England, all run by volunteers, sell a wide range of donated goods in order to raise funds. The shop closest to Bordean House is in Petersfield. Sue Ryder's husband was Leonard Cheshire of the Cheshire Foundation, which runs hundreds of homes for the handicapped in scores of countries.

Selborne Museum, Gilbert White

Gilbert White (1720-1793) 'Though I have now travelled the Sussex Downs upwards of thirty years, yet I still investigate that chain of majestic mountains with fresh admiration year by year,' he wrote in 1773. His vision of the beauty and intricacy of nature has never dimmed, and the *Natural History and Antiquities of Selborne* (1789) remains the third most popular book ever published.

East Meon, view from Peak Farm

Once inside you can have a look at a conspicuous side chapel and the font, some carvings on the pillars and an exceptionally colourful mural with moons, stars and all sorts of flowers. Note the round windows and the Victorian heating system. We will come across quite a few rather exceptional churches north of our road in these last two chapters, and this Neo-Norman one is a fitting introduction to them.

building. For the interior too the Victorian architect Blomfield had a good look at Salisbury before he started building in a 13th century style (in 1876). If you like that sort of thing you can go and get a key from a local farm.

Just north of Privett some maps indicate a monument in Basing Park. And indeed you can see some edifice there, octagonal and old. It is called the 'Round House', but it is not a monument. The present owner of the estate thinks it may have been a game larder. But the siting makes it more likely that it was built as a gazebo or eyecatcher.

Back on the A272. The tunnel a mile before we get to the A32 is a left-over from the time when there were considerably more railway lines than nowadays. The Meon Valley Railway was closed in 1955. Just beyond the tunnel to the left is a little road up to Peak Farm, which is owned by Trinity College in Cambridge. It was left to them by the previous owner who had no children and little regard for his wife. In all probability this is the oldest – Saxon! – working farm in England, according to the university experts. The earliest farmers knew what they were doing: good soil and good views, with Privett church in the distance, not that the earliest farmers could see this spire. The buildings are not all that old or attractive. It's just another farm to look at, but its age makes it a special one.

year-old fort of which the ramparts can be recognised. And yes, of course there are fine views and walks. And yes, of course it is also on the South Downs Way.

In the 17thC English villages began to build pest houses, usually as general places of quarantine. They came in handy at the time of the Great Plague of 1664-65. Not many of them are left. The one at East Meon's was one of the

146

*Just on our seven mile limit north of Petersfield is **Selborne**, world-famous because of the work of its curate **Gilbert White**. England's first ecologist lived most of his life in the house called The Wakes. Pick up a brochure and do the Literary Walk about him. His house is now a museum. It was acquired with money from the Oates family, which explains why there are displays on the explorer's family's exploits (this is the only Polar Museum in Britain, they claim). Everything in the house is as authentically 18thC as research and diligent application can make it. Even the food they serve is made using 200-year-old recipes. The garden is being restored according to Gilbert White's own writings. It is in an exquisite setting. Noteworthy is the two-part **ha-ha**, of stone and of elm. The museum has 20,000*

The West Meon Hut at the crossroads of the A32 is one of the best-known pubs in the area because it serves as an orientation point and has been there for donkey's years. I have tried to find out more about its history, but so far in vain. Here's one for the kids: there are differences between the building itself and its representation on the sign – spot them. ✱

A few things here in the area are of passing interest. The round building up on the hill to the left at Meon Hut is an old mill, now a dovecote. The houses on the left are called pest houses, because they stand where there were once hundreds of little pest houses, (as I was told, but it does sound an exaggeration). Lowlands Farm, which we just passed, sells a surprising range of goods and produce, like a village store. A great deal of effort goes into running it as a specialised organic farm.

If you look carefully at the trees coming up on your left after Lowlands Farm you will discover some redwood trees among them. They used to be part of **Brockwood Park**. The estate with its house, built in 1769, was acquired by **Krishnamurti** in 1969 to establish an Educational Centre. The lower floors of the water tower are used as classrooms. One of the school's main objectives is to

The A272, from Brockwood Park

Krishnamurti (1895-1986) was a spiritual leader, born in India, where he was discovered by the theosophist Mrs Besant. He was sent to be educated in England, where he grew up in the household of Edwin Lutyens. From 1929 until his death he travelled the world teaching, talking and debating, and he published over 30 books. His aim was (in his own words) to set people free psychologically, so that they might be in harmony with themselves, with nature and with others. Though he underwent profound spiritual encounters of a Buddhist kind, he did not want to promote any faith and didn't want followers as such. But he did found schools. Six in India, one in the USA and one, Brockwood Park, in the UK.

Ha-ha [haha]. The device was imported from France, early 18thC, the word being onomatopoeic: an ejaculatory warning to stop or take care (compare uh-oh). Formerly sometimes spelt haw-haw, or ah-ah, as Cobbett did. The ha-ha epitomises the typically English feeling about gardens and nature. It's a sunken fence, a ditch, usually walled on the side of the house, designed to keep the animals out of the cultivated garden without interrupting the view towards the more natural world beyond. The two areas were supposed to blend and a ha-ha is in principle inconspicuous. In Gilbert White's ha-ha at Selborne however the edges are accentuated in two places, contrary to common practice. He obviously liked the break in the view, and his garden didn't have the look of landscaped grounds anyway: he had flower beds and a quincunx of fir trees. An early photograph of the ha-ha exists, with a border of flowers. It was constructed in 1760 and the workmanship, 'exclusive of carting of stones' cost £1: 8s: 10d.

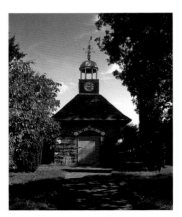

Bramdean House, apple house

Sarsen. The word comes from Saracen, the name of a Syro-Arabian nomadic tribe. Saracen was used generally for Arab or Muslim. Here it means heathen, foreign or unusual. Sarsen stones got this name because these boulders were used in seemingly outlandish prehistoric monuments like Stonehenge and Avebury. They are sandstones, relics of layers of quartz sand cemented together.

Stone circle. There has been some confusion about this monument since the turn of the century and the last properly qualified person to give an opinion was Dr Glyn Daniel. As others had done before him he called it a tetralithon (four stones), presumably because the basic form consists of three uprights covered by one larger stone. In his Walter Neurath Memorial Lecture of 1972 Daniel placed it in between genuinely old megalithic monuments and modern imitations, and called it a strange affair. He didn't want to commit himself. What can I say? The megalithic stones may be as old as Stonehenge, but the present configuration could be relatively new. For the time being it remains something of a mystery. Fine.

visitors a year and is still growing. A new study centre will soon offer extra possibilities.✸

Elsewhere in the village were the Mallinson Collection of Rural Relics and the Romany Folklore Museum and Workshop about gypsies and their caravans. Did you take a good look at the drinking fountain? What a village!

Alton, with its brewing industry and peculiar war memorial in the shape of a tall

prepare pupils for the Open University. That is, academically speaking. But what they really want is to develop free and creative personalities. Staff (about 30 in number) and students (about 60) share life, work and play as much as possible. As part of the curriculum, classes make trips abroad that generally last four to six weeks. It is certainly a special place.

On the crossroads for Woodlands and Brockwood an exceptional **sarsen** monument can just about be seen when the weeds haven't grown too tall. It is directly by the side of the A272 in the corner of the right-hand turning. It's usually described as a **stone circle** commemorating a horse. Made in the 1830's by a Colonel George Greenwood, who wrote a book called *Hints on Horsemanship* in 1839. (His favourite hunter is supposed to be buried on the opposite side of the A272, under the heap of flints there, and rumours that it had silver or golden shoes actually made people try to dig it up.) Close up you can see that there used to be five or six units, consisting of a few stones supporting a larger boulder, much in the way of megalithic chambered tombs, but smaller. Well, minilithic then. It looks like a circular cemetery for prehistoric garden gnomes. One of the most English of English monuments. It may not immediately satisfy everyone's criteria for calling it a folly, but it is a surprising structure, idiosyncratic, relatively useless, highly

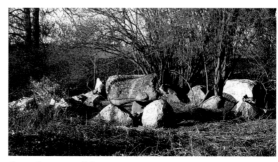

Bramdean, tetralithon

cobble beehive, is a bit too far north for us. But I should mention it at least as the starting point of the Hanger's Way, a 21 mile-long footpath from Alton to the Queen Elizabeth Country Park south of Petersfield. Slopes are steep, villages small, nature rich and people scarce. More often than not this part of Hampshire looks like a National Park, devoid of tourists. Cobbett described the views from the dangerously steep

last to be built, in 1703, and was prudently placed as far away from the village as possible: on the parish boundary at Stroud. It later served as a poorhouse and it still survives.

West Meon used to be served by the Meon Valley Railway, of which only a few overgrown remains subsist. West Meon wishes the same fate on the A32 from Alton to Farnham, but it is still here and will be for the

foreseeable future. The road is a heavy burden for this otherwise pleasant village. One of the two pubs is named after the founder of Lord's cricket ground. Thomas Lord is buried in the local churchyard. There too are the ashes of the infamous spy Guy Burgess. He was cremated in Moscow in 1963, but the urn was later put in the family plot. The church itself was rebuilt in the 1840's by the young architect George

Hawkley Hanger in glowing terms: 'Never, in all my life, was I so surprised and so delighted!'

Chawton, where Jane Austen's house attracts many admirers, the great majority women (80%, according to my 90 minutes' observation in the parking lot), is also over our northern limit, but **Upper Farringdon** fortunately is just a few miles south of there, so I can mention Massey's Folly. I doubt if I could have

found it in my heart not to anyway. For the Reverend Massey was a great eccentric and one of my favourite folly builders. Over a period of thirty years (1870-1900), and sometimes assisted by a bricklayer by the name of Gilbert, he constructed this immense red whatsit. This whatsit has never been fully explained and never will be. Thomas Massey built because he had the urge to build, and when he didn't like certain

pleasing and so on. So: why not? And it is right beside the road.

Bramdean denotes a valley (dean) where broom grows. On Bramdean Common, in the woods north-east of the village, A. C. Bishop (good name) built a church for the gypsies who lived there at the time. The date 1883 is picked out in stones in front of the gate. The most remarkable thing about the church is that it was made of corrugated iron and painted bright green and white – the blue waterbutt hurts the eye. It is still used sometimes in summer. In 1992 a graveyard was laid out and one lady lies buried there. You couldn't ask for a quieter grave.✳

Back on the A272 the Fox Inn (on the left) is older than it perhaps looks: it is about 400 years old. George IV granted it the right to display his royal arms after he had been pampered there. Among the few major houses in the village and also directly on the A272 (right) is Bramdean House. Its garden is open six days a year and by prior arrangement. The central axis of the garden has as its focal point a good eyecatcher. It may have started life as a **gazebo**, (also in view of the largish windows in the sides), but is called 'the apple house', since from time immemorial apples used to be stored there. Probably built in 1740 by Catherine Venables, it is square, brick-built, with a bright blue arched door under a decorated stone arch with two heads and a tiled pyramidal roof ending with a clock under a little cupola on columns that has a jaunty weathervane on top. Let's have a picture anyway.

Bramdean Common, Gypsy church

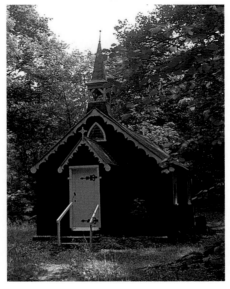

Let's also have a **ghost story**: it's among the best recorded from the 18thC. **Hinton Ampner** is where the

Gilbert Scott, who later built such great monuments of Victorian taste as the Albert Memorial in London.

Following the A32 south we come to *Warnford. The church here lies in Warnford Park and to get to it you experience the same pleasant feeling of authorised trespassing that we had in Buxted ES. It looks as if we are in the grounds of a great estate. In a way*

Ghost story: Hinton Ampner. It is (probably) all about Honoria Stewkeley, who came to Hinton Ampner after her sister Mary had married Lord Edward Stawell. Mary died in 1740 and Honoria began an affair with and was made pregnant by Edward, according to village gossip. The baby was murdered to prevent scandal. Again, according to village gossip. Edward died in 1754 and Honoria four months later. The house was rented out to a merchant family and ghostly activities began: footsteps, doors slamming, later followed by shouting, bangs, crashes and even gunshots. The tenants were terrified and moved out. A second family moved in and soon moved out again, for the same reason. The house became derelict. A few decades later the haunted place was demolished and in the process a skull was found beneath the floorboards. The new house suffered from the same phenomena to a lesser degree, but since the fire of 1960 nothing untoward seems to have occurred, except that the last Lord Sherborne fell down the stairs. Aha. Well, accidents do happen. Ralph Dutton himself, in his family history (1968), tactfully observed that 'the truth will never be known'.

How is this for Englishness?

Gazebo [guhzeebo] was originally the name for a turret or lantern on a house, commanding a prospect at which one could gaze, but is now used of an ornamental building from which one has a view, either of one's own garden or of things further away. Gazebos were built to watch a hunt for instance. Facilities for sitting down and having a drink were often provided in order to be able to enjoy a view at leisure, which brings the meaning of the word close to 'summerhouse', which is how Americans use the word.

Follies are hard to define. In fact the Folly Fellowship (of which I am proud to be a member) has so far steadfastly refused to give a definition, and one can well understand why. Few areas of expertise will have so many and varied borderline cases. But I have never been very happy with letting confusion reign the field, and, for what it is worth, I'm going to try a definition and an explanation.

Follies are idiosyncratic buildings whose primary purpose is to please. From the middle ages onwards the word has denoted relatively useless or extravagant buildings. 'Foolish', 'folly', ordinary people said. Then in the 18thC English landscape gardens began to be adorned with all sorts of buildings, sometimes even made to order from pattern books. Follies of fashion, so to speak.

Another major category are follies of passion. More personal and sometimes with improbable stories attached to them. These buildings and structures can be extravagant in style, size, ornamentation and expense. Follies can be there for silly or wrong reasons or be buildings that have found improbable second functions. They are still being built, by all sorts of people with the right kind of 'foolishness', as individual as their builders' creativity. Follies are idiosyncratic buildings that inspire pleasure. In short, follies are funny buildings. Funny peculiar and funny ha ha.

In the early 1990's even tourist officers hardly knew the word. Rita and I often had to explain what we were after. Nowadays the meaning of the word has become so diluted (and come to denote a great variety of useful and useless garden buildings), that we may soon need another word for true follies, perhaps using the key term to describe follies (idiosyncratic) to coin the word 'idio' (which is like 'curio' and pleasantly close to idiocy).

Farringdon, Massey's Folly

parts he demolished them and started afresh. *The best of **follies** are often built this way. What you can certainly say about this one is that it is huge, red and wonderful and that it jars with anything that might be part of an English rural community. Part of it is used as the village hall and the rest consists of offices for architects who, one assumes, must be very jealous.*

Wayfarers' Walk (some 70 miles between Emsworth and Inkpen Beacon near Andover) crosses the A272. As it stands now the place is much the creation of one single man: Ralph Stawell Dutton, 8th and last Lord Sherborne, who wrote books on the history of interiors in the middle of the last century and died in 1985. The estate is very old. The first part of the name means high homestead, or possibly monks' homestead. Both would be applicable. It's on a hill, and the second part of the name is a corruption of the word almoner, the functionary of St Swithun's Priory in Winchester who managed the place. The house itself literally changed face a number of times. It was abandoned, was demolished, built anew, rebuilt again and burned down, but is still there. Not a grand Stately Home. Smaller than Petworth and Uppark in all respects, but a pleasant National Trust property, with peaceful gardens, open a few days a week. Obviously someone's home, where the television is thought to be not later than early 19thC. Tasteful objects and paintings, some by minor Dutch masters. The garden is a good example of mid-20thC design, using various English styles of garden architecture. From a modest 18thC-looking 1950's temple an avenue of hedges and wonderful old trees stretches towards a little eyecatcher obelisk, marked 'monument' on the map. Tranquillity is what the owner was after, and he got it. Parts of the church in the grounds date from before the Norman Conquest. It contains many family memorials.

Warnford, George Lewis's grave

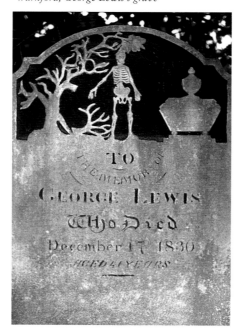

TO THE MEMORY OF
GEORGE LEWIS
Who Died
December 17 1830
AGED 41 YEARS

we are, and this one may actually have been landscaped by Capability Brown. Note the church tower and the Saxon sundial at the south porch. A good thing to learn is that gravestones can be fun too. George Lewis's near the church door tells the tale of his death: he was struck down by the falling branch of a tree. Village people say that this was revenge, taken either by the tree or by God himself,

Mary Windebank's tombstone in Upper Farringdon's churchyard tells quite a tale, but not much more than a four-poster bed can still be made out (see p. 140) – for the rest of the story read the leaflet in the church. The main features of this churchyard I would say are the **yew** *trees. The Yew Tree Campaign (what a very English institution) has given out an official certificate that the two oldest yews*

Farringdon, yew tree

Opposite the Hinton Arms pub (formerly the Jolly Farmer, but happily re-named, showing some sense of history, hip hip hooray) a small pool is often to be seen in the field. This is one of the places where the Itchen rises, the river that runs through Winchester. The official source, as indicated on the map, is west of Hinton Ampner. In the first field to the right, going south from the A272 towards Kilmeston, [kilmestun] or even [kimstun], the river Itchen comes up out of the ground. You can't actually see a well springing, but the field has an uneven surface where the waters gather slowly before crossing underneath the A272. The field is fit for sheep only, I was told (cows would be too heavy – can you picture them standing and sinking slowly into the ground?).

The crossroads between Kilmeston and Cheriton is called New Cheriton or Hinton Marsh, depending on whom you speak to. Officially it is connected to Cheriton. Anything south of the A272 used to be called Hinton Marsh and anything north used to be called Cheriton. But life is not that simple. The garage south was called New Cheriton Garage and a house north was called Hinton Marsh House. Authorities like post offices and mapmakers are not in agreement. Most of the locals feel that the name New Cheriton was forced on them and they would prefer to have their own identity between Cheriton and Kilmeston and call themselves Hinton Marsh. Some of the locals I talked to asked me to find out what it was and then come back and tell them. So pay attention, please. I am going to don the mantle of authority here. Hear ye, hear ye. After thorough investigations I have come to a conclusion. My vote goes to the people and I herewith proclaim the crossroads to be **Hinton Marsh!** ★

So we may safely say that **Cheriton** is the next village. The name could mean church farmstead, but could also be derived from early Welsh and mean

Hinton Ampner, garden temple

because he was sawing wood on a Sunday. The Neale family monument inside the church is worth a good look for the charming children depicted kneeling down and praying. Four of them died before their parents, as we see by the skulls they are carrying. ✳

Three miles west of Warnford and less than two miles south of the A272 at a crossroads below Beauworth [bo-worth] is the olde worlde

Yew trees have always been holy trees. The foliage is considered to have played an important part in pagan ceremonies. They have been called 'the Hampshire weed' but there are plenty in the church-yards of East and West Sussex too. Various reasons are given for this, and they are probably all of them right. Some say that Edward I ordered their planting for the protection of the church against wind and weather. Others say they were planted there to discourage people from grazing their animals in the churchyards: yews are poisonous. Still others say that it used to be customary to plant a yew at the same time that the church was built. That would explain why there are so many claims for 'the oldest yew': the reasoning being that if the church is that old the tree must be that old. Because of their longevity yews were naturally regarded as symbolic of everlasting life. That is also why churches were decked with yew branches at Easter and sprigs were often cast on coffins as they were lowered into the grave.

The earliest churches were built beside yew trees, not the other way round, as the greatest expert on temperate trees, Alan Mitchell, says in *Trees of Britain*. (Living or dead, he still remains the greatest expert.) The oldest yews I have found along the road are in the churchyard at Upper Farringdon: up to 3,000 years old, according to certificates. If that is true it may well be the oldest living thing on earth. About as everlasting as you can get anyway.

Sculptors often love working with yew as the wood has a lively, grainy and colourful look. It makes good bows, and the sprouts excellent arrow shafts. Yet another plausible reason for planting them. I read somewhere that soldiers on their way to the Battle of Hastings plundered the church yew in Lindfield WS for shafts.

Crop circles suddenly started to appear in the fields some decades ago, and nobody seemed to know where they came from. Big circles, key-shapes, all sorts of patterns were flattened out in the crops shortly before harvest time. Always on very conspicuous slopes. Soon they were all over the world. Foolish pranks or messages from outer space?

It got to the stage that a serious national newspaper was holding a competition to see if circles could convincingly be made overnight. In the early 1990's a couple of farm hands confessed to having made a large number of the first crop of circles with large sheets of cardboard at the dead of night. Nevertheless claims that only extra-terrestrial intervention can explain all the cases continue to abound. Extra phenomena have been discovered, including a peculiar sound audible within the area of certain circles, at exactly the same frequency, they say, as has been measured in similar circles in Australia. Believers in the extra-terrestriality of the circles – or cereologists, as they have started to call themselves – can hear these things much better than sceptics.

In early 1996 the Unexplained Phenomena Research Society was founded in Petersfield HA and the first lecture for the members (by chairperson Lucy Pringle, author of the book *Crop Circles: the Greatest Mystery of Modern Times*) was on crop circles. Meetings were held with the Wiltshire Crop Circle Group and others.

Studying crop circles seriously is a very English thing, you might think, but Americans are even more hooked. A Rockefeller has just put millions into cereological research. And I will rightly look silly if a connection is found between so-called paranormal events and unexplained phenomena like ghosts, flying saucers, crop circles, poltergeists and Margaret Thatcher.

here are 1,500 and 3,000 years old, probably the oldest in the country. Both are hollow. There is room for a couple of chairs in one of them - it looks like a natural bower. ✗

*A*nother folly is at **East Tisted**, two miles south. The village was built for the workers on the estate called Rotherfield Park. The house, adapted to Victorian taste in the 1880's, is open to the public a few days a week and the

Blueish summer fields near Cheriton

Cavaliers of King Charles I. Twenty thousand soldiers hazarded their lives on that spring day, according to the monument erected here in 1975 by public subscription. It was placed near the site of the battlefield, just over a mile north-east of Cheriton where the road from Bishop's Sutton comes down. Why William Cobbett should call Cheriton 'a little, hard, iron village, where all seems to be as old as the hills that surround it' is difficult to say. It's a good thing he later added the word 'pretty', or he would have been in trouble with the jury of the Best Kept Village in Hampshire contest. **Cheriton** has won the first prize no fewer than three times.

*B*ack on the A272. Less than two miles towards the south, past Beauworth, is the splendid Milbury's pub, mentioned under Warnford in the lower section of this chapter. About one mile from Cheriton the road is crossed by the South Downs Way, the footpath that starts at Winchester and goes south-east here and

Corhampton, sundial

folly was built as a tall sham castle and called Gardener's Tower. It is a private house now. The other, slimmer, tower is a chimney.

*W*hile we are on the subject of follies: there are some peculiar buildings some miles due west of here. Some of them came into being as a result of a competition between two bankers' families who lived in this area north-east of Winchester. Their names have kept their

'barrow': there is a very noticeable long barrow east of it. The green with the surrounding houses and the little bridges across the baby Itchen make Cheriton a pleasure to drive through. Or mooch around in. The pub is called Flowerpots.

*O*n 29 March 1644 the Roundheads gained a notable victory over the

the Milbury's Inn, dating from c. 1700. The restaurant menu provides some interesting historical information, but what most people come to see is the giant wooden treadwheel, used to hoist up buckets of water from the well. It is inside and can be viewed from two floors.

*A*nother Saxon sundial can be seen beside the south porch of the church (13thC wall-paintings) at **Corhampton**, further down

fame in British banking to this day: Drummond and Baring (page 176).

At **Northington** *The Grange was built by William Wilkins, c. 1810. It was one of the earliest neo-classical mansions, grand and Grecian, in a landscape that seems to have been designed to show it off. Not a folly. Pevsner called it a national architectural monument and that probably saved it from demolition in the*

1960's. The outside has been restored, but the inside is still gutted. I was very pleasantly surprised by articles in national newspapers in early 1998, telling me that there were plans for a production of Mozart's Le Nozze di Figaro later that year, organised as a first by the Grange Park Opera. It may be too early to judge the chances of success in the long run, but a new function for the building is always better

William Cobbett (1762-1835) farmer, radical, and journalist, Chesterton's 'stern horseman of the shires, / His face red with the light of Luddite fires'. His most famous writings are certainly the *Rural Rides*, a penetrating account of southern England in the 1820's. Edward Thomas could not get enough of the *Rides*: 'It is like watching a man, a confident, free-speaking man, with a fine head, a thick neck, and a voice and gestures peculiarly his own, standing up in a crowd, a head taller than the rest, talking democracy despotically.'

Cheriton. Now I understand: this business of the two names of New Cheriton and Hinton Marsh is all a conspiracy by some of Cheriton's competitors in the Best Kept Village contest. They want New Cheriton to be considered part of Cheriton, because that might detract from the beauty of Cheriton. Very English (?). But **Hinton Marsh** it is. I also like the name because it is reminiscent of the source of the Itchen.

Crop circle, Cheesefoot Head, Telegraph Hill

then continues east until it finishes at Beachy Head, south of where our A272 started. A gradual climb of another few miles brings us to **Cheesefoot Head** [chezfut]. The land around us is very open. The views are terrific and you feel as if you are on top of the world and master of all you survey, especially if you have climbed this on a bicycle. **Cobbett** did everything on horseback and he wasn't crazy about what you could see around here, because in his day the fertile lands were too far off for his taste, but he did mention that he had 'a view of a circle which is upon an average about seventy miles in diameter'. He thought he was on Morning Hill. But he was actually on Cheesefoot Head. (What a name! Don't think of cheese, by the way, but rather of ches / cesil, a word or element meaning gravel or sand, and the foot of the hill; remember Chesil Beach.) The notice board in the car park on top of the hill is captioned 'Cheesefoot Head and D-Day' and talks of the many military, naval and air bases in Hampshire towards the end of the war. The world boxing champion Joe Louis fought a match at the Devil's Punchbowl below this point and General Eisenhower may have addressed the troops here – if you should know for sure, please contact Hampshire County Council.

The slopes round Cheesefoot Head are famous, or infamous to some people, for the regular appearance of **crop circles** and other patterns in the fields. In fact it was here that they were first seen. In 1995 there was a fairly simple circle and I also saw the letters: TIS FOR ENGLAND very clear in the flattened corn, meaning that a Southampton football player (Matt Le Tissier) should be selected for the national team. Another field where crop circles are often found is on the south

the A32. It is of a type that divides the day into eight parts rather than 24. You were supposed to bring your own little stick or twig and put it in the hole in the centre to provide the shadow. Then you could see the time and often also when the service was going to be held – the line at the 9 am mark e.g. might be a bit thicker. The yew tree in the churchyard here is one of the biggest in the land and underneath it are

Pious Portal. It has struck me how often doorways, porches, gateways etc. are left standing or are even re-built out of piety for a building that used to be there. I call them pious portals. We have seen a number of them so far, e.g. at Possingworth Park, at Popes Oak Farm and now here at East Stratton HA. I am a collector of pious portals anywhere. That is to say I try to identify them, find out about the original buildings, make lists and collect photographs. An innocent hobby that is quite useless and leads absolutely nowhere, as far as I can see. If you know about any pious portals anywhere, please write to me at my publisher's address.

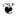

Edward Young (1683-1765) achieved European fame with his lugubrious *Night Thoughts*. Dr Johnson, comparing Young to Shakespeare, opined grumpily that Shakespeare surpassed Young as the ocean does a tea-kettle, but in a better mood he nevertheless called Young a man of genius. His best-known line has become proverbial: 'Procrastination is the thief of time'.

Northington, eyecatcher lodge

than leaving it in limbo.✳ *In the (private) grounds at the south end of the lake is a real folly: a ruined castle-like eyecatcher lodge, badly in need of restoration. The book* Follies *describes it as a 'fierce little Pekinese of a castle'. A grant for the restoration has been applied for and will probably be awarded, on condition that a public footpath be provided. That's how these things go nowadays.*

side of the A31, on White Hill near Bishop's Sutton, three miles away as the saucer flies. Patterns were very intricate there in 1995 and the farmer quite irate.

Cheesefoot Head was on the first Winchester bypass: in the late middle ages, if you wanted to avoid Winchester on your route between London and Southampton, you went from New Alresford to Cheesefoot Head and then straight on to Morestead and Twyford. Silly of course to avoid Winchester, but it takes all sorts.

Near Chilcomb Down the A272 joins the A31. In the mid 1990's some changes in the road numbers were made that begin in this area, but they mainly affect our road in the next chapter, after Winchester. What exactly happened will be explained at the beginning of Chapter 7. We want to go to Winchester first in any case, and I am assuming that a number of people will have maps with the old road numbers. We will follow the A272 as it used to be up to 1996. So aim for Winchester. ✵

Winchester is indicated to the left at the junction of A272 and A31. If you turn right instead, you come to a roundabout with a pub called 'Percy Hobbs'. He was a local farmer who went religiously to the pub every day for 63 years – when he died in 1983 the place had already borne his name for over a year. To the right is the A31, which follows the old Roman Road here, and to the left just before the pub is the B3404, also following this Roman Road straight into Winchester over the M3. The No Man's Land on the right here was just a gap between the parishes. The cemetery area on the left is called Magdalen Hill, often shortened to Morn Hill. This must be the Morning Hill that

At nearby **East Stratton** *George Dance the Younger added a portico to Stratton House in 1803. The house was knocked down in 1960 except for this colonnade, saved by order of the local council as a* **pious portal**. *A modern squarish house of glass, steel and brick was built (1965) right beside this Dance portico, which looks majestically forlorn between the new house and the old* **landscape garden** *or*

five early 19th century graves with brick 'vaults'.

Hambledon *is a very attractive, mainly Georgian, village. Lots of desirable properties. A bit too far south for us, to be honest. I mention it not because it is the birthplace of cricket as we know it, or even because it is a lovely village (it is), but because you can have Bed and Breakfast here in a folly. Hopton*

park. It's all in private grounds, but there is a public footpath nearby. The little obelisk or rather cross you can see in a field there marks the location of the previous village church. The highly visible lodge west of the M3 is Stratton Park's London Lodge.

S*outh of here is Micheldever Wood (Micheldever is on the other side of the M3). There is an archaeological trail here, a joint*

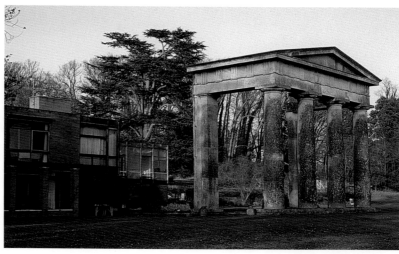

East Stratton, Dance portico

Cobbett named, when he described Cheesefoot Head. But enough. None of this is the recommended route into Winchester. So be good and then we'll start again.

Winchester is indicated to the left of the A272 and A31 junction and we duly turn left in the direction of Winchester. We have **Chilcomb** on the left here. The name means 'the valley below the steep slope' and Chilcomb was a huge manor owning some 15 square miles of land in the middle ages. Today it is a hamlet consisting of largeish houses, some farms and a simple little church (always closed), between a motorway and Danger Areas. Unnerving.

We follow the signs for Winchester round a few roundabouts. We have to make a choice here: do we or do we not take the car into Winchester? The city provides a superb service for those who don't really want to or need to. Winchester wasn't built to cope with the ten million cars that invade it every year. So now there is a Park and Ride system. You park in one of two security-patrolled car parks here between the M3 and the city, and every ten to fifteen minutes comfortable, reliable buses go into town and you can get off and later on again at something like ten different stops. Parking costs £1 a day and the

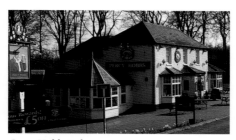

Percy Hobbs pub

Tower, three storeys, 19thC, belongs to Folly House, just off the centre.

B*ishop's* **Waltham** *[walltum] is one of the many places where a palace for the Bishop of Winchester was built. This one was begun in 1136. It grew into a sumptuous residence with a large estate, but didn't survive the Civil War: Oliver Cromwell destroyed it in 1644. The people responsible for the site are trying to*

make more of it than a romantic background for wedding pictures, but it is hard to make these ruins attractive. Bishop's Waltham is a nice enough little town however, with a museum, a vineyard, a working water mill and a well-preserved centre, especially St Peter's Street (to the church), with its Georgian houses. ✳

T*he poet* **Edward Young** *was born at his father's rectory in the next village, Upham,*

Landscape garden. In the beginning of the 18thC a new type of garden architecture began to develop in England. Sir John Vanbrugh reacted to the formal rectilinear French style and designed gardens that looked more like the English landscape. The poet Alexander Pope gave this his philosophical approval, calling upon people to 'consult the genius of the place in all'. Other sources of inspiration were the experiences of Grand Tourists and popular paintings by Claude, Poussin or Salvator Rosa. In harmony with the landscape trees were cut and planted, hills and even villages were moved, lakes were dug out and this 'natural' environment was further adorned with buildings of great variety. We find Greek temples as summerhouses and grottoes with classical statues. Ruins, hermitages and monuments, belvederes and eyecatchers. Famous for this style were William Kent, Lancelot 'Capability' Brown and later Humphry Repton. Sir William Chambers advocated outlandish elements like Chinese temples. The 'English' landscape style was also exported to the continent, together with the term English Garden.

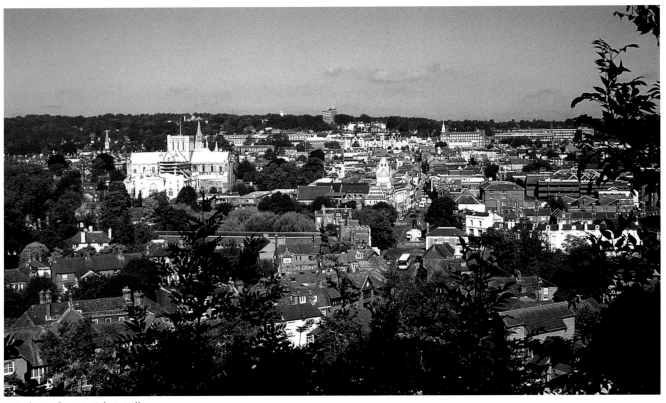

Winchester from St Giles's Hill

Thomas Hardy (1840-1928) achieved his first great success with *Tess*, subtitled at the last minute 'A Pure Woman Faithfully Presented'. Argument raged in England over how pure Tess was, partly stoked up by Hardy's decision to publish a self-bowdlerised version in instalments before the main book came out.

Mary Russell Mitford (1787-1855) is best remembered for *Our Village*, sketches of rural life, which are set in a village near Reading and make charming reading, my reference books say. She is compared to Crabbe, with a 'wealth of homely "Dutch" detail'. I would be interested to know what that means.

bus ride is free. What more could anyone want? Shopmobility perhaps. Well, if you need a wheelchair or other forms of help: you can find them in The Brooks Shopping Centre.

Before we enter Winchester and while we are still on the eastern side of the river Itchen, we could try and get an overall view of the city. There are a few hills here and Winchester lies in a river valley, so the views should be good. And they are indeed. But they are much more fun if you can recognise what you see. So in practice it is better to go and explore Winchester first. However, since we deal with everything going east to west, I must tell you about the viewpoints here.

whose name is self-explanatory. The church is built of grey flint and has a red tiled roof. Cromwell's soldiers used (or rather abused) this place of worship as a stables.

Along the road from Upham back to Corhampton is an enormous field for what are called High Health Pigs. These pinkest of pigs are either roaming free or enclosed in their own private little homes, of which there

are countless rows – trapezoid or barrel-like, with large sunshades stretched over the spaces in between them here and there. Visitors by appointment only. A most curious and slightly frightening sight to a city slicker. They must be the healthiest of Hampshire hogs and they are looking for all the world as if they are in training to take over the leadership in Orwell's Animal Farm. Or our own society, possibly. ✱

venture between the Forestry Commission and the County Council. A gentle walk, with explanatory panels, along barrows, banks and forest glades.

We turn south towards Alresford [allsfud], where Charles Kingsley finished The Water Babies. New Alresford dates from about 1200 and doesn't look any older or younger than Old Alresford.

*The centre of **New Alresford** gives the impression of being spacious. There are two good craft shops and one second-hand bookshop. Broad Street (where the writer **Mary Russell Mitford** was born) deserves its name and is considered one of the most attractive streets in Hampshire. Note the row of nicely coloured houses before the town ends abruptly in the east. Alresford is a prosperous place, as*

St Catherine's Hill, mizmaze

First, St Catherine's Hill, a nature reserve in the south-east of the city. One year in the early 18th century a Winchester schoolboy was kept behind at the end of term by way of punishment for his misconduct. In order to have something to do in the daytime he cut out a maze, a turf maze about 100 x 100 feet, on St Catherine's Hill. This maze is still there on top of the hill beside the pleasant clump of trees. Employing a local term for a maze cut out in the turf, as opposed to hedge mazes or others, people mostly call it **mizmaze**. A good footpath with steps climbs up to it from the direction of the city. The Itchen valley can be seen and the cathedral of course. The open space among the trees could do with a bench or two. It is a beautiful spot on a hot summer's day, only visited by a pigeon or two and sometimes a couple of love birds. You cannot get away entirely from the noise of traffic in the distance, though.

A better overall view of Winchester is to be had from St Giles's Hill to the east of the city. The look-out point there is much closer to the centre and everything is recognisable. A plaque explains a great deal and also shows an engraving by 18thC artist Nathaniel Buck, which makes an interesting comparison. The square building on the horizon is the main Police Station. Left of that is the prison. In **Thomas Hardy**'s novel *Tess of the d'Urbervilles* (1891) Tess is hanged in the city gaol – Winchester being thinly disguised as Wintonchester.

Winchester is a peculiar name. The second part, 'chester', comes from Latin *castrum*, Old English *ceaster*, meaning fort or town, and recognisable in other placenames as well. The first part, 'win' comes from

Mizmaze. This maze had almost become effaced by the middle of the 19thC. It was then re-cut by the Warden of Winchester after an oldish plan of it. This may explain why certain experts find something wrong with the mizmaze. They say that the cutter or re-cutter of it didn't quite understand the principle of the maze, since you have to follow the ditch and not the turfed dykes here, so to speak. This is indeed at variance with normal practice. It is different from the maze we saw on the gravestone in Hadlow Down ES for instance, at the very beginning of the A272. But why not? It makes life more interesting. Who are we to say how the creator of a maze should do his job?

The pig Napoleon at Upham

Speaking of animals, it is time to move on to Marwell Zoological Park. It is run by the Marwell Preservation Trust, which is a registered charity. Which in turn means that this is more than just a zoo. Built round the historic Marwell Hall, the park gives ample space to the animals, but a lot of benign research goes on as well. It attracts more than 300,000 visitors every year, which is an awful lot, and the

Daniel Defoe (1660?-1731) had a mixed career as merchant, spy, satirist, pamphleteer, and mercantile theorist before beginning *Robinson Crusoe*, his first novel (and some would say, *the* first novel) in his sixtieth year. He had already published enough to be considered the most prolific writer in the language. The introduction to *A Tour thro the Whole Island of Great Britain*, published anonymously between 1724 and 1727, remains interesting to any writer of guidebooks.

'In travelling thro' England, a luxuriance of objects presents it self to our view: where-ever we come, and which way soever we look, we see something new, something significant, something well worth the traveller's stay, and the writer's care; nor is it any check to our design, or obstruction to its acceptance in the world, to say the like has been done already, or to panegyrick upon the labours and value of those authors who have gone before, in this work: a compleat account of Great Britain will be the work of many years, I might say ages, and may employ many hands: whoever has travell'd Great Britain before us, and whatever they have written, tho' they may have had a harvest, yet they have always, either by necessity, ignorance or negligence pass'd over so much, that others may come and glean after them by large handfuls.'

Serpent: a wind instrument invented in France in the late 16thC. The wooden tube, made of walnut, is seven feet long but sharply curves back on itself a few times. It usually had six finger-holes and keys. Most of the serpents still extant in England were made in the 19thC. This one was actually played inside this church in c.1840, it says. Dictionaries talk about serpents in the past tense and call them obsolete.

Daniel Defoe already thought in the early 18thC. Invigorating. The church looks spacious as well. The churchyard has been tidied up and the headstones have been placed side by side to form a fence on the eastern edge. Above the door is a Saxon figure of Christ in high relief. A glass cupboard in the back of the church shows a collection of stones. Two of them stand out. One is from the **Ziggurat** *at Ur, 3000 years old.*

Another one is from Nebuchadnezzar's Palace at Babylon. Both stones are inscribed. How did they come to be here? Well, the archaeologist Sir Leonard Woolley found them in 1924 and gave them to the Rev. Pellatt, who in turn donated them to the church. In themselves these stones are not worth much, but the historical value is unparalleled. Both stones are in a way related to the Tower of Babel. People toy with

'venta', a word probably meaning '(chief) place of ..' and derived directly from the grandmother of European languages: Indo-European. The Romans called Winchester Venta Belgarum (Place of the Belgians), since immigrant **Belgae** tribes were established here. After the Romans had gone the old 'venta' element was linked with the Roman 'ceaster' element and 'venta-ceaster' became Winchester.✳

Winchester is the most English of cities. The history of Winchester is the history of England. There were Celtic tribes on St Catherine's Hill, followed by the Belgae and the Romans, and then came what might be called Arthurian times with British and Saxon tribes. Many books have equated Winchester with Camelot, King Arthur's residence. With the unification of England in the 9thC, Winchester became the capital. If we can put a date to the beginning of England it would be 827 when Egbert was crowned king in Winchester. The greatest monarch, King Alfred, lived here. King Canute and William the Conqueror lived here. In the 13thC most government functions were moved to London, but Winchester retained much of its importance. It was known as Royal City, the Old Capital and even as the Holy City. Charles II almost brought the government back to Winchester in the 17thC. He did bring Nell Gwynn here. The Mother of Parliaments convened for the first time here, in 1265. Sir Walter Raleigh heard his death sentence pronounced here (1603) and important trials are held here to this day, whether they are about grisly murders or about bribes in football. Winchester has always earned its place in history. And I'm just giving a few examples. William Cobbett admired the taste of the ancient kings who made this city their chief place of residence. He goes to extremes in his praise, as usual. Among the finer spots in England he believed 'there is not one so fine', though its situation, 'in one of the deepest holes that can be imagined' was indefensible.

New Alresford, church cupboard

Marwell Zoological Society has a quarterly magazine.✣

Marwell Hall is also the place where, according to Hampshire Ways *by F. E. Stevens, an oak chest stood for many years that became the death trap for a girl. The poignant story goes that a bride in the spirit of mischief 'hid herself in a great oak coffer, the lid of which accidentally shut down upon her, so that*

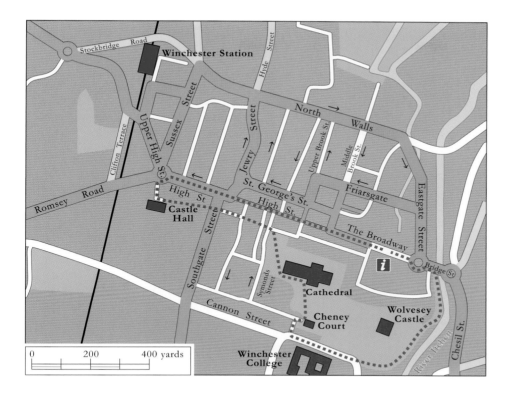

Winchester just can't be done in a few hours. I can't begin to mention the artists it has inspired or the celebrities who have visited it. What I can do and should do within the framework of this book is tell you about some of the more striking things along the route of our A272 as it was until 1996. We will follow the road first. This procedure will have the advantage that it will make you familiar with the layout of the city – designed by King Alfred, by the way. After that we will come back for the city walk. Apart from being the starting-point for a number of long-distance walks, Winchester offers you the best city walk you can take any-where. It is not exactly like Mecca for Muslims or the Grand Canyon for Americans; let alone like seeing Naples, after which you may die. But it's a city at

Ziggurat. The information provided in New Alresford church rather un-helpfully explains that a ziggurat is an artificial hill like the Tower of Babel in the Bible. 'And they had brick for stone, and slime they had for mortar. And they said, Go to, let us build us a city, and a tower whose top may reach up to heaven...' In fact a true ziggurat is a series of terraces on top of each other, each storey smaller than the one below it, with a temple on the platform on top, a building type popular in old Assyria and Babylon. The tower of Babylon was reputed to have no fewer than seven of these terraces.

Some people entertain the idea of the Tower of Babel being the oldest recorded folly in the world. This looks attractive at first sight. But it is a foolish tower rather than a folly tower, built with a deadly serious mass hubris rather than in a pleasing spirit of individuality. But the story is legendary anyway, even if the building isn't.

❦

Belgae, or Belgians, were a tribe liv-ing north of Paris and south of Holland, roughly in the area now called Belgium (see note on the Netherlands, page 183). During the Iron Age the Belgians, called the strongest of all the tribes by Julius Caesar, colonised parts of England. Their ploughs could cut through heavier turf and they had learnt to throw clay on the potter's wheel. They cleared forests and founded towns on sites at Winchester and Chichester. In the first decades AD the Belgic king Verica ruled an area that included what is now Hamp-shire, and issued coins sporting a fine boar. The name Verica sounds remarkably like the 'Old Belgian' word 'verke'. It is the same word as Old English 'fearh' from the Latin 'porcus' (pork), meaning boar or pig. Mind-boggling.

by unhappy chance, she was not discovered until long after death'. Incredibly sad, but sadly credible. Isn't it? Is it?

I *went to see a musical instrument that had never really become common: a* **serpent.** *It was in the next village. I had long mispro-nounced its name:* **Owslebury** *([owlsbery?]), before I looked it up and found [ussle-, ossle- and ozzlebery]. [Ozzle-bery] must be correct,*

since that is how Peter Hewett pronounces it, and he has an Owslebury bottom. At least, that is the title of the book he wrote about the vil-lage of his youth, Owslebury Bottom, *1991. It is 'a personal recollection of life in what was then an isolated village', with no radio, TV, public transport, newspaper or even telephone. Hewett, one of the early founders of the Open University, remembers his boyhood fondly.*

Church. On the left-hand side of the street we find one of the examples of a decent alternative use of a church after it is no longer needed for worship. It is the old 'St Peter upon Chesulle without Eastgate' ('without' meant 'outside, beyond') and from the earliest times it has taken up part of the road. Another case of being in everybody's way for eternity, but alright. In the 18thC it was still used as a place for worship of course, and the next-door neighbour made a grating in a closet in the connecting wall in order to enable his elderly mother to follow the services. A sort of squint, in other words. And nowadays the church is used as a theatre. The tower is a wardrobe store; the vestry very appropriately is a dressing room and the nave is occupied by the stage. The audience is on the choir, giving a new meaning to the word choir stalls. And why not? It may be easier to find an alternative function for a church in a town than in the country, but that is no excuse to just hand them over to the Churches Preservation Trust and not think about them creatively.

Elisabeth Frink, Horse and Rider

Winchester, King Alfred

the idea that the Tower of Babel is the oldest folly of all. One could imagine the Folly Fellowship organising pilgrimages here.

*O**ld Alresford** is worth going to for some people if they are in the area, on account of the modern sundial in the churchyard. The execution of the design is craftsmanship at its best and so is the explanation provided: even confirmed non-mathematicians like me can*

the centre of a part of the country that English people should come and see, I think, if they haven't so far. Back to the roots. And for readers of this book there is always more than for others: we have of course developed an eye for architecture. The city walk only takes you along certain streets and buildings and of necessity leaves out a number of attractions elsewhere. We will get round to some of those after we have done the walking and have rejoined our cars. And if you think you can do everything on foot, you are right.

BY CAR

Coming from the direction of St Catherine's Hill we go along Bar End Road and come to Chesil Street, which has some old houses and used to be a lot busier in the heyday of the Itchen Canal, when there were nearly a dozen pubs along Wharf Hill and Chesil Street. On old maps you can find the name as Cheese Hill, but 'chesil' is supposed to mean gravel. There are railway tracks on the right, but they are no longer used. The Winchester Dramatic Society has found a home in a **church** here.

After we have crossed the Itchen at the City Mill we are in trouble as far as the exact route of the A272 is concerned. This is because the A272 used to go up

And charmingly, I may say, from what I have read of it. In some ways the village hasn't really changed much since those days. It is on a hilltop and has a 14thC church with its own Murder in the Cathedral story. In the 1550's a local priest got into trouble with Henry Seymour, brother-in-law of Henry VIII. The priest had said Mass in Latin and was arrested. He escaped and sought sanctuary in this church.

But it did him no good: he was shot at the altar and Owslebury has been in shock ever since. Note the oak chest in the tower. Too small to contain a bride.

*W**e** are close to Winchester again now. The discovery of what constitutes an 'open gable-end bell turret' (R. Potter, Hampshire Harvest, 1977) in the Norman church of Morestead, I leave to you.*

come away from it thinking they have learned something. The unexpectedly modern temple-like mausoleum of the Schwerdt family, built in 1939, deserves congratulations as well. The churchyard has fully as rewarding a view as many in Sussex. ✳

The Mid-Hants Railway has been shortened to the Watercress Line, running from New Alresford to Alton. It is now mainly run by volunteers. A round trip takes about two hours. There is an exhibition of steam locos at the intermediate station of Ropley. Special lunch, cream tea, and dinner trains are run, and even Real Ale trains. Plus special steam and diesel events and what not. Long may they survive.

South-west of Alresford is **Tichborne** which has a church at the end of a bit of a sack road. The inside is interesting. There is a little

Hampshire Hog. The word hog may have referred to various sorts of one-year-old animals in previous centuries (some books say: 'hoggett' means pig or sheep), but there is general agreement nowadays that a hog is a pig. In 1709 a mock heroic poem appeared, called *Hoglandia, or, a Description of Hampshire* and by the end of the 18thC the term Hampshire Hog had established itself in dictionaries. Hilaire Belloc's map of Sussex has the indication *Hantunscire – hic porci* in the west (meaning: this is where the pigs live). The term is often used as a jocular appellation for a Hampshire man. Hampshire sports teams are often nicknamed Hogs. Ever since the first pictorial allusion to the Hampshire Hog, on a coin of the Belgic king Verica, minted some 2,000 years ago, the connection with hogs has remained strong. Hampshire has for centuries been famous for its pig breeding and the quality of its bacon. Today the soubriquet Hampshire Hog is accepted with some pride. The leaflet that tells you What's On in Winchester is called The Hog. It is edited from Hog Towers and part of it is Hogwash.

the Broadway and on into the High Street, but a vigorous city council has made them traffic-free. A pity for the status of the road perhaps, but they were quite right of course. Until 1996 the A272 was officially suspended at the roundabout with the King Alfred statue, and the A3092 temporarily took over. We turn right into Eastgate Street and left into Friarsgate, and this is where the A272 continued on its own again. Four days a week a small market is held in the Friarsgate area. Left at the end, round The Brooks shopping centre, into Upper Brook Street and right again into St George's Street. At the corner here is a house with a plaque. Near it special stones and bricks are cleverly built into the wall and you have to look twice to see them. It would be hard to think of a better way of displaying these little fragments from Roman, Saxon and Norman times. You can't stop your car there and have a leisurely look; you have to move on. All motorised traffic continually tries to move on here, and wistfully one remembers John Keats's description of Winchester as 'the pleasantest town I was ever in, where the good air is worth six pence a pint'. It is worth a lot more now. Halfway up St George's Street and on the left down a corridor is the nicest second-hand bookshop in Winchester, with assistants who look as if they all play chess professionally, and a bit further on is one of the entrances to the Royal Oak pub. At the end we turn left again and then right into the High Street. On the left in this stretch is a *Horse and Rider* sculpture by Elisabeth Frink, 1975. Near and mostly opposite the Westgate are the County Council offices and its information centre. The county symbol is the **Hampshire hog.** You can see it next door in a version by David Kemp, 1989). Through the gateway is another

Hampshire Hog

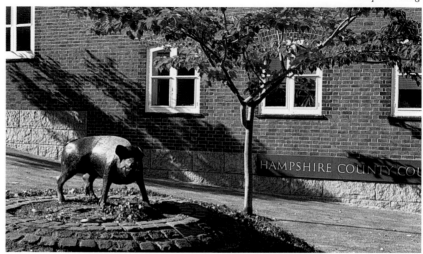

Eastleigh became as big as it is because of the railway. There is a museum about Eastleigh in the 1930's and temporary exhibitions, a leisure centre, a tourist office and a modern shopping precinct, and that about sums it up. It may be pleasant enough for lots of people to live in, but falls outside the scope of this book. So does Chandler's Ford on the other side of the M3.❧

The **Tichborne** family have attracted a fair number of **stories**. The first tells of a curse cast by a gypsy witch, who was refused food at the house. The youngest son, Richard Tichborne, then a baby, would drown on a certain day. In a bid to save him the servants took him away from the nearby river on that fateful day. However, he fell from his carriage and drowned in a cart rut. I have told you before: these curses are not to be trifled with.

The second story is about the Tichborne Claimant. We came across that when we were in Loxwood WS in chapter 3. A film about the claimant was released just as this book was published, so it's obviously still a gripping yarn.

The third story is the oldest. Lady Mabella Tichborne was on her deathbed. As a last favour from her husband she asked him to give the value of some land to the poor of the village. He didn't want to do that and cruelly told her he would give the produce of as much land as she could go round. Bravely she got up and crawled round 23 acres. This happened in the 13thC, and started the custom of distributing the produce of the land in the form of flour among the villagers on Lady Day (March 25th). This became known as the Tichborne Dole, and it is still handed out every year.

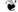

Protests. Serious objectors climbed trees and even tried to live in them to prevent them from being cut down. Because so many 'normal' people were involved in the protest (and not only 'professional' protesters) the actions were well received, generally speaking. But famous people spoke up as well. Sir Dirk Bogarde, himself involved in the protests against the improvement of the A27, later said: 'No one, and God knows they were brave, has stopped Twyford Down being raped.'

Tichborne church, monument

door (15thC?) and narrow steps behind it that lead nowhere now (there used to be a rood loft) so they look a bit silly, but the main claim to fame for the church is the Roman Catholic chapel behind the screen. Unique, or almost: only St Nicholas in Arundel has something similar. The village became C of E, but the **Tichborne** family stayed RC and have their chapel in the north aisle. Most endearing is the

hog, by Eric Gill, and if you look up you will see, far above you at the top of the spire, a third hog, this time in gold. The county council provides a leaflet on the history of the Hampshire Hog.

At the beginning of Romsey Road the Castle area houses five military museums. In Upper High Street near the West Gate an obelisk has as a base the very stone on which deals were struck 'Whilst the City lay under the Scourge Of the Destroying Pestilence' of 1666. The Society of Natives was founded in 1669 to help the victims of this plague and added lustre to its 90th birthday by erecting this obelisk. The inscription touchingly tells us that the 200th anniversary 'Was celebrated By a Public Commemoration When the Society of Aliens And all classes of the Citizens United with the Natives Society in one Grand Festival October 14th 1869'.

Next to the Record Office in Sussex Street is another piece of open air sculpture (*Mother and Child*, by Glyn William, 1990). It is easily loveable: the Hampshire Sculpture Trust should include it in a trail.

The A272 used to continue along Upper High Street. Funnily enough Clifton Terrace, also running north-south on the other side of the railway, was officially considered part of the A272 as well. As I indicated before: Hampshire County Council does seem to be able to make a hash of things. Halfway along Clifton Terrace a dry drinking fountain is trying to hold its own in between the trees. It's a very Victorian tribute from a son to his mother. You might expect him to be called Lancelot and he is. Clifton Terrace and Upper High Street meet at St Paul's Hill, which comes out at Stockbridge Road and from this point onwards things used to be straightforward again. The A272 ran unequivocally westward here. But a fine mess it was.

Mother and child, *linked by more than love.*

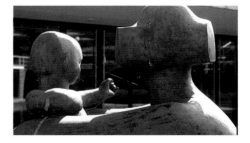

child in the red dress. Those feet, how sweet. For such a small village it is remarkable that no fewer than three **stories** about it survive.

*I*tchen Stoke *lies west of Alresford. I know I have mentioned churches a lot, and often because they are about the only buildings open to the public in all these wonderful villages. A lot of them are very characteristic of England or even Great Britain, and the history of the* village is often reflected in the church. But this one in Itchen Stoke is something else. It looks slightly pedantic, perched on its hill. But I see reasons to call it a 'little cathedral'. It was modelled on the Sainte Chapelle in Paris, the royal chapel of Louis XII of France, and shows other influences unashamedly. After the 'waiting rooms' left and right in the porch one big space opens out to the visitor towards the east

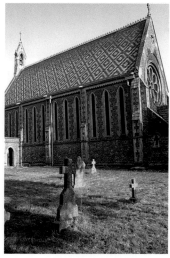

Itchen Stoke church

I said it earlier: we want to turn back into town at this juncture, so we turn right and go along the North Walls. As you might guess, they used to be the old city walls. They make the neighbourhood behind them uninpeepable from here, but I can tell you that there are mostly houses nowadays and a bowling green. That area used to belong to Hyde Abbey, where King Alfred and his family were buried. Very little is left of the abbey. Nearby is a big leisure centre and all sorts of sports grounds, where on a good summer evening one can watch two cricket games at the same time. Keeping right at Union Street takes us back to Eastgate Street and the roundabout near King Alfred.

ON FOOT

It is time for our city walk. Of course a rich history like Winchester's is reflected in its buildings. From pubs like the **Royal Oak** and the Guildhalls to the cathedral, from the college to the castle. Within the framework of this book I can't provide you with details about all the sights along the route that the city walk takes. There are indoor and outdoor works of art and there are several art galleries, all too many and too much to describe here. There are guide books to the city. They are fine. There are brochures for special purposes as well, all good for visits and leisurely strolls. There is a Family Walk about Kings, Queens and Beasts for instance. Perhaps the best thing for our city walk is a special brochure that will tell you all you want to know. It is called *A walk-around guide, Winchester, where to go and what to see* and is excellent value at only 60p. Just go to the Tourist Information Centre along the Broadway, in the 19thC Guildhall near King Alfred's statue, and ask for it.

Royal Oak pub. This is believed to have been a subterranean alehouse, built by the monks of St Swithun in *c*. 950. It claims to be the oldest bar in England. Entrance was through the archway down the stairs – you can see where it is now blocked off – and a tunnel led to the cathedral. Any citizen who was persecuted could claim it as a sanctuary. Stephen le Fox, one time mayor of Winchester, brewed ale in the property. In the 1630's the bar was renewed using old ships' beams.

The story of Charles II, who successfully escaped from Parliamentary troops by hiding in an oak tree in Boscobel Forest, is well-known. But having a Royal Oak pub-sign and not showing Charles himself is missing a great opportunity, I would say. Fortunately the Royal Oak in Petersfield's Sheep Street (*below*) was fine in that respect.

*S*outh of Winchester a number of villages lie east of the river Itchen. The M3 goes right through Twyford Down, which caused major *(Major)* **protests** in 1994 when the plans to build it there were actually carried out. The campaign had no direct success, but what started here, taken together with later protest about the Newbury Bypass, persuaded many people to rethink their stance on road-building. Much to the surprise of everyone interested, even Tory cabinet ministers with hindsight later said that the protesters had probably been right – a rare climbdown by the party that ought to be conserving the country.

*T*wyford *[twi-fud] itself has good cultural connections. The sculptors Flaxman and Nollekens are both represented in the church.*※ *Twyford school is in* Tom Brown's Schooldays,

Bell-ringing at eight was instituted by William the Conqueror as a safety measure. At eight o'clock the housewives needed to be reminded that it was dangerous to leave the fire burning brightly overnight. It was safer to cover it. So the bell was rung and the order 'cover-the-fire' was shouted out, in French: 'couvre-feu'. Couvrefeu became our word 'curfew'. So here in Winchester we have the original curfew alarm-bell, we could say.

Jane Austen (1775-1817) lived most of her life in Hampshire, notably in Chawton and in Winchester, where she died and is buried in the Cathedral.

> Ne'er did this venerable fane
> More Beauty, Sense and Worth
> contain

wrote her brother James on her death.

> In her (rare union) were combined
> A fair form and a fairer mind
> Hers, Fancy quick, and clear good
> sense
> And wit which never gave offence:
> A heart as warm as ever beat...

Winchester Cathedral

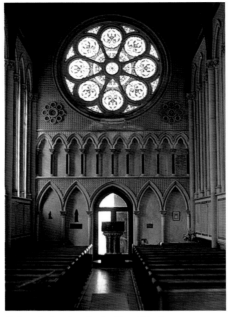

Itchen Stoke church, the Rose Window

windows. *This is so exceptional that a warning not to stumble against the font is useful. Stone flower panels line the walls and there are high arches and wooden panels against the ceiling. The floor of the rounded apse is covered with a maze in green and brown tiles. Looking back from there we have a grand view of the rose window above the slender arches and pillars. Note the metal grille on the pews, and the*

So we'll follow the 'walk-around guide'. But not necessarily in the exact order in which it deals with things. To begin with: walk up the Broadway towards the High Street. This very street is where Roman soldiers used to march. Where kings and queens rode on horseback or were driven. Where pilgrims walked. Look round. This used to be the A272. Look back. That's St Giles's Hill. The broad shopping street with historic elements, the King Alfred statue, the hills, the sky: this is Winchester. If you don't love this, you haven't read this book so far and you can't be reading this now.

The tower on the left in the Broadway and through the passage is a surviving part of a church of *c.*1400, but incorporates a much earlier doorway, zigzag Norman. Gravestones are used in the paving here. Back on the Broadway walk on to the 15thC Butter Cross and sit down on the high steps. Let the city walk by. The big clock there is where a bell is rung at eight in the evening. Every evening. And this **bell-ringing** at eight has been going on for nine hundred years! Does England change over the centuries, or is it really the same?

See the old Guildhall. And Godbegot House. Read about them in your

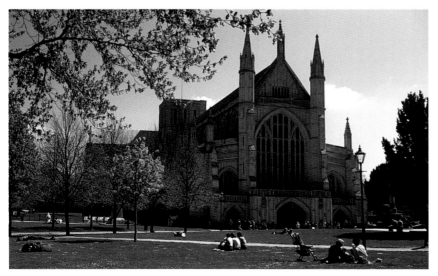

the young Alexander Pope studied and was unhappy here, and the multi-talented American Benjamin Franklin wrote part of his autobiography at Twyford House. And we have another fine yew tree: at least 650 years old, clipped.

Stoke Park Wood in Bishopstoke is part of *what used to be the Forest of Bere. It was fully as large as the New Forest (which it*

pulpit that can only be reached from outside this one big sacred room. Note also the chair with its short hind legs near the wooden altar. There are blessedly few monuments: a few plaques, one enamel, and two little old brasses for those visitors who can't do without them, but that's it. The architect, Henry Conybeare, left a touching inscription at the base of the font (1861): OH! FOR THE TOUCH OF A VANISHED

The Broadway, Victorian clock

guide. There is an entrance to a tunnel inside the pub on the other side of the alley, the Royal Oak; an interesting building, this. Visit the Westgate with its little museum and the Castle Great Hall with that huge dart board, the Round Table. Near it is an authentic 13thC garden, Queen Eleanor's Garden. Our next stop is the cathedral. On the way you might have a look at the Square, almost back at the Butter Cross, which also had a good second-hand bookshop. Gone with the wind.

We come to the longest Gothic church in Britain, 560 feet outside, 526 feet inside. Buy the guidebook and walk round. If you are in luck there will be the sound of clear singing coming down from the fan vaults. This edifice was started in 1079 and glories in a number of styles.✳ **St Swithun** was reburied here. Look for the graves of **Jane Austen** and (in the south transept) Izaak Walton – the author of the amazingly well-known *The Compleat Angler, or the Contemplative Man's Recreation*, of 1653.✳ Most endearing, I think, are the 12thC Flemish St Nicholas font and the William Walker statuette (which reminded me of similar things in eastern

The Butter Cross

almost touched), and was a favourite hunting ground for those who could afford to chase deer and boar for sport. It used to cover the area we have just been through. The Meon valley is also one of the few areas left of it.

Southampton, *with its fine city walls and museums and what have you, is too far south for us. It is, by the way, the only place in our area mentioned by J. B. Priestley in his*

St Swithun (or Swithin) (d. 862) was bishop of Winchester and tutor to King Alfred's father Ethelwulf. He was famous for his charitable works, and when Winchester became the first monastic chapter in England his body was moved to a shrine in the cathedral. This 'translation' was marked by numerous miracles, not least very heavy rain. Hence some folksy wisdom:

St. Swithun's Day, if thou dost
 rain,
For forty days it will remain;
St. Swithun's Day, if thou be fair,
The forty days will rain no mair.

St. Swithun's day is the 15th of July.

The shrine became the destination of the first great wave of pilgrimages in England, but is said to have been destroyed by Henry VIII which is not at all unlikely, if one goes by his reputation – but in that case Oliver Cromwell is also a good candidate.

Jane Austen died three days after St Swithun's day 1817, and her last known writing is a poem describing the wrath of the Saint, who rained off a race-meeting held on his day.

Shift your race as you will it shall
 never be dry
The curse upon Venta is July in
 showers.

*Winchester Cathedral
William Walker monument*

Barbara Hepworth, Crucifixion

Barbara Hepworth (1903-1975) studied together with Henry Moore and some of their abstract sculptures are very similar. Her *Crucifixion* for the Cathedral Close in Salisbury was hated so much that at one stage an incendiary bomb was planted underneath it – fortunately defused in time. Barbara Hepworth was burned to death at her studio in the artists' colony of St Ives in Cornwall – she nodded off with a cigarette still burning.

P. E. Ball, candle holder

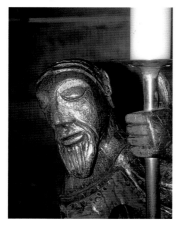

HAND, AND THE SOUND OF A VOICE THAT IS STILL, after the death of his child. Outside the church please note the patterns of the rooftiles, best seen from the churchyard on the north side. That people do not regularly follow religious services in this gem of a building is the most convincing proof of secularisation yet. In fact there are so few services that a notice board at the gate says: OUR EVENSONG THIS YEAR WILL

Europe: the size smaller than life, the heroism larger than life), but there are so many treasures.✳ Have a look at the series of panels in the Lady chapel. They were made and painted (in 1935) to protect the paintings behind them, representing the miracles of the Virgin Mary, as the old murals did. The colours look faded, but no wonder: the originals, commissioned by Prior Thomas Silkstede, date from *c.* 1500. At least one modern artist must be mentioned. Notice how easily the impressively poignant modern work of Peter Eugene Ball fits into this versatile building. The first time I saw this cathedral I went and sat on the lawn outside afterwards. I needed it and I can still recommend it. My wife Rita went back in for another hour or so. Near the entrance is Hampshire's best-known epitaph, on a grave to Grenadier Thomas Thetcher, reminding you not to drink small beer.

Enjoy the Close area south of the cathedral: it must be the loveliest square in Britain. Read about it all in your guide. You will also see the *Crucifixion*, a work by **Barbara Hepworth** (1966) that was meant as an act of faith: her son had died, her husband artist Ben Nicholson had left her and she was in the hospital with cancer when she made the first sketch for it – it's an impressive piece of work. I call it Crucifixion for short, but the title is more complicated. Officially it is *Construction (Crucifixion) 'Homage to Mondrian'.* Hepworth knew Piet Mondriaan when he lived in London. Once you know that he is connected with the sculpture it begins to make more sense. We leave The Close through the King's Gate. Over the road here is St Swithun-upon-Kingsgate. The present church is

P. E. Ball, altar

English Journey *of 1934 and in Beryl Bainbridge's repetition of the journey some fifty years later. Both praised the town in their own way. 'Not a bad town, this' and 'not a bad place to live', they said, respectively, but even English readers will admit, I think, that this is lacking in straightforward enthusiasm.*

Also too far away for us are the many attractions along Hampshire's south coast,

BE ON -such and such a date. I would love to hear a concert in this church. Are there other possibilities for alternative use? Could the Churches Preservation Trust, who have held it for more than 25 years now, be a little more creative, please? See for yourself. Search out the key, if it isn't open.

Less than a mile north of Itchen Stoke is Folly Hill. It's a farm with a windmill

15thC and replaces an earlier one. Turn left and you'll see Winchester's oldest bookshop. Go past Jane Austen's house and Winchester **College** (1382! – note the Entrance Gates sculpture to the wooden-vaulted chapel). Walk along the Bishop's Palace and Wolvesey Castle towards the river Itchen. Follow this path north to the City Bridge and City Mill (rebuilt 1744). The mill used to be a youth hostel. In the mid-1960's Rita and I had breakfast in the high-ceilinged common room you can see, and we boys were supposed to wash in the Itchen. Between the City Mill and King Alfred the almshouses of St John's Hospital (note the diapers!) provide residence and maintenance for 44 inmates, the plaque says, but more than 120 people receive housing and help in that area nowadays. St John's Hospital Society itself goes back to the early 10th century. Nip into this court and have a quick look round. A bit further in the direction of the TIC where we started is

like museums relating to the Army, the Navy and the RAF. Very liberal with their brochures, these people.

Back north a bit we are in the Itchen Valley. One can still see lots of trees around here, but this area is where the New Forest and the Forest of Bere almost touched. Gone, mostly. But it's not only large forests that have disappeared. Woods and copses and

now, but there used to be a folly here, a wooden tower, presumably visible as an eye-catcher from the Baring-Ashburton House in the village.

*Little places like **Itchen Abbas** and others just north of the Itchen do not give you the impression that you are anywhere near a bigger city. Itchen Abbas is an unpretentious village in the very heart of Hampshire and doesn't look*

Winchester water mill

College. William of Wykeham [wickum], Lord Chancellor and bishop of Winchester, founded Winchester College in 1382. Note the two different uniforms, for Scholars (resident) and Commoners. The Old Boys are known as Wykehamists and they tend to find high places in commerce and politics regularly and readily. The official school motto is 'Manners Makyth Man'. The school song is a Latin poem and is traditionally said to have been written by a schoolboy who was kept behind during the holidays for having committed a serious offence – which, as you will remember, was exactly the story we had for the maze on St Catherine's Hill. The only thing is that the maze is usually dated at least one century later. Something has got to give here. Public schools do not keep behind centenarian schoolboys, do they? But the lesson here is that punishment makes pupils creative. The title of the Winchester school song is *Dulce Domum*, meaning Pleasant House (Home Sweet Home), which people may remember as an alias for the delectable columnist and novelist Sue Limb.

Cathedral Close, Cheney Court

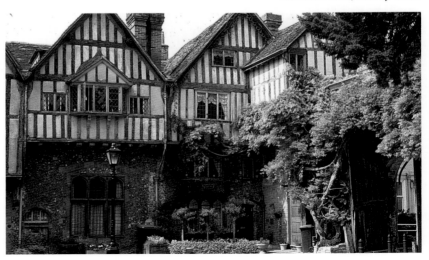

First known when lost

I never had noticed it until
'Twas gone, – the narrow copse
Where now the woodman lops
The last of the willows with his
bill.

It was not more than a hedge o'er
grown.
One meadow's breadth away
I passed it day by day.
Now the soil is bare as a bone,

And black betwixt two meadows
green,
Though fresh-cut faggot ends
Of hazel make some amends
With a gleam as if flowers they
had been.

Strange it could have hidden so
near!
And now I see as I look
That the small winding brook,
A tributary's tributary rises here.
Back to business again.

Edward Thomas

Winchester cathedral doors closed

Avington Park church

*as if it is inhabited by commuters. Unspoilt, some would say. Except for the flowers growing from the well, others would retort. **Easton**, with its good country pub, lies south of the river and gives the same impression. The meadows near the water have caused these villages to exist. Peaceful. A quote from Cobbett about the Itchen valley may be in order here: 'There are few spots in England more fertile or more*

Abbey House, the official residence of the mayor of Winchester. Here too is the public park, Abbey Gardens, with a children's playground and ducks to be fed. The little temple was put up purely to hide the ugly view of the industrial building behind it. A folly. Why not? It might be a good idea to sit down in the park and look through the walking guide again at the end of your walk.

Cornucopian Winchester is good for a few blissful days. Don't fob yourself off with an afternoon's walk. Take your time. There is more, but I'll only mention a few things. One for the kids first, near Romsey Road, I was going to say, but Intech has moved to the futuristic building you get to just before Winchester.

In 1996 The Brooks Experience was opened down in the basement of this covered shopping centre. A few scenes from Roman and medieval Winchester are to be seen and heard. You could send the children there while you buy a book; admission is free. There are also plans for art exhibitions, small fairs and more music in this active shopping precinct.

Winchester has five old Hospitals. The name is related to the word hospitality (just as in Christ's Hospital near Horsham WS), and means almshouses. Winchester has a Christ's

*individual trees have gone as well. Here and elsewhere. It's a process that makes me sick at heart. I'm going to be very solemn for a few lines. Let us praise the laws and the people that try to protect our woods and let us lament the vanishing of the trees through the ages by reading a poem by Edward Thomas, who lived nearby and often expressed his regret at man's threat to nature: **First known when lost**.*

pleasant; and none, I believe, more healthy.'
Avington *[short a] House used to belong to the Dukes of Buckingham. 'This is certainly one of the very prettiest spots in the world,' exclaimed Cobbett, who loved the perfect 'parterre-order' of the place. 'Like Pope's cock in the farmyard we could not help thanking the duke for having generouslsy made such ample provision for our pleasure, and that, too,*

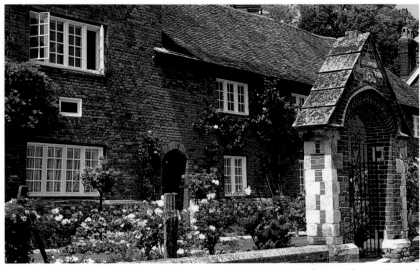

Almshouses, Christ's Hospital

Hospital too. It's a lovely old building in Symonds Street and was founded in 1607. But the finest, serenest Hospital is in the south of the city along the river Itchen: the Hospital of St Cross. Keats walked in that direction and wrote his *Ode to Autumn* afterwards. Founded in 1136 this Hospital is probably the oldest of its kind in England and it still provides a home for people and it still even provides food and drink for weary travellers. This is the Wayfarers' Dole, today given in smaller portions and to a limited number of people, but they do keep up the tradition. The Dole is free, and that sounds very nice of them, but there is an admission charge of £2. You might have known.

Some people will say that Winchester's **traffic arrangements** for pedestrians and cars in the last twenty years have amounted to a concerted effort by local authorities to ruin the city. That may be true to a certain extent. Other people might add that this cannot even be called surprising, with a bumbling County Surveyor's Office so close by. But I still maintain that Winchester is a fabulous little city.✳

Winchester is twinned with two cities on the continent. Laon in Champagne was once the seat of a king too, and is famous for its city walls on which you can walk. The cathedral has seven towers and dates from *c*.1300. The archaeological museum has a 12thC Templars' Chapel in its garden. Giessen in Germany has two castles, one old and one new. There is a Liebig university and a Liebig museum, named after Justus von Liebig, the great 19thC chemist, but Giessen is mainly an industrial city and, being near the middle of the country and the German railway system, it could be called, I suppose, in that wonderfully

Traffic arrangements. King Alfred, who designed the street plan of Winchester, cannot be blamed for the way cars slalom through the city centre from east to west. His ideas worked well until fairly recently. The city can be blamed for not realising their problems soon enough and condoning the county's mistakes (as with the A272 recently, when they made the east-west bypass unattractive and confusing).

Cranbury Park, water tower

In between the Itchen valley and the M3 are Otterbourne and Shawford. **Otterbourne** *is where Charlotte Mary Yonge used to live. Who she? – you might well ask. Well, she was a novelist (1823-1901) who popularised John Keble's views of High Anglicanism and produced 160 (!) books, now mercifully forgotten, mostly. Otterbourne has a little footbridge over the motorway into Cranbury Park on the other* *side (Chapter 7). West of the road is a nice-looking lodge. East, on the Otterbourne side, the turret in the field is a water tower or reservoir. It has been made to look medieval, with machicolations, castellations and arrowslits and all. The door curves along with the wall and has a coat of arms over it. A curio, not worth going to see. But for those whose curiosity has been aroused I include a picture. See?*

Dutch connection. Here is a story that nobody knows about. Heusden in Holland is a beautiful old fortress town. It is of the sort that has fortifications round the centre in the shape of a huge star, and is surrounded by water. The second Lord of Heusden was called Boudewijn and he went to England in the middle of the 9thC and served King Edmund at his court in Winchester for a while. He fell in love with the king's daughter, Princess Sophia, and she agreed to elope with him, whereupon he took her back to his home town in north-ern Brabant. They married and lived happily. At first King Edmund was furious about it all, but later the couple's children, his grandsons, vis-ited him in Winchester and they were graciously received. Edmund finally resigned himself to the state of affairs and allowed his daughter to remain abroad, on condition that her English descent was in some way expressed permanently. As he remembered her best for her passion for spinning it was decided to incor-porate a spinning-wheel in the coat of arms of the town of Heusden. It has stayed there to this day.

This story was dug up from the archives in Heusden. Especially for this book, I'm proud to say.

Shawford Down, daubing stone

merely to please us as we were passing along.' St Mary's Church, completed in 1771, is very much part of the estate. It is pure and unspoilt and as such very rare. The interior is reminis-cent of Dutch Protestant churches. There are box pews, a three-decker pulpit and a musicians' gallery with a euphonious barrel organ. The vicar is justly proud of this, and quite willing to wind it up and let you hear the*

Shawford Down, war memorial

sound. At least, he was with us. He proceeded to wax lyrical about the chancel monuments. We couldn't leave without taking a picture. The church also has an 18thC 'Vinegar Bible', so called because of the misprint of the word vine-yard. Note the gravestone path and the Shelley mausoleum on the other side of the road. And also note the copper beech in between: it went through divorce and remarriage.

complicated language, 'ein Eisenbahnhauptknotenpunkt'.

Winchester has always had unofficial relations of friendship with towns in other countries of course. A city with so much history – it goes without say-ing. It almost did. It is only natural that I tried to find links with the Netherlands. Well, here is a **Dutch connection** that nobody is aware of any more.

Shawford Down *is a wide open space where people walk their dogs and enjoy the views of the Itchen valley, Winchester cathedral and Twyford. There are two war memorials, of which the one for the Second World War is the more interesting. Not so much because the cross is three-dimensional, but mainly because of the flat-lying stone at the foot of it. The people of Shawford want to keep their war memorial* clean and would-be graffiti artists are asked not to deface it, but to use the stone especially provided for that purpose, if they really can't control themselves. WRITE ON THIS – NOT ON OUR WAR MEMORIAL. The idea may not be en-tirely original, but it deserves full marks for conservancy and care. I am happy to report that the memorial was clean when I saw it. A daubing stone. How very very English. ✳

The Folly Fellowship

The Folly Fellowship was founded in 1988 to protect and promote follies, grottoes and garden buildings. I have never understood why they don't see grottoes as garden buildings or structures, but I am a foreigner. Anyway. The Fellowship organises several outings per year for the members to various British and occasionally foreign venues. An international magazine called *Follies* comes out four times a year and carries scholarly, concerned and amusing articles on follies in the widest sense of the word. Since 2001 there has been another publication: the annual *Follies Journal*, with more serious and academic articles on follies, replacing one of the magazines. And in 2007 *foll-e*, an e-bulletin, was started for news and less formal information, freely downloadable from the website.

The members (some 500 around the world and they need more, visit website www.follies.org.uk or write to me, hon. sec. for Continental Europe, Tarantostraat 41, 5632 RE Eindhoven, the Netherlands) act as a pressure group and also give advice to folly owners and builders. There is an archive and a picture library that lends slides and photographs. The Fellowship celebrated its tenth anniversary by organising a symposium on follies and related subjects. And now it has reached maturity: more than twenty years old.

Once a year, in August, there is a Garden Party for all the members of the Folly Fellowship at some famous folly site. The weather is glorious and some of the ladies wear hats. There is a picnic and then the follies are sought out and admired. Later everybody comes together for a sort of reception. Pimm's and cucumber sandwiches are served. And the greatest moment of the day is when the big cake is cut, by a local celebrity. This cake is always in the shape of one of the follies there.

The Folly Fellowship, a registered charity, is full of activities, seriously academic and frivolous in turn, all carried out by volunteers. But what I like best about these people is that, entirely in keeping with the spirit of the folly builders, they do everything with great enthusiasm and a sense of humour.

My country is a paradise, for cyclists. Except for a small part in the south the Netherlands are flat and for England you have to get used to slopes. And for steep slopes you want to resort to getting off the saddle and standing on the pedals, which is a different technique altogether. It's a good thing that the hills along the A272 are gentle, or I would have been in trouble. Another advantage is our cycle paths. Normal country roads have cycle paths running alongside them, often on both sides. In towns we often have special provisions for cyclists, like tunnels and bridges. They are mainly for safety's sake of course, but they also get you away a bit from the noise and the fumes of motorised traffic. All very different from Britain. Here you're often only inches away from jostling juggernauts.

Not that I have felt very unsafe. A cyclist in rural England is still such a singular sight that motorists tend to show some respect and give you a wide berth. As they should. My most frightening experiences were only partly to blame on cars. One time I scared a pheasant by the roadside into flight and the stupid bird came to within a foot from my face as I was riding along, and I could have grabbed it in mid-flight. Just when I put out one hand I realised that that would be a moronic thing to do, as it might easily unbalance me. So, no pheasant for dinner that night. Another time I was just quietly cycling along, my thoughts somewhere else, when WOOF! a dog suddenly barked furiously, within inches of my ear. Cars had overtaken me all the time of course. But then this small lorry came along and in the front cabin was a dog standing on the seat with its head out of the open window.

– – – ***– – @@ – – ??-! –

It caused something of a heart attack.

Bicycles are vulnerable. Bicycle tyres are very vulnerable. In my eagerness to get close to something described as a monument on my map, I rode on a narrowing track with wild roses along both sides. I could just about push the bike through. It was difficult, but worth it, and back on the A272 I had just congratulated myself on the success of the detour when I noticed that my back tyre was slowly

but surely deflating. A puncture.

This was not supposed to happen and I had agreed with myself beforehand that if it did happen I would be in trouble, since I didn't want to carry any repair kit. West Meon Hut was two miles ahead, so I got off the bike, pumped up the tyre and rode as fast as I could. After a good half mile I had to repeat the procedure, and then once more, and I was fairly exhausted when I reached the pub. Lunch first. I noticed there were a lot of motorbikes around. In fact the pub was used as a resting-place on a day's outing of a motorbike club. They always look like Hell's Angels to me and I was slightly apprehensive. But I went up to a group and asked them if they carried repair stuff that could be used for my bike. They referred me to a club member who was a family man and had a sidecar to his bike. And sure enough, he carried repair stuff in it and was willing to help me. All I had to do was turn the bicycle upside down. He wouldn't even allow me to do the repair myself. 'Happens all the time to my boy's bike,' he said. I offered him a beer in the pub, but in vain. A Hell's Angel. An Angel.

On the whole it was a great trip. But still, there ought to be a cycle path all along the A272. That would make bike life comfortable. And there is one other thing I want to nag about: drain covers. Have you noticed how the people who are responsible for the abundance of drain covers in the road never know how to do things properly and create dangerous pot-holes? As a breed these people must be related to plumbers. If they were any good at their job – that too would greatly contribute to making England a paradise, for cyclists.

Stoke Charity church

Chapter

7

West of Winchester

Baring's Bank, founded in the 18thC, is remembered in the history books for causing the Baring's crisis, which profoundly shook the London money markets thanks to reckless and unsupervised lending. And that was in 1890. The second Baring's Crisis, in 1995, finished the bank off. Fortunately a Dutch bank stepped in, took over and helped Baring's on its feet again. Or, one could say, they bought them for a song (in this case just one pound).

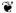

John Flaxman (1755-1826), draughtsman and sculptor, started as a designer for Wedgwood. Friend and collaborator of Blake, and like him famous for his courtesy to everyone, regardless of rank: 'he addressed his carvers and workmen as "friends" and made them such by his kindness,' said Blake's biographer Gilchrist.

Flaxman's best works are his drawings and the smaller kind of monument, in which he showed great and sustained originality. The extraordinary neoclassical purity – even emptiness – of his drawings had a Europe-wide impact at the end of the 18th century.

Micheldever, church monument by Flaxman

*North of Winchester the river Itchen has four villages on its right bank that are called 'worthy'. Worthy in this part of the country usually means a small curtilage or court, enclosed together with the house. From east to west we have (1) Martyr Worthy, after the Frenchman Henri la Martre, (2) Abbot's Worthy, which was held by Hyde Abbey, (3) Kings Worthy, which was the king's, and (4) Headbourne Worthy, named for the little stream there. These **Worthys** are now distant suburbs of Winchester.*

*A few miles further north is **Micheldever**. The river is pronounced [deever], but the village is [mitcheldevu]. If you take the second turning to the left towards it, the one that runs east-west, you will notice that this village is very exceptional in having a drive up to it. That*

This chapter looks like any other on the face of it, but there is something awkward about it. As in the other chapters there is a middle part accompanied by a northern and a southern section. But the middle part is different in that it does more than just follow the route of our road. It describes the A272 as it is now – as well as the A272 as it was before 1996. Hey, this is where I have some explaining to do.

In the first few years of the 1990's the M3 motorway from London to Southampton reached its finishing stages. When something major in the field of roadworks happens, such as the completion of a motorway nearby, it gives the county authorities occasion to rethink their local network. Traffic streams will probably alter and money becomes more readily available. In the case of Winchester the opportunity arose to do something about congestion in the city centre. New routes were devised and the phrase 'rationalising the road network' became meteorically popular, much to every civil servant's satisfaction. The plans were officially proposed in 1993, but the effects were not really noticeable until July 1996 and the implementation (e.g. re-signing) was not completed even then. Let's take 1996 as the year of the Big Switcheroo.

Some of the proposals were about the roads south of Winchester and do not concern us here. What does concern us is that 1) all the existing A roads within the city itself were reclassified as B roads, 2) the A272 was rerouted to avoid Winchester city centre and 3) the direct road between Winchester and Stockbridge was reclassified and renumbered B3049.

Here in this book about the A272 the consequences must be studied in some detail – which means a couple of dense paragraphs, I'm afraid. Feel free to skip on (to page 179/80). You will remember that we came down towards

The A3090 south-west out of Winchester runs along Oliver's Battery. Also called (Oliver) Cromwell's Battery on older maps, it recalls the activities of the Parliamentary armies in the Civil War. Winchester was besieged and captured in 1645. Six years later Cromwell destroyed the castle. He has managed to work himself into this book as destroyer and defouler a number of times.

*Oliver Cromwell's son Richard became known as Tumble-down Dick. He was a reluctant Lord Protector of England for a few years, was forced to go abroad for a while and was eventually buried in the next village we get to: **Hursley**. The monument is in the church tower. Another celebrity in his day who lies buried here is Thomas Sternhold, who together with John Hopkins versified the Psalms in the*

*must be a relic from the times when the private estate WAS the village. Micheldever has a lovely group of black and white cottages. St Mary's, where the founder of **Baring's Bank** is buried and where he turned in his grave in 1995, has some dramatic relief sculpture in the choir. By **Flaxman**. The oddest thing about the church is the high and mighty octagonal nave that was put plumb in the middle of this otherwise*

Hursley, Lychgate Cottage

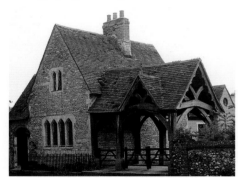

vert traffic to the north and let the east-west travellers join the A30 between Sutton Scotney and Stockbridge. Or, in a wider perspective, between Basingstoke and Salisbury. This was fair enough and might have been done without any further disruptions, but the Surveyor's Department of Hampshire County Council in their infinite wisdom decided to change the numbers of the roads as well. Which now means that the A272 is supposed to overlap with the A31 as soon as the two come together near Chilcomb Down. Then just before they hit the M3 there is a roundabout and the A272 splits. One part goes south and west for a mile, going over another roundabout and continuing until it has crossed the M3, and then it finishes at the roundabout at the foot of St Catherine's Hill.

early 16thC. There are some fine old houses in Hursley, with overhanging upper storeys, some with brick patterns. Picturesque. Here at the end of our journey is a village that recapitulates some of the elements of Englishness that we have seen so far. The hanging baskets, the one-and-a-half lychgate attached to Lychgate Cottage, the difference in character between The Dolphin and The King's Head, the rustic

*normal Tudor church at the time of its restoration, c. 1810. George Dance Jr, whom we saw at nearby East Stratton, did the deed. Opposite the church, the primary school has all the looks of a church itself. Micheldever made the national news a few times in the 1990's, because of controversies over Micheldever **new town**.*

Landowners in the first half of the 19thC often thought trains scary or

Winchester from Cheesefoot Head. Near Chilcomb Down we came upon the A31. Until 1996 the A272 used to follow the A31 from this point and come into Winchester from the southeast, the route we followed in Chapter 6. In the city itself things were a bit messy, but eventually the A272 left Winchester in the west and went on to Stockbridge. So east-west traffic went right through Winchester and it was a burden the city centre could well have done without. The solution was to di-

New town. In the mid-1970's the insurance company Eagle Star started buying land in Micheldever. In 1990 they came with plans for what at first they called 'a 5,000 home development'. The villagers protested vehemently. 'We don't want 9,000 new houses here: Micheldever is fine as it is,' they argued. 'Up to 10,000 homes – a total non-starter,' a spokesman for Winchester City Council said. People were quickly up in arms over it. Media reports demonstrated the depth of the mutual distrust. Debate involved ruthlessly discrediting the opponent's arguments. A cooling-off period was considered prudent. In 1998 things flared up again when an official report said that 300,000 houses could be built in south-east England. Eagle Star have naturally thought that this boosted their case. The residents' action group have naturally concluded the opposite. All parties concerned are still in the trenches, and the slightest provocation (such as Winchester College selling Bartons Farm land for a housing scheme, not too far away) is enough to make everyone look to their weapons again. And for mud, for this is a very rural and earthy conflict.

Hursley

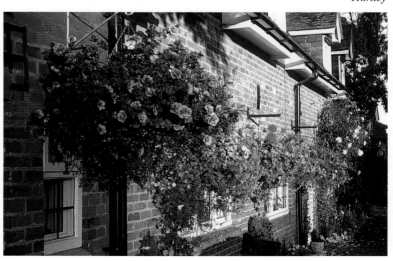

Comment. Well, just a few things then about Hampshire County Council and their plans to 'rationalise' the roads around Winchester in connection with the coming of the M3 (London to Southampton). Some things must be said. One is that in early 1995 I asked the County Surveyor's office for information about the A272. I enquired about future plans. Their plans for 'rationalisation' had been on the official books since September 1993, but they said nothing about them to me – or indeed to locals. I only found out when sympathetic people alerted me in July 1996. 'We had no reason to tell you,' they said later. 'We never do.' The other thing is that when I asked them later why these roads had been reclassified and renumbered the answer was that there was no real reason. They had done it, but it didn't affect them at all, they said. 'Purely administrative', were their own words, and 'purely bureaucratic'. I don't think this needs any further comment from me. But perhaps it does from British taxpayers. Maybe a 'rationalisation' of the Surveyor's Department is in order?

Cranbury Park, 'The Castle'

vulgar and didn't want them close by, so stations were often built at a safe distance. Micheldever Station is two miles to the north and looks typically Victorian. Columns and drainpipes are in the same colour and there is a canopy on all four sides, as if it were wearing a hoop-skirt. Being halfway between Winchester and Basingstoke it was called Andover Road Station until 1856, with Hampshire perversity.

*L*ess than two miles west of Micheldever is **Stoke Charity**, *nothing more than a hamlet. I am going to be illogically brief about the church here. St Mary and St Michael's church is Norman in principle, and contains a magnificent mixture of all manner of monuments, windows, arches, graves, steps, a mural, coats of arms, beams and whitewashed walls. A double, Y-shaped squint. Go and see it. Boldly march*

The other part goes north until the next roundabout and then overlaps with the A34 trunkroad that turns north and west for a couple of miles until the roundabouts at a place called Three Maids Hill. This is also the point where the A34 touches on the old Roman road that runs north-west out of Winchester (B3420). From here the A272 then continues north-west following the course of this Roman road until it comes to the A30. There it stops, and the B3420 starts again. This is called rationalisation. It is hard for me to restrain myself in my **comment.**

*S*o my beloved road (and yours, of course) doesn't run right through Winchester any more and doesn't continue to Stockbridge. Since 1996 it has stopped at St Catherine's Hill and at the A30. The A272 comes to Winchester like an arm from the east and then a hand opens and the city is grabbed by a thumb in the south and the other fingers in the north. The good news is that the total length of the road remains exactly the same. All the rest is bad news. It's a great loss for a book that is named after a road. But we won't let ourselves be cheated out of a Chapter 7. West of Winchester there is still a world to be won.

*F*or the sake of the balance of this book it will be convenient to take the old route of the A272 between Winchester and Stockbridge as the central part of this chapter and anything north and south of it will be discussed using the same pattern employed in all the other chapters. Most maps will probably show the old order of things anyway.

*B*ut first a few words about the newly designated northern bit of the A272, whether overlapped by the A34 or not. As you can imagine there is very little to report. The main thing about these

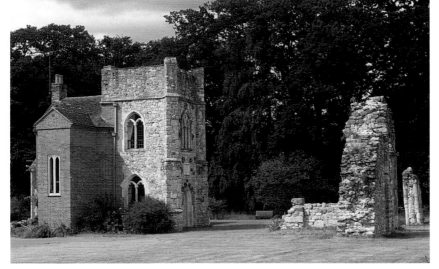

bus-stop and the chimneys across the road there are as uniquely English to us as kissing gates and knives that won't cut.

*T*he magnificent 19thC restoration of the church was the work of its vicar **John Keble** (whose name was given to the new circular 19-mile footpath here). The village has been sliced up more than most by the road and the traffic.

up the path through the field, scattering the animals before you. Its situation, the exterior and even the floor plan are special. Of all the conventional English village churches in the area of the A272 this one is surely the loveliest. In a way the richest and in a way the simplest. Immaculately accessorized, you might say. Read the little guide book that you can find inside, which tells you all about it.

*The area north-east of here is called Egypt. Egyptians as in Gypsies? Ten people in the **Sutton Scotney** post office failed to produce a historian between them to tell me what the connection was. One of them shrugged his shoulders and said there was a Jerusalem south of here as well, so why would I worry? Later I found Egypt Mill here on an older map and names like Palestine and Enham Alamein near*

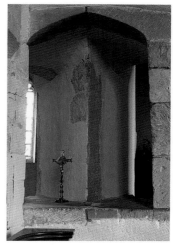

Stoke Charity, double squint

stretches is that there are more than two lanes, which is highly out of character for the A272. North-west of Winchester one bit of A272 runs north-west, looking like a severed limb, more than three miles in the direction of Andover. It follows the route of the old Roman road. This historical importance yields a certain feeling of satisfaction and it would have made me proud if the straightness of the road wasn't equally out of character for the A272. This bit of road is not particularly attractive. Let's be honest: apart from a small oil production plant, which is concealed and not open to visitors, it is dull. It ends at the A30, Hill Farm junction. Opposite is a garage that claims to have done very well out of the re-routeing and renumbering of the roads, since there is a lot more traffic. Yes, why not? Somebody at least should profit. But the road ends somewhat ingloriously. Well, it started ingloriously too, so there is some justice there, and balance, in pietering out.

Hursley chimneys

To the right is Sutton Scotney, to the left is Stockbridge and straight on is the Roman Road, running by the side of a firing range until the river Test forms a barrier. On the OS map you can see that this old road crossed the Test and continued past Andover on and on almost indefinitely. Compared to that, our roads and classifications seem a bit petty.

We proceed to what used to be the A272 (now B3049) west out of Winchester as the last stage of our

West and north of Hursley is Hursley Park, with Merdon Castle in it. Once it was one of the ten residences of the Bishop of Winchester, Winchester being the richest see in England. Now Hursley Park is one of the countless residences of a major computer firm. That's life.

*South-east of Hursley is **Cranbury** Park. Thomas Dummer lived there in 1770. In*

John Keble [keebl] (1792-1866) poet and parish priest, has been called the greatest Anglican of his age. In 1833 he initiated the revival of high church practice in the Church of England known as the Oxford Movement, with his sermon *On National Apostasy*. His sacred verse holds a worthy place in the great tradition of dignified Anglicanism inherited from the 18thC. *The Christian Year,* published when Keble was 35, was perhaps the most popular book of religious verse of its time, and earned him his appointment as Professor of Poetry at Oxford. Some of Keble's hymns remain standards to this day.

> The trivial round, the common
> task
> Would furnish all we ought to
> ask;
> Room to deny ourselves; a road
> To bring us, daily, nearer God.

The restoration of Hursley church, where he was vicar for more than thirty years, was paid for by royalties from his books and poems. 'If the Church of England were to fail,' he declared, 'it would be found in my parish.'

Oxford's Keble College was founded in his memory.

Tablet on Farley Mount pyramid:

UNDERNEATH LIES BURIED
A HORSE
THE PROPERTY OF
PAULET ST JOHN ESQ
THAT IN THE MONTH
OF SEPTEMBER 1733 LEAPED
INTO A CHALK PIT TWENTYFIVE
FEET DEEP A FOXHUNTING
WITH HIS MASTER ON HIS BACK
AND IN OCTOBER 1734 HE WON THE
HUNTERS PLATE ON WORTHY DOWNS
AND WAS RODE BY HIS OWNER
AND ENTERED IN THE NAME OF
'BEWARE CHALK PIT'

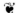

Country. The land here looks rich, agriculturally speaking. Farming is the main occupation round Stockbridge. But relatively few people are actually employed for the amount of business that is done. You only need some four people for 2,000 acres, I was told. Some farmers are called Barley Barons and are millionaires. What few hedges are left are reasonably well kept on the whole, but irregular. This countryside is different from other areas that we have seen and certainly not spectacular, but churches like Hunton's and communities like Wonston make it just as endearingly English.

Red Cross Branch. It is a training centre, a shop and a museum now, where various displays of aspects of Red Cross work can be admired. This Balfour Museum of Hampshire Red Cross History is supposed to be self-supporting financially, but the entrance fee is small. The National Red Cross Museum is near Guildford and certainly worth seeing, I'm told, but a smaller place like this tends to affect you more immediately and directly.

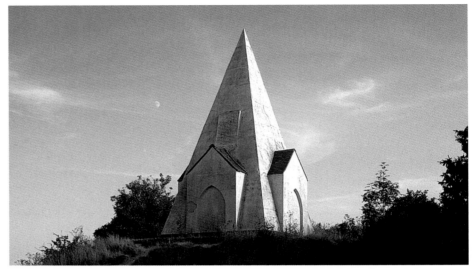

Farley Mount

journey. It is a beautifully hilly stretch of road, but architecturally speaking there is very little indeed to be seen. Once you have left Winchester behind, it is hard to identify the location of the few villages along this B3049. You have to know where to look. But on the other hand these places, Littleton, Sparsholt and Crawley, are so close to the road that you cannot but admit that they belong to it. So they will be discussed as lying directly on the old A272. Then after Stockbridge we have the same problem we had before the road actually commenced. There we talked about the places north and south of the A272 as if the A272 had continued from the A265, which also runs roughly east-west on the route between Winchester and Canterbury. So now, similarly, after Stockbridge we will think of the old A272 as continuing east-west 'underlapping' the A30 and we will think of the A30 as the dividing line between things north and south of our road. ★

Going out of the centre of Winchester on the Stockbridge Road one comes through **Weeke**. The name denotes a specialised farm, usually a dairy farm, but nowadays Weeke is typical suburbia. The local 18thC manor house, on the left at the corner of Dean Lane, houses the Hampshire County Branch of the **Red Cross.**

accordance with the taste of his time he decided to embellish the park-like grounds with various non-essentials. Some of these are still there, on private land. Others have gone, like the shell grotto, which was destroyed by a falling tree a few years ago. One thing gloriously remains and can be viewed. Dummer had decided that it would be nice to have a ruin in his garden. It wasn't too difficult for him to get one, for he

also owned Netley Abbey which was already ruined. Remnants of the north transept were re-erected in the garden and with them came a tower, attached to the gardener's lodge behind it, and the whole was called 'the castle'. The sign put up after the restoration in 1992 calls the castle a folly. It is very conspicuous along the public footpath through the park. The Latin hexameters in the tablet on the tower explain

*Andover. Funny peculiar. North of Winchester and Stockbridge the **country** is fairly flat. An open river landscape.* ✳

Just as there are New Towns there are New Villages. Lots of them. I mean neighbourhoods of new houses, sometimes completely apart from the older settlements. A good example is **Barton Stacey**, but that is not saying that I recommend going to have a look at this or

other neighbourhoods. Old Barton Stacey has a church with some specialities, like funny faces up on the tower. I couldn't find the true story of the superbly carved wooden altar in the church. It looks slightly out of place and Roman Catholic to me, although there are French lilies and English Tudor roses in the panels. The three virtues of Hope, Faith and Charity are employed as caryatids. Dutch 17thC chests

Littleton is on the right, only a few hundred yards from both the old and the new A272. If you think that after six chapters of this book you can make an educated guess as to the meaning of the name Littleton... you are right. At the main crossroads are the Flowerdown Barrows and a sarsen stone. The stone came from elsewhere, but the barrows are genuinely local bronze age burial mounds. Look at the size of the second, well-preserved circular one with the moat. You could bury a whole village there. Maybe they did.

Books that deal with architectural features sometimes tell you about a 'weeping chancel', meaning that the chancel of a church is at an angle with the nave. Littleton church is a good example of that. There is a new balcony inside and it is well done, but it will presumably take a thousand years to look as old as the rest of the church. One of the gravestones near the porch is for Temperrences Fiffild. Temperance is one of those odd **Puritan names** for a lady.

Back on the A272 we get to the point where the driveway from Lainston House used to end. Straight lines of trees mark the old grand avenue that led up to the house from the Winchester direction. Nowadays you come on to this drive about halfway. Lainston was built in the 17thC as a private home. A robust dovecote and the genuine ruins of a small medieval church stand near the entrance. Another fine country house and estate turned into an hotel – this time belonging to the group of Exclusive Hotels whose splendid little booklet doesn't mention prices.

We are in **Sparsholt** [spar-sholt] here. In spite of the modern pronunciation the word comes from speares-holt, meaning a wood that produces tools and weapons such as spears and spars. Ideal near a city, military camps, ports and so on, this wood production. Sparsholt is best known for its Agricultural College, which is indeed impressive. They manage more than 1500 acres of land and husband a

Puritan names. The Puritans were extremely resourceful in giving their children names. The Bible was systematically plundered and they put their own imagination and value system to work. Often words denoting virtues were chosen. The children themselves were hapless victims. At least, one can hardly conceive that they derived much joy from names like Temperance or Thrifty. What do you think of Increased, Changed, Accepted or Repentance? You could just about get used to them. A bit worse are Fearnot, Hopestill, Goodgift and Bethankfull. This was before the NSPCC. Definitely cruel, crippling and punishable by law, I shouldn't wonder, are monstrosities like Performe-thy-Vowes and Fly-Fornication. All these names occur in church records or in cemeteries along our road, by the way. In America the Puritans went even further. Job-Raked-out-of-The-Ashes, The-Lord-is-Near, Fight-the-Good-Fight-of-Faith as choices for first names were followed by Biblical names and phrases like Mahershalal-hasbaz, Mene Mene Tekel and Notwithstanding (the result of picking a word blindly). One wonders if and how they shortened these names.

Barton Stacey, funny faces – yes, they are there

how these things came to pass and advise you to enjoy the rest of the garden. Well, unfortunately that is just not possible nowadays, since most of it is private.

Chandler's Ford, *as I indicated in Chapter 6, may be pleasant enough for people to live in, but falls outside the scope of this book. Closer to the old A272 near Sparsholt is a pyramid with a **tablet** inside. The tablet explains the*

*raison d'être of this folly. The pyramid is in **Farley Mount** Country Park, which consists of more than 1000 acres of unspoilt woods and open land and is very popular with people who need their daily constitutional, and with dog-lovers. Inevitably it is also used for open air study and for school outings. In the south-west corner along a footpath is this folly: a monument to a horse, on a high grassy knoll. It has*

Wessex is the old name for the area where the West Saxons established themselves in the 6thC. Roughly speaking, it covered what is now Berkshire, Hampshire, Wiltshire and Dorset. The capital was Winchester, and the kingdom of Wessex developed into the kingdom of England. Hardy's Wessex is Dorset.

❧

William Makepeace Thackeray (1811-1863). The heroine of *Vanity Fair* finds herself employed by a real baronet. Becky's romantic notions of the nobility hardly last beyond the gate of Queen's Crawley:

'"There's an avenue," said Sir Pitt, "a mile long. There's six thousand pound of timber in them there trees. Do you call that nothing?" He pronounced avenue —evenue, and nothing —nothink, so droll; and he had a Mr. Hodson, his hand from Mudbury, in the carriage with him, and they talked about distraining, and selling up, and draining and subsoiling, and a great deal about tenants and farming – much more than I could understand. Sam Miles had been caught poaching, and Peter Bailey had gone to the workhouse at last. "Serve him right," said Sir Pitt; "him and his family has been cheating me on that farm these hundred and fifty years." Some old tenant, I suppose, who could not pay his rent. Sir Pitt might have said "he and his family", to be sure; but rich baronets do not need to be careful about grammar, as poor governesses must be.'

The ending of *Vanity Fair* is famous: 'Ah! *Vanitas Vanitatum!* which of us is happy in this world? Which of us has his desire? or, having it, is satisfied? – Come children, let us shut up the box and the puppets, for our play is played out.' Well, you still have a few more pages to go.

Barton Stacey, altar

often have the same theme. In fact I wouldn't be at all surprised if the whole altar had come from **the Netherlands.**

Most villages were reluctant to receive electricity. **Chilbolton** *people had to be bribed in 1933. It says something about their way of life and the village atmosphere in those days. There are a number of tea-cosy cottages. On the other side of the Test, which*

variety of animals. I was proud to see 120 Friesian cows among them – from the Netherlands originally. You can study anything from three-year full-time courses on agriculture to short courses on tree-climbing. No kidding. The College also houses a Conference Centre that offers accommodation and facilities for every kind of junketing. It bears the old name of the region: **Wessex.**

But for the post office and general store, which was built making use of the old well and must be the tiniest ever, there is little to see in the village. A large part of Sparsholt became a Conservation Area in 1991. Many of the villagers work in Central London. I bet that doesn't surprise you as much as it surprised me when I heard it. �

On the road again. Just over two miles from Winchester is another entrance to the Lainston estate. The walls that curve inwards towards the gate here are not just for show, but serve a useful purpose. They were mainly constructed in this way to allow room for horse-drawn carriages to turn. This is not unique, as you might imagine, but again one of those things someone should point out to you.

Going further west there is something awkward going on with the direction signs: one encounters first WINCHESTER 4 – STOCKBRIDGE 5 MILES, then WINCHESTER 5 – STOCKBRIDGE 4, and then WINCHESTER 4 – STOCKBRIDGE 5 MILES again. The funny thing is that the recent re-signing brought no change in this situation. A good County Surveyor's office can be a source of endless joy.

After the pub on the left we see Folly Farm on the right. You never know with folly farms and there are a lot of them about in England. There may have been a genuine folly here, but usually the name is chosen because of a conspicuous clump of trees nearby, often on a hill. And this is the case here: no wondrous idiosyncratic buildings and none in the farm's history either, unfortunately.

an open porch on one side and a stone bench inside. Again a monument to a horse. And again a pyramid. And again almost unutterably English. It was last restored in 1870, but it is in a vulnerable spot on its perch, and now has open cracks along the edges. That means that water can get inside and destroy it from within. Hampshire County Council should step in and rescue this unique memorial. ✳

The southernmost place I'm going to mention in this chapter is **Romsey** [rumsi]. It is definitely over our seven-mile limit, but it's quite a presentable town, with its huge Norman abbey and old market centre. It featured as Kingsmarkham in the TV series Ruth Rendell Mysteries about police inspector Wexford. To the north-east of here are the Sir Harold Hillier Gardens and Arboretum, famous for hardy

*can also be reached by a footbridge following the Test Way, is **Wherwell**. Here too are some heartening timber framed and thatched cottages. A great place for photographs, if the cars are not in the way. The churchyard here is dominated by a sturdy mausoleum that looks as if it has half sunk into the ground. Together Chilbolton and Wherwell are as nice a pair of remote villages as you might wish to find.* ✳

*Another pair of places with lots of old-fash-ioned heavily thatched cottages are south of Andover: **Upper Clatford** (note the dainty little white bridge across the river Anton if you are there) and **Goodworth Clatford**, also called Lower Clatford. Between here and the A3057 is something that looks like an aborted church. It started life as a water tower, but is now used as a donkey stable. It is clad with wood, and a*

Wherwell, mausoleum

Rather small roads lead from both the pub and Folly Farm towards the right, to **Crawley**. Just as in the case of its much bigger namesake in West Sussex the word means crow-clearing. This scrumptious slow-motion village just north of the road is worth the small detour. It is thought to have been a model for Queen's Crawley in **Thackeray**'s *Vanity Fair*. Going through it from east to west you first come along the pond, where the village pump hasn't worked for donkey's years. Besides the splendid pub on the left, the village has a great number of beautiful houses of various architectural parentage.

These people are proud of their village. Most of it has been a designated Conservation Area since 1972. Though none of them is really spectacular, there are some two dozen listed buildings. You could hardly get a higher percentage if you lived in an Open Air museum. Along the path through the churchyard is Archdeacon Jacob's Post (for another Jacob's Post, see p. 42). It has come down from Crawley Gap, where the rector of Crawley-with-Hunton had it erected around

Sparsholt, post office and general store

trees and shrubs, and colourful in all seasons. It was started in the early 1950's and now has close to 50,000 plants and trees in 166 acres. There are guided walks and workshops.

North of Romsey is **Michelmersh**, where the detached wooden church tower looks just as grey as the flint church itself. The interior is light and has a crusader tomb. An unusually large barn on staddle-stones stands opposite

this church. Note the thatched tree-trunks at the Bear and Ragged Staff Inn along the A3057, if you should find yourself in this area.

North-west of here are again three villages related by name. Or rather: two hamlets and one village. **Up Somborne, Little Somborne** and King's Somborne. The Somborne ('swine-stream') is a little tributary to the Test, but is now mostly dry. The best way to King's

The Netherlands. My country is better known as HOLLAND, which is in fact only part of the Netherlands, albeit the most important part. The words mean 'low-lying land' and 'woodland'. The adjective DUTCH, used to mean 'of the people' in the middle ages. Later it meant 'of those people in the nether lands'. That's when the word came into English, where it retained this meaning (later still Dutch came to mean both German and Netherlandish, related to the German word Deutsch). Dutch as a language is spoken by people in the Netherlands and an older form of it is spoken in our former colony South Africa. A variety of Dutch, Flemish, is spoken in the north and west of Belgium, Flanders. The south-eastern part of Belgium, Wallonia, speaks Walloon, a form of French. Holland, Belgium and Luxemburg were united as the Kingdom of the Netherlands in 1815, but Belgium and a divided Luxemburg became independent countries in 1839. The south of the Netherlands and the north of Belgium have always had a lot in common. Dutch people usually feel closely related to Belgians (and we have lots of jokes about each other: Irish jokes, if I may say so). Luxemburg has always had ties with both Belgium and the Netherlands. The three of us together (Benelux) are still united in some minor respects and are often referred to as 'the Low Countries'.

Goodworth Clatford water-tower

Legends are often mentioned as such in books, and then you never know what is the truth of them. In the case of the Woolbury Hill figure different sources mention that a traveller was attacked on the old A272 here at a place called Robbers' Roost. A cross of flints is supposed to mark the exact spot where he was killed. But his horse was only wounded and it struggled on, presumably to get help. Horsy heroics. Other sources say the picture of the horse was to celebrate the steed of the highwayman who plied his trade here in the copse called Robber's Roost. All very English and what not, but is it true? Nobody I talked to knew of local legends, and I think I talked to the people who would know if there were any. There is no flint cross to be found, but it might have been overgrown. The County Record Office has no mention of a monument there. No cross. And no place called Robbers'/Robber's Roost on any of its old maps either. Could it be an unofficial name? All in all, no joy. But we might be comforted with the thought that sometimes it is a pity to find out the truth about things.

funny old thing it is. One wouldn't expect it to date from 1936. ✳

North of Stockbridge our seven mile limit is marked by the A303, so the elusive Deadman's Plack Monument in Harewood Forest is just outside. So is **Andover**. Its reputation as a modernised old market town may not sound too alluring to many people anyway, but as a specialised interest I must mention the

1850, after he had got lost in a snowstorm. Dower House opposite the church is where the Crawley Court servants used to live. For unknown reasons it has a tower in the middle: square, brick, castellated, with an octagonal staircase turret. Crawley Court played a large and beneficent role in the past. Around the turn of the 20thC Ernest Philippi came to live there. Through loving care and investments he managed to improve the appearance of the village and through restrictive covenants he managed to keep it small. Today **Crawley Court** is the headquarters of NTL: National Transcommunications Limited. Among other things they broadcast the signals of ITV and Channel 4, and provide them with technical know-how and amenities. �

Before we get to Stockbridge two car parks make it easy for people to go to **Woolbury Hill** on Stockbridge Down. First a car park on the right, later a car park on the left. Woolbury Hill is an iron age hill-fort of about 500 BC. Why place-name books should have problems explaining the name is a mystery to me, but they do. They suggest 'fort of riches' or 'fort of the streams', admitting that neither seems correct or appropriate. The elements seem straightforward enough to me: wolf, as so often, and barrow or borough. Anyway, fourteen barrows have been counted in the area and an ancient field system, consisting of terraced fields, is still intact. The National Trust sees to it that the place remains enjoyable for lovers of nature as well as lovers in general.

Most interesting about Woolbury Hill is the hill figure in the shape of a horse. The earliest reference to it dates from 1859. Various books about hill figures

Woolbury, horse hill figure

*Somborne is not through the Somborne hamlets, but via another hamlet: **Ashley**. There are only a few houses, an old well-head (1616), the earthworks of a castle and a church, all cosily close together on a hill top. The church used to be the castle chapel. It is early 12thC, but with Saxon elements and is now redundant.*

The church at **King's Somborne**, with some nice old houses and a lovely green nearby,

Hawk Conservancy three miles west of the town centre, which is all about birds of prey. Andover also safeguards artefacts dug up at Danebury, a hill-fort nearby, in the Church Close museums and the **Test Valley Tapestry***, a communal embroidery by local people depicting their area.*

*T*he river Test can be crossed in the direction of **Longstock** *one mile north on the A3057,*

coming from Stockbridge. This is one of the beauty spots where you can see a thatched fishing hut. There are more of those about, but this one is close to the road. If you have never done any trout fishing yourself you can at least experience part of the charm here. The solitude makes it easy to become a fisherman's friend.

*L*ongstock Park's wooded water garden is sometimes open to the public. The church

Test Valley Tapestry. A celebration of the natural beauty and rich history of the Test Valley. Brainchild of the Mayor of Andover in 1983, and finished in 1990. Forty groups and individuals worked together on this, all giving a picture of the villages or towns where they lived, collected on panels. The artists were given some licence, but had to conform to a pattern. They did this in a playful manner. An embroidery with a strong sense of tradition and variety. Just as in the Bayeux Tapestry (and in this book) there is a broad middle part with borders above and below. The series of nineteen panels is on show in the conference suite of the council offices in Weyhill Road, Andover. The rooms are often in use, but it's not too hard to make an appointment. There is a book about it and a series of postcards.

and such things mention it, saying it probably dates from the 18thC, was repaired and whitewashed in 1929 and remade in 1967. They say it is 27 feet long (which makes it England's smallest hill figure) and talk about local **legends**. Well, what can I tell you? I saw it on an aerial photograph of 1928 (yes, very early), where it looked a lot like a fat sheep. And since then it has shrunk considerably. If it was 27 feet before, it is only half that now. It has one more leg than in the picture of 'Woolborough' (sic) Horse in one of the books. The differences are easily explained. This hill figure is not cut out of the turf, as is the case with most of them, but is laid out with flint stones pressed into the ground. The whole thing can be altered in appearance in ten minutes. A determined vandal can destroy it in two. Maybe he did and some unsung hero remade it, only smaller. Who knows? Rita and I cleared it a bit for a photograph. You can see the old A272 from the horse, but you can't see the horse from the road. It is on the southern rampart of Woolbury Camp, just below the NT property.

We are one mile from the official end of the former A272. One mile all downhill. That bit was glorious on the bicycle. But suppose you start doing the A272 in Stockbridge. If you can do the same mile uphill without getting off your

Longstock, fishing hut

Crawley Court was rebuilt in 1877 as a large Gothic mansion to the design of Frederick Pepys Cockerell, whose father Charles was President of the architects' organisation RIBA and one of the great classicists (he also built Oxford's Ashmolean Museum in 1845). Pevsner called Crawley Court undisciplined, as well he might, but it was splendidly Victorian. In 1901 Ernest Philippi, head of the cotton thread firm Coats, moved in and proceeded to give the village its model appearance. He took good care of the house. When the Independent Broadcasting Authority (later NTL) bought it they didn't think it was suitable for them. They felt they had to pull it down and they did so in 1970. Sinful. Philistinism. A new sixties-looking head office (reminiscent of Brasilia) was built in its stead. Money talks. And they carried enough clout: the Queen herself came to open the place.

Stockbridge, former end of the A272

has a broad double-door lychgate, but is relatively new. Near the pub are earthworks that have been identified as the remains of a dock or harbour, built and used by the Danes. Did King Canute have a fleet here? If so, why here and not nearer Winchester? If this is what it seems to be, it is very rare. Some serious research should be done, perhaps. More serious than I could ever do, anyway. ☆

bicycle at all, then you are in better condition than I am. Which is not saying much, perhaps.

Stockbridge means log bridge, wooden bridge. There must have been one before a stone bridge was built over the river Test. For 500 years of its long history Stockbridge had a romantic hump-backed bridge, but since 1963 there has been this modern one you can see. Stockbridge is, among other things, a **fishing** village. Technically speaking the village is a borough with a town hall. Odd, and very English. Equally typically English is that the borough used to be a 'rotten borough' with two Members of Parliament for 500 people and Stockbridge was described as cutting 'a handsome figure in the annals of bribery'. An epitaph in the old churchyard (John Buckett) commemorates the corrupt days when votes could be bought more openly than nowadays. Stockbridge still retains the pre-Norman Courts Leet, meaning that some forms of justice can be dispensed locally. Burgesses are elected to a Jury and they decide how the more than 200 acres of common land should be used. Being on the river, the A3057, the A30 and of course the old A272, it has a history of catering for travellers. A hundred years ago there were still more than ten inns and taverns. Not bad for a village of 500 souls. At that time Stockbridge was also famous for its races, on a par with Ascot and Goodwood. The grandstand is still there, now derelict and still waiting for creative plans, but the racecourse itself was closed in 1900. The Prince of Wales (later Edward VII) used to come and rent two houses at the bridge annually, one for himself and one for Lillie Langtry, their gardens connected by a private footbridge.

Bicycle. You may be more fit than I am, but I'll bet I'm more used to cycling. As a means of transport the bicycle is much more popular in the Netherlands than in Great Britain. We have slightly more bicycles than inhabitants, which makes us the No. 1 bike nation of the world. 60% of Dutch school children go to school on bikes. Almost all of the rest walk. In Britain only 3% cycle to school. Overall 30% of Dutch journeys are by bike. In Britain this is 2 to 3%. Much too low, really. One has to find a good balance between the bike and the car. The hills and the climate may look disadvantageous for cycling, but the main reason why you don't cycle is that you don't cycle enough. You simply lack the infrastructure. But the times they are a-changing. In a few years' time you are going to have 20,000 miles of cycle paths, often making use of old railway tracks. These are mainly for recreation of course. But plans for safe cycling in the towns and cities are also worked out, supported by the organisation called Sustrans (see p. 46). You English people are learning, perhaps.

was one of many that were 'improved' in the 19thC, but it hasn't suffered too much. It contains two of England's oldest brasses. In front of it is a war memorial by Edwin Lutyens. Behind it is a field where there must once have been some large building, but excavations in the mid-1980's failed to reveal a tangible reason why King's Somborne should have been a royal manor. The only royal name connected with the

area is that of John of Gaunt, the father of Henry IV. Gaunt acquired the Deer Park and the late 14thC enclosing banks can still be seen here and there. It is between the village and the Test, and between the crossroads of some footpaths in the north and Horsebridge in the south. These footpaths haven't been in the area long. They are the **Clarendon Way** *and* **Test Way.** ✳

One might think that if the Danes had settled in Longstock they must have had something to do with nearby **Danebury Hill**. Not so. Danebury Hill used to be spelt Deanbury and before that Dunbury, which is better still, since dun means hill in Old English. So the name Danebury means exactly what it is: a hill-fort. It is owned and managed by Hampshire County Council and they have been doing their best to make the site educational. Ever since 1969 excavations have yielded all sorts of artefacts which are kept in Andover. Danebury was a settlement for a long time. The earliest burials there took place c. 2000 BC. The first defences were erected in the 5thC BC. There may have been as many as 100 houses on the ramparts, some of them 20 ft in diameter, and there must have been more in

Fishing. People (like me) who don't know anything about these things may be surprised to hear a few figures: it costs between £80 and £200 per day to fish in the Test for one rod, and if you want to own one 'beat' in the river (over one mile) for one season you pay £15,000 to £20,000, which is why people usually join syndicates. All fishing rights are privately owned. The local Grosvenor Hotel (the one that projects into the road on pillars) houses the headquarters of the most exclusive Fishing Club in the country and the oldest in the world. Its membership is limited to twenty-four. They own nearly all the fishing in and around Stockbridge and down to Houghton. Upstream from here is the Leckford Fishing Club. In Stockbridge fishing has been turned into an art form. Hundreds of different types of flies are for sale, to entice the trout to rise. Hundreds? I asked. Hundreds, they said. All very well, but for normal people this type of development tends to make certain facilities like hotels, antique shops and restaurants a little ritzy. Upmarket. Upmarket as you know often means needlessly expensive.

The A272 died appropriately at a churchyard, on entering Stockbridge, one could say. The Old St Peter's church there was built in the 12thC on the site of an earlier one. Most of it was demolished when a new St Peter's church was built in the High Street in 1866. What was left, the chancel, was restored by the parishioners in the early 1990's. The little exhibition inside the church shows what a good

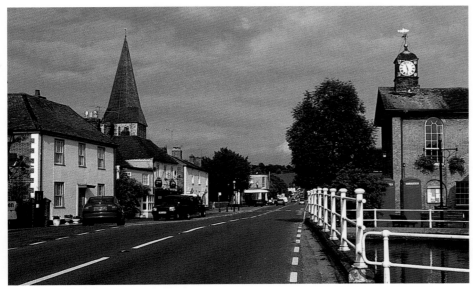

Stockbridge

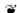

Clarendon Way and **Test Way** are two of the four long distance footpaths created by Hampshire County Council in the 1980's. The others are the Wayfarers' Walk and the Solent Way. The Clarendon Way, named after Clarendon Park in Salisbury, starts near the Avon at Salisbury and ends near the Itchen at Winchester and provides a great variety of views and countryside over 26 miles. The Test Way uses the old railway line along the Test (the Sprat and Winkle line) starting from Inkpen, just over the Wiltshire border where the Wayfarers' Walk also starts, and goes north for 46 miles, to Totton, just south of the A2.

Horsebridge *used to be on a railway line (nicknamed the Sprat and Winkle line) and the old station has been preserved. It is a bit reminiscent of Barcombe ES. Nostalgic. A railway carriage can be seen from the Test Way footpath, together with some old railway station paraphernalia. The place is run as private dining rooms now. There used to be a proper Railway Inn too. Well, the railway is gone as* such, but not the inn. Fortunately, for it is a nice place. It is now called the John of Gaunt. This is where the old Roman road used to cross the Test, just south of where the Wallop comes to join it. The river has developed schizophrenia here. There are at least four major and a number of minor subdivisions. A psychiatrist would diagnose a serious identity crisis. You have to cross no fewer than eleven bridges across the

Pub signs were required by law in the middle ages, when illiteracy was rife and people were used to interpreting symbols. The earliest of inn signs must have been the bush, as symbolic for the vine or bunch of grapes associated with Bacchus, the god of wine. This marked the beginning of the use of a stock of symbols and concepts for inn signs, later often misunderstood. Important sources of names were the following categories. 1) *Heraldry*: coats of arms, badges and crests produced Dragons, Boars, Swans, Roses, Feathers et cetera. 2) *Religion* inspired Angels and Lambs among others. 3) *Royalty* provided their own names and stories like the Royal Oak. 4) *Celebrities* gave us Nelsons, Gladstones, Robin Hoods, Pepyses and such. The Queen's Head pub sign in Bolney for a time showed a picture of Freddy Mercury (of the rock group called Queen), as a joke. 5) *Trades* were often represented by e.g. Jolly Farmers and Masons Arms, with 'arms' often jocularly in more than one meaning. 6) *Animals*, not only as symbols but in their own right, like Horses, Foxes and Pigs in various colours. After all, pubs were places for Cock and Bull stories. 7) *Local stuff*, like Bells, Railways and X's Arms. And of course 8) *Miscellaneous*, with proverbs, puns and misunderstandings like The Cat and Wheel from St Catherine's Wheel. Pub signs are the most visible of medieval traditions that have come down to delight us. They can be very inventive, sometimes even with double symbolisms, like chess-pieces to represent the name King and Castle. Rarely (too rarely) do we find things that seem wrong. In Chilgrove between Petersfield and Chichester the White Horse pub posed too much of a problem for the artist, who wasn't confident about painting a horse. But she did good cats. So the White Horse sign has a lovely, fluffy cat. ★

the centre. Plus room for animals, granaries, a variety of workshops and ritual buildings. But soon after 100 BC the settlement seems to have been abandoned. Why? This was before the Romans came. The need for defence must have lessened. And it can be bleak in winter. People just spread out over the land. It happened all over Britain. All sorts of inconclusive reasons. So the answer probably has to be: why not?

Nether Wallop, thatched wall

The views from Danebury Hill are fully as good as might be expected. For one thing you can see the old grandstand of Stockbridge racecourse, covered in ivy. The footpath on the ramparts is impressive. Seen from outside these walls are steep and generally over 30 ft high. No wonder this hill-fort became a local centre. In the middle of the hill the sheep are trying to cover the ground with a layer of droppings.

job they did. A lot of work was done on the churchyard too, such as straightening the gravestones, and now, according to the notice board, everything is being done 'to preserve the wildlife on the churchyard'. For some reason that sounds funny to me.

The Test Way long-distance footpath can be joined at the White Hart Inn on the roundabout at the eastern side of Stockbridge. In front of this always familiar-looking and elegant building the eye is drawn to the inn sign, one of the oldest in existence in a nation famous for its **pub signs**. And to a wooden table that is sculpted from one big piece of wood. Inside a less weathered and well-polished specimen graces the reception area. I love that sort of thing. Keep it up!

The High Street might have been called Broad Street. Not unusual for medieval market towns. It might also have been called Only Street. Surprisingly urban architecture, with houses in various colours. I am always pleased to see a hill closing off the view of a street. In Stockbridge we have this view on both sides, the town lying in the valley between two old hill forts: Woolbury in the east and Danebury in the west. Danebury Hill is just beyond the hill you see in the west. Why this hill at the Test should be called Meon Hill is a very English mystery to

same river in less than a mile to get from Horsebridge to Houghton on the other side.

*The neat village of **Mottisfont** takes its name from: moot's font, or 'the spring of the meeting place'. It produces 200 gallons a minute of clear water at 50ºF, I was told. Mottisfont Abbey, which is run by the National Trust and open to the public since 1972, has a Gothic flint summerhouse and a rustic fishing hut. The*

garden is known for what are called old-fashioned roses. There is a London Plane tree that has the biggest spread in Britain, c. 250 years old. The abbey itself is most famous for the Whistler room, which is covered with marvellous trompe l'oeil paintings by Rex Whistler.

*Houghton Lodge, a big house that was built shortly before 1800 in the **cottage orné** style, maybe by the **Regency** architect **John***

And they are succeeding. 'The Turret', as indicated on the map, sounds like a building, but it is only a hillock.

The Wallop is a brook that flows into the Test. To the west of Danebury Hill are three related villages that bear its name. Nether, Middle and Over Wallop. To begin with the latter: Over Wallop is quiet and relatively traffic-free, with fine old-world cottages.

Nether Wallop must be praised as one of the loveliest villages of Hampshire. It follows the course of the river. One of its quaintnesses is a thatched wall. We will see another thatched wall in Broughton later, and there are more of them about in this area. The best view of Nether Wallop is from the elevated churchyard. And a rare churchyard it is. Not only for the view of the village and the valley.

Cottage orné is an awkward term, half English, half French, the second part related to ornate and ornamented. It means a building that mimics an old thatched cottage, often half-timbered and sometimes like a root-house. In the late 18thC-early 19thC this idiom of studied rustic charm was developed for houses and lodges for the gentry, the main difference being that the cottage orné is often larger than its model. In our own day the architect Robert Adam has come close to developing a traditional building style that makes modern houses look a lot like cottages. Good. And to the delight of Prince Charles, I dare say.

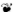

me. Apparently Hampshire has its little perversities too.

The Test in this area provides the finest dry-fly chalk stream river fishing in the world, the townspeople say, and Stockbridge is much in demand by the particular type of sportsmen for whom these words make some sense. Of course the facts that Stockbridge is a quaint little town and that there is easy access from London and the airports contributes to its popularity. Trout are sometimes even seen in the streams and pools along the High Street, where they may be fed but not caught.

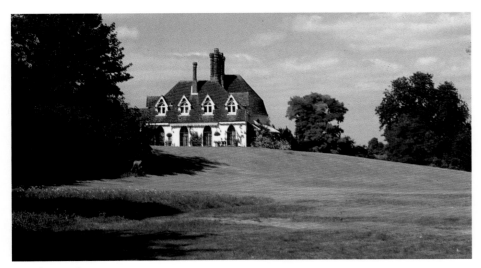

Houghton Lodge

Nash. *Great lawns slope down toward the river on one side. There is a mysterious monument to the left of a serpentine path – if you know what it is, please tell me. There is a photograph of it at the end of this book, for the path itself is in private grounds. You will also find some topiary at Houghton Lodge. The Main Garden has been classified as being of special historic interest. There is a garden shop as part of the*

Hampshire Hydroponicum. Hydroponics is the art and science of growing plants in nutrient-rich solutions or moist inert material instead of in soil. You know: those dry brown round granular thingies. They know a lot about that stuff here, in this 'garden of the future in a garden of the past'. Houghton Lodge is the headquarters of the Hydroponic Society of Great Britain, and don't tell me you knew that.✳

John Nash (1752-1835), described himself as a 'thick, squat, dwarf figure with round head, snub nose and little eyes'. His wife, though, was very pretty and was almost certainly the mistress of the Prince Regent. This might explain why Nash got so many of the best commissions of the period; but he rose to the challenge superbly and more or less created the **Regency** style, a light-hearted classicism with oriental touches. The Victorians disapproved of the 'comp and lath and plaster shams of the Regency' but had to admit that Nash had a genius for the bold conception. He was responsible for Regent's Park in London, together with all the villas around it and Regent Street, which led from the Park to the Regent's palace in Carlton House Terrace, later replaced by the grand Nash Terraces. He also built in Italianate, Gothic and Cottage styles (see above), but his most famous design must be the 'Hindu' Royal Pavilion in Brighton, which we glanced at in Chapter 1 'made up of pagodas and turrets, and crowned with teetotums,' as the architect Barry of the Houses of Parliament said.

189

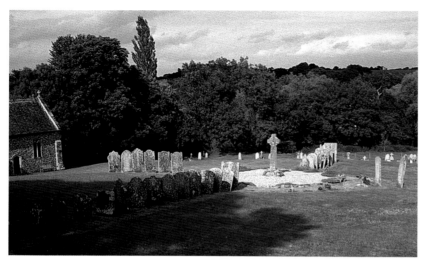

Nether Wallop, churchyard

Text Stockbridge bridge (*c*.1450):
SAY OF YOUR CHERYTE A PATERNOS-
TER AND A AVE FOR THE SOWLLYS OF
JOHN GYLMYN OTHERWYSE SEYD
LOKKE AND RICHARD GATER AND
MARGARETE THE WYFE OF THE FOR-
SAYD JOHN AND RICHARD FOWN-
DERYS AND MAKERYS OF THE SAYD
BRYDGE YN WHOS SOWLLYS GOD
HAVE MERCY

Nether Wallop, mausoleum

There is a 15-foot high pyramid here, the mausoleum for a Dr Francis Douce. In order to be sure of its continued maintenance by the villagers he laid them under a debt by giving them a school. And it worked. So here near the end of the A272 we have a pyramidal tomb, just as we had near the beginning: Mad Jack Fuller's in Brightling ES. In fact this is not entirely coincidental. Douce was related to Fuller,

There are all sorts of shops and restaurants in the High Street, one of them is a good crafts shop. Going westwards and over the bridge to the left is **Drovers House**. It is one of the oldest in the area: part of it dates from the 12thC. It's now a private house, but it used to be an inn. It is a relic of the times when drovers took their flocks and herds from South Wales to the coast, to sell them to the Royal Navy. Stockbridge between the **hill-forts** was a favourite stop on the way and the words inscribed on Drovers' House in big letters comment on the facilities in early Welsh.

The nice little bit of Modern (!) English **text** on the bridge over the Test going west out of Stockbridge was taken over from the previous medieval bridge. Among other things it shows you the earlier name for Hampshire: County of Southampton. The need to advertise good deeds is nothing modern.

To those who can't get enough of going west I would say: you should continue along the A30. Leave Stockbridge. After seven miles the A343 joins the A30 and you are in Wiltshire at a place called Lopcombe Corner. Just a bit further, on the left, is Roche Court Sculpture Garden. This is relatively new, but the quality of the exhibitions and the permanent works of art is high. Even the surrounding landscape forms part of it. And of course going west after that you come to Salisbury. That cathedral! And

Houghton [ho-tun] village is a ribbon development, with Bossington Mill in the south and the charming 'centre' with the church near the northern end. In between Houghton Lodge and Houghton the road has two sharp bends. In the first one a peculiar building is seen. A square flint folly, consisting of four pointed towers and connecting walls, somewhat castle-like. It was built in 1880 to form an extra

and also a cousin of Paulet St John who put up the pyramid for his horse at nearby Farley Mount. It is mentioned in the lower section of these pages. A further special feature of this churchyard is that the 'revamp the churchyard' movement has struck here too. More vigorously than elsewhere even. All the old tombstones have been brought together and put up standing behind each other in the shape of a large

cross, with the grave of a local hero as its centre. St Andrew's church itself bears traces of most of the centuries in which it was 'improved' and contains some of the oldest and finest murals in the county.

N*orth-east of Middle Wallop is the* **Museum of Army Flying,** *next to a military airfield and its camp. It's nice for those who like that sort of thing. I had never given it*

Hill-forts. Causewayed camps and henges are the peaceful relics of the first inhabitants of Britain. Later, when the Celts came and established themselves, it became more necessary to protect the communities. Rampart farmsteads and villages began to be built. Hills formed natural places of defense. The last millennium BC saw an increased activity in the erection of hill-forts all over Britain. Banks and ditches enclosed the hill tops. Gates and fortifications were constructed. The forts were used as cattle corrals, places of refuge, sacred places for rituals and strongholds for chieftains. The larger ones became villages, with wooden huts, penfolds and workshops. Thousands of them have been recorded. Most of them were built around 500 BC. Later they were often abandoned and only the largest and strongest remained in use. In England the last hill-forts were dismantled by the Romans. In Scotland and Ireland they lasted much longer – they were still being built until *c.* 1000 AD.

the Close! It rivals Winchester. And then there is Stonehenge. The single most important prehistoric monument of Europe. And so on. And so on. And so on. There is more to England than the A272. You knew that. Of course. But my contention is that at the end of these ninety miles you have already seen it all. The A272 is the

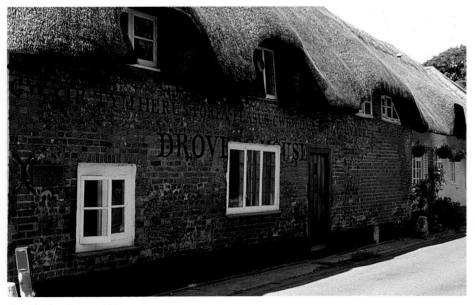

Stockbridge, Drovers' House

little entrance to the estate behind it. The door on the road is closed. At the other end there is no door, just an opening in the wall. There is one room inside with rounded corners that is completely empty. And always has been empty, as far as anyone now living can remember. Surprisingly, for the thing has always been called 'the grotto'. So besides being a mock gate, a mock castle and a mock lodge, it's a mock

grotto as well. It belongs to Houghton Lodge, of course.

F*or those who can't get enough: there are some nice villages west of here. Butt's Green, Lockerley and the Tytherleys. But it may be time to head back. Just one more. West of Houghton is* **Broughton** *[brawtun]. Near the bridge across the river you can see the spot where the cars used to go right through the*

Drovers' House. Not only cattle and sheep, but even geese were driven all the way from Wales along the broad drove roads (which you can recognise by their outsize verges). The text on the front of the house reads: GWAIR TYMHERUS PORFA FLASUS CWRW DA A OWAE CYSURUS. A Welsh friend of mine tells me it means HAY SEASONED, PASTURE DELICIOUS, BEER GOOD AND BED COMFORTABLE. It must have been a popular guest house in the past. Pity that somebody has now run a window right through the inscription. Cavalier, but they did tell me that Stockbridge was cowboy country.

The geese, by the way, were shod to save their feet on the long way. With a little stud nail wrapped to the web with tar, if you please.

191

Best Kept is a common phrase for a number of contests aimed at keeping the English countryside *in optima forma*. Best Kept Small Village. Best Kept Large Village. *Et cetera*. City people can hardly be aware of the amount of trouble that country people go to in order to compete. As an example let me cite the possible entries for the Test Valley In Bloom campaign. You can compete for the following categories: Best Front Garden, Best Schools Project, Greenest Commercial Premises, Best Kept Village, Best Shop or Business in Andover town centre, Best Shop or Business in Romsey town centre, Best Kept Street, Best Public Service, Best Hotel or Guest House, Best Allotment, Best Woman's Institute Project, Best Garage and Best Sheltered or Residential Home. According to the special brochure on the subject independent and appropriately qualified judges will, among other things, look for absence of litter, graffiti and vandalism and for enthusiasm and visible floral impact. Southern England in Bloom is the first stage of the annual nationwide Britain in Bloom competition organised by the Tidy Britain Group. So watch out: they are coming your way as well. I may make it sound ominous, but they deserve every form of success of course.

much thought, but in my naivety I had supposed that the UK like other countries had an army with ground vehicles, an airforce with planes and a navy with boats. How complex life can be becomes clear even if you only read the guide book. The collection was started in 1947, but wasn't opened until 1984. You can experience a bit of the history through the exhibits, but there is no actual flying for visitors. The planes can only be seen on the outside, some helicopters also inside. The museum attracts close to 50,000 people each year and is far enough away from the Wallop villages not to make too much of a disturbance.

*To round off this section, and referring to a very English custom, I would like to say: the three Wallops must regularly score highly on the **Best Kept** lists, I should think.* ☆

most English of English roads. With all its history. With the people along the way. With its hills and valleys, its forests and rivers, its towns and villages. With its diversity, its inconsistencies, its richness and its beauty. The A272 is England.

Broughton

Broughton dovecote

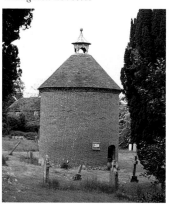

water of the Wallop: a real ford. Here too, as in Nether Wallop, are a number of thatched walls. These walls belong to a type of old houses and farm that has become rare now. Enclosing walls were also covered with tiles sometimes. The few that are left nowadays are listed. The village boasts an elaborate well-house with good oak beams. In the churchyard is a round dovecote. You can get a key to have a look inside.

Probably 14thC, later rebuilt and restored. Interesting, if you have never seen one. Modern sculpture can be seen at The Garden Gallery in Rookery Lane, and it is not bad at all. What can I say? Broughton is another village on a little river (just before it wallops into the Test) and has been perfectly preserved, showing the usual mixture of half-timbered cottages and brick houses. As typical and as lovely as any.

I DO BELIEVE HER THOUGH I KNOW SHE LIES

I do not like being tested through randomly proffered temptation. But I might have been forgiven for starting to hit people. Here is what happened. At the roundabout just before Stockbridge the owner of the hotel had shown me a green little guide to the town, saying that it should be for sale. *Where?* I asked. Ah well, my best bet would be the general stores. So I went there and was told that they had never heard of it. A guide to Stockbridge? Who would need one? Who would want one? *I did.* Maybe I should try the newsagent's. But the newsagent and his customers had never seen it and didn't think it existed. Explanations about the village? This is a cowboy town, they told me, and nobody knows anything. We all do what we like around here.
Was I sure I had seen it? *Yes I was, a green little guide. And I had seen a village hall or something as well. Would people there know anything about it?* Indulgent smiles. Village hall? Some persons will be very cross if you call it village hall. This village has a town hall. But it is not open. It's always closed and nobody will know anything anyway, so the best thing I could do if I really believed in this thing and was sure I wanted it was maybe to find Mrs C. She's on the council. She won't be at home now, but she often works at the butcher's. *Thank you,* I said. I began to get curiouser and curiouser about this town.

So I went to the butcher's. *Is Mrs C. of the council here, please?* Of the council? What council? *I don't know; town council or parish council, perhaps?* Phew, do we have a parish council? What for? *You should do, I think.* Really? Yes we do, someone else smiled coming from behind, and Mrs C. is on it, and she might know about a town guide, but she is out on her lunch break. If I wanted it straight away I could try the hotel opposite. So crossed the road and asked at the hotel. No, they were sorry. But the police in this town always know a lot. Would I try them? *Yes, why not?* So I crossed the road again and found the police station closed. Back at the hotel I asked if they had any other ideas. Well, there is another newsagent opposite. Had I tried them? *No. I hadn't.* So I tried them. Hard luck. Had I tried the gift shop nearby? *No, not yet.* This gift shop didn't have little green handbooks, but they did have the idea I could ask the garage man opposite, since he was one of the older inhabitants of Stockbridge. He was, but he didn't know about a guide book. The church next door has a guide, he said. So I went and had a quick look, but that wasn't it. Maybe Mrs C. is back from lunch in the mean time. Ah, no, not yet. But here is another suggestion. If I had seen this book, I could perhaps borrow it from the owner and try and make photocopies.

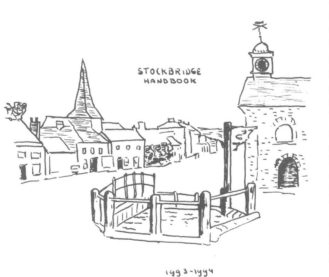

STOCKBRIDGE HANDBOOK

1993-1994

Hey, that's something. *Where can I make photocopies?* Oh, ah, that's a bit tricky. In fact they didn't think it could be done at all. So let's see, what can we do? The antiques shop near the roundabout has some second-hand books. You never know. *No, you never know.* So I went to the antiques shop. And lo and behold: there it actually was. Green handbook. No problem. For a pound it was mine.

Later I saw some message in Welsh on the front of a private house that had been an inn a few centuries ago. The Drovers' House. I thought it would be interesting to talk to the people who lived there and ask some questions, but they were not in. So I went to the next door neighbours and enquired about this message. *What did those words mean?* Well, it was something like: this is a nice place. *And if I wanted to know exactly what it was?* Ah, I had them there. But wait. A few years ago a town handbook had been published with all sorts of information. The answer to my question was sure to be in it. They were positive this handbook was green and it was for sale. But where? My best bet would be the general stores. *Yes, of course,* I said. *Thank you,* I said. *Good idea,* I said. I am not very happy seeing amiable citizens crucified needlessly. Tranquil, stoical, serene, quiet, calm now am I.❈

Looking

In the year 2000 the 90 miles or 144 kms of the A272 were intersected

by Roman Roads:
at Maresfield: the Roman Road from east of Brighton to London;
at Haywards Heath: the Roman Road from west of Brighton to London;
at Billingshurst: Stane Street from Chichester to London;
between Midhurst and Chithurst: the Roman Road from Chichester to Silchester;
and north-west of Winchester: the A272 follows the route of the Roman road from
Portsmouth to Cirencester;

by railroads:
at Buxted: from Uckfield to London;
at Haywards Heath: from Brighton to London (Clayton Tunnel);
at Billingshurst: from Littlehampton to London;
at Petersfield: from Portsmouth to London;
and at Winchester: from Southampton to London,

and by dismantled railways
four times;

by rivers:
Uck, Ouse, Adur, Arun, Rother, and Itchen,
most of them several times;

by long-distance walkways, also from east to west:
Vanguard Way, Weald Way, Forest Way, branch of Sussex Border Path, Downs Link,
Wey-South Path, Lipchis Way, Sussex Border Path, Hangers Way, Staunton Way,
Wayfarers' Walk, South Downs Way, with the Test Way, Clarendon Way, and King
Alfred's Way nearby;

by countless roads, among others
the A23: east of the A23 is AA Roadwatch Region 9C, tel. no. 0836 401 125;
west of the A23 is AA Roadwatch Region 9D, tel. no. 0836 401 126;
the A3: west of the A3 zone 3 starts where roads get numbers beginning with 3;

by the Greenwich Meridian
between Newick and Chailey;

by countless footpaths
 and bridleways;✤

by electricity transmission lines:
eight times;

by county boundaries:
twice;

and by district boundaries:
five times. ✳

Going from east to west you have gone through
6 (ES), plus 17 (WS) plus 13 (HA)
equals 36 parishes,

and you have passed the following items along the road:
19 petrol filling stations,
11 newsagents,
4 cricket fields,
34 telephone boxes,
 (13 red, 15 modern, 6 pairs),
3 AA telephones,
2 RAC telephones,
47 postboxes
 (13 red pillarboxes),
4 lychgates
 (sounds impossibly few),
0 Folly Farms, since 1996,
13 sets of traffic lights,
1 extra traffic light
 for road works, I guess,
33 roundabouts (and counting),
28 hotels or B&B's,
21 churches, and
32 pubs. Cheers✳.

test

I hope you have had as much joy reading this book as I have
had writing it, and that you have seen everything properly,
as a good reader should. In that case you shouldn't
have a problem recognising the picture opposite
or any of the ones on the following pages.
The one on page 202, on the other hand...
It is not much of a test, of course, but
what is it?

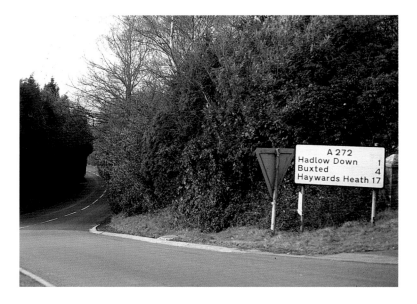

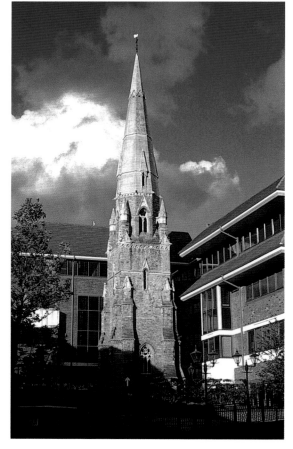

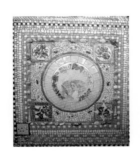

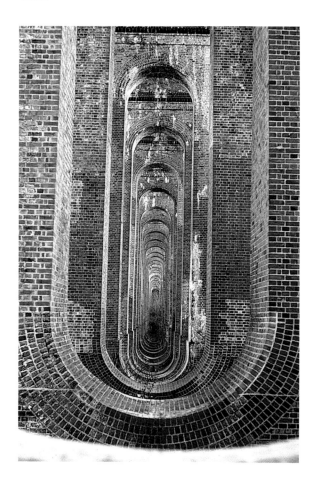

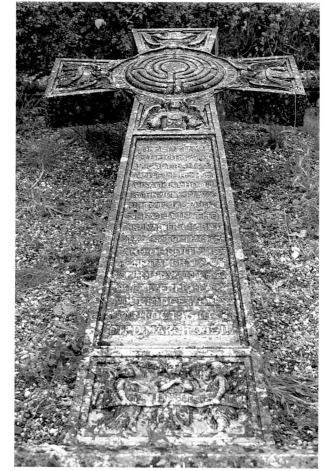

answers

Page 196:
clapper bridge at Lickfold WS

Page 198
centre:
Green Man, Barton Stacey HA
clockwise from top left:
St Nicholas, Buxted church ES
Beginning of the A272, Poundford ES
Church spire, Horsham WS
Maze, Parham WS

Page 199
centre:
Rape of the Lock mosaic, West Grinstead WS
clockwise from top left:
Charity, altar detail Barton Stacey HA
Intech at Morn Hill, Winchester HA
St Bartholomew's, Brighton ES
Carved heads, Bury WS

Page 200 clockwise from top left:
Balcombe Viaduct WS
Chimneys, Hursley HA
Maze grave, Hadlow Down ES
Sheep Street, Petersfield HA

Page 201 clockwise from top left:
Crucifixion, Lodsworth WS
Jack and Jill windmills, Clayton WS
Whipping post, Ninfield ES
Cowdray colours, Easebourne WS

Page 202:
I don't know what this is either, but it's at Houghton Lodge HA.
If anybody knows what it is, please write to me
c/o my publishers, at the address on p.255

Gazebo cum dovecote, Nymans

addenda

with Rita Boogaart

The fascination with the A272 was not over with the publication of
An Ode to a Road. We kept travelling along it, taking notes
and more pictures, finding out about changes
and new facts that we wanted to include.
And then there were the letters from the readers...

Everything that did not fit in the revised and updated preceding pages,
but that we did not want to withhold from readers,
you will find in this newly added section, updated in 2010.

Each item is headed with the star that signals it in the main text;
and is concluded with the number of the page to which it refers
followed by M for middle text, or

N for north,
E for east (notes in the wings of uneven pages),
W for west (notes in the wings of even pages), and
S for south.

eleven years on...

INTRODUCTION TO THE ADDENDA

The publication of the book *A272, An Ode to a Road* caused quite a stir – for a travel guide. It seemed to touch a nerve. What it was exactly that people liked about it, I don't really know. The idea of writing a book about a road with a number? The way it was put together? The essays between the chapters? The general tone? Possibly a combination of these. Many readers confessed to sharing my love for this particular road. Perhaps it was the A272 itself that raised so much enthusiasm in them. Anyway, after a number of radio interviews and TV appearances it sold well, much to the publisher's delight. He had really gone out on a limb on this one and was rewarded in reprints.

It also sparked off some unexpected side-effects. A series of walks was inspired by the book and a CD with folk music was compiled in its honour. Scores of letters were sent to the publisher's address. In fact, I had brought this upon myself: I'd invited readers to respond. And it has given me tremendous pleasure reading these letters. Indeed I was quite moved by some of them. One correspondent wrote that she had only one quibble: she loved the book and now she had to buy four more copies, one for a friend and three for her sons!

I am enormously grateful to everyone involved. Especially to those who have taken the time to explain things to me or tell me what I had missed or just remembered things and let me know. It hasn't been easy to collect it all and think of a way to work it into the book. You see, the nature of the *Ode to a Road* makes it virtually impossible to put new data in without leaving something else out. I can't put in a new paragraph without having to shift one of the notes or pictures to a following page, with disastrous consequences for that page and indeed the whole book. In some cases I could make the pictures smaller, but on the whole they are too small already. It was a huge job to balance the book (text for the road itself, the north and south sections, the choice of the notes and the positioning and size of the pictures), and I simply can't upset the system. That is why we have chosen to revise and update the book wherever possible within the system, and so keep it very much as it was (after all, it was already near-perfect, wasn't it?!) and make additions to the text at the end of it.

Still, we had quite a job adding new information at the appropriate places. But this is an ongoing process and we had to stop somewhere. And then you see a new book, for example, and you hesitate again. Crap Towns came out. I much enjoyed reading this funny little book, especially about the towns that we also talk about in the A272 area like Horsham and Winchester, but do we dignify the abuse, half-truths and ludicrous remarks by commenting on them? Do we? No, we don't. Wouldn't be fun anymore. In one way it's a pity, but we must indeed put an end to our work after eleven years.

Enjoy the Addenda! After the complicated way in which you had to read all the previous pages, you will like the fact that you can read smoothly on till the end.

As we said on the previous page: lots of people have responded to the various editions of this book. They have written letters or have gone out to do research for us They have given us photographs or tips. They have given us whole books. Some have given us drinks, meals, a bed for the night even. It goes without saying that we are enormously grateful. Good people: thank you very very much for your generosity. We hope you won't blame us for not mentioning all of you here. There are simply too many of you who have been kind to us. We run the risk of disappoinment here, but you didn't do it for a mention in the book, did you?

Terwick Common: church with lupins

★

I ought to tell you about the **Sussex Book Club**. From the moment this *A272* book was published it proved to be a firm favourite with members of the club, founded a few years ago by my fellow writer David Arscott, whom I quote a few times with great pleasure. No county has more books written about it than Sussex, which no doubt explains the club's great success. Twice a year David produces a free newsletter with dozens of new titles from the leading publishers of Sussex books, together with some produced by enthusiastic one-man bands. So if your bookshop, by some awful mischance, hasn't got a copy of *A272 – An Ode to a Road* you know where to get one. The Sussex Book Club is now run by Judy Moore, 6 Castle Banks, Lewes BN7 1UZ, sussexbookclub@sky.com. 8 S

✳

The love of the South Downs was expressed in a poem called *England's Green and Pleasant Land* in the anthology *Thoughts of a Dying Man*. It is by Michael Myers (1920-1992), who lived along the A272 near Petworth. He was convalescing from a life-threatening illness when he entered a competition to write a poem with this title. It was his very first poem, and it won first prize; here are a few lines:

But still the silent clouded hills are mine
To view once more, this time with sanguine hope.
Later this day, in pale autumn sky
The sun, a chariot of fire, will blaze a bow
Of burning gold. Encouraged by this shining
Countenance divine, I too will show my strength.
 9 M

✪

Since this book was published the use of internet has boomed dramatically. Nowadays a cleverer surfer than I am can find much useful information on numerous subjects through the web. This might be the right place to refer you to the internet for changeable data like accessibility, opening hours and entry prices. Some basic sites to start with: www.visitbritain.com, www.tourist-information-uk.com, www.sussextourism.org.uk 9 E

Of course I mention certain literary figures where they are relevant, but this book doesn't specialise in all the writers in the area. I know of only one that does for (part of) Sussex. In 2007 a book was written by Peter Anderson and Keith McKenna, called: *West Sussex Literary Trail*. Peter Anderson by the way had also co-operated on books on footpaths in the area: *The Sussex Ouse Valley Way* and *A Companion on the South Downs*, both being delightful publications, full of reliable and interesting information. But this literary trail book has so many details on authors and the landscape that it surprised me on many occasions. Written with a sense of humour into the bargain. I can recommend it and I'm waiting for an East Sussex version. 10 W

Later in the 18thC there was a time when people of Horsham could only reach London by going via Canterbury. Arthur Young, who came from Suffolk, described this around 1800 as 'one of the most extraordinary circumstances that the history of non-communication in this country can furnish'. 15 M

Roads like this one are gradually getting more and more unsafe. That's why nowadays you regularly see signs that certain stretches deserve a High Risk Route warning. Again: please drive slowly and safely. I wouldn't like to lose customers. 20 S

In a more northerly approach to the A272, you could visit the village of **Wadhurst** with its hanging tiles on the houses and its lovely little bookshop. 24 M

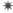

Mad Jack Fuller of the Rose Hill estate in **Brightling** came from a family who had made their fortune in the iron industry. He had two other

View from the Sugar Loaf to the rotunda temple, Brightling

nicknames, Hippopotamus and Honest Jack, both equally deserved. 'Hippopotamus' was due to his figure – he was a large and burly man with a booming voice; 'Honest' because he was outspoken and straightforward in his opinions. One of his mottoes was NOTHING IS OF USE WHICH IS NOT HONEST. It is the text beneath his bust by Sir Francis Chantrey in Brightling church. This often got him into trouble when he was an MP. He was all for slavery at a time when that had become unfashionable –

Bust of John Fuller by Chantrey

he profited by it in a big way. Devoutly conservative he suspected plots against king and country everywhere and on these occasions he would rant and rave, insulting people and making enemies everywhere (calling the Speaker 'an insignificant little man in a wig') until he was physically removed from the House. Later he would sometimes regret his behaviour and apologise. His was an extravagant, not to say tempestuous career in Parliament, which lasted about ten years. Mad Jack always remained a bachelor and a character. He helped found the Royal Institution and counted among his friends such widely divergent men like the scientist Michael Faraday, the physiologist and linguist Peter Roget of the *Thesaurus*, the landscape architect Humphry Repton, the sculptor

Joseph Nollekens, the composer William Shield, the painter J. M. W. Turner and the architect Robert Smirke, who probably designed some of the follies.

24 M

Surely there is more to be said about the house called Bateman's in **Burwash** than I did in my cursory introduction to the place ten years ago. I'll make up for it now. It was a beautiful home to Rudyard Kipling and the National Trust still takes good care of it. Almost all year round they organise special events, like walks, exhibitions and evenings, and they are very inventive. You can have dinner there occasionally and learn about flowers or furniture at other times. You can have a look at Kipling's study where he wrote his books and at his 1928 Rolls Royce in which he would explore the Sussex countryside. But the main attraction is the whole atmosphere of a family home which could still be lived in. My wife Rita spotted three stages of the willow pattern in the collection: on Nanking ware and 19thC Staffordshire Ashworth real ironstone China, if that means anything to you. If it doesn't, go and sit in the garden somewhere as an alternative. I did. Or go to the shop or the tearoom. There is something for everybody, also for visually impaired people. It's a beautiful place that attracts close to 100,000 visitors per year. If you have read *Puck of Pook's Hill* or *Rewards and Fairies* you will sense the history and myth of the place even more convincingly, as they are both based on Bateman's.

24 M

209

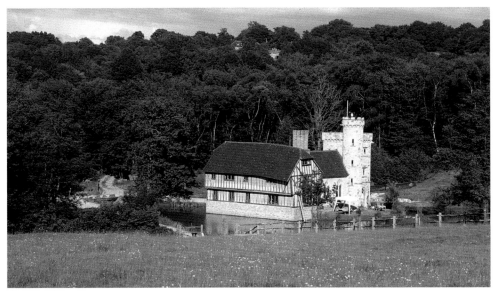

Braylsham Castle

rather: don't talk to John Mew, for although he is happy to call his castle a folly and is very hospitable to his friends and acquaintances, he is not keen on receiving unannounced strangers (would you be?). Besides, the lanes leading down to the castle are too narrow for traffic, really. But imagine the shock and surprise you would get if walking along the public footpath you unsuspectingly and suddenly came upon this centuries-old castle, built just a few years ago! 25 M

At about the same time I was preparing and writing my book on the A272, John and Jo Mew were building their **Braylsham Castle**, roughly between **Broad Oak** and **Mayfield**. John Mew is a dentist, or rather an orthodontist, a highly specialised one, who built the castle partly out of frustration with the profession, he told me. The castle is on a little island in a lake. The lake is fed by a contributory of the eastern river Rother and took two years to dig out. Then in 1995 they started the actual building process, which lasted until the year 2000. They did most of the work themselves. For example, the whole family joined forces putting in the drains, but John did the lion's share and actually carved the oak beams himself. There is a drawbridge, a dungeon, a minstrels' gallery, secret passages and a pillory. The Great Hall is a miniature version of Westminster Hall. The keep was inspired by visits to local castles, basically on the pattern of the 12th and 13th centuries. The stairs are cut in such a way as to suggest ages of wear and tear and in short: not only the exterior but also the interior with all its paraphernalia looks as if it has been there for centuries. But there is modern plumbing in the back rooms, because this has been the Mews' home since 1998. Do you want to know how to make a modern table look 400 years old? Talk to John Mew. Or

– So you've come all the way from Uckfield?
– It isn't very far.
– I know, but it sort of sounds far, doesn't it?
Noël Coward, *Present Laughter*, 1947 25 M

The book *Eccentric Britain* by Benedict le Vay tells me that on the last Monday of August the Sussex Bonfire Society Marching Season starts in **Rotherfield**. Sounds exciting. Apparently there is a procession and things do get burned. Later there is more of the same in Uckfield, Fletching and Littlehampton, right until November. They promote these happenings on their websites, with fireworks displays. I wonder where they all go on Guy Fawkes Day. 26 N

The ground floor of the Gibraltar Tower in **Heathfield** Park is octagonal, while the main part of the folly tower is circular. In the past ten years we have regularly tried to get into the park in order to photograph it, but we have never been successful. The best

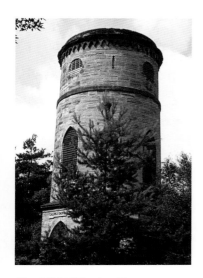

Heathfield Gibraltar Tower

pictures we have of it come from The Neville Hawkes collection in the archives of the Folly Fellowship's Picture Library of which Rita is the guardian. They date from 1966! One of them shows the entrance over which the words CALPES DEFENSORI are visible, to the defender of Gibraltar. The tower still is in a sorry state, but how sorry? Some trees are in the way if you have a peek from outside the fence. 27 S

I could mention the village of **Buxted** and I could also mention countless other places like Lewes and Uckfield to remind you of the terrible floods we had in this area in the autumn of the year 2000. The first intimation I myself had of what was going on, was when we happened to be sitting at the breakfast table in a hotel in Halland and saw a police car towing a trailer carrying a huge boat, followed by an ambulance with an inflated

lifeboat on its roof. A most unusual sight. We asked what that was about and heard that there had been floods. Later that day we found that we couldn't go to Lewes as we had intended, because the roads were all flooded. As tourists we were hardly affected ourselves (we watched the developments on the hotel TV mostly), but we took the opportunity to have a good look round the next few days and were genuinely impressed by the sheer size of the damage that was done and the misery it caused. I guess that few people will be happy to be re-minded of that awful period and I will stop talking about it, but I do think that the episode is important enough in the history of the area to warrant a picture. This photograph was later sent to me by Dr Robert Harrison of Buxted and shows part of Buxted in the floods. The A272 is there somewhere. In 2009 Johan Stegers sent me one of his contributions: photographs to show how a pair of flood water tunnels was constructed at the bridge in the hope to prevent future disasters at this bottle-neck. But if that can turn the tides? 28 M

☆

In 2009 we found the Cuckoo Trail extended from Heathfield to Eastbourne in the south, but the exten-sion northwards to London still hampered by reluctant landowners.

Down the A267 and a bit to the west is the village of **Chiddingly**, where Antony Penrose has recently turned Farley Farm into a museum, first opened in 2000 for guided tours with refreshments. He is the only son of the surrealist painter Sir Roland Penrose (1900-1984)

Buxted, autumn 2000

and the American surrealist model and photographer Lee Miller (1907-1977). Antony is a farmer really, but twenty years after his parents died he got more and more fascinated by what they and all their friends left him in the 35 years they spent there. This was no mean circle of friends. Lee's former lover in Paris, the surrealist photographer Man Ray, Pablo Picasso and Joan Miró (Roland was biographer of these three), Paul Eluard, Henry Moore and others were regular guests at the weekends. It was on these occasions that his mother Lee served such delicacies as green chicken, blue spaghetti and pink cauliflower in the shape of women's breasts. Roland Penrose and the guests left their traces. Apart from the Lee Miller Archive of photos and negatives Farley Farm contains a number of murals and bizarre objects and you should feel privileged to see it – group visits only. It is expensive, but then you are getting something special. It's not too far from Charleston Farmhouse anyway. Just as Farley Farm was 'The Home of The Surrealists in England' its barn is now developing into a gallery and an arts centre by the Farley's Yard Trust, set up to carry out educational work and encourage young artists. 28 S

<div align="center">*</div>

Eridge estate itself may be private, but what is accessible, and was formerly part of it, is **Eridge Rocks.**

This is a 'majestic sandstone rock outcrop among mixed woodland', as the Sussex Wildlife Trust says. In 1997, when the Trust bought this site, designated Site of Special Scientific Interest because of the rare mosses, liverworts and ferns growing there, the rocks were hardly visible at all for the rhododendrons. Now after clearing these Victorian 'weeds' away there is a good footpath along the 660 yards of stony projection, lying there in the middle of a varied landscape full of chestnut and holly, of ferns and bluebells and of woodland birds. Ideal for half an hour with the children, or for picnics. Alas, climbing the creviced sandstone cliffs is only allowed along a few routes set out by the British Mountaineering Club according to 'the sandstone code of practice'. And the British Pteridological Society has an information board on the fern world along the path. All in all rather surprising. You can trust me – as always, I was there. Park your car or your bikes in the car park nearby. The entrance to it is a small (private?) road off the A26, near Eridge church and a bus stop. 29 N

<div align="center">✳</div>

I was told that between **Uckfield** and **Horsebridge** the milestones have the Pelham Buckle at the top. This commemorates the Pelham family who came here with William the Conqueror and were granted lands in and around Hailsham. During the wars in France John Pelham helped to capture the French King John, and was given the buckle of his sword belt. The Pelham Buckle appears on the stonework of churches at Laughton, Ripe, Chalvington, Chiddingly, East Hoathly, Wartling and Waldron. The family had houses at Laughton and later at Halland. The first John Pelham was buried in Canterbury Cathedral, where there is a stained glass window to him in the Chapter House. The family became Dukes of Newcastle and also Earls of Chichester.

32 W

Eridge Rocks

In 2009 we were in **Maresfield** again. By the way (literally): the ornamental lamp that I had mentioned (and that presumably made Jeremy Paxman in Newsnight cry out that I had extolled the virtues of every lamppost along the road) looked as if it had had some work done on it. Good.

32 M

The Thai restaurant and house altar at **Ringles Cross** were given up for a new housing estate in 2008-09.

32 S

Between **Halland** and **Framfield**, on the High Cross Estate, a half-Dutchman called Nicholas van Hoogstraten has been building a sumptuous neo-classical residence for himself, Hamilton Palace. He started in 1985. Its dimensions (on Google Earth you can see the vastness of his enterprise) will probably cause it to be called a folly in a few years' time, if it ever gets finished. Van Hoogstraten made made his pile in Zimbabwe and dealing in houses in the Brighton area. He is very controversial, if only for ploughing the footpath to keep his property private, and there are all sorts of rumours about him. He was in prison for a year for implication in a manslaughter case and released and cleared in 2003. One of Van Hoogstraten's adopted names is Adolf von Hessen, but in the press he is often called Nasty Nick. Anyway, he was providing a lot of business here, to put it charitably, until the building was abandoned in 2006 after problems with contractors and the sacking of his architect (according to rumours). He is staying in Zimbabwe himself, being a friend of President Mugabe. Nice friends.

33 S

In order to celebrate the Millennium the people of **Ringmer** paid for the construction of a clock tower. It has seats on all four sides and a weathervane with a tortoise on top. This is in memory of Gilbert White's Timothy Tortoise. Gilbert's aunt was from Ringmer, and she passed the little animal on to Gilbert before he moved to Selborne, I understand.

One correspondent told me among a whole wealth of details that some famous people got married in Ringmer church. William Penn for one (second marriage) and John Harvard, founder of America's oldest university in Cambridge, Massachusetts, for another. He felt rightly proud to mention that he got married there himself.

33 S

Ringmer Millenium clock tower

Hamilton Palace

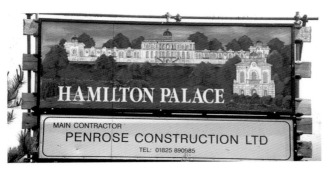

Near Halland is **East Hoathly**, where Thomas Turner (1729-1793) once lived. He was a teacher and grocer and in his diaries, which belong to the classics of that genre of English literature and were reprinted many times, he painted a vivid picture of rural life in Sussex. I was greatly surprised that the Dutch national newspaper I subscribe to quoted a few pages from it and I was sorry to have left him out of the first edition of this book.

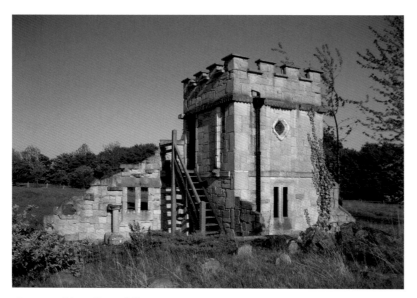

East Hoathly, Jullian's folly

The diary comprises only eleven years, 1754-1765. It was recently edited by David Vaisey, who calls it a unique chronicle. Thomas (I know him intimately now) was not only shopkeeper (groceries, clothes, haberdashery, accessories), but also undertaker, schoolmaster, taxgatherer, churchwarden, overseer of the poor and much besides: an important man in the village. I like his little philosophies. 'Oh! What happiness must there be in a married state when there is sincere regard on both sides and each party truly satisfied with each other's merit; but it is impossible for tongue or pen to express the uneasiness that attends the contrary.' His first marriage was not a happy one. His wife was sickly and quarrelsome and she died young, just when he started appreciating her: '... she has ever been a virtuous and discreet woman and to me the best of wives.' Thomas describes village life colourfully. He plays cricket, goes to the races in Lewes, gets drunk occasionally and is pitifully sorry about that. 'Sure I am possessed of some demon that I must be so stupid!' But this too fits with his world-view: '... most people are blind to their own follies.' Altogether moving descriptions are when his wife, 'poor creature,' dies and when he is present at an autopsy when a woman and her fœtus are examined. Later, at the end of the diary, he marries again and they have seven children. The pub Thomas Turner regularly went to in East Hoathly (now called The King's Head) is near where his shop was. Part of it is used at present as a

micro-brewery, where David Seabrook does brewery tours. There is a cosy little bookshop nearby too, also for rare and second-hand books. Yes, in East Hoathly. The owner, Jane Seabrook, is a heroine.

East Hoathly meanwhile has acquired yet another claim to fame: it was mentioned in the magazine of the Folly Fellowship because one of the members had discovered that a new folly had been built here: Jullian's Folly, after Jullian Akers-Douglas who created it. It's at Barham Farmhouse, a charming little two-storey tower, castellated, buttressed and with some stained-glass windows. When the sun shines they cast 'a magical light over the interior, which is fitted out with a staircase to give access to the roof, providing "a bit of a prospect"'. At the back of the tower is a fake ruinous wall and a pet cemetery. The whole has an ecclesiastical look about it. Jullian herself has moved away from East Hoathly, but the new inhabitants of the place are friendly enough to allow you a closer look if you are not satisfied with a peek from the first bend in the drive up to the farmhouse. 33 S

The horizontal barber's pole under the arch of the lodge to **Maresfield** Park has gone in the meantime, hopefully for good. Maybe they have read this book.

The Chequers Inn at Maresfield may look Georgian (a new plaque for this grade II listed coaching inn states that it was built in 1734 by London merchant Nathaniel Newnham for the reputed sum of £400, as a staging post on the way to Lewes) but that is only partly so. Other parts are older or much older. Especially the area around the well, which is inside and may have a tunnel connection to the church (but we have heard that one before). 34 M

The Lavender Line in **Isfield** is not much fun on workdays, I said. But in preparation of the new 2011 edition of this book I looked them up on the internet and was pleasantly surprised. It turned out to be an

attractive website, all about the signal box, the model railway, the children's playground and the Cinders Buffet and all that. Which made us go and have another look. This time we were in luck, for there were at least a few people present that we could talk to. They explained to us that the line was still very short. Using a steam locomotive costs 400 pounds for every ride to nowhere in particular and they had to wait till the summer until they had groups of ten people for the return trip. The recent recession also took its toll here of course. However enthusiastic the volunteers are, it is still tough going for them. A pity that we could not enjoy a train ride on this day, but now at least we came away with more than a few brochures. 35 S

※

In 2010 the Bluebell Railway 50th Anniversary Appeal was launched to raise £4 million for clearing away the last obstacles between Kingscote and East Grinstead station. Better late than never! 36 N

☆

Barkham Manor in **Piltdown** produced an excellent white wine, they said. And I repeated it, although I wasn't entirely sure what that meant: national or international standards? Anyway, the discussion has become purely academic, since the property changed hands. No vines anymore. But what is worse: the little monument that indicated the spot where the Piltdown Man was found (along the drive up to the Manor) can't be seen, as it is on private land now. In order to prove the existence of the little monument,

Piltdown monument

here is a picture of it in better days, as it was before the new owners took over. And by the way, the Piltdown Man pub sign has changed again and lost its fun aspect. The publican said to blame it on the change of brewery. The pub itself was thriving when we last saw it and had a children's playground beside it, fenced with giant pencils in gay colours. 36 M

❄

Barcombe Cross used to have a railway station and a pub, but both are now private houses. My spies had told me that the pub, the Angler's Rest, was closed in 1999. It used to be a romantic place, but apart from the railway lines themselves (along which you can walk and also ride a bike) there is nothing very special to be seen there any more. The same spies had also told me that there was talk of re-opening the line between Lewes and Uckfield, while the Lavender Line at Isfield might come to an end. I haven't heard about the former, but the latter is definitely not on, fortunately. See also the addendum on Isfield Lavender Line on page 214. 36 S

✱

A Mr Reynolds wrote to me explaining about the village pump in **Newick**: 'the part visible is purely ornamental and immovable. The working mechanism is located on a ledge down the well shaft. To get to it two men (one of small stature) enter a man-hole a few feet away and crawl along a short tunnel. The smaller man stands in a rope-loop and is lowered down the shaft. He disconnects the pump which is pulled up to be worked on on the surface. The reverse manoeuvre is carried out to reinstall it.' He obviously knows what he is talking about and was probably trying to explain the problems. But it doesn't sound difficult to me at all! Newick is a small village, but is there a shortage of small plumbers? And if they can manage robots on Mars, there must be a way to work the pump from the surface, I would think.

Mr Reynolds also wrote me about Newick Park, the iron industry, the railway line, Fletching, Danehill and cricket at Sheffield Park, sending me a lunch menu for a cricket match against Australia on 12 May 1896, with twenty-seven items to choose from, plus four wines, brandy and whisky. Highly educational. 37 M

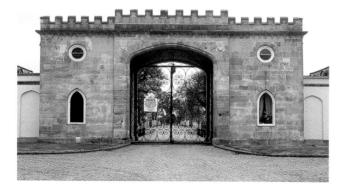

Sheffield Park, North Lodge

The North Lodge at **Sheffield Park** got its additions in the 1970's. Local people were appalled at what was done. In the pub nearby I heard the lodge described as the Ladies and the Gents.

In the first edition of this book I had called this lodge the West Lodge. I had found that piece of information in a lovely book called *Trumpet at a Distant Gate*, by Tim Mowl. But then a lady actually living in the former West Lodge contacted me and told me that I had been talking about the North Lodge. She had done some investigating and found that what is now known as the North Lodge was originally just called The Lodge, then Park Lodge and at one time Keeper's Lodge – but never West Lodge. Either North Lodge or North Park Lodge would be fine. The former West Lodge is further south along the A275, dates from 1912 to replace an older lodge, and is inconspicuous. Isn't it nice to dive into these things and find out? 38 N

Another inhabitant of **Lewes** was Thomas Paine (1737-1809). On the occasion of the 200th anniversary of his death a book was published about the connection between Tom Paine and Lewes. He lived here from 1768 to 1774 and here he developed into the inventor and revolutionary intellectual that he was. He later became one of the Founding Fathers of the United States of America and the author of a number of books, among others *The Age of Reason*, in which he criticised

Christianity. That made him very unpopular and there were only six people at his funeral in New Jersey. A remarkably low figure for such a famous philosopher and activist.

A few years after his death the grave was dug up by William Cobbett with the intention of taking the remains to England for reburial, thus saving it from abuse and vandalism. Some say that Cobbett kept the remains in a trunk in his attic and upon his death, his son began auctioning off the bones. Unfortunately, the whereabouts of the body are lost, but several people claim to have his skull. The Thomas Paine Museum in the USA claims it has the brain stem buried in a secret location on the property. 38 S

The landlord of the Bull Inn in **Newick** told me that each year 4,500 torches are burned for Guy Fawkes and the festivities are attended by as many as 10,000 people. They even close the road temporarily on that day. Close the A272? How dare they! Once we saw people needing ladders to build the huge bonfire, while Guy's effigy sat waiting fully dressed and in a hat at the Bull's fireplace. Dangerously close to it, I might add.

On the other hand, in keeping with the tradition in the village that the A272 is the main connection between the two places of pilgrimage, Winchester and Canterbury, the publican has converted the stables behind the pub into guest rooms which he calls the Pilgrims' Rest. For the price of one night nowadays your medieval pilgrim could organise the complete journey, but that is by the way.

Newick Guy in the Bull, 2004

The same landlord also confided to me that the bull in the pub sign should naturally be a Sussex bull, but is in fact a Hereford. Of course, I had thought so all along! Note the

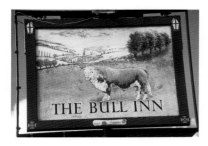

Newick, pub sign

mitres, the Tudor roses and the papal bull in the frame around the pastoral bull scene in the picture; the present sign may be different again.

Meanwile the Bull Inn in Newick was bought by another restaurant that is close by and right on the A272. Its name is.....wait for it.....**272**! How wonderful. I would have thought that as writer of this book on the A272 I would always be welcome to a free meal, but unfortunately that didn't prove to be the case (although I didn't really try too hard...) Seriously, it seems to be a very good restaurant and they are earning money as well: they bought the Bull Inn after only a few years of doing business. I have looked at the menu. It all sounds deliciously yummy and goes for more than I could afford normally speaking, but I find it extremely gratifying to come across that name, 272, along my road. (Alas, it has turned into Dino's with a new owner since 2010.) 39 M

A friend of mine read my ramblings about introducing the terms sack road and sack street into the English language and immediately supplied four alternatives: Boomerang road, Appendix, Trap road and U-road. He added the remark that the term U-road would definitely appeal to the British, as it will unconsciously and therefore irresistibly rouse negative euro-linked sentiments. Well, does it? And what about Bag End? I think I'll stay with sack street, though; it's closer to the original which it is supposed to replace.

The same friend later rang me up and asked if I heard of the term in the German language: Sackgasse. I hadn't, or I couldn't remember. Apparently the Germans have been using the word for ages and they have probably been employing the same line of thinking as I have. Literally translated it means sack street. So why would you favour an ugly and obscene French term over your own recreation of an old and venerable idea, that of sack street or sack road? I ask you. 40 W

I am sorry to say that **Horsted Keynes**'s North American Indian Centre & Museum disappeared with the owner when he sold The Forge a few years ago. It was a weird sort of attraction anyway, for this quiet village. So: no more ululations where they were hardly appreciated. 42 N

The Green Man pub in **Horsted Keynes** is where Scan Tester grew up. I read the biography of Scan Tester (*I Never Played to Many Posh Dances*, by Reg Hall), which was sent to me by Simon Haines. Pretty interesting stuff, not only for those with an ear for traditional music, but an eye for social background as well. Simon Haines had rung me up one day and asked me if he could use the book *A272, An Ode to a Road* as a source of inspiration for a CD of folk music he was going to compile. Of course I felt highly honoured and delighted (better praised ye canna be), and I told him to go ahead, please. A good year later he sent me a copy of his CD, all done by his group Sticks and called *Between the Downs*. There are only four members in Sticks, but they play a great variety of instruments, from hurdy-gurdy and dulcimer to bagpipes and bodhran. I can well imagine that to some people folk music is the most beautiful music in the world. I have always had a fondness for it and this particular CD goes straight to the heart. Maybe I'm prejudiced. Let me quote from the text on the CD itself. 'This recording comprises traditional songs and music from the area the A272 passes through, as well as new compositions inspired by places and events along the route.' I am particularly proud of Dodging the Turnpike, the Piltdown Waltz and The Tulip Folly Jig. I can heartily recommend this tribute. *Between the Downs* by STICKS, KM Records KM-GOB072, total time 60.15. Simon Haines and his friends perform live too, at venues for folk dancing and folk music. 43 N

One of the 'Brave Poor Things' at **Chailey** Old Heritage School for handicapped children is Alison Lapper, born without arms and with short

deformed legs. She came to Chailey six weeks old and left the school at seventeen to become an artist. Her work – paintings, photographs, installations and computer imaging – focusses on how people see her and her handicap. It is shown in major exhibitions and gets much publicity. She has already been rewarded with an MBE for her services to art. Recently Alison came in the spotlights of the national and international news when in the spring of 2004 Marc Quinn's sculpture of her, nude and eight months pregnant with her son Parys, was chosen to go on the empty plinth in Trafalgar Square for eighteen months. A modern *Venus of Milo* – without vertigo I hope. 43 M

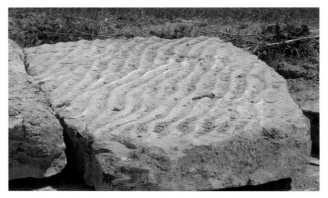

Horsham slabs ripplings

Much more should be said about the **Horsham** slabs, especially since we paid a visit to the quarry where they are still being dug out of the ground. I ought to say: extracted with machines as opposed to delving by hand. Where it all happens is at Lower Broadbridge Farm on the north-eastern edge of Horsham. It's a fascinating business, this firm, that was revived in 2004. We were cordially received by Ivor Warren who came to live here when he was 22 years of age and started farming. As a boy he had seen men with pick-axes and he thought that was wonderful. So he started farming and the stone-digging became a by-product. He still is a farmer and he is still digging stones, and he is in his nineties! Only, it's now all done by machinery and managed by his son and other co-workers mainly. In his 4x4 he took us for a drive across the fields to where the actual quarries were. A few times we had to cross a very narrow bridge, just a few horizontal cement planks really (a few millimetres left on both sides of the car). He drove slowly but with a casual bravado as if he had just acquired his driver's licence.

Later we saw the sheds where stones in all stages of production were assembled. Modern Horsham stone is used for flagstoning and paving, for natural walling, cropped walling and dressed walling, and for rockeries and other garden features. They can cut and split it any way you like it. All kinds of official cultural organisations use it for church restorations and for other listed buildings and even in new housing developments. But the most visible way in which it is employed is as roofing slates. Countless churches and other buildings have these stone slabs on their roofs, and not only in the

Horsham area either. The history of the use of Horsham stone goes back at least to Roman times. The Roman villa at Bignor shows the evidence. The slabs became precious. Horsham stone labourers worked on London buildings and were paid three times as much as any other workers, we heard from a local historian. Some of the stones have ripple marks, that the tides made on the sandstone beds. They are like the ripples you sometimes see on wet sand beaches.

If you want to know more, read the book *Sussex Stone, the Story of Horsham Stone and Sussex Marble*, by Roger Birch. As I said: a fascinating business, and responsible for much of the traditional building techniques that we have come to love in the area. At the end of our visit Ivor Warren showed us his beautiful house (his wife is a beauty too). He hopes to live to be a hundred, in good health. He has already come a long way and we feel sure he will get there 44 W

Slightly north of Franklands Village in **Haywards Heath** is an area called America. In the 1830's a local philanthropist set up a scheme for providing housing and land for poor people as an alternative to going out to America or the colonies. Traces remain in the names of the streets and in old people's memories. 46 M

I heard that in the year 2001 the National Cycle Network of Great Britain was opened. Hallelujah.

The Sustrans website www.sustrans. org.uk claimed in 2010 that the NCN now covers over 12,000 miles, and 55% of British people have access to the NCN within a mile from their home, or 75% within 2 miles. Which is most telling? The Safe Routes to School scheme and the blue signs with a white bike and route numbers will be familiar to many of you, and you will all be in-volved in their present campaign MORE HASTE, LESS SPEED for sustainable local travel by 2020. It's beneficial to your health and the environment. 46 W

Brighton City airport is at **Shoreham**. We spent a lovely afternoon there one summer looking at the Grade II list-ed Art Deco building (the sort of edifice that Hercule Poirot used). We had lunch there and were surprised at how busy it was. All kinds of light airplanes were flying to and fro, some of them very rare (like an old Catalina, that can land on water too). We can definitely recommend a few hours of leisure there, with Lancing college in the dis-tance. 47 E

Clayton railway tunnel was built in the 1840's. At 1¼ miles it was the longest tunnel on the London Brighton Line. Only one train was allowed in it at any one time, and signal boxes on both sides used a single needle telegraph to indicate that the train had come out the other end before the next one could go in. In 1861 it went wrong because of a failing sign, just when three trains wanted to pass at intervals of only a couple of minutes. The second stopped in the tunnel because it had seen an emergency red flag. When the first one was reported out of the tunnel the third was released, and sadly collided into the second train, which had by then started reversing to investi-gate. This Clayton Tunnel Disaster killed 25 people and injured 176 others, even today a large number, a major disaster. 47 S

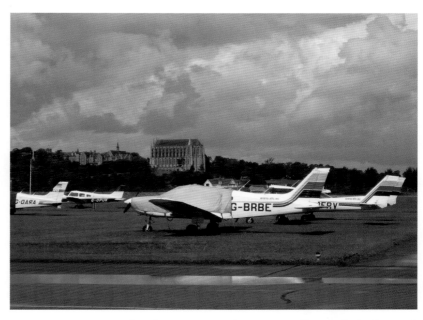

Shoreham airport, with Lancing College in the background

The attractiveness of a town for me is also determined by the number of second-hand bookshops, as I said on p. 48. Apart from the local charity shops **Haywards Heath** had good qualifications in that respect, because of the second floor of the Halcyon bookshop, where these books could be bought and sold. I remember spending a lot of pounds there. But, alas, the whole bookshop was no more the last time we checked, which was in May 2009. It didn't say on the window what would happen to it. I imagine things were difficult going, there on the overdeveloped traffic island over the railway track. 48 M

There wasn't a dolphin in the Sergison's Arms, was there? I wrote about the renamed Dolphin pub in **Haywards Heath** with not a little arrogance. But later I asked at the pub and learned that there was indeed a dolphin in the Sergison arms! Three of them, no less, although they look more like little sea horses or funny shrimps to me. Here follows a short description in the

official patois of heraldry people: 'The arms are blazoned: *Argent, on* *a chevron between three dolphins naiant embowed sable, a plate between two fleurs-de-lis* of the first.

Apparently the seafaring family. born in 1654, was in the Royal Navy Pepys) in addition Sergisons were a Charles Sergison, Commissioner (like Samuel to being MP for Shoreham. He bought Cuckfield Park from the Bowyer family in 1690; the house was 100 years old then. The actual age of the Dolphin pub is uncertain, but it is timber-framed and has some medieval bricks in its walls.

48 M

Rudyard Kipling wrote, in *The Glory of the Garden*, 1911:

Our England is a garden, and such gardens are not made

By singing: –'Oh how beautiful!' and sitting in the shade. 49

The gardens at Nymans

Cuckfield transmitter tree masts

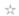

Has anybody ever told you that masts for modern telecommunication appliances like mobile phones have from the late 1990's sometimes been disguised as trees? Long shafts dressed up (as fir trees usually) with branches of various lengths are manufactured to make these masts less conspicuous in the landscape. It's a fact. Imagine then our surprise when we came across a few of them standing together south of the **Cuckfield** bypass. There was some variety in the way they looked, so we guess that they were on trial to see which ones would best blend in with real trees. It looked for all the world like a nursery for transmitter tree masts. We don't know how long they will stay together – they might be needed somewhere else, but as long as they are there you could go and see this quaint sight if you're passing anyway.

54 M

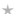

In the spring of the year 2000 **Borde Hill** Garden, together with the Surrey Sculpture Society, developed a sculpture trail which had more than 60 sculptures. Made of a wide variety of materials, such as marble, wood, stone and bronze, the works of art ranged from the classical figurative to the modern abstract. Everything was for sale. It has become an annual spring event. 55 N

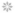

The **Cuckfield** Society have decided that some extra attention to the historic find of the dinosaur teeth

Information panel, Cuckfield dinosaurs

would be useful. So in the north of the village out on Staplefield Road, running west along a prominent ridge where in the early 19thC there were the Whitemans Green quarries supplying stone for building the Royal Pavilion at Brighton (the quarries now lie beneath soccer pitches), a monument to Mantell and his wife Mary Ann was erected in 2000, close to the car park. A lot of noteworthy information is to be had there, as long as the site remains reasonably vandal-proof. It is explained that the legend of Mary Ann Mantell finding the tooth of a dinosaur is only loosely connected to fact. From 1818 Mantell (born in Lewes in 1790) had paid Leney, the head quarryman, to send him teeth and bones found in the quarry. Teeth of what later proved to be from both the Megalosaurus and Iguanodon had been reaching him from that time. Mantell and his wife paid the quarry a family visit in 1820 and although Mary Ann did find some fossilised teeth on that occasion, it was not as important a find as legend implies. 55 E

⁂

The cleaning of the ceiling of the church at **Cuckfield** was completed in 2002 and the colours are vibrant again, particularly in comparison with a few untouched patches. Several details have re-emerged, the most notable being an early Christian symbol immediately over the altar. In the meantime the Millennium inspired a new embroidery for the church with a tree of (Christian) life and the four elements, all figured forth in modern techniques, by a group of parishioners under the inspiring guidance of Rosa McNamara. 56M

The new County Mall in **Crawley** sports two pavement mazes by the world-famous maze designer Adrian Fisher. He also was involved in the small mazes and the very large annual (since 1998) maize maze for Tulleys Farm Maze Fun Park at nearby Turners Hill, a popular family summer attraction. In his book *The Amazing Book of Mazes* Fisher further lists the Parham path-in-grass maze (Veronica's maze, after an embroidery design on Parham's Great Bed and executed for the Year of the Maze 1991) and the Shawford paving maze (see p. 254) as his projects. 57 N

⁂

James Forsyth died February 2005, aged 91. **Ansty** will need digital techniques if it wants to preserve his old popular sign for future generations. The pictured pub sign of the Ansty Cross disappeared from the front several years ago. I thought it was pretty unique! 59 M

Embroidery, Cuckfield church

Not far from Portsmouth the village of **Titchfield** had the whole history of the area condensed in six panels by local artist John Harper. Many villagers contributed to the colourful and densely populated embroideries in stump work, three dimensional stitching. It was inaugurated in 2000 as the Titchfield Millennium Tapestry and is on permanent display in The Parish Room.

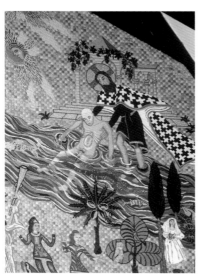

Detail Scaynes Hill stitches

Titchfield is just outside our area, but **Scaynes Hill** is very much on the road. Here is a detail of its stitches (see page 43). 59 E

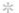

Sadly, we heard in 2002 that the philosopher publican of the **Henfield** Tavern, who wrote famous quotations on a notice board put outside his pub, soon had to discontinue this habit because of complaints of obstructing the pavement, and that he had died. Look what taking away a person's hobby can do to them. There is no philosophy against death.

But somebody else from the area is very much alive. Janet Bryon obviously thought that I had underappreciated this bit of rural England and wrote me a letter from Vancouver in Canada where she had emigrated after having grown up here. And, in a way I had. My excuse is that I couldn't do everything in this book. For instance, she told me that **Littleworth**, north of **Partridge Green**, had a pub called The Windmill. I knew that: I had had a few evening meals there. But I hadn't realised that I had seen no windmill there. Apparently Jolesfield Mill, a smock mill of 1790, lost its purpose when the steam mill came around 1900 and it is no longer there. It was moved to Gatwick Manor in 1959 where it is grinding corn again with six stones, but now powered by electricity. Nice to know.

This lady also drew my attention to **Ashurst**, a few miles south of Partridge Green, for which I shall always remain grateful. Ashurst is lovely. The flint-built St. James church with a Horsham slab roof has a vamping horn,

a sort of loudspeaker or loudsinger, one of the few remaining ones in the country. Sir Lawrence Olivier, whose home was nearby, was celebrated in his funeral at this church. Michael Fairless (Margaret Fairless Barber/Dowson), author of *The Roadmender*, the scene of which was set in the Ashurst area, lies buried under an oak cross in the churchyard. And Ashurst has a splendid pub called The Fountain, which in summer has plenty of room to enjoy lunch outside, near where the ducks are swimming.

Our B&B landlady Thelma in Littleworth directed us to a very minor memorial of a biking accident with an early tricycle near Partridge Green. It is south of the old railway bridge on the B2135 near Littleworth. A Celtic cross with a David star in the heart at the bottom of a steep slope to a stream was 'Erected in loving memory of W. H. W. R. Burrell, ... who through an accident that befell him at this spot was suddenly called to the presence of his creator 19 July 1883, aged 26 years'. He is buried in West Grinstead. A window in the church of St George (which has a vault for the Burrells) also mentions him. Didn't bikes have brakes in those days?

Partridge Green cyclist memorial

This landlady and her husband George are much like local historians. In 2009 they gave me a book to read, called *When the Whistle Blew, the Story of West Grinstead, Partridge Green and Dial Post in World War II.* It had appeared the year before, shortly after the founding of the West Grinstead Local History Group

and was based on some people's personal stories of war experiences, before they died out, if I may put it irreverently. It contains some fascinating details of several aspects: children, farming and other rural matters, doctors and nurses, the home guard, plane- and glider-crashes and so forth. There is even a list of earliest telephone numbers of Partridge Green. Most of the stories are a bit grim, naturally, but they paint a satisfactory picture.

But back to **Henfield**. I realise that I have been short-selling the village hall a bit, and in particular the museum. The hall is nice enough with its embroidery, meeting rooms, bowls court and what not. But the museum at the entrance shows that there have been a number of inventive people in and around Henfield. What do you think of a mousetrap for three mice at the same time? I don't for a moment imagine it can have worked but it's ingenious. Or what do you think of the familiar sticky flytrap, invented by a local chemist? Or the information about the botanist and 'Henfielder' William Borrer – all absolutely interesting when you have ample time and get to thinking of things you didn't know you didn't know. 61 S

Old Mill Farm just outside **Bolney** along the Cowfold road has a children's farmyard with nature trails, tractor and pony rides and other things parents might want for their children. And Bookers vineyard in Foxhole Lane is now advertising its shop and its vineyard trail at the roadside. Bookers is one of the oldest 'new' vineyards. It was started in 1973 producing award-winning English white, red, rosé and sparkling wines, and has facilities for visitors too. I should have mentioned them in the first edition, but I didn't know about them. 62 M

*

Dr Annabelle Hughes, historian at Horsham, suggested to me that 'the probable reason for the magnificent brass of the last prior of Lewes being at **Cowfold** is that members of his family (Nelonds), who lived in the vicinity (there are/have been houses called Naylands at Balcombe and Slaugham) "rescued" it from the iconoclastic attentions of Thomas Cromwell and installed it in the nearest church that would have it and which had room.' 63 M

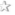

St Mary's House at **Bramber** is medieval and has extensive gardens with topiary animals. We haven't been there yet, but it comes highly recommended. It figures in Simon Jenkins' book on the thousand best houses. Grade I listed, they promise an Elizabethan Painted Room, and the internet shows nice photographs. 63 S

John Taylor (1578-1653), the Water Poet, was a travel writer, well-known until a century or more ago and now almost forgotten, employing poetry as well as prose in his reports. He started life as a waterman on the Thames, but found his vocation with stunts like sailing down the river in a paper boat (he got as far as Gravesend); he then made a living selling poetry about these exploits, and became a more or less full time travel writer. Not always inspired: about **Steyning** he wrote:

August the 18. twelve long miles to Stenning
I rode, and nothing saw there worth the kenning...

Boy, was he wrong! 63 S

*

In the first edition of this book I said that stoolball was thought of as a uniquely Sussex game for girls, and I shouldn't have done that. I was promptly (and rightly) approached by stoolball clubs in Surrey and Hampshire that invited me to a game. And I went. I talked to the president of a stoolball club in Surrey and I saw matches by teams from Hampshire. What can I say? I enjoyed watching them very much. It looked a bit like a cross between a social happening and a family outing. Mothers watched each other's children while they were playing; there were refreshments and what not. Girls of all ages from eight to

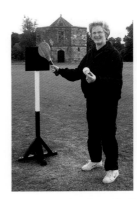

Shirley Reed with stoolball equipment in front of Cowdray round house

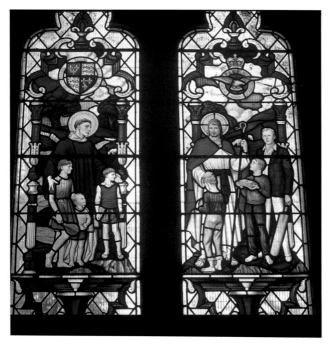

Lurgashall, church window with stoolball and cricket bat (see page 108)

eighty. At **Easebourne** there was a complete tournament going on beside the ruins. We were made to feel very welcome and the whole thing made us realise that we should take more time off once in a while and enjoy the more leisurely pursuits in life. I will never underestimate the importance of stoolball again.　　63 E

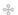

An unreadable gravestone in **Cowfold**'s graveyard facing the wrong way is rumoured to be a witch's grave.　　64 M

In the first edition of this book I said that the water-tower at **Wappingthorn** was lived in by a friendly modern hermit. No longer true. In 2003 the water-tower was for sale, with planning permission to build an underground annex to make room for permanent habitation. The owner (a Dutchman, by the way, with the appropriate name of de Boer, which means the Farmer)

must have developed slightly different plans for it. Anyway, with the water-tank in situ it had considerably less space than the very similar water-tower for Leweston House near Lillington, Dorset, also designed by Maxwell Ayston around 1930. That one is higher, bigger, with a wooden outside staircase, and has recently been restored and made into a holiday home with ingenious inside stairs too – and it is just as private. Are there any more Aystons in England?　　64 S

Selehurst, a garden opposite Leonardslee between Crabtree and Lower Beeding on the A281 is sometimes open to the public. A sham Gothic tower with shell work is set over a pebble work waterfall in a romantic valley. There are some lakes and a beautiful bamboo pavilion and some bridges as well in this paradisical ensemble that is still being developed. If you should get half a chance: go and see it.　　65 N

Selehurst garden

The tiny shop left of the road going out of **Cowfold** was a florist's when we first saw it. It then became a bespoke cast signmaker's business. Traditional hand-painted signs, and in exchange for an A272 book we now have one of his little products next to the door where we live in Eindhoven. But a few years ago the signmaker moved; the place changed hands again and now an antiques dealer plies his trade there. He buys and sells all sorts of things, like furniture, but of course he can't do that from this showroom. He does that elsewhere, and here he has his smaller merchandise, like toys and especially toy cars. A good idea: mini-shop and mini-cars, Dinky-toys in a dinky shop. The name of the business was changed to Cobwebs of Cowfold. We wish him luck.　　65 M

If only to keep the peace with my wife Rita I must mention the fish shop on the left-hand side of the road before the left turn to **West Grinstead**. It used to be the post office and it is called the Salmon Shop, but they do more than salmon of course. For a while they even sold this book there, because they liked it so much, and they offered to give Rita a crash course in deboning fish, since I am so afraid of the bones (see also *Frisking the Haddock*, page 139). Anyway, it is a great little shop for quality fish in a weird place for this kind of specialism, I think. 65 M

We noticed a very similar firemark to the **Cowfold** one (see picture on page 65) at the Rose and Crown in Tonbridge, Kent. It was No 175210, issued in 1800 by the Royal Exchange Assurance. Both show as emblem the second Royal Exchange building in London, built in 1669 and burned down in 1838 (really – almost as preposterous as the burning down of the fire station in the town where I used to live.). If Cowfold's insurance number is serial and complete, this firemark could be more than 200 years old. It's a pity that the top lip with the royal crown is missing from the Cowfold mark. 65 E

St Leonard's Forest - I haven't told you about St Leonard yet. My information comes from the plaque

Horsham St Leonard's Dragon

in the new maze in Horsham park, near to the bronze figure of the dragon he is supposed to have slain. Originally he was a French hermit, believed to have lived in the 6thC. Not only was he the patron saint of pregnant women and prisoners of war, but he protected lost souls at sea too. He became very popular through-out Western Europe and his followers came to England, where 177 churches were named after him. Local legend says that he fought with a dragon in this forest near Horsham, but it is uncertain that he ever set foot in England himself. The plaque also has a poem dedicated to him. 66 N

How does a Roman Catholic priest get married? Simple. He first becomes a priest for the Anglican church, gets married, all legally, and then converts to Catholicism, and he stays married, all legally (think of Cardinal Manning and his wife). That's what the priest of the Catholic church of **West Grinstead** did. We know, because we talked to his wife who showed us something special in his house (vicarage? parsonage? pastorage? priestage? Ah, the intricacies and limitations of the English language. Anyway.) We went to the priest's house because our local landlady Thelma had told us that there was a priest's hole there, a secret place for a priest to hide at the time of the persecutions. We should ask the priest or the priest's wife to see it. Well, there was the beginning of a tunnel that a priest could use to crawl into a cubicle, but that had been blocked off in the past. And there was something the priest's wife (I can't get enough of the term) called a secret chapel in the attic of the house. That can hardly have been really se-cret, but it was nice and cosy and even nowadays it is used regularly, for reasons of intimacy, instead of the big church. Good one. We gratefully said goodbye to the priest's wife. 66 M

The practice of inscribing the names of neighbouring farms in the pews of a church, as done in **West Grinstead**, is not entirely unique; it was done in nearby **Shermanbury** too, for instance.

It took us eight years all in all to find someone who could track down the key of West Grinstead's St George's church. But eventually we got in all right and I could fully appreciate the reason why Simon Jenkins (*England's Thousand Best Churches*) wrote that it is 'like an old Sussex farmer in a tweed coat'. There is not much left of the great things that were foreseen for West Grinstead. There is a fine example of the Green Man in

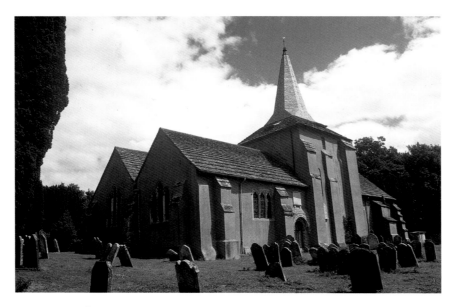

West Grinstead, St George's

The A24 is called London Road where it crosses the A272. The junction is now also referred to as McDonalds Corner (you may guess why) and serves as an assembly point for group travellers, just as the tea and refreshments stall at the corner used to be for the regular passers-by.

67 M

In 2003 the donkey in Piries Place in **Horsham** (see picture on page 70) carried two baskets full of bright flowers along its sides while pulling Pirie's cartful of children. Yes, I had always thought this donkey looked very bronzed and fit. 70 N

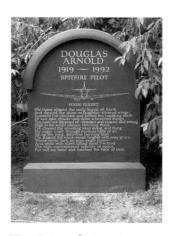

West Grinstead, airman's grave in the churchyard

leaves on the oak lectern, dating 1891, but the Rysbrack is a little out of character – I prefer the warm tweed over the cool marble draperies – and the Flaxman is disappointing. Still, the architecture of the church itself remains interesting, especially in its surroundings. And at the western side of the churchyard we found a modern grave of a Battle of Britain pilot, with a beautiful Spitfire and poem engraved on the headstone. Worth having a look.

With the village of West Grinstead gone, really, most of the parishioners come from **Partridge Green**. But there is still the bell-ringing practice (six bells) on a summer's evening (Thursdays at 8); that should be lovely. And the view of the church from across the river (there is a footbridge there) is simply idyllic. 66 M

The Scouts window in the church in **Shipley** was donated in 1984 by the first Shipley & Southwater Scouts to commemorate their first 50 years, and not of the Scouting movement in general. That was founded 77 years before 1984 of course, as is acknowledged in the window prayer: 'We give thanks for 77 years of Scouting, For the vision of our Founder, Robert Baden Powell, & for the dedication of men & women who

West Grinstead, inscribed pews in St George's

have given of their time and talents to support young people throughout the world.' 70 M

Somebody well schooled in the classics wrote to me about the sundial in **Horsham** saying that there is a sundial with the same inscription in Latin at Michelham Priory. *Numero horas non nisi serenas.* She suggested that *serenas* was generally linked with serene and therefore translated as 'happy', but in fact *serenas* means: 'clear, fair' and, in the sundial context, therefore: 'cloudless'. So: 'I only count the cloudless hours.' Correct. 72 N

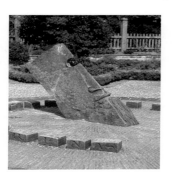

Horsham sundial

Still no news about why Tower Hill in **Horsham** is called Tower Hill. The local History Society should dig down deeper, obviously, and unearth foundations or something. But there are a number of recent developments to report about in this lovely town. First the sad news. Both second-hand bookshops have gone. Their role was taken over by the charity shops in the town, of which there are many. Only, what's missing are the cosy chats, the fear of spending too much money, the smell of old printwork, the feeling of getting lost in the numerous little departments and the expert advice you could get from the staff of these second-hand bookshops. Many a time certain authors were recommended to me that I hadn't discovered yet and I wouldn't like to have missed them. Or certain books. But. The romance has gone out of the business, it seems. It's all done by internet nowadays. Enough of this lamenting. Back to Horsham and its novelties. Horsham in Bloom. The Forum. Et cetera. There is almost too much.

A new work of art is in the centre of the maze in Horsham park. It has the shape of a dragon and is reminiscent of the Minotaur (half man, half bull) that was confined in the centre of a labyrinth in Crete and was fed on human flesh, according to classical mythology. But here, so close to St Leonard's Forest and its legends, a dragon is much more appropriate of course. Done, well done, by artist Hannah Holmes Stewart. And there were a few sham ruins which we hadn't seen before. Only small, but we are very fond of sham ruins.

But the *pièce de résistance* for the town is the Horsham *Heritage Sundial*, unveiled by the Queen in 2003. It was made by Lorne McKean and Edwin Russell (assisted by Damien Fennell), a sculptors' couple. Lorne McKean had already created more things in Horsham, such as the *Swans* in Swan Walk Shopping Centre and *Piries Donkey and Cart* in Pirie's Place, while Edwin Russell had done the *Celebration of Life Roundels* for the war memorial. The heritage sundial is placed on the Forum, the open space south of West Street –

Horsham Heritage sundial

Blackhorse Way. It consists of a three-dimensional open ring, made of bronze and pierced by the gnomon, with a series of sculpted depictions of aspects of the history of the Horsham district from the age of the dinosaurs to the present day. It is both stunning and unique. A real treasure; and educational too. J. Knight wrote a booklet about the origins of the artwork, *Tales from the Sundial*, explaining all the scenes in different paragraphs or chapters, and giving some details about the sculptors. It is very good and recommendable. 73 N

Horsham Heritage sundial detail: Quakers, Pippin apples, Tower of Learning – grammar school, Horsham horses, St Leonard's Forest

227

*

I heard that **Warnham Court** was being converted to apartments in 2000. There were also plans to restore the grotto that used to be there. 73 N

*

Broadbridge Heath can boast a modern church with a very unusual expressionist crucifix hung outside. The church was built in 1963 with an empty cross. In 1964 the crucifix was added by the artist Bainbridge Copnall, previous President of the Royal Society of British Sculptors. It was a gift in memory of his father who lived in the village for many years. If you are passing that way, note especially the eyes, drooping like the eyes of the famous Chichester *Lazarus* relief, full of sorrow. A pregnant addition to Rita's collection of (pictures of) crucifixes.

As all the above was written in 2004, we now report on the developments. My publisher sent me a newspaper clipping that said that the people of Broadbridge Heath had had enough of this expressionist crucifix that was hanging outside the church for everybody to see. They thought the black coal-dust and resin figure was too depressing. There is a lot to be said for the feeling. So the crucifix was removed from the church wall. And where did it go? To the museum in Horsham in 2009. It's hanging there in the petite garden. Incongruously, I might add. It's definitely out of place there, opposite the wall of the Ladies toilet, scaring the ladies who come out (although Christ's face is averted as if he's trying not to have a peek at the Ladies). Maybe another spot in the same garden would be better. But it's still a splendid little museum – highly recommended. 73 N

Broadbridge Heath crucifix in Horsham

The combination of Roman and Saxon background must be why on entering **Billingshurst** there is a new village sign for the historic village on both sides of the road, one with a Roman guard and one with a chap of Saxon appearance. 73 M

A272 at Billingshurst with the two different signs

Hilaire Belloc has a French name. He was born in Paris with a dash of Irish blood in him, and his mother moved to England after his father had died. Anyway, Belloc wrote *The Stane Street, A Monogram*, which is about the history of Stane Street, the Roman road through **Billingshurst**; it is 314 pages, no less. He used to drive round in a car together with a friend, to investigate and measure things. Another book on a road. 73 M

*

Billingshurst was where one of my correspondents escaped a ticket for speeding because he was driving a special car, a Triumph 1300TC. He told about the incident in a column for the Triumph Club magazine, and he was so complimentary about the road A272 that I cannot but quote a few lines. 'This particular event took place a few years ago on the A272. This is my favourite road of all time. It runs east-west all the way from Maresfield in East Sussex to Stockbridge, west of Winchester, with lots of nice twisty bits and some good fast straights and a number of villages and small towns along the way.' Elsewhere he says: 'I always come home this way as it's such a great road to drive along, especially at night when it's quiet. During the day the going is a lot slower, but for anyone who just fancies a drive

through the Sussex countryside I can thoroughly recommend trying the A272 and some of the smaller roads off of it.' Now that's what I call corroborating the spirit of this book. 73 M

❄

If you are driving near **Christ's Hospital** school with the car windows down and you hear music being played round about lunchtime, it is because each day the pupils are rounded up and marched off to the refectory by a band consisting of pupils (who also regularly perform at the ceremonies of the Lord Mayor of London). Now isn't that nice? I wonder how old the custom is and if Peter Symonds might have heard it in his time. Peter Symonds died in 1587 and he decreed in his will that 60 pupils at Christ's Hospital should receive a packet of raisins and a new penny every Good Friday. Forever. In 1962 some of the boys must have missed the dole as they were in the Netherlands for a series of performances of Shakespeare's *A Midsummer Night's Dream*. They came to my grammar school. I still have the programme and I know I saw the show, but I remember nothing of the performance. I only recall that we were supposed to let the boys sleep at our home (I played host to one of the Ledeboer brothers whose name sounds Dutch), and it was all very exciting and colourful. It was only recently that I found out that my own connections with the A272 were that early.

Christ's Hospital has a long history, never more troubled than at its beginning perhaps, with religious divisions and Queen Mary's Catholic enthusiasm.

Then came a quieter period, in which the famous 17thC diarist Samuel Pepys cuts a surprising figure. The school was still in London then. It only moved to the Sussex countryside in 1902 and through the ages it has of course had its share of celebrities among the Old Blues, as the former pupils are called.

Christ's Hospital is a charitable institution. Currently 14% of parents pay nothing at all and only 5% pay the full fee; those in between pay on a sliding scale according to income. It's good to keep these things in mind. The school tries very much to be the centre of a community. They employ almost 500 members of staff for 840 pupils. Their facilities are often shared by people from the nearby towns and villages, and during the holidays they are used for activities and events such as weddings, language courses and filming. The school even brings out a Community Bulletin regularly.

The uniform is one the school's most distinctive features. The blue coats, almost black, and the bright mustard-coloured stockings almost transcends ridiculousness in the 21stC. In the Netherlands this uncomfortable-looking uniform would be considered child abuse, but we don't have school uniforms at all. The brave pupils who wear this uniform (and they all do so willingly, I presume) must be very proud indeed of their traditions. However, I must admit that the school's famous band parade before lunchtime is an absolutely lovely spectacle to behold and we were delighted to see it on one occasion. They were practising for a particular show and threw the batons high up in the air (and then caught them again skilfully). And the music itself sounded very classy, so to speak. 74 N

Southwater, Christ's Hospital Band

Maybe I have only myself to blame for not having seen the garden at **Little Thakeham**, called by Lutyens himself 'the best of the bunch', for it was in the 1999 yellow book of gardens open for charity. This yearly Yellow Book is growing heavier every time, probably because more and more gardens join; even very commercial ones often have a few days for charity. This National Gardens Scheme under the patronage of the Prince of Wales is a great success. It must be a hell of a job to update this guidebook – not all are open every year, and dates must be settled well in advance. That is probably why they now have a website too, where you can search for whatever you might want to know – venues, maps, opening hours, special types of gardens, like bog-, lily- or rock-gardens, or places in specific areas. This internet site is a lot easier to work with than the book, and presumably more up to date. That is where I saw that Little Thakeham wasn't ready for open days in 2004. It has reverted to residential use now; it is private. In the revised index we have made a separate entry for gardens regularly open under the NGS that are mentioned in this book. 74 S

I said in the earlier editions of this book: '**Billingshurst** is the sort of place where you should never have to pay to park your car'. I still say it. Totally superfluous. There can't be a parking problem in this village unless it grows to twice its size, in my opinion. Imagine my indignation and anger when last year I wanted to park near the library and found an unintelligible sign that took me ten minutes to

Billingshurst parking ukase

read and try to understand. Like most people I hate having to read small print and the colour scheme makes me dizzy. They talk about discs and vouchers without saying where on earth I could get these discs or vouchers. They talk about Blue Badges, exemption from Road Fund Licence fees and Penalty Charges and I don't understand any of it. I'm not being deliberately dense, I am stupid by nature. What nonsense, all of it. Billingshurst people can say that it is the fault of Horsham District Council who put the ukase up, but that is a poor excuse. The whole thing clamours for civil disobedience. Arise, citizens! 75 M

Southwater used to have a lot of clay pits. The village had its own brickworks, but also had connections with Stewartby in Bedfordshire. The clay was excellent material for the so-called Fletton bricks. These bricks are made of deep Oxford clay, nicknamed 'the clay that burns', which needs less fuel in the baking, a process first experimented with at the Fletton brickworks near Peterborough. Not many people know that. I bet you didn't. Nor would I have known, if I hadn't happened to have a special interest in the huge brickworks of Stewartby. They owed most of their success to these Fletton bricks (see *Curiosities of Bedfordshire* by Pieter and Rita Boogaart, SB Publications, 2000).

But there is much more to be said about Southwater. In the previous paragraph I talked about the claypits and the brickworks. Well, they are history now and in its place in the meantime a new development has been realised. It consists of a newly-built shopping centre with parking places, a pub, health centre and community-centre-cum-library: the lot. We have spoken to people who think that half the village is spoiled and ruined and we have also spoken to people who are wholeheartedly in favour of the development. The latter ones lived or worked there themselves, so I think it will be considered all right in the end. It was costly enough: some 25 million pounds were put into the project, which was opened in 2006. We noticed that the whole was built in a traditional style, but on the other hand there were broad door openings with facilities for the disabled. Modern and British, in short. It's called Lintot Square.

Near Southwater railway station the remains of an iguanodon were found in 1925. That was the

Southwater Iguanodon in Lintot Square

reason why Hannah Stewart (who also made the dragon for the maze in Horsham park) did a bronze sculpture of an iguanodon, 3.30m long and 2m high. You can't miss it: Iggy is in front of the shops, on a pedestal of Southwater bricks.

Lintot Square, I said. So why is it called Lintot Square? Let me quote from the brochure given out by the local community services. 'Bernard Barnaby Lintott (he later dropped the last t) was born on 1st December 1675 at Southwater... he learned the book trade... In 1714 he agreed to publish the *Iliad* by the up and coming poet Alexander Pope... with Pope he transformed eighteenth century publishing and the look and style of books. Over the next 25 years he became one of the great booksellers and publishers of his day. He was praised in poetry by the author of *Gulliver's Travels*, Jonathan Swift, and mentioned in poems by Pope. He retired to his estate in Southwater in 1730 and was nominated High Sheriff of Sussex but he died before he could take up the post...'

After all that I bet you can't wait to hear what Swift said about him. In his *Verses In Praise of Lintot* he said among other things:

> Others with Aldus would besot us;
> I, for my part admire *Lintottus*.
> His character's beyond compare,
> Like his own person, large and fair.

Aldus Manutius was a Venetian printer. Other celebrated printers and publishers in those days that Swift mentions: Joan Blaeu, Christoffel Plantin and Abraham Elzevir are all Dutch. He goes on to say about them:

> Their books are useful but to few
> A scholar, or a wit or two
> Lintot's for general use are fit
> For some folks read, but all folks – .

– sh*t, I assume, knowing my Jonathan Swift a little. 75 N

⁂

Unfortunately, Summers Place at **Billingshurst** is not Sotheby's anymore. In 2009 it was being redeveloped for housing. Pity about the man-eating dogs that patrolled the place, but personally I feel much safer now.
 76 M

⁂

The Water Poet John Taylor, whom I mentioned at Steyning, also visited **Billingshurst** or Bellinshurst/ Billinshurst. He stayed six nights, and wrote a great deal about the town, concluding:

> Thus Billinshurst thy bounty I extoll,
> Thou feastedst me in body and in soule.

What more praise do you need? 76 M

⁂

The vast castle at **Arundel** also has gardens. One of these is the new Collector Earl's garden. It was designed by Julian and Isabel Bannerman as a re-creation of what the formal garden at Arundel House in London might have looked like, with gateways and pavilions. The most impressive building is Oberon's Palace on top of a rockwork mount, based on a design by Inigo Jones in 1611. Inside is a shell lined hall where a gilded coronet dances on a jet of water! Everything was built using green oak, which is easily replaceable. A temple with antlers. A nymphæum. Arcades, columns, pergolas,

Arundel, Oberon's Palace in the Collector Earl's garden

was covered with lightly-clothed people lying about on the grass, but you don't need hot weather to enjoy it. However... most local people seem to hate it. Oberon's Palace was called 'temple of doom', absolute eyesore, hideous, etcetera in the *West Sussex Gazette*, which gave a survey of the various opinions. Local yokel conservatism? Go and have a look yourself. As I said: we may be prejudiced (we are because we have a predeliction for follies!), but we think it's wonderful. 76 S

vases, even sofas. Some water features play a part as well. Indeed wonderful stuff, this folly-building in the 21stC. The Collector Earl's garden was opened by Prince Charles in 2008. When we were there the lawn

☆

Through Clare, an early peace campaigner, we learned that there was going to be a monument to celebrate Greenham Common, albeit not a national one. And now you can read about twenty years of peace movement on several websites. I'll give you the essentials.

It all started with the Greenham Common Women's Peace March, which left Cardiff on 27 August 1981. The idea was to prevent the arrival of nuclear weapons – too dangerous guard dogs that cannot distinguish between friend or foe – and later the marchers protested against the weapons' presence here by setting up the famous camp at the entrance to military base. The end of the cold war, perhaps partly due to their persistence, meant that the nukes were dismantled; the last one went in 1991. The women's camp remained until 2001 when the Greenham Common base became a trading estate.

In the meantime at the tenth anniversary of the March an American officer visited the camp and declared that the women deserved a permanent monument. From then on women in the peace movement were discussing, planning and fundraising for it themselves. They wanted good documentation for posterity, and a permanent

Arundel, temple in the Collector Earl's garden

Clare Luckin, the reluctant farmer's wife

reminder, preferably in Cardiff or Greenham Common. The project was rewarded the TGWU Frank Cousins Peace Prize in 1991, but it was only on the twentieth anniversary of the March that a life-size bronze sculpture was unveiled in Cardiff. It shows a woman in trousers with a child on her hip. The child holds a peace dove, and the woman a bunch of prickly all-sorts to show disapproval of nukes for the sake of the environment. She wears purple, green and white ribbons on her ponytail, and a chain around her waist to remind us of the suffragettes, and her shirt shows the feminised green CND symbol. This very life-like *Greenham Marcher* by Anton Agius was unveiled in July 2003 at her permanent setting in the Foyer of the City Hall of Cardiff. The Greenham Common campsite has now been turned into a commemorative garden for two decades of peace movement. All organised and funded by the Peacemakers themselves. Well done!

79 M

*

Brinsbury Agricultural College, south of **Adversane** along the A29, holds a twelve-hour lawnmower race in August. Endurance tests for walk-behind and ride-on models. A curiosity, to say the least. 83 S

*

The house in **Bury** where John Galsworthy used to live has been converted into flats. I was told that the bizarre carved heads on the general stores, now a private house nearby, came from Arundel and the estate manager who removed them was fired, very appropriately. The plan of the village is gone. It was replaced by a millennium parish map in the village hall that doesn't show the recent developments of Bury.

Bury millennium parish map

From Bury we briefly visited the church of **North Stoke**, for no other reason than that the brochure of the Churches Conservation Trust spoke of an idyllic rural setting on the South Downs, within a loop of the river Arun, and the well-known Pevsner called it unrestored and delightful, outside and in. Both sources are highly complimentary (personally I wouldn't be), but you should judge for yourself, perhaps. 87 S

✪

What I am not going to discuss at great length is Selhurst School near **Petworth**. There is an excellent reason for this: it doesn't exist. What does exist is a book by Humphry Berkely, *The Life and Death of Rochester Sneath*, 1974. Sneath is the fictitious headmaster of a public school near Petworth. 'In early 1948 Sneath began his brief and glorious career,' says the publisher on the inside jacket. It seems that letters from Sneath were received by other headmasters of public

233

Rochester Sneath

schools, imparting pompous and eccentric advice on a great variety of subjects. These were taken seriously and answered privately and in the press. Selhurst School became famous. People began to apply for places and were put on the waiting list for the Waiting List. All in all one of the best literary hoaxes of recent years. Later the whole correspondence was assembled for the book. A friend of mine in the Netherlands put me on its trail and it's taken me years to acquire it, but now I am the proud owner of this hilarious little spoof, with stylish 'pictures drawn by' Nicholas Bentley. 89 M

The old Town Hall in the Market in **Petworth** is now usually called Leconfield Hall. On the second floor we found an original water colour of artist Stefan Oliver, of 2001. It's about Petworth in the year 2000 and with a lot of wording, little drawings, maps, jokes etcetera it gives a history of Petworth in colour. It's a good piece of work and hopefully lots of 'Petworthians' have a smaller version of it in their houses. We found a copy in the renewed Angel hotel in Angel Street, which, by the way, seems to have an excellent restaurant and a couple of ghosts – not that these last two are related. During the renovation of the Angel some 14thC wattle-and-daub was found, making it more likely that this medieval hotel was indeed a pilgrims' rest as I suggested on page 20. 90 M

A good example of diaper brickwork can be seen in **Winchester** on St John's almshouses in Bridge Street (page 167). Here it consists of red crosses. 91 E

David Mortimer, volunteer with the Conservation Hit Squad of the Sussex Wildlife Trust, wrote to me: '**Ebernoe** Common is very ancient woodland, home to some rare funguses, but also an extraordinarily large number (83, I think, but I'd have to check) of lichens – the second highest concentration anywhere in the southern half of England, I understand (the highest is a wood in Hampshire which has one lichen more than Ebernoe Common) [...] Just this year (2002), Ebernoe has scored higher on the Ancient Woodland Indicators than anywhere else currently scored in Britain. This isn't because it's suddenly aged more than anywhere else, but they have introduced a more detailed list of indicators than was used before. I should add that this doesn't mean it's stood undisturbed for thousands of years. We know from old maps and descriptions that in some places which are now dense with trees there used to be fields where cattle grazed. It's now 50 years since cattle grazed, so many of the grass-filled glades they browsed have been overgrown by trees. But, as of today, cattle are being re-introduced for the first time in half a century to browse where grass remains and to feed on shoots which will prevent the further spread of trees. This is all under the auspices of the Sussex Wildlife Trust.' 92 N

In one of the many antique shops in **Petworth** Rita acquired a good but modern plate with the willow pattern that we needed for an item in that other book of ours, *Curiosities of Bedfordshire*. We had researched a part of Wrest Park that was modelled to represent the scenery of the well-known **willow pattern**. It still has a Chinese high-backed bridge and a Chinese pavilion with pagoda roof. It was this roof that Rita copied for a 'folly-hat' contest when we had the Folly Fellowship's garden party there. This hat (which Rita models on the back cover) gave rise to many

questions from readers, and now you know the story. You all know the willow pattern of course, the best-spread English bit of chinoiserie, but do you know the story that it represents?

A mandarin (living in the two-storey house on the right, with a pavilion, an orange- and a peach-tree) had only one daughter and she fell in love with the secretary. The father disapproved of a possible match. The secretary was expelled, the garden fenced off (foreground) to keep the daughter inside. She often stood under a willow at the waterfront, the lover living on an island (far left) writing poems for her. The daughter tried to elope with the secretary but was spotted by her father who chased them over the bridge (foreground left) to a rough island with gardener's cottage. And he would have beaten them to death with his whip had not the Gods come to the rescue and, touched by their love, immortalised them as two turtle-doves flying in the sky together. In some versions they escape by boat and live on the island for some time before meeting their death and metamorphosis. 93 M

<div align="center">✳</div>

Petworth's disused railway station of 1894 at Coultershaw Bridge has been restored into an up-market B&B where you can spend the night in style in one of the three fully equipped Pullman carriages, if you can afford it. 'Now the perfect place to relax in colonial splendour', they say. 93 M

<div align="center">✳</div>

At Bignor Park Lord Mersey had a rotunda built in 1992, with an inscription running round the top inside: 'BETTER LOVED YE CANNA BE – WILL YE NO COME BACK AGAIN'. The great storm of 1987 had blown down a lot of trees and a gap was filled by this little temple to commemorate his mother's 80th birthday, together with her ancestor Lady Nairne, who wrote the Jacobite songs 'Charlie is me darlin'' and 'Will ye no' come back again?'

Wind and music have more connections in this garden. A beautifully smooth-shaped æolian harp was made by the artist Geoffrey Stinton. An æolian harp used to be a kind of wooden box with strings attached. It would be positioned to catch the wind and then the

Bignor Park rotunda

strings would make eerie sounds. Stinton now uses polyester to make wonderful shell- and tuba-shaped instruments to guide the wind over the strings attached. Several were on show on Bignor Park's open-for-charity day in 2000 and in later shows. 93 S

Æolian harp by Geoffrey Stinton

The **Barlavington** estate is also home of Lodge Copse, which is the most established and successful centre of the British Trust for Conservation Volunteers (BTCV) in the country. A few days a year, every other year, you can come and watch how traditional coppicing methods are used in these woods. You and your children can also take part in all sorts of activities constructing wattle fences, charcoal burning, making willow sculptures and what not. A day out in the sticks.

94 S

Petworth Park, Moonlit Path in daylight

I mentioned that Edward Elgar, of Land of Hope and Glory fame, found inspiration in the Swan inn at **Fittleworth**. A friend of mine raised his eyebrows when he read this and commented: 'Edward Elgar would not be pleased with this description. He disliked the words. So don't hurt him posthumously, and describe him instead as "the composer of *Pomp and Circumstance*" adding a note for the uninitiated explaining that March No. 1 is also known as Land of Hope and Glory.' Done, with suitable apologies.

94 S

We came across the following about Coates Castle on the web following a complicated url (travel.uk.msn.com/inspiration and more of this nonsense, but you can also simply Google 'castle cottage B&B') saying: Castle Cottage B&B and Treehouse **Fittleworth** (Coates Castle): 'The treehouse, tucked into a huge sweet-chestnut tree on the edge of a wood, is particularly recommended. A thatched room, with a double bed set between branches, looks over the treetops through large glass doors. An en suite shower with glass roof is covered with handmade mosaic tiles. A large balcony with swing seats is an added touch for lazily reading the Sunday papers or for evening drinks.' Adding: 'The treehouse costs from £140 a night for two, including a sumptuous breakfast.' (2010.) It would need to be pretty sumptuous for that kind of money. But it's undoubtedly an exceptional type of room.

95 S

The art of Andy Goldsworthy is often ephemeral; he uses for instance colourful leaves and petals, icicles or driftwood. Fortunately he has taken the precaution of preparing several books with good pictures of his art so he is known to a wider public than the character of this work would lead you to believe; and these books have made him Britain's most popular artist.

In the summer of 2002 Goldsworthy was commissioned several works of art in the South Downs area. The one for **Petworth** was called *Moonlit Path in Petworth Park*. It was a winding chalk trail through the Park and the Leconfield Estate. Three nights around a full moon each month one could buy a ticket and silently walk the path only lit by the moon; a magical experience. Even in daylight one can envisage the exciting view of the moonlit valley and the lake when coming out of the dark woods. This was only for one year, but the Chalk Stones Trail that Goldsworthy designed on the South Downs will be permanent (see also addendum for Cocking, p. 239).

96 M

Time for a quotation from John Taylor again. He had something to say about **Petworth** as well.

I rode to Petworth, 7. good Sussex miles.
To set forth Petworth, its worth more worth is,

Then I am worth, or worthy; but know this,
Northumberland the noble, there doth dwell,
Whose good housekeeping, few lords parallell.
There honourable bounty is exprest,
With daily charity to th'poor distrest.
I speak not this for any thing I got
Of that great lord, I felt or saw him not:
For had I seen him, my belief is such,
I should have felt and found his bounties tutch:
But I, for my part, never was so rude
To flatter, fawn, or basely to intrude,
Yet I declare him liberall, honourable,
And there I din'd well, at his stewards table.

Meanwhile, the Twinning Association in Petworth has caught another partner town: San Quirico d'Orcia in Tuscany, or is it San Quinco d'Orcia? The twinning people don't seem to be sure. The internet doesn't seem to be sure either. Petworth millennium map even has San Qunco, so my guess is that there are several misspellings of the same. My map of Italy has a San Quirico d'Orcia in the hills of Tuscany. We happen to know the area fairly well, because not too far away there is Montegabbione which has one of the most amazing follies of the world. I wish I could tell you more about that, but time is money and space is limited. San Quirico d'Orcia is partly walled and famous for its 12thC Collegiata in the Piazza Chigi. 96 M

★

The name **Pitshill** could be derived from Pictshill, the same as the Pitshill in Bedfordshire, where the authorities seem to agree on the etymology of the word. This is another indication that some Pict(s) settled near Petworth, perhaps (see note Pytta on page 88-89). 103 N

✤

In 2009 when we went to check on Noah's Farmyard in **Tillington**, there was no sign of it along the road; we found nobody at Grittenham Farm, nor could I find Noah's Farmyard on the internet later. I assume it has vanished into thin air? Would be a pity. But the farm itself is not gone. Its listed Barn is on the West Sussex County Council's list of approved ceremony venues in 2010. 103 M

✳

When this book first came out, it had all sorts of effects. One of the nicest was that one lady (Annie; her name is Ann Lindfield) thought it would be a good idea to organise a series of thirteen (!) walks in the A272 area. This was for The Downsmen, a group of people who regularly go for walks in the South Downs. A number of them seem to be retired, but there is nothing inactive about them. They are often led by Annie. I hesitate to call this lady elderly, although she is in her eighties. Annie goes in front and sets the pace. And she doesn't mess about: there is no slacking. Good heavens. Rita and I joined them for a bit one day and we had a lot of trouble keeping up. This was in the Petworth area and they had had lunch in Midhurst. The funny thing was that we were being followed by a camera crew that day and The Downsmen had agreed to be interviewed during a pub lunch. But the camera crew was later than they expected and when they finally arrived, the walkers were ready to go again. So Annie hurriedly answered a few questions and they set off, chased by the TV people who wanted to catch them walking. They didn't stand a chance. The Downsmen were soon out of sight in the narrow streets of Midhurst and the camera crew had to give up on them. Later that afternoon, when they had passed the Queen Elizabeth Oak area, Rita and I joined the walkers at **Lodsworth** and tramped through the woods to their destination for the day, the tearoom of Petworth House, from where they had started in the morning. We said our goodbyes full of admiration for their enthusiasm and walking spirit. There must be a lot of this walking going on all over England, done by these unpretentious groups of enthusiasts. One of them told me that the parish of Buxted alone counts seventy-seven numbered footpaths. Amazing. 105 N

✪

Opposite the pub at **Halfway Bridge** is the sign for Peter's Barn Gallery, which is set in a wild wooded water garden. The garden gallery in South Ambersham, opened in 1995, is named after the late Peter Munn and exhibits contemporary ceramics usually, but also bigger sculptures outside round the pond, and artworks in other media like glass and prints in the barn. A nice, quiet place. 105 M

About the inscriptions on the stones behind the lychgate at **Lodsworth** that puzzled me: I subsequently learned that 'the inscription is a quotation from Paul's First Epistle to the Corinthians, chapter 15, verses 42-3, and it refers to the Resurrection of the bodies of believers in Jesus Christ, whether bastards or otherwise.'

106 N

Easebourne, Queen Elizabeth oak with author

In the course of the year 2000 a new little folly was constructed on the east bank of **Benbow Pond**, opposite the car park. The temple is associated with the public arboretum that is still being planted there, and is a memorial to the late third Viscount Cowdray of Cowdray House, near the famous ruins on the other side of the road. It is a monopteros with six pillars, three relief crowns in between (under the cupola) and the name of the artist who designed it: Fiona Hamilton Lamb. Just below the cupola is a series of bronze panels, one of which simply reads 'Weetman John Churchill, 3rd Viscount Cowdray, 1910-1995', while the others illustrate all his various sporting interests. The floor of the little building bears the date: 2000. It is not open to visitors and there has been no publicity about it since the planning application by the fourth Viscount. It is to be seen from a path not far behind it or from the other side of the pond.

The Tree Register (www.tree-register.org) recognises the hollow Queen Elizabeth Oak near **Easebourne** (a *Quercus petraea* with a girth of 41 foot/ 1253 cm) as one of the largest in Britain.

106 M

If prizes were going to be awarded to villages for their Millennium monuments, my vote would go to **Cocking** (for towns it would obviously be Horsham). Here the villagers have worked together and erected a bronze column on a plinth with a history of Cocking and surroundings in a series of scenes spiralling downwards from the top. Some examples: 1859 village cross blown up by small boy; 1919 armistice of Great War; 1926 Cowdray estate permits firewood gleaning because of the general strike; 1940 Cocking bombed; 1993 playground rebuilt costing £15,000; etc. etc.

Cocking millennium column

Benbow Pond, memorial temple

Near Benbow Pond are the new Cowdray Park Holiday Cottages. They are mainly for people who play polo and golf and go in for clay pigeon shooting and such things.

106 M

Cocking millennium column, detail of the making

Cocking millennium column, detail of the armistice

There are maps and jokes and symbols. Everything and anything remotely relevant to the village. Some superb modelling and carving, at which they got help from Philip Jackson, who designed it. It looks as if the villagers want to keep this wonderful thing for themselves: they have hidden it a hundred yards west of the A286 behind some houses.

By the way, it is amazing what towns and villages have done to celebrate the new millennium. It had become a standard question of ours for these last few years: what did you do for the millennium? Some villages only had a big community party on new year's eve when midnight struck. Others had special concerts or had made more lasting things like documents and plaques, often in the churches and village halls, such as the maps in **Shipley** and **Bury**. Or a new painting with a lot of local history and maps, which people could buy a smaller copy of, like **Petworth**. **Alresford** devised a new Millennium trail. Others again had a new church window, like **Lurgashall**, or had built monuments, like **Linch** which renewed its war memorial with a sculpture and **Ringmer** which had a new clock tower made. Or they latched on to other occasion of celebration, like **Bishop's Waltham** did with their new clock. **Shawford** had a maze constructed with tiles. East and North **Marden** a tapestry of the local interesting buildings. **Horsham** had its Heritage Sundial. And so Cocking had its History Column. All very gratifying and this must have strengthened the sense of community spirit a great

deal. I have often wondered: is this typical for England? I know for a fact that in my own country, the Netherlands, these things hardly ever happened. It must be something to do with a communal feeling of trying to make things happen in smaller communities, instead of just muddling through in Old Blighty. Anyway, I love it. 106 S

*

Another route to West Dean is to walk from **Cocking** along the five miles of the Chalk Stones Trail to **West Dean** Park with a map in hand. Andy Goldsworthy, renowned environment artist (his most famous work is *The Wall That Went for a Walk* (1989) in Grizedale Forest in the Lake District), designed this trail along thirteen white chalk stone sculptures of his, looking like giant snowballs in the South Downs landscape – out of place although you know that the material is literally very local. It makes you think. 106 S

☆

West Dean College's weaving department opened its Tapestry Studio in 1976 as a commercial workshop with a commission of eight tapestries after drawings by Henry Moore, mostly on the mother-and-child

239

View from West Dean College gardens

❋

Staddle-stones, as mentioned with the grainstore at **Singleton,** are flattish, mushroom- or cone-shaped stones, mainly underneath the corners of granaries or barns, supporting them like little stilts in order to prevent rats et cetera from entering from the ground. In certain areas one may find lots of buildings on staddle-stones; there is one for instance at West Dean, in front of the entrance, and one in Michelmersh HA (page 183). Today most staddle-stones keep cars off turf along the path. 108 S

theme. Since that time they have woven some more for Moore, and many more for other contemporary artists like John Piper and Philip Sutton, commissioned to be hung in both private and public places. 106 S

In August 1997 a bronze sculpture of Tennyson, seated at the top of his garden at Aldworth House, Haslemere, was unveiled by his great-grandson. The poem lines on page 110 are in bronze at his feet, very appropriately. 110 N

*

In June 2001 we revisited **West Dean** College gardens and this time we were impressed by the improvements. The restorations are finished now; only some minor works on the rare pumice arches and bridges of the Water Garden were in progress. The new Visitor Centre, local flint and brick in the vernacular style, got the approval of Prince Charles in his opening ceremony in 1996, and is now filled with information and food. The great storms did a lot of damage to the arboretum, but it is replanted, and Edward James can now rest in peace in his beloved 'green room' under the slate slab with the simple text: Edward James, poet, 1907-1984. While still alive he used more words:

> I have seen such beauty as one man has seldom seen:
> Therefore will I be grateful to die in this little room,
> Surrounded by the forests, the great green gloom
> Of trees my only gloom –
> And the sound, the sound of green.

108 S

The **Weald and Downland Open Air Museum** near Singleton had a new 'Gridshell' built in 2002 to an

Weald and Downland Open Air Museum gridshell, exterior

Weald and Downland Open Air Museum gridshell, interior

award-winning design by Edward Cullinan Architects. It is intriguing as a timber-framed building, the walls being sinuously curved and high and wooden, the inside showing a sagging trellis pattern, and it was used as a workshop-cum-exhibition-space when we last visited. That more people find it interesting is illustrated by the fact that in 2006 a 50p stamp was produced with it in the picture. 110 S

❋

The idea behind the Cowdray 'mural' in Knockhundred Market in **Midhurst** is that we should be grateful that the Spanish Armada was defeated. 'As in Armada days – So in our own', it says, and 'Thanksgiving for Deliverance'. It is a post-war thanksgiving memorial painting depicting Cowdray House at the time of the Armada, 1588.

In this bend of Knockhundred Row the little shops seem to change hands regularly. There are no bookshops anymore, either first- or second-hand. The only place where you can get second-hand books now (besides the charity shops) is at Wheelers, upstairs, where you also have easy chairs to sit quietly, in between browsing through this wonderful collection.

Knockhundred Row in Midhurst features in the excellent brochure Midhurst Town Trail, which you can get at the tourist office and which gives details about the town's architectural and indeed generally cultural aspects. 113 M

☆

Sculpture at **Goodwood** is now called the Cass Sculpture Foundation. It is still at the same spot

north-east of Goodwood House and there are lots of signs in the area, but I mention it here to avoid any confusion. 113 S

❋

The poet William Cowper (1731-1800) was seized with panic when he saw the **South Downs**. He was 'daunted by the tremendous height of the Sussex hills' – but they are nowhere higher than 870 feet.

It will be fun watching the development of the plans to turn the South Downs into a National Park. There were all kinds of newspaper articles about this in the spring of the year 2000. West Sussex County Council was strongly in favour, and so were many organisations including the Ramblers' Association. But local authorities expressed strong reservations, particularly over planning. National Park status would give the Downs wonderful opportunities and strong protection. Long-term conservation and enhancement projects would enjoy guaranteed funding and one would be assured of tailor-made recreational facilities. I'm all for it. If I may say so: I would like to see more woods planted. And some trees trimmed where they obstruct the view, as at Duncton Down. 114 S

❋

After the publication of *A272* I did go into the Spread Eagle in **Midhurst** once, under the protection of a radio reporter so to speak, and I was mildly surprised that the staff would let me, this tie-less person, in. It looked distinctly cosy inside. If you do go in, ask to see the sculpted cuckoo-clock near the stairs, so gigantic that it could house a peacock! 115 M

☆

Stansted Park has several classical lodges, in one of which St Paul's church seems to be established. The house was originally designed by William Talman (whom we will meet at Uppark too). The house was first owned by the Earls of Arundel, and later by Lumleys, Scarbroughs, Halifaxes and others, up to the Earls of Bessborough, the last noble family that had it for its own. But the most colourful inhabitant was

Richard Barwell (1781), a swashbuckling adventurer who grew to be an 'Indian Nabob' and employed Capability Brown to sketch plans for the garden. The chapel inspired John Keats to his famous poem *The Eve of St Agnes*. In the late 20thC the estate was handed over to the Stansted Park Foundation and a number of offices have found a home there. The Bessborough rooms are full of family portraits and there are a lot of minor Dutch masters (in so far as any Dutch master can be called minor!). In principle everything is open to the public and especially the vast 'below stairs' part of the house, the servants' quarters, is worth seeing.

Stansted is run sustainably with a garden centre, tea room, gardens, an arboretum and all the modern facilities. The yew maze, which replaced Ivan Hick's garden, is ready to receive the public from 2010. We walked around the so-called Dutch garden, but we couldn't for the life of us see what is so typically Dutch about it. Because it's walled? One of life's mysteries. But even if they don't have all the answers, you can always ask: there are lots of helpful people about. Besides, *Enchanted Forest, the story of Stansted in Sussex*, a book by the Earl of Bessborough and Clive Aslet, gives an elaborated history of the place. 116 S

☆

Woolbeding House, Gothic summerhouse by Jebb

The church guide at **Woolbeding** church of All Hallows has all sorts of interesting details about the writers that lived here at one time. We also read that on the walls of the churchyard there grows a little plant called fairy foxglove (Erinus alpinus), bluish purple, in

Woolbeding churchyard, fairy foxgloves

early summer. We were there halfway through May one year and when we came out of the church – lo and behold, there was the little fellow, all over the wall. We had hardly noticed it before. Why it grows on these walls is a bit of a mystery, it seems. Elsewhere it only occurs on Hadrian's Wall and on the continental European mountains, where it comes from, so the church guide claims (but we have seen much the same flowers on the garden wall of Stanway House, Gloucestershire).

The church guide also has a lot of information on the history of Woolbeding House, a National Trust property, leased to Simon Sainsbury, of supermarket fame since 1972. Simon kept his privacy, but was a great patron of the arts; he created the Monuments Trust in 1965 and with his two brothers built the Sainsbury wing at the National Gallery in 1991. Anonymously he contributed generously to innumerable cultural causes, culminating in one of the most significant art bequests

to the nation, a collection worth about £100 million. With his partner Stewart Grimshaw he had the gardens of Woolbeding House further developed to a design by Lanning Roper in the 1970's, with hard landscaping by Philip Jebb. This is the more classical part, with a swimming pool, an orangery, an Italian fountain, an arbour, a hornbeam tunnel, tall hedges and sweeping lawns, with a haha. Towards the end of the 20thC Isabel and Julian Bannerman (who had worked at the grounds of Prince Charles's Highgrove House and later created the new garden at Arundel) joined in. They delivered new pleasure grounds with a ruined abbey brought from Scotland, a thatched hermit's hut, a Chinese bridge, a grotto with a river god, a Gothic summerhouse and a waterfall. There is also a feature called 'the four seasons', which is harder to describe, and a stumpery. As authors of this book we got a sneak preview in August 2010 and saw everything; for which we are very grateful to the National Trust, who took over the gardens when Simon Sainsbury died in 2006. From April 2011 they are open to the general public (when Mr Grimshaw isn't in residence) and we can promise you: everything is executed in the most exquisite taste. These gardens, beautifully landscaped, were a real and total surprise to us: there is much more follywise than our favourite Tulip Folly (by Philip Jebb) to enjoy. 122 N

★

Quoting David Mortimer, Sussex Wildlife Trust volunteer, again: 'In case it's of any interest, I will just mention that the Sussex Wildlife Trust took over **Stedham Common** in, I believe, 1999 after 30 years in which it had ceased to be a common grazed by villagers' animals. The Trust fenced it, reintroduced a small herd of cattle, and has cut back a lot of the birch scrub overgrowing the bell heather and the heathland in general. Luckily, bell heather seeds can lie dormant for a hundred years or so, and the effect has been that the heather is now flourishing and, more importantly, the uncommon Dartford Warblers are thriving, and their numbers growing, and so also the silver-studded blue butterfly. During World War II, Canadian troops used Stedham Common as a training ground so, if you leave the paths across it, you will find pits and potholes amongst the heather that seem to be without explanation until you know that they were dug as foxholes and trenches by the Canadians … sixty years ago.' 122 M

✳

In early 2000, on leaving **Midhurst** along the Petersfield road, we saw a sign for the Edward Lawrence Studios on the left with OPEN. We heard that it was newly opened just before Christmas, and we saw an exhibition there of smaller work by a sculptor with an international reputation, Philip Jackson. We had a chat and learned that behind the high brick wall at the verge of the A272 Jackson had worked for eighteen years in privacy on his many grand sculptures: the gracious masked Venetian figures in flowing gowns, nuns

Philip Jackson, Serenissima

with outrageous headgear, the sweeping Chichester *Risen Christ,* London's very life-like *Young Mozart* to mention just a few. A recent one, showing four football players with the World Cup they won in 1966, was unveiled by Prince Andrew in London in 2003. Now that his wife runs the gallery, he didn't mind disclosing where his studios are, although it is not advertised along the road. 122 M

✪

The technique of pushing little flints in walls between the bricks (also done with regular pebbles) is called 'galleting', from the French *galet,* meaning pebble. 123 N

✳

The sculptor John Stickings, who was at the corner of the little road to **Chithurst** just before the bridge at Trotton, still had his house and studio for sale the last time I checked. They are planning to move they know not where. 123 M

*

St Andrew's church south of **Didling** is certainly worth a visit for those who like to see quiet, silent churches surrounded by beautiful landscapes. If you do go there, which we recommend for your peace of mind, notice the new embroidery with sheep on the altar reredos and the head of the green man to hide the keyhole of the chest, reworked into the pulpit. Other details about the church are on the information board. 124 S

*

It was brought to my attention that St Christopher (see picture on page 6) at **Treyford** had been missing for quite a while. In the 1950's some villager moved to Suffolk and decided he would take the signpost away with him. This had been forgotten by everybody until the 1980's, when a photograph of it appeared in a magazine called *This England*. It had turned up near Manningtree in Essex, but meanwhile it was completely

Treyford, St Christopher restored again

overgrown again. Mr Richard Bowerman of Treyford, whose parents lived in that area, managed to track it down however, and it was restored before it was put up again at Treyford, where it belonged. One wonders how people in Manningtree had coped with the information that Harting was nearby. Another newspaper article said that the makers of this way-post were a Mr and Mrs Stuttig of the London Central School of Arts and Crafts, in 1924. An unlikely story. Who is called Stuttig? Ah, Frederick; OK. By the way – St Christopher wasn't complete when we first saw him. He now has his shepherd's staff restored with the sign 'to Cocking' pointing to his right. 125 S

*

Trust the Trust – they did take care of the lupin field of **Terwick** common, lupinless on page 125. We kept going past it and in June 2001 we found it ablaze with colour, as you can see in the new photograph on pages 206-207. 126 M

*

Rogate. We need to solve a mystery here. Both my wife Rita and I distinctly remember driving through the village and reading a sign that Rogate was twinned with Clochemerle. We saw it more than once in 2002 and made a note. I wanted to know more about this and looked Clochemerle up on the internet. I learned that Clochemerle didn't really exist and was a fake name for a village in France: Vaux en Beaujolais, north-west of Lyon. Gabriel Chevallier it was who wrote a novel that satirized the confrontation of secular and religious forces over the construction of a public urinal in this small wine-growing village. Clochemerle stands for Vaux en Beaujolais. I read the book *Clochemerle* (which was fun) and I personally went to Vaux-en-Beaujolais to look for clues. Nothing. The book became quite popular. It was even turned into a musical. But anyway, how can Rogate be twinned with a purely imaginary literary village in France? I still wanted to know more. I called the local press and they had no explanation to offer. They referred me to the parish council and they had no explanation to offer. Am I slowly going mad? Has Alzheimer struck? Can the culprit step forward, please? As I say: we need to solve a mystery here. 127 M

*

P. G. Wodehouse mentioned *The Petersfield Sentinel* no fewer than four times in his novels *Frozen Assets* and *Uncle Dynamite*. He must have been a regular reader of *The Petersfield Post,* or maybe *The Petersfield Herald*. 127 E

❧

A recent acquisition for the church of **South Harting** is another major sculpture by Philip Jackson, unveiled by the bishop of Chichester in April 2009. This time it's a life-size *Archangel Gabriel,* made of an artificial stone to match the medieval stonework of the church, off-white. Hanging from the roof he seems to float into the church. The organ had to be replaced for his arrival. We are not going to discuss here whether angels are male or female. Male, I should think, looking at the bare breast. Let's say: he/she looks appropriately androgynous. It's another splendid artwork by Mr Jackson, commissioned by an anonymous benefactor. We asked him by email to explain about the material and various texts and he answered promptly: 'The wording on the skirt is in Latin and says AVE MARIA GRATIA PLENA DOMINUS TECUM. The ribbons that hang from Gabriel's head cloth carry a dedication personal to the benefactor. The sculpture depicts the Archangel Gabriel descending with wings outstretched, hands spread to slow his progress while his foot is extended ready to land in the Church's transept. The arch of the wings echoes the shape of the arched mullions of the

South Harting Archangel Gabriel

window behind.' Gabriel has already been dubbed The Angel of the Downs. Gabriel. After all, this is the St Mary and St Gabriel church. Some villages seem to have all the luck. 127 S

*

B etween **Harting** and **Petersfield** is Yew Tree Cottage (now Badger Cottage), where Peggy Guggenheim used to live (her daughter Pegeen went to school in Petersfield – Bedales?). She entertained lots of artists there, according to her autobiography *Out of this Century, Confessions of an Art Addict* (1979). Peggy Guggenheim, who gave her name to her museum in Venice, was perhaps the greatest art collector and connoisseur (connoisseuse?) of the last century, partly because she intimately befriended many of the key figures. Love of art runs in the family – the (Solomon) Guggenheim museum in New York developed an offshoot in Bilbao, and who knows where next? 128 S

✳

A lso in **Linch**, north-west of the church this time, at a crossroads, there is a little war memorial adorned by an even littler figure of *St George*. This proud-looking knight stands at ease, but has his sword at the ready, and dragons had better beware. Very petite. What a lot of expression you can put in a small figure like this! But maybe it's no wonder, for the effigy was made by a master of his trade: the internationally

Linch, St George

renowned Philip Jackson again. He keeps on beautifying the whole area with his sculptures. This was erected as a millennium project. 129 N

✩

Liphook has a Literary Walk: dedicated to Flora Thompson (1876-1947), who wrote the *Lark Rise to Candleford* trilogy (1939-43). She worked in Grayshott post office for a while, and educated herself with books from the library and second-hand bookshops.

A friend of ours told us to go and have a look at the funniest statue she had ever seen. It was at the entrance to Foley Manor. The entrance to Foley Manor wasn't so easy to find, but there it was. It is an equestrian bronze of the 19thC Field Marshal Strathnairn, and nicknamed 'the banana man' because of the growth on his helmet. A picture is worth a thousand words again. A chap who lived there explained to us that the statue had come from London originally, where it had stood since 1895 outside Harrod's in Knightsbridge, until it proved too troublesome for traffic. It was then moved to a scrapyard

Liphook, 'Banana Man'

where a Mr Northcott saw it. He could have it for free if he could move it to wherever he wanted. He wanted it for Foley Manor, where it was re-erected on 24th January 1965. 131 N

✳

The Square in **Petersfield** is changing. The Victorian toilets on the side of the churchyard were cleverly converted into Cloisters Continental Cafe in 2009, adding another opportunity for al fresco revitalizing. The Market Inn has been boarded up for several years now, with no prospect of new prosperity. On the opposite corner The Square Brewery got a new pubsign around 2006 when they changed brewers; it is quartered, with pictures of the pub, the beer cart, the tun lifting and the William on horseback, with the pub in the background, just like The Market Inn's.

Rumour has it that the sculptor of the equestrian statue in The Square, Petersfield, dating from 1753, committed suicide after he had discovered that he had forgotten the tongue of the horse. How do all these rumours get started? Some school mistress thinks she has an interesting anecdote to

William with injured leg

offer? Or what? John Cheere died in 1787, aged 78!

Here is a picture of the horse and its missing tongue at a time when William's leg had been pulled again in 2004. 132 M

✺

In spite of my reservations about Longmoor Camp in **Woolmer Forest** somebody told me about a Dutch connection here. In order to have suitable motive power for the continental railways after the invasion at the end of war, nearly 1100 large freight locomotives were built between 1943 and 1945. The thousandth British-built

locomotive was ferried across after D-day and received the name 'Longmoor', since Longmoor was the site of the Military Railway run by the British Army's Royal Engineers to train (no pun intended) military personel in all aspects of railway use. It was subsequently bought and used by Dutch Rail and is now preserved in the Railway Museum at Utrecht in the Netherlands ... 133 N

※

St Laurence Roman Catholic church in **Petersfield** was the parish church of Sir Alec Guinness who starred in some of the greatest films ever made, from *The Bridge on the River Kwai* to *Dr Zhivago* and from Dickens films to *Star Wars.* He lived in Steep Marsh and was vice-president of the Petersfield Hi-lights, a theatrical society, for more than 40 years until his death in August 2000 at the age of 86. 133 M

※

Petersfield's most endearing attraction is no more. Alas, alas. The owners retired from the business and the teddy bears were sold at auction a few years ago. The shop is closed. Only the black iron sign that was there, portraying the teddy bear picnic, is still visible near what used to be the front door of the shop. One has to recognise that everybody has a right to retire, but this was one of the two major attractions in the area of the A272 for children. The first was Pooh Corner, the shop that is devoted to Winnie the Pooh, and the second was this teddy bear museum. We feel cheated out of a superior treat. Incredible, that the otherwise engaging town of Petersfield has allowed this disaster to happen. Have they done enough to save the teddy bears? I would like to instigate a full investigation, but I'm a foreigner. Don't you British people care? DO SOMETHING! Questions should be raised in parliament; an enquiry initiated; the guilty miscreants punished and the whole situation redressed. Heads must roll. Ahhh. Sob. Sob. But seriously, we miss it dearly. 133 M

✻

Don Dennis has moved out of **Milland**, unfortunately. But we have found something else instead: **Tuxlith** chapel. It is hidden in the woods to the northwest, to be reached from the B2070. Tuxlith is the old name for the parish. The chapel is late Saxon in origin and the Friends of Friendless Churches have assumed responsibility for it. It is peculiarly L-shaped and there is a lot of useful information inside. It is popular for weddings and such; and for funerals, for most of the graveyard is quite modern. Going through the 1999 lychgate and walking on, you come to what is called the Roman Staircase. The view is not so good because of the trees, but there is this staircase meandering down towards Milland. The stone steps, some 75 of them, look very old, but it is doubtful if indeed the Romans built them to scale the hill. The course of the Roman Road here is drawn a few hundred yards away to the north

Milland, Roman Staircase

on my map. I'd like to know more. How does one find out about these things? As an ancient sign of civilisation it is a remarkable sight in the middle of nowhere in particular. 134 N

✳

When in Milland, if you want to see how a camel can turn into a dromedary, you could study maps with footpaths and go along one of them towards Ivy Folly. Keep to the public walkways, though, and maybe bring binoculars. As I said: Ivy is exactly 1 kilometre east of Milland crossroads. 134 N

✺

Near the beginning of the High Street in The Square in **Petersfield** we come upon Rams Walk, with a

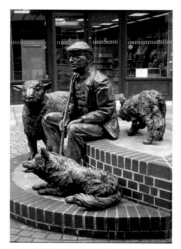

fairly new sculpture of a resting shepherd, a ram and two dogs, done (well done!) by Andrew Cheese in 1999. It was the first commission by the community since *William III*, according to a plaque. This is the sort of art that is immediately loveable and can be appreciated by anyone. Let's hope it remains vandal-proof as well.

134 M

Petersfield, Rams Walk

❉

South of **Chalton**, and just beyond our self-imposed limit really, is something one of the letter-writers drew my attention to. The sleepy village of **Rowlands Castle** has a monument by the side of the footpath along the B2148, close to its junction with the B2149. He described it as an inconspicuous, rectangular grey stone pillar and later sent me a picture, as I had missed it when I was in the area for my researches. The monument has an inscription that reads:

Here
on 22 May
1944 His
Majesty
King
George VI
reviewed
and bade
God Speed
to his troops
about to
embark for
the invasion
and
liberation
of Europe
Deo Gratias

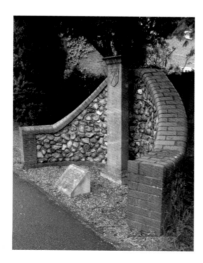

Rowland's Castle monument

If you imagine tens of thousands of troops marching along the B2148 to be saluted by their king on the way to possible slaughter, it is indeed impressive enough to warrant a mention in this book. So that's been put right. Since the king's stone in Rowlands Castle was repaired and made more obvious in 2005, it even warrants a picture.

135 S

❋

In the 2004 edition of this book we reported about the charming but rather primitive works of art by Len Ede in **Petersfield**. Three pictures and some text. We took a risk putting it in, and now we have to take it out again. Len Ede has moved house taking Milenge with him. Nothing is left.

But relatively new is the Petersfield museum. Especially since they acquired the historic costume collection from Bedales school it has a lot more to be proud of. And then there is their connection with Flora Twort of course. Her paintings plus the cottage where she lived until her death were donated to the museum by Hampshire County Council in 2009. The building is somewhat hidden in a lane behind St Peter's church. The otherwise excellent Petersfield Blue Plaque Trail on the town's architecture almost misses it.

Finally, there is some positive news about the Grange Farm and abattoir area that I complained about. A great big supermarket has arrived there in the mean time and the old house has become a surgery.

However, on the cheesecake front things still leave a great deal to be desired.

136 M

★

And when you end of the Hampshire side –
Butser's as old as Time and Tide.
Rudyard Kipling, 'The Run of the Downs,' from *Rewards and Fairies*, 1910

142 S

❋

Two people sent me excerpts from the book *Mind over Motor* (1956) by W.H. Charnock, who had written various poetical works about motor-cars before starting on this prose book about motoring. It is fun. It

has a truly British style of humour and may be read by fellow enthusiasts and non-drivers alike. Some chapter titles are: Cars I Have Owned, Bicycles I Have Disowned, The Compleat Automobilist, Funny Hats, Fads and Fancies, The Car That Nearly Died of Shame etcetera. But the reason some bits of the book were sent to me was that one chapter was entitled A272. It starts off with 'Every driver has his pet road' and continues with 'I'll settle for A272 any day, or rather for the 20 miles of it which run between **Winchester** and **Petersfield**. Not much of a road really, but for a combination of faultless surface, driving interest and breathtaking beauty not easy to beat in the Southern Counties.' Then follows a poetic, idyllic, not to say delirious account of what driving on this road is like. I couldn't express it better and I wish I had known this text before I wrote my book. I would have quoted from it joyfully and extensively. As it is, I can do no better than recommend it heartily. It is a book to borrow from your local library and enjoy at leisure, for hours of rapture and chuckles. 143 M

✪

The Wellingtonia was introduced in Britain in 1853 and thought so impressive and massive that it was named after the famous general and duke who had died the year before. The colonial cousins were so incensed that they promptly rechristened 'their' tree after their favourite general and called it Washingtonia! The largest is nicknamed General Sherman tree, and the third largest the General Grant – we saw them both in Sequoia National Park, California. I don't think there is a tradition in England of naming individual sequoias after generals. 144 W

❋

The Harrow Inn at **Steep** was in a national newspaper when late in 2004 the landlady died. Ellen McCutcheon was honoured by half a page in the Daily Telegraph as one of the few pubkeepers who together with her customers in a grassroots revolt succeeded in fighting off all the renovations suggested or rather ordered by the breweries. It has remained the pub it always was, inclusive of the outdoor toilets. The Harrow Inn had some colourful clientèle, among others the columnist Mandrake, a dog that smoked a pipe, poachers and sailors and my favourite science fiction author John Wyndham. At the moment Ellen McCutcheon's daughters Claire and Nisa run this pub that I have heard called 'the best pub in the world'. In 2008 it was 'unspoilt pub of the year'. Please don't go there all at once. 145 N

✳

The **West Meon Hut** is only slightly less of a mystery. We have found out that the list of Hampshire Treasures of Hampshire County Council has the Meon Hut as dating from the 18thC, and notes that it was formerly The George Inn, an old coaching inn. 147 M

✴

The whole garden of **Selborne** was recently done up and rightly won a prize for its restoration. There is an almost convincing statue of Hercules painted in trompe l'œil on a flat cut-out shape with the wood as backdrop (the way the Dutch were advised to conjure up an eye-catcher or folly cheaply in those days), and there are a few other landscape elements like a reconstruction of White's revolving observatory tun in which you can sit and admire the view. All tastefully done.

Et in tunna ego

Selborne is also mentioned in the book *Eccentric Britain* as the place where a dole should have ended more than 500 years ago, but is still going strong. '... the old people of the village receive a loaf each on

Gilbert White

St Thomas's Day (December 21) although the priory which ordered this closed in 1486. Magdalen College, Oxford, took over because of its interest in priory lands, for the next 500 years, but recently sold the lordship of the manor. The new owner continues the tradition, however.'

And by the way, both the collection of Rural Relics and the Romany Folklore Museum have evaporated. 148 N

In the hot summer of 2001 in the woods near the **Bramdean** Common Gypsy church we saw a warning or an encouragment, depending on your phobia, hammered on a tree. It said: 'Snakes and adders in Bramdean wood. In hot summer they are not alert and you can meet them.' We did not shake hands with any of them. 149 M

Imagine my surprise when, after having gone to the excruciating trouble of finding a name for the crossroads at **Hinton Marsh**, the next time I came past I saw a sign saying **'Cheriton'**. One can argue that at last and at least a decision has been taken by the authorities in the matter, but don't writers like me get taken seriously anymore? It's a shame and I am miffed. Must be that cussed, contrary Hampshire County Surveyor's Office again. 151 M

The church in **Warnford** is dedicated to Our Lady and was founded by St Wilfrid in 682. The sundial that we saw there years ago must have been one of the five scratch dials on the outside of the porch to regulate

service times. We now discovered the real Saxon sundial inside the porch over the south door, very similar to the one at nearby Corhampton (page 152). Not much use if you need a light to see it since they built the porch over it. Below it you can see a 12thC inscription in Lombardic letters.

The village was originally nearer this church, but was moved half a mile at the end of the 18thC when prisoners from the Napoleonic wars were building the new A32. 151 S

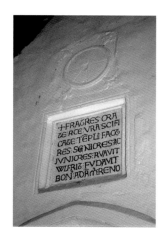

Warnford sundial

Andrew Young in *The New Poly-Olbion* discusses the 'numinous yew', including the Forthingall Yew, 'in whose shade Pontius Pilate played as a boy, his father in command of the Roman camp'. 152 E

Grange Park and its orangery are restored now with some half a million pounds from English Heritage. In 1998 it became the summer home of the new Grange Park Opera. It is the third of the three rural English opera companies (Glyndebourne, 1934, and Garsington Opera, 1988, are the others). In 2003, its sixth successful season, plans were made to discreetly build some more rooms between the Grange and the orangery to have more indoor space for stage and audience. 154 N

The futuristic building you see in front of you before you get into **Winchester** is the new location of Intech at Morn Hill, an £11m educational centre for technology and science, particularly for children. It is called Intech 2000 because it is a Millennium Lottery Project, and it opened in 2002. Full of wonders and

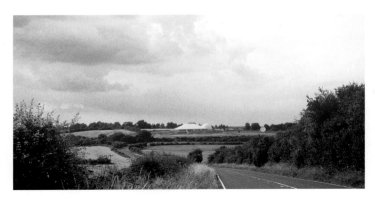

Intech on Morn Hill from the A272

wonderful, literally. Many colourful hands-on exhibits in the tent-shaped building, and a beautiful auditorium with a planetarium planned in the white cupola. And a view back on the A272 from a magnificent vantage point – see the long and winding road. The disk is the teleport station of neighbour NTL who donated the land for Intech 2000. 154 M

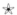

In St George's Square in **Bishop's Waltham** a fancy millennium clock was put on a pole in the year 2002, we were told. But it turned out that if it was indeed a millennium clock, it was at least combined with another occasion for celebration: the Golden Jubilee of Queen Elizabeth II, for that is what it says on the plaque. Two other plaques were missing. Bishop's Waltham couldn't do without adding a bishop's mitre on top of the four-faced clock of course. 155 S

Bishop's Waltham clock

In the local Brushmakers pub at **Upham** you can always find people who can tell you stories about Pig City, as the area is called. I forget the exact figures that were mentioned of course, but they were pretty impres-

sive. Nice pub, by the way. It has a certificate inside that says that it's haunted: a murdered brushmaker doesn't leave it in peace, apparently. 156 S

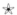

Interesting new archaeological research has taken place in the vicinity of **Winchester**. In the year 2000 Kevan Halls found with his metal detector in a (so far undisclosed) field the so-called Winchester Hoard. It contained two torcs, two bracelets and several fibulæ (brooches or clasps), all of pure gold, together about 1000 grammes of gold from, presumably, a rich native ruler's grave. This exciting find was first attributed to Iron Age people. The British Museum studied the circumstances of the find with the Portable Antiquities Recording Scheme, another Heritage Lottery Funded project, and acquired the treasures for the nation. After careful scrutiny they now conclude on the basis of the techniques of the goldwork, particularly granulation, that all this was definitely made by a Roman or Hellenistic craftsmen, between 70 BC and 30 BC and cannot be the product of local craftsmanship. Perhaps it was the gift of very powerful Romans, maybe even Julius Cæsar himself, to a local chieftain, before the invasion of the Romans. It may have been a bribe to win the sympathy of the barbarians and ensure local support for the Roman takeover. 158 M

When we saw John Cleese's film *Fierce Creatures* we wondered if its Marwood Zoo had anything to do with **Marwell Zoo** – is it an obvious disguise? Well, *Fierce Creatures* was filmed at Pinewood Studios, west of London, where they built a reconstruction of a zoo. But in May 1995 several shots with larger animals were taken in a three-day session at Marwell Zoo, much to the excitement of its employees who were allowed to film the filmers. 158 S

Old Alresford church, about a mile north of the town, is famous for its connections with Mary

Sumner whose husband was rector here in the 1870's, as one correspondent wrote. Mary Sumner founded the Mothers Union, which is now a world-wide movement dedicated to the preservation of Christian marriage. Many people come to see her memorials in the church and in the adjacent rectory. For some reason this bit of information had escaped the first edition of this book. I had an idea that I was missing out on some potential customers. The omission is hereby rectified.　　161 N

I was greatly surprised to come across **Chandler's Ford** in a 'travel guide' by Dixe Wills: *The Z to Z of Great Britain*. Every possible placename beginning with a zed is in it. (Stephen Fry calls the book 'Exquisitely dotty, yet irresistibly charming. A project so pointless as to be vital to our national well-being.') One of these places is Zion Hill Farm, as the author says 'just awry of Chandler's Ford'. The book explains why it is called Zion Hill Farm, how to get there, what are the things to do and to look out for (barn-turned-garage, bollard, hedge), what's in the neighbourhood, what's furry, what lives in green bins, and as far as the role in Civil War is concerned, that Oliver Cromwell once spent the night there, though 'why he did so is not entirely clear. One can only assume it was night and he was tired'. The entry is concluded by a 'killer fact' of coincidence which I'm not going to reveal – you will have to read it yourself. Very witty book. A friend of mine gave it to me remarking that it was just as barmy as my *A272, An Ode to a Road*. I was not amused.　　161 S

The big, broad church at **Twyford**, partly medieval and partly 19thC, acquired an exquisite Russian icon, painted in 1999 by Sergei Fyodorov, examples of whose work are in several Russian and English cathedrals. This one here is in the iconographic 'loving kindness' style. The information beside it quotes George Herbert:

> A man that looks on glass
> On it may stay his eye,
> Or if he wishes through it pass,
> And then the heavens espy

Twyford Icon

That's the whole idea about icons: that you may see heaven. Look what this icon shows you. Heaven? No? Then you are a bit like me. I admit: it's a good icon, but you'd have to be in religious ecstasy, I think, in order to see heaven. Maybe I'm jealous.

If you climb the Jacobean-panel-clad balcony you have a close and very instructive view of the new stained glass window by John Hayward. St. Mary's church also boasts twelve Druid stones (presumably left-overs of a Druidic temple) under the Norman tower, and the oldest and largest clipped yew tree in the country shading the churchyard for reputedly over 1000 years.　　163 S

Twyford clipped yew

Enjoy the wooden scale model of the church in the south aisle of **Winchester** cathedral, solid enough to be instructive for 'hands-on' children and the visually impaired – if they can find where it is.　　165 M

In the Silkstede Chapel in the south transept of **Winchester** Cathedral, now called the Fisherman's

Winchester, Walton window

Chapel, you will see the grave of Izaak Walton and his commemorative window, a gift of the fishermen of England and America. It shows him lying by the side of a river, reading a book with his fishing tackle unused at his side (or is the basket full of fishes?) The motto below it, *Study to be quiet*, will appeal to teachers and parents alike. 165 M

I mentioned on page 144 that the black marble font in East Meon church was one of seven very similar fonts in the country, and that another one was in **Winchester** cathedral. I should have mentioned the connection again when describing the arts in Winchester. The picture of the East Meon font showed Adam and Eve evicted from paradise. The Winchester one has miracles of St Nicholas around it. With the help of the note on

Winchester, Cathedral, font

page 106-107 you can recognize them. You will find the font in the north aisle, near Jane Austen's grave. 166 M

We spent a day in **Winchester** again in 2009. It was as pleasant as it has always been. The Park and Ride is now £2.80 (and will probably be over £3 when you read this), but still worth it for the free bus ride. The City Walk brochure is £1, but for the disabled and for children it is free. We asked at the tourist office what the building near Intech was going to be, and they said it would be a Holiday Inn. That's good news for the city. Good news is also that Winchester City Mill mills flower again after a hiatus of at least 90 years. Very bad news is that the youth hostel moved out of this watermill in the autumn of 2005. That can't be good; no earthly good. For the nearest youth hostel you have to go 20 miles away to Salisbury or other places. How can the council allow that to happen? Off to the salt-mines with them! On the other hand, they did something right: a number of new works of art are on display in the centre. The most conspicuous ones being the column *Luminous Motion* by Peter Freeman, which works on text messages by mobile phone, and the *Kite Flyer* by Marzia Colonna, which hangs high over Parchment street. And the second-hand bookshop still is there in St George's Street, which is an extremely comforting thought. We mooched around in the

Winchester, St Cross Hospital: Rita's dole

centre, did some shopping again, asked for information here and there and the entire day was concluded by Rita staying another hour at St Cross Hospital where she enjoyed the famous Dole and boys sang Gregorian-

sounding music, while I sat daydreaming in the car. In short: a splendid day. 169 M

character in the popular TV series *One Foot in the Grave* and Britain's grumpiest pensioner. Real people brought real flowers to the spot and grieved. I have a mind to quote him, saying: 'I don't belieeeve it!' 170 S

✳

Apparently the local people in **Shawford** have always thought that their Red Layne had been called Red Layne ever since about 1200, because the body of Rufus passed that way when Rufus (which means Red, we are talking about King William II Rufus, c.1060-1100) was killed in the New Forest, in what's generally called 'a hunting accident', and from there carried through Shawford, where he rested, to Winchester, where he was buried. I can think of several other reasons why a Red Lane would be called Red Lane, but that's beside the point (and why not Rufus Lane then?).

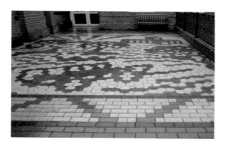

Shawford maze

Let these people have their fun, I say. Anyway, the idea of celebrating the event was reason enough for the parish council to call in Adrian Fisher (the world-renowned designer of mazes) and he built this maze, consisting of tiles on the ground. It was executed at the village hall in two parts: first a square with arrows in all directions and then a larger area with a mosaicky three-coloured scene of how the king was killed and carried away. There is a lot of (sometimes confusing) information about it inside the village hall. It manages to look a bit cheerful, even on a rainy day. Well done. The question that remains is why the villagers have chosen to honour this particular king. A choice out of poverty? Rufus was in the words of the contemporary Anglo-Saxon Chronicle 'hated by almost all his people'. He stole from the church, didn't keep his promises and was assassinated (indirectly) by his brother, the later king Henry I. Hunting accident, my foot.

And now for something completely different: at the Bridge Hotel in Shawford Victor Meldrew was killed in a hit and run accident in 2000. He was the main

★

The weird dish on a pedestal you can see away to the west of the junction of the A272 and the A30 is **Chilbolton** observatory. The observatory was built on the site of a World War II airfield in 1967 for research on radio wave propagation and atmospheric physics, and it was very advanced equipment at the time. It was therefore an unexpected near-disaster that after three months the dish could not be moved without a terrible squealing and that subsequently with great expense and great effort the azimuth-bearing (the centre of rotation for the antenna) between the concrete base and the 25-meter aluminium dish had to be replaced. It has worked flawlessly ever since and is now operated by the Radio Communications Research Unit, who have another branch five miles away: the multi-frequency satellite-receiving system in Sparsholt. RCRU also use metereological radar facilities to produce the Chilbolton Weather Web. My apologies for sounding so technical. Amazingly, you can get information about crop circles there, according to the 2003 Wiltshire Crop Circle Study Group calendar. I suppose they monitor aliens too.
 180 M

Chilbolton Observatory

✳

In 1995 Mrs Cornelius-Reid of **Sutton Scotney** granted a 99-year lease on some land to the Wessex Children's Hospice Trust, for which the rent is a dozen red roses, payable each Midsummer's Day (all according to Ben le Vay's *Eccentric Britain).* 181 N

✪

Hardy's map of **Wessex** stretched from Cornwall to Berkshire, but he usually meant Dorset. 182 W

⚜

We noticed something new in **Sparsholt** opposite the little shop and the village hall at the bus stop. Local primary school pupils' designs had been eternalized in mosaics (with help from Hilary Shand). The project was funded by a grant from Winchester City Council for environmental improvements. Hooray for Sparsholt. We would like to see more of those things. 182 M

✳

In 2009 the monument to a horse at **Farley Mount** looked splendid again. An unfortunate restoration in 1950 was put right between 2000 and 2004. Apparently people had read this book. Something should be done about graffiti writers, though. They rarely beautify; they mostly uglify. Above the porch we noticed in big letters: 'abandon all hope'. I don't mind so much when graffiti are witty, but they seldom are. Here it is just inane. I admit I enjoyed the one I saw down in a London underground station once:

> The cleaner's work was all in vain
> The underground poet strikes again 182 S

✻

Somebody informed me that the place-name **Wherwell** should be pronounced [horel] and that it

Wherwell

came from Whore's Well. Interesting. He didn't remember the details, but rather thought that some unfortunate woman of that profession drowned herself in the well. Readers from Wherwell, can you confirm this? 183 N

✳

In August 2000, when we last saw it, there was a new housing estate built opposite the water-tower at **Goodworth Clatford**, and we were told it was still functioning as a water-tower. But people were thinking of a new use for it, maybe an artist's studio. 184 N

✺

It would happen of course at **Crawley**: NTL was bought by an Australian company and named Arqiva. Same business, same people, but different road signs everywhere. And by the way: the village pump still doesn't work; the pipes are blocked. 184 M

☆

Of the village of **Longstock** it should be mentioned perhaps that there are many cottages with remarkably steep thatched roofs. And there is something else. In a curiously off-hand way I mentioned Longstock Park in earlier editions of this book. I knew it was once the property of John Spedan Lewis (of the famous shops), but I underestimated his influence as an employer and gardener. I need to put this right. Spedan Lewis (as he is also called to distinguish him from his

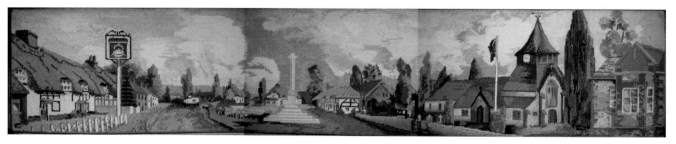

King's Somborne embroidered

father John) assumed control over his father's two shops in London, Peter Jones and John Lewis, at a relatively early age. After his father's death he officially formed the John Lewis Partnership in 1928 and afterwards all employees became partners and shared in the profits. In 1933 the Partnership bought Jessop and in 1937 the Waitrose supermarkets (off Mr Waite and Mr Rose). Spedan moved to Longstock in 1946, where he started the water garden round the lake that was already there in the Leckford Estate. He retired as chairman of the Partnership in 1955 and since then could often be found in the thatched summerhouse at the lake. Books have been written about him with subtitles that speak of an experiment in industrial democracy and advance in civilisation and perhaps the only alternative to communism. In 2002 a BBC poll voted John Spedan Lewis Britain's greatest business leader. North of the water garden is Longstock Park nursery, also part of the Leckford Estate and fully owned and managed by Waitrose. Here (and elsewhere of course) the products are grown that are for sale in the Waitrose supermarkets. But it's a normal nursery as well, where you can buy plants and implements and have refreshments. All in all, John Lewis and Waitrose (and Greenbee and what not) are fascinating businesses and I am sorry to have underestimated them before. 186 N

*

We saw the unspoilt old church at Little Somborne. Redundant but charming. A second visit to the church of **King's Somborne** revealed a few things that either we had forgotten or were not there the first time we were there. I expect the latter. There was a lot of embroidery on long cushions, with scenes of village life. And a memorial window by John Hayward for aviation

pioneer Sir Thomas Sopwith (1888-1989). 'Twice his foresight saved the nation in time of danger,' it says on a plaque. His complete life's history as a designer of fighter aeroplanes is behind glass.

From King's Somborne we paid a brief visit to the little church at **Eldon**. A friend of ours had said to us: 'If you mention a place like Ashley, you should also go to Eldon.' She was right. We had some trouble finding it on the map (it's two miles south of King's Somborne), and we were very grateful not to meet any oncoming traffic or we would have had to drive some of those miles in reverse, the road was so narrow. But it was worth it. The parish church of the smallest parish in England. Cared for by the Churches Conservation Trust, the 12thC building looks like a barn and has indeed been used as such at some stage, but now it is a redundant church. There is a small squint at the back. There were chairs inside, but that may have been only temporary, for a concert or so. Otherwise everything is peace and tranquillity; the silence is almost deafening.

186 S

*

The pub sign of the White Horse in **Chilgrove** was such a curiosity that thieves tried to steal it. Unfortunately they cut the wisteria to get at the actual sign. But that was so difficult that they didn't succeed. I was told that the cat was inside for a while to recover from the shock.

See: the times they are a-changing. Now The White Horse pub itself is no more and what is worse: the pub sign (which – to be honest – had a white horse painted on the other side) has also disappeared. The owner sold the pub and took the sign with him. Rita tracked him down through the wine-merchant there and he promised not to take it away to New Zealand when

Chilgrove White Horse; Limeburners near Billingshurst; Barcombe Royal Oak; Piltdown Man

he's going to emigrate. However that will end (Rita suggested a museum), you can still eat and drink here; the pub has changed into a fancy fish restaurant. I must admit, the decor is well done and the soup is great, but this yuppie Fish House is far removed from the nice, cosy pub it was. We heard about posh plans for enlarging the place with new accommodation (they had already started) and even an open-air jacuzzi. We shall see.

We have often wondered at the speed with which pubs change their signs. We can't remember having seen the Green Man in Horsted Keynes depicted as a lumberjack – that may be due to our forgetfulness. But the Limeburners, west of Billingshurst, Noah's Ark in Lurgashall and the Piltdown Man are just a few examples of signs that have changed from one year to the next. This is usually due to take-overs by breweries, we understand; a typically British thing. The Limeburners changed breweries six times over the last fifty years. This may not seem too much, about once every ten years, but it is particularly annoying when we speak highly of one, or show a picture of another in this book, and then it isn't true anymore. For example: I talked about the picture in a picture in a picture of the Market Inn in Petersfield, on page 132. This one may be back, for the pub's future hangs in the balance, but at the moment of writing it's not there anymore. It's exasperating. However, we found comfort in the new Square Brewery pubsign in the opposite corner (see also page 246 for 132 M). The proper Royal Oak picture in Petersfield (see page 163) soon disappeared, but in 2009 we saw a good new one in Barcombe. 188 W

Lurgashall Noah's Ark mediaeval; Lurgashall Noah's Ark modern; Petersfield Square Brewery; Horsted Keynes Green Man

*

The description on pages 190-191 of the folly side entrance to **Houghton Lodge** was evidently too complicated; we heard a report of someone having discovered a toy castle without recognizing it from our circumlocutory remarks. We are therefore providing a picture to prevent future misunderstanding.

Besides the hydroponics business **Houghton Lodge** is developing into a garden centre. We talked to the head gardener who had a theory about the mystery object that we had asked to identify (see page 202): he thought that at a certain stage of building or restoration someone had a number of bricks left over and had made this thing as a joke. His theory is as good as any. Or do you know better? In that case: please make us wiser than we are because we are still in the dark. But maybe the mystery monument has inspired another new development in the gardens of Houghton Lodge. A low curving wall, of stones and bottle bottoms, has been built around a stone drum for a

Houghton Lodge: side entrance folly from inside the garden

topiary peacock. There are several other topiary peacocks about and one bronze one. We also saw a new wooden summerhouse in a field where some outlandish beasts, called Tom, Dick and Harry, were roaming. Things are still happening here.

189 S

☆

Nether Wallop. We get so used to village names that we tend to forget how strange they must sound to other ears. Let me quote from a P. G. Wodehouse book: *Indiscretions of Archie.*

'As a matter of fact, Bill tells me that she was brought up in Snake Bite, Michigan.'

'Snake Bite? What rummy names you have in America! Still, I'll admit there is a village in England called Nether Wallop, so who am I to cast the first stone?'

192 N

I was complaining about the unavailability of a book on **Stockbridge** in the short story concluding Chapter 7. And then out of the blue in 2001 *A Portrait of Stockbridge, from 500 BC to 2001 AD*, was sent to me by the author, Hugh Saxton. Mr Saxton is a retired doctor who had moved to the place only five years before he started writing this book as a Millennium project. I think the book is a magnificent achievement. It describes the place as it should be described, with many illustrations, and it must be the envy of all the villages in the area. I mean, I can say something superficial about Stockbridge's quaint Courts Baron and Leet in my book, but the whole procedure is explained by Hugh as if you are present there and then, and that makes it ever so much more interesting. Lutyens worked for the place (designed the war memorial), Stockbridge Down used to be a site for the execution of criminals, houses owned by the Leckford Estate are painted dark green, there was a Passion Play in April 2000 for which the road was closed, and other fascinating details make up a book that provides good reading for everyone. All very local, but that's what I like about it.

193 M

♣

The countless footpaths and bridleways that cross the A272 also include smugglers' tracks. Smugglers were active all over the woods near the south coast. There were times when you couldn't cross Ashdown Forest without stumbling over them and they were not particularly friendly people. Ashdown Forest was a dangerous place once. But smugglers' routes are also obvious north of Woolbeding for instance, and further west near Blackdown. A friend of ours, Hilary (named after her godfather Hilaire Belloc), told us that they were even specially indicated on a map provided by the authorities in the forestry car park north of Rogate. Not

for smugglers who had lost their way of course, but much later, to make it exciting for tourists. 195

＊

I can't tell you how often the A272 is intersected in the air by aeroplane-routes but I can tell you it is intersected by a series of Telegraph Hills. In the 19thC the authorities built a straight line of signalling towers between the Admiralty in London and Portsmouth at the coast. One such Telegraph Hill is on Woolbeding Common; there is Telegraph House north of North Marden and the next Telegraph Hill is further to the south-west near Compton. So the line crosses the A272 at Trotton Common near the bridge. All these Telegraph Hills had similar towers with housing attached. There is only one of these towerhouses left, at Chatley Heath near the M3/M25 crossing. It was built in 1822 and restored in 1989, since when it is occasionally open to the public. We took a picture there. A great pity these towers have disappeared from the A272 area. 195

Chatley Heath telegraph tower

❋

My conclusion at the end of the book was: The A272 is England. J. H. B. Peel in *Along the Green Roads of Britain*, wrote:

Is there, I wondered, any place in Britain, at which a man can nowadays feel safe from builders and motors and aircraft? The voice of John Ruskin answered *ex tenebris*: 'Wherever I travel in England, I find that men have no other desire or hope, but to have large houses and to move fast. Every perfect and lovely spot which they can touch they defile.

We shouldn't be so gloomy. Hey, let me tell you something. While staying somewhere on the A272 I read Ruth Cobb's *A Sussex Highway*, 1946, about a walking tour from Lewes via Westmeston to Ditchling. She commented on Edward Thomas's poem *Roads* before quoting two stanzas. In her words: *And as I stepped on to the main road, my journey done, I knew with Edward Thomas, the poet:* I loved roads, *And one road especially.*

> Roads go on
> While we forget, and are
> Forgotten like a star
> That shoots and is gone.
>
> On this earth 'tis sure
> We men have not made
> Anything that doth fade
> So soon, so long endure.

Just like Ruth Cobb I can identify with this. Both Thomas and Cobb were thinking about different roads, but it's true of my own road too. That's the spirit. The A272 remains a beautiful and inspiring road. Long may we travel and enjoy it! 195

The A272 near Benbow Pond

We have reached the finish now and can start again. The road still goes on, the long and winding road. And the travelling goes on: the writing goes on. We still welcome more comments and updates. The A272 book has reached 272 pages, but is that enough? Not for us!

index

This index lists virtually all people, objects and villages described, however scantily, in the text. Place-names outside the A272 area are seldom given. Artists on the other hand find their way into the index quite easily. Pubs and churches are hardly there at all, since they are considered part of village descriptions. When descriptions cover more than one page, the bold number in the index refers to the start of the description. For the revised edition of this book the index has been considerably enlarged. A number of entries have been subdivided so that it is easier to look for certain subjects – follies, for example, or footpaths – that may interest you. Numbers in *italic* refer to illustrations Numbers in **bold** refer to principal entries in the text Numbers in ***bold italic*** refer to notes [Figures in square brackets] refer to grid positions on maps

A272 - An Ode to a Road

Text, photographs and design © Pieter Boogaart 2000, 2002, © Pieter and Rita Boogaart 2004, 2011
The moral right of the authors has been asserted

Drawing on p. 91 by Andrew Plumridge and on p. 234 by Nicholas Bentley. Other drawings by Rita Boogaart

An Arundel Tomb, by Philip Larkin reproduced by kind permission of Faber and Faber

Maps by the wonderful Ted Hammond, sorely missed, with additional lettering by Mary Spence

Scanning by Olympic Press, London

Editor: Alexander Fyjis-Walker
Assistants: Jenny Wilson, Barbara Fyjis-Walker and Ava Li
Special thanks to Richard Fyjis-Walker Design editor: James Sutton

First published 2000
by Pallas Athene (Publishers) Ltd, 42 Spencer Rise, London NW5 1AP
Second impression March 2000
Third impression with revisions September 2000
Fourth impression April 2002
Second edition, with new photographs, updatings, revisions, addenda, expanded test and index August 2004
Third edition, further revised, expanded and improved, August 2011

If you would like further information about Pallas Athene publications, please visit our website:
WWW.PALLASATHENE.CO.UK

All rights reserved

ISBN 978-1-873429-86-0

Printed in China

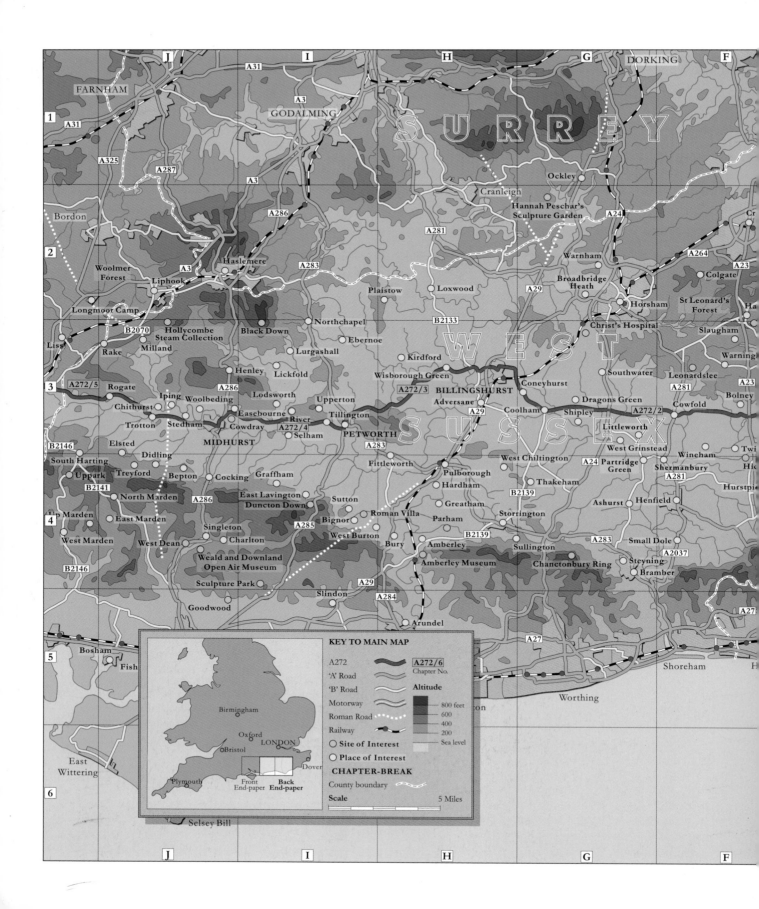

J A31 **I** A3 **H** **G** DORKING **F**

FARNHAM

1 A31

A325

A287

A3

A286

2 Bordon

Woolmer
Forest

Liphook A3 Haslemere A283

Longmoor Camp

B2070

Liss Hollycombe Black Down
Steam Collection
Rake Milland

3 A272/5 Rogate

Chithurst Iping Woolbeding A286

Trotton Stedham Easebourne River
Cowdray Selham
Elsted MIDHURST A272/4

B2146

South Harting Didling

Uppark Treyford Bepton Cocking Graffham

B2141

North Marden A286 East Lavington
Duncton Down

4 Up Marden East Marden Singleton Sutton
Bignor
West Marden West Dean A285 West Burton Roman Villa

B2146 Charlton Bury

Weald and Downland
Open Air Museum

Sculpture Park

Goodwood Slindon A29 A284

5 Bosham Arundel A27

Fish

SURREY

Ockley

Cranleigh

Hannah Peschar's
Sculpture Garden

Warnham A24

Broadbridge
Heath

A281 A29 Horsham

Plaistow Loxwood

Christ's Hospital

B2133

Northchapel

Ebernoe WEST

Lurgashall Kirdford

Henley Lickfold Wisborough Green

Lodsworth A272/3 BILLINGSHURST
Upperton Adversane
Tillington A29 Coolham
PETWORTH SUSSEX
A283

Fittleworth Pulborough

Hardham

Greatham B2139

Parham Storrington

Amberley B2139 Sullington

Amberley Museum Chanctonbury Ring

Coneyhurst

Southwater

A281 A23

Dragons Green

Shipley A272/2 Cowfold

Littleworth

West Grinstead

West Chiltington Wineham
A24 Partridge Shermanbury
Green
A281

Ashurst Henfield

Small Dole A2037

Steyning
Bramber

DORKING

Cr

A264 A23

Colgate

St Leonard's
Forest

Slaugham

Warning

Leonardslee

Bolney

Twi
Hic

Hurstpi

A27

5 Shoreham

Worthing

6

KEY TO MAIN MAP

A272 ~~~~ A272/6
 Chapter No.
'A' Road

'B' Road **Altitude**

Motorway

Roman Road ·········
 800 feet
Railway 600
 400
◯ **Site of Interest** 200
◯ **Place of Interest** Sea level

CHAPTER-BREAK

County boundary

Scale 5 Miles

Birmingham

Oxford LONDON
Bristol Dover
 Front Back
Plymouth End-paper End-paper

East
Wittering

Selsey Bill

J **I** **H** **G** **F**